Love and Loss

Love and Loss

AMERICAN PORTRAIT AND MOURNING MINIATURES

ROBIN JAFFEE FRANK

Yale University Art Gallery New Haven, Connecticut

YALE UNIVERSITY PRESS
NEW HAVEN AND LONDON

Printed in Singapore by C.S. Graphics PTE. Prepress by GIST, New Haven, Connecticut.

LIBRARY OF CONGRESS CATALOGING-IN-PUBLICATION DATA

Frank, Robin Jaffee.

 Love and loss : American portrait and mourning miniatures / Robin Jaffee Frank.

 p. cm.

 Exhibition catalog.

 Includes bibliographical references and index.

 ISBN 0-300-08724-1 (alk. paper) ISBN 0-89467-086-7 (alk. paper)

 1. Portrait miniatures, American—Exhibitions. 2. Miniature painting,
American—Exhibitions. 3. Miniature painting—Connecticut—New Haven—Exhibitions.
4. Yale University. Art Gallery—Exhibitions. I. Title

 ND1333.N49 Y354 2000

 757'.7'09730747468—dc21 00-032084

The paper in this book meets the guidelines for permanence and durability of the Committee on
Production Guidelines for Book Longevity of the Council on Library Resources.

10 9 8 7 6 5 4 3 2 1

CONTENTS

This book is published on the occasion of the exhibition *Love and Loss: American Portrait and Mourning Miniatures,* organized by the Yale University Art Gallery, New Haven. The exhibition and catalogue have been made possible in part by The Henry Luce Foundation, Inc., and a grant from the National Endowment for the Arts, a Federal agency. Additional support has been provided by the Virginia and Leonard Marx Publication Fund and the Mrs. Lelia Wardwell Bequest. Conservation of miniatures was supported by the Getty Grant Program.

EXHIBITION DATES
Yale University Art Gallery, New Haven, Conn.
October 3–December 30, 2000

Gibbes Museum of Art, Charleston, S.C.
February 10–April 8, 2001

Addison Gallery of American Art, Phillips Academy, Andover, Mass.
April 27–July 31, 2001

We are pleased to present *Love and Loss: American Portrait and Mourning Miniatures,* the first book and exhibition to fully explore the strong ties between the history of the miniature and American private life. Miniatures have long been recognized as commemorating highly personal, frequently hidden associations between sitter and beholder. These tokens of love and loss have found their interpreter in Robin Jaffee Frank, associate curator of American Paintings and Sculpture, who organized the exhibition and wrote the catalogue. We owe special thanks to her for pursuing myriad threads of inquiry in an effort to restore to these objects the ties of family and friends that brought them into being. I would also like to express my gratitude to Helen A. Cooper, The Holcombe T. Green Curator of American Paintings and Sculpture, for her unwavering support of this project. In the acknowledgments, Robin Frank thanks the many colleagues, including the Yale graduate student fellows, who have been instrumental in the realization of this exhibition and publication. I can only underscore our appreciation for their important contributions.

We are proud to share *Love and Loss: American Portrait and Mourning Miniatures* with the Gibbes Museum of Art, Charleston, South Carolina, and the Addison Gallery of American Art, Phillips Academy, Andover, Massachusetts. For being such enthusiastic partners, our thanks to the staffs of both institutions, and especially directors Paul Figueroa and Adam Weinberg, and curators Angela Mack and Susan Faxon, respectively.

Above all, we are indebted to Davida Tenenbaum Deutsch and Alvin Deutsch, Esq., LL.B. 1958, whose timely promised bequest to Yale of their distinguished collection of American miniatures significantly enriches this exhibition and publication. Most important to a university museum, by enhancing existing strengths and filling gaps, their bequest makes it possible

to teach the history of the American miniature comprehensively by using the finest examples. This exhibition and publication makes the Yale collection, considered among the finest in the world, accessible for the first time.

But the story of the American miniature would be incomplete without the addition of critical loans of several superb miniatures, important paintings of people making or wearing miniatures, and artists' tools that elucidate the creative process. We are profoundly grateful to our lenders, who have deprived themselves of treasured objects so that we can illuminate the little-understood but rich role that the miniature has played in art and social history.

This project has received crucial and generous funding from The Henry Luce Foundation, Inc., and was supported in part by a grant from the National Endowment for the Arts, a Federal agency. Additional support was provided by the Virginia and Leonard Marx Publication Fund. We are greatly indebted to the Getty Grant Program for supporting conservation treatment of the miniatures. We also thank Allen Wardwell, B.A. 1957, who shortly before his untimely death directed a bequest from his mother's estate in support of the American miniatures project.

Jock Reynolds
The Henry J. Heinz II Director
Yale University Art Gallery

ACKNOWLEDGMENTS

When my colleagues and I first conceived of this book and the exhibition that would accompany it, our goal was to offer a history of American miniature painting using Yale's collection as the armature. The story I tell here benefits from the quality and breadth of that collection, but also is circumscribed by its limits. The generosity of lenders made it possible to convey a fuller picture of the role of the miniature in America, but some important artists are inevitably omitted, and some regions of the country more strongly represented than others. Nonetheless, it is hoped that this in-depth investigation makes accessible previously hidden aspects of a little-understood art form and provides the groundwork for building an even more complete history of the miniature.

It has been a privilege for me to investigate these miniatures and the personal stories behind them over recent years. It is now an even greater joy to share them with a wider audience. This exhibition and accompanying catalogue are made possible through the enlightened generosity of The Henry Luce Foundation, Inc., and I would especially like to acknowledge Ellen Holtzman, who played a key role in encouraging this project from conception. The project is also supported in part by a grant from the National Endowment for the Arts, a Federal agency. Additional funding was provided by the Virginia and Leonard Marx Publication Fund and by Allen Wardwell, B.A. 1957, whose encouragement of the miniatures project continues a family tradition. Mr. Wardwell was the grandson of former Yale curator John Hill Morgan, who, along with his wife, Lelia, during the 1940s gave to the Yale University Art Gallery miniatures of exceptional beauty and significance. The Morgan collection — and the equally notable miniatures given by Francis P. Garvan, B.A. 1897, M.A. (Hon.) 1922, as part of the renowned Mabel Brady Garvan Collection in the 1930s — remain the backbone of Yale's collection. Remarkable for its scope and diversity, that collection continues to grow,

occasionally through selective purchases but primarily through the gifts of loyal alumni and other individuals dedicated to American arts at Yale.

The present exhibition affords the opportunity to present to the public more than a hundred portrait and mourning miniatures principally selected from the Yale collection and from the substantial promised bequest of Davida Tenenbaum Deutsch and Alvin Deutsch, Esq., LL.B. 1958. On a personal level, I am deeply indebted to Davida Deutsch for her exceptional depth of knowledge, generosity of spirit, and contagious love for these objects, gifts that she and her husband have so generously shared with all of us and with future generations.

We are indebted to our lenders for their generosity in parting with cherished objects and thus furthering the study of the American miniature. Gloria Manney and the Gibbes Museum of Art have lent exquisite miniatures from their distinguished collections that are critical to an understanding of the history of this art form. To exemplify the role miniatures played in private life, and the complex processes used to create them, we have received crucial loans of paintings showing people wearing or making miniatures from the Detroit Institute of Arts; the Maryland Historical Society, Baltimore; the Mead Art Museum at Amherst College, Massachusetts; and the New York State Historical Association, Cooperstown; as well as loans of artists' tools from the Museum of Fine Arts, Boston; the New-York Historical Society; the Stamford Historical Society, Connecticut; and the Winterthur Museum, Delaware.

The farsighted generosity of the Getty Grant Program made it possible for the Art Gallery to engage Katherine G. Eirk, a leading expert in the field of miniatures conservation, to treat the watercolor-on-ivory miniatures in the Yale collection. The range and fragility of materials used in miniatures pose unique problems for museum professionals charged with their care. Ms. Eirk collaborated closely with me and my colleagues Helen A. Cooper, Theresa Fairbanks, chief conservator for works on paper, Mark Aronson, chief conservator for paintings, Patricia Garland, paintings conservator, and, on issues involving casework, Patricia E. Kane, curator of American decorative arts. The insight, enthusiasm, and dedication of Katherine Eirk and Theresa Fairbanks made close

examination of these objects an especially rewarding process. It yielded previously unknown information about materials and techniques and led to the discovery of hidden dates, inscriptions, and signatures, in many instances raising and eventually resolving important questions.

It is a pleasure to be able to thank the many people who contributed to this exhibition and catalogue. First, the graduate students, an integral part of the American Arts Office, who served as interns and fellows, receive my heartfelt gratitude. During the past year, curatorial interns Dennis A. Carr and Diane Waggoner provided invaluable assistance in every aspect of the exhibition and publication, and I thank them for their many contributions. For research assistance at various stages in the project, my thanks to fellows Amy Kurtz, Jennifer Harper, Jordana Mendelson, Sarah K. Rich, Jennifer L. Roberts, Laura Simo, Manuela Thurner, Tavia Nyong'o Turkish, and Lyneise Williams. This project has benefited from their multiple perspectives, limitless energy, computer savvy, and sense of teamwork.

At the Yale University Art Gallery, many friends and colleagues assisted me. I greatly appreciate the efforts of Louisa Cunningham and Kathleen Derringer, associate directors; Susan Frankenbach, L. Lynne Addison, and Jennifer Bossman, registrar, associate, and assistant registrar, respectively; Mary Kordak and Ellen Alvord, curator and assistant curator of education, and Linda Jerolman, programs coordinator; John Pfannenbecker and his crew in security and visitor services; and Marie Weltzien, for coordinating public information and press coverage with inimitable grace. In the American Arts Office, Tracie Candelora, administrative assistant, gathered photographs and attended to innumerable details with efficiency and good humor. Bursary students Cynthia Matthews and Ying Tin Li also deserve my thanks for their constant willingness to help.

At Yale University Press, my thanks to Judy Metro and Mary Mayer for their encouragement and trust. I am most grateful to Susan Laity, whose wise and sensitive editorial pen improved the manuscript immeasurably.

For designing a book that responds so sympathetically to the small scale and private purpose of miniatures, my sincere thanks to John Gambell and

Jenny Chan. My appreciation to John Robinson, Frances McMullen, and Tim Nighswander at GIST in New Haven for producing digital photographs that make vivid the painstaking art of miniature painting.

Conveying the private meanings of tiny works of art in a large public space is an impossible task. For accomplishing the impossible, my thanks to Chris Müller for his evocative exhibition design at Yale, enhanced by the subtle lighting effects of Robert Wierzel and multimedia elements by Carol Scully, director of the Digital Media Center for the Arts. I appreciate the efforts of Clark Crolius, coordinator for special exhibitions, Burrus Harlow, installations manager, and their excellent crews.

My work builds on the firm foundation of earlier publications on American portrait miniatures. I am indebted to the scholarship of Carol Aiken, Theodore Bolton, Robin Bolton-Smith, William Dunlap, Davida Tenenbaum Deutsch, Anne Sue Hirshorn, Dale T. Johnson, John Hill Morgan, Martha R. Severens, Susan Strickler, Ruel Pardee Tolman, Anne Ayer Verplanck, Harry B. Wehle and others whose contributions are cited in the notes.

Many colleagues contributed to my thinking about miniatures. For stimulating debates regarding attributions, I thank independent miniatures consultants Sarah D. Coffin and Elle Shushan. For illuminating the role of costume in portraiture, my thanks to Claudia Brush Kidwell, National Museum of American History, Smithsonian Institution, and Nancy Rexford, independent consultant. For making available objects in their care, I thank Carrie Rebora Barratt, Metropolitan Museum of Art, New York; Andrew Connors, formerly of the National Museum of American Art, Smithsonian Institution; Derick Dreher, Rosenbach Museum and Library, Philadelphia; Jeannine Falino and Erica E. Hirshler, Museum of Fine Arts, Boston; and Angela Mack, Gibbes Museum of Art, Charleston. For sharing information, I thank Carol Aiken, independent miniatures conservator; Anne E. Bentley, Massachusetts Historical Society, Boston; Alice S. Creighton, Nimitz Library, U.S. Naval Academy; C. Patton Hash, South Carolina Historical Society, Charleston; Ellen G. Miles, National Portrait Gallery, Smithsonian Institution; James W. Tottis, Detroit Institute

of Arts; Kristen Weiss, Peabody Essex Museum, Salem, Massachusetts; and John Wilson, formerly of the Cincinnati Museum of Art.

My greatest and most treasured intellectual debt is to Helen A. Cooper, The Holcombe T. Green Curator of American Paintings and Sculpture at the Yale University Art Gallery. I began my curatorial training in American arts as a fellow working under her direction and, so many years later, I have pursued this topic under her sagacious eye. She remains my best critic, supporter, and friend. I would also like to express my gratitude to Jules D. Prown, Paul Mellon Professor of the History of Art Emeritus, who first introduced me to American art history and material culture, and set a standard of excellence for the field. I also owe special thanks to Jock Reynolds, The Henry J. Heinz II Director of the Art Gallery, for his energetic support and encouragement for this project.

I reserve my final thanks for my husband, Robert, and son, Jared. Writing this book about potent tokens of love often took me away, physically and mentally, from those I love most. For waiting for my return with patience and understanding, I dedicate this book to them.

Note to the reader Unless otherwise indicated, all miniatures are reproduced at actual size, although details are all enlarged. Works in the Yale University Art Gallery are designated "Yale" in the figure captions, while miniatures belonging to the Promised Bequest of Davida Tenenbaum Deutsch and Alvin Deutsch, LL.B. 1958, in honor of Kathleen Luhrs, are designated "Promised Deutsch Bequest." Complete information on each work illustrated appears in the List of Illustrations.

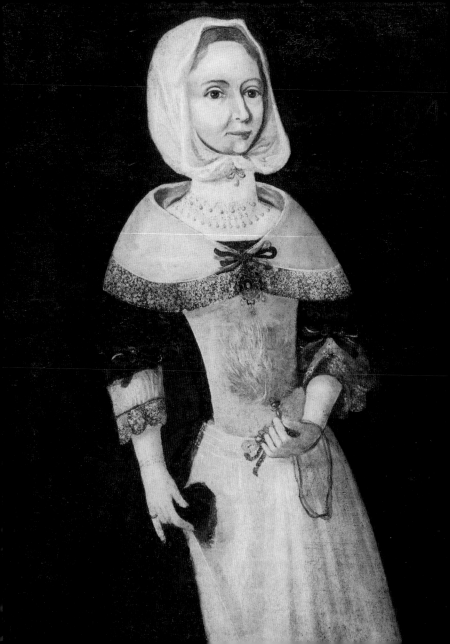

Introduction

The portrait miniature stands apart from any other art form in its highly personal associations. Whereas easel portraits present a public self meant to face outward, portrait miniatures reveal a private self meant to face inward. Stepping back to see a full-scale portrait in its entirety provides a fundamentally different experience from bending toward a miniature to see details. Both portraits may faithfully record the features of a child, a lady, or a gentleman, but the larger portrait was intended to be displayed on the wall while the smaller version was meant to be worn or cherished in private. Like the less costly and more ubiquitous wallet photograph today, the miniature was portable. Painted upon commission, frequently on the occasions of births, engagements, marriages, deaths, and other joinings or separations, miniatures were often substitutes for an absent loved one. These tiny objects are weighted with meanings, telling us in material form how individuals responded socially to joy and bereavement. As such, they invite inquiry into the particular bonds between sitter and beholder that they were made to commemorate, and by extension into a lesser-known aspect of American private life.

The European miniature tradition inherited by the American colonists had gradually evolved from medieval manuscript illumination. The term *miniature* actually derived from the name of the red lead ink, *minium*, used to ornament manuscripts, and was a reference to technique rather than size. Painted in watercolor on vellum, the ornamentation sometimes included a small-scale portrait of the patron either praying or presenting the sacred text to a saint. In the sixteenth century the French artist Jean Clouet, possibly the first to paint such portraits as illustrations in roundels, further detached the devotional portrait from the manuscript page, creating a separate work of art.[1] To make portrait miniatures, also known as limnings, artists applied pigments ground in a water-based gum solution to vellum attached to a card.

Despite its origins in France and Flanders, the portrait miniature was produced sporadically on the Continent, but in England it became a unique art form that can be traced continuously through some four hundred years of history. During the late sixteenth and early seventeenth centuries watercolor-on-vellum limnings became a British specialty, exemplified by the works and writings of Nicholas Hilliard, portraitist to Queen Elizabeth, who painted miniatures to commemorate honors and to mark important relationships.[2] In addition to limnings, oil-on-copper miniatures, often termed portraits "in Littell"— a technique introduced to England by Dutch painters before the mid-sixteenth century — offered a less fragile alternative. Not only the aristocracy but also the gentry and middling ranks commissioned miniatures.

European settlers brought with them to the New World little portable portraits that served as records of ancestors as well as mementos of family and friends left behind. A colonial family's miniatures were treasured possessions, esteemed for their fine craftsmanship and for the memories they evoked. Many of these heirlooms were probably set in jewelry or protected in boxes; they were painted in watercolor on vellum or oil on copper. A large-scale oil portrait of 1664 from the New England colonies, which depicts a child wearing a shawl fastened with a miniature housed in an early seventeenth-century English style locket, offers evidence of the value placed on such remembrances (fig. 1).[3] Specific information on British and other European miniatures transported to the colonies by artists and other settlers is scant, but they may have provided models to local artists.

For a period of about a hundred years, beginning around 1740 and increasingly after the Revolution, Americans craved new images, many of them painted in the contemporary method of watercolor on wafers of ivory sliced from tusk or whalebone. Venetian artist Rosalba Carriera introduced the innovative support, but it was mastered and popularized in England by Bernard Lens III, whose

1. (overleaf) Unidentified artist, *Elizabeth Eggington,* 1664, oil on canvas, Wadsworth Atheneum, Hartford, Conn.

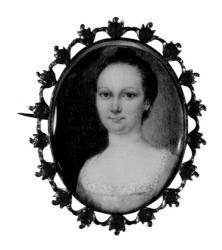

2. Mary Roberts, *Woman of the Gibbes or Shoolbred Family,* 1740-50, Carolina Art Association, Gibbes Museum of Art, Charleston, S.C.

earliest known miniature in watercolor on ivory is *The Reverend Dr. Harris* (1707; Yale Center for British Art). Mary Roberts, an artist who was born and trained in England, probably painted the first ivory miniatures made in America in Charleston, South Carolina, during the 1740s (fig. 2). The first miniature known to have been painted by an American-born artist is a self-portrait by Benjamin West limned in 1758 or 1759 (see fig. 24), which will be discussed in Chapter 2. The majority of American miniatures are limned in watercolor on ivory, but examples in other media (graphite or watercolor on vellum, oil on copper, oil on wood, enamel on copper) reflect the technical diversity of the tradition as it was transported from Europe to America.[4]

The miniature's rise in popularity in the North American colonies in the mid-eighteenth century coincides with both an expanded market economy and a significant shift in social attitudes toward love, marriage, and family. Like large-scale portraits, miniatures generally record the upper classes and upwardly

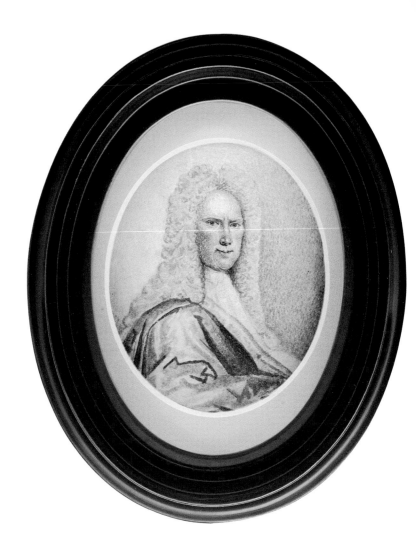

3. John Watson, *David Lyell*, c. 1715–25, Yale.

mobile middle classes, which included the landed gentry, merchants, and professionals, although the range of sitters varied from artist to artist, within regions of the country, and over time.[5] Affluence among these groups contributed to the demand for luxury goods like miniatures that could adorn both the home and — worn as lockets, brooches, or bracelets — the homeowners' wives and daughters. Although colonial artists like John Watson created miniatures on vellum earlier than mid-century (fig. 3), there was no precedent for such a high consumer demand for miniatures of any media.

In the decades immediately preceding the Revolution, English taste was highly prized in the colonies, especially among the established and aspiring elites. And the popularity of miniatures in America coincides with a revival of interest in them across the Atlantic for similar social reasons. In the 1760s the desire for miniatures in England was further fueled by the establishment of the Society of Artists in London and the public exhibition of miniatures in conjunction with full-scale oil portraits at the Royal Academy. American artist Charles Willson Peale exhibited miniatures with the society in 1768 when he was visiting London to study with Benjamin West.

The growing clientele for miniatures in the colonies was less numerous than that in England, and it was concentrated in urban centers. In fact, as we shall see, throughout much of the hundred-odd years that the miniature retained its popularity in America, the world in which it resided was quite circumscribed. Individuals linked by kinship and social ties often commissioned miniatures from the same artists and exchanged and viewed these intimate portraits within the boundaries of their immediate circles. Miniatures crafted identities, elevated status, and cemented social bonds, giving a public gloss to a private art.

Choosing the miniature, an art form associated with the English court, offered sitters the patina of established wealth, of families for whom the tiny portraits represented heirlooms of a distinguished line. But upward emulation of the English or the local elite does not fully account for the felt need for miniatures. Often housed in jewelry and painted on ivory, their preciousness not only satisfied a superficial desire for valuable goods but also expressed a deeper wish to carry a picture of a loved one. Portraits in any medium or size communicate

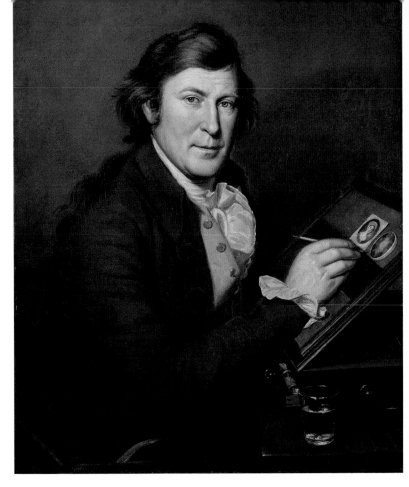

4. Charles Willson Peale, *James Peale Painting a Miniature*, c. 1795, oil on canvas, Mead Art Museum, Amherst College, Amherst, Mass.

cultural values, and miniatures resonate with the greater value placed upon sentiment in an era newly enthralled with family life.

The classes that generally commissioned miniatures are the same groups most affected by the profound evolution beginning around 1760 in relationships between the sexes and the generations. The vogue for exchanging miniatures to mark life's passages — from birth to death, marriage to mourning — reflected the culmination of decades of change in how husbands and wives, as well as parents and children, interacted. Whereas "distance, deference, and patriarchy" characterized marriage before about 1760, after that the "companionate marriage" featured stronger familial bonds within the nuclear family and less association of sexual pleasure with sin and guilt.[6] When choosing a partner for life, compatibility weighed heavily in the decision, balanced by economic and social considerations. In the second half of the eighteenth and the early nineteenth century, these more affectionate couples raised their children in a less authoritative manner than previous generations. Miniatures celebrated this greater enthusiasm for romantic and familial bonds.

The growth of increasingly private, child-centered families made loss harder to bear and contributed to the miniature's popularity as a token of mourning. Mourning miniatures in America, inspired by European — especially English — examples, served to ease the grief of family members at the death of a loved one. Additionally, memorials made to commemorate the death of George Washington led to a new, public function for the mourning miniature. But most commemoratives, whether posthumous portrait miniatures or tiny scenes of weeping mourners, were private tokens that emblematically kept the absent family member within the circle of the living.

The physical characteristics of miniatures embody their role as substitutes for the beloved. Portrait miniatures are composite objects classified as both paintings and decorative arts. A disassembled miniature (fig. 5) reveals the complexity of its parts. Usually small enough to hold in the palm of the hand, these personal portraits of friends or loved ones were traditionally painted in watercolor on thin disks of ivory.[7] In a portrait (fig. 4) showing one of the finest miniaturists, James Peale, at work, the painter's furrowed brow and intense gaze make us feel that we

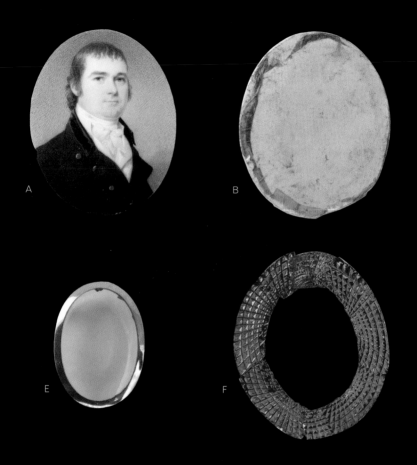

5. Robert Field, *Benjamin Frederick Augustus Dashiell,* 1803, Yale (objects reduced from actual size). Disassembled miniature. The portrait painted on a thin sheet of ivory (A) was attached to a card made of laid paper, with goldbeater's skin still visible on the edges (B), which was used to dust-seal the portrait into the convex cover glass framed by a thin, gold-over-copper bezel (C), which protected the portrait. These three elements formed one group on the front of the miniature.

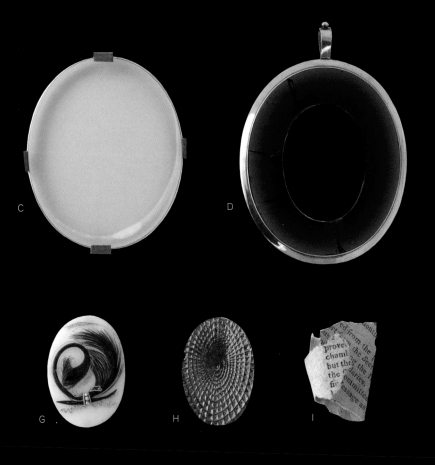

The reverse of the locket consisted of a cobalt-glass surround, set into a bezel, set into the gold-over-copper rim, with a strap bail (hanger) and ball finial (D); a protective convex glass (E) that has cut teeth inside its bezel to secure it into the cobalt-glass surround; sections of pressed foil covered with magenta-toned coating (F) that, when placed behind the cobalt glass, created a radiant effect; a hair ornament decorated with gold wire and half-pearls and mounted on opal glass (G) that was set on top of another foil oval (H). Folded newspaper (I) provided packing to ensure a snug fit of all parts within the case.

are the subject undergoing several tiring sittings. His large hand poised above the diminutive ivory conveys how painting in miniature is made challenging by the constraints of medium and scale.

The ivory oval, attached to a rectangular backing paper that allows the artist to handle the ivory while the paint is still wet, rests beside a tiny palette on the tilted desktop. The ivory's slippery surface, which repels watercolor, necessitated special preparation involving degreasing, bleaching, smoothing, and affixing the ivory to the backing before any color could be applied. The requirements for adding gum arabic (generally used by miniaturists as a binder), water, and sugar candy were all precise.

The artist is holding a small brush called a pencil that—contrary to popular assumption—did not consist of a single hair but rather was full-bodied, with a sharp point. A slightly opened drawer reveals watercolor pigment, which will be moistened by the brush, dipped in the glass of water in the foreground. When a miniaturist finished painting a portrait, he trimmed the backing paper, after which the ivory was set in jewelry so that it could be worn, or mounted in frames of papier-mâché or wood to be hung in a private space, or housed in hinged leather cases that would be carried in a pocket, placed on a table, or secreted away in a drawer. The type of setting varied over time and in response to the function of the miniature.

Many watercolor-on-ivory portraits are housed under glass in finely worked metal lockets, often rose-gold over copper. As seen in the disassembled miniature, the reverse side sometimes incorporates a decoratively arranged lock of the sitter's hair, frequently intermingled with the hair of the person who commissioned the portrait. Unlike flesh, hair survives time and decay. This imperviousness explains its significance in tokens of affection, meant to outlast death, and in commemoratives. Like a fetish, hair has been used to represent love and loss in rituals the world over. In eighteenth- and nineteenth-century America, it was chopped up or dissolved[8] to paint mourning miniatures, knotted in bracelets, plaited in lockets, or simply displayed on the reverse of a portrait (figs. 6–9).

Charles Fraser, who recorded the private faces of Charleston's most public citizens, defined miniatures as "striking resemblances, that will never fail to

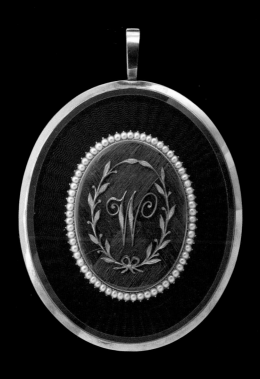

6. Hairwork on the reverse of Attributed to William Lovett, *Lucretia Tuckerman Wier*, c. 1797, Promised Deutsch Bequest, Yale.

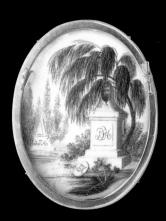

7. Unidentified artist, Landscape on the reverse of *Lady*, c. 1775, painted in watercolor and chopped hair on ivory, Promised Deutsch Bequest, Yale.

8. Unidentified artist, probably with the initials G. K., Memorial on the reverse of *Gentleman*, c. 1820–25, painted in watercolor and natural and chopped hair on ivory, Yale.

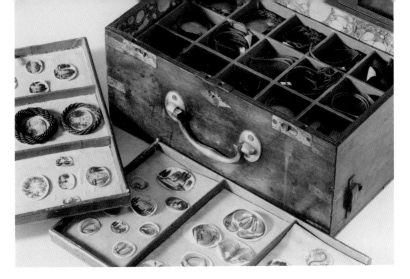

9. Miniaturist's sample case containing braided hair and designs worked in hair on ivory, offered for inspiration to clients, Winterthur Museum, Winterthur, Del.

perpetuate the tenderness of friendship, to divert the cares of absence, and to aid affection in dwelling on those features and that image which death has forever wrested from us."[9] Regardless of whether the sitters' accomplishments remain memorable to us today, the existence of their likenesses in miniature means that somebody cared deeply about them. More often than not the reason was never known publicly or has been lost. We may not even know the identity of the artist, as few miniaturists signed their portraits. Wherever possible, I have endeavored to give back to these miniatures what has been torn from them — the ties of family, friends, authorship, and place that originally brought them into being. Rediscovering the identities of artists and sitters, and understanding the personal associations that miniatures commemorate, returns to them their power to move us.

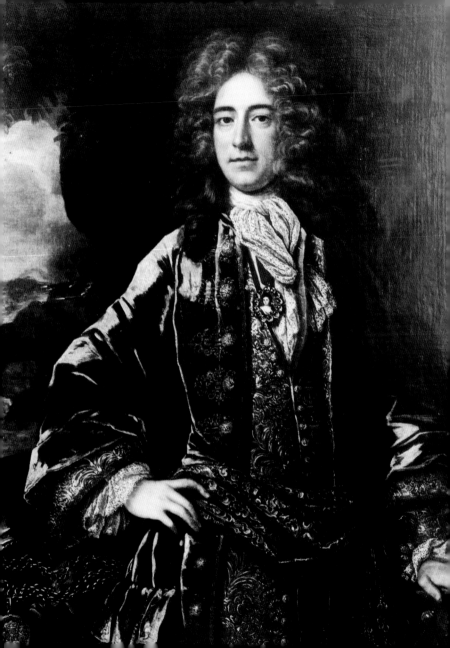

1 Public Display of Private Devotion

Depictions of people wearing miniatures eloquently testify to the personal significance and social function of these tiny mementos. Both sexes were portrayed in miniatures, and both commissioned, collected, and cherished them. However, paintings of miniatures worn as fashion accessories indicate that women were much more likely to engage in such public declarations of private devotion than men. What at first glance appears to be an exception instead proves the rule: a full-scale portrait made in England of Daniel Parke, a Virginia gentleman, with his lace neckerchief deliberately pushed aside to reveal a portrait miniature of a lady (fig. 10). Her visage had political, not personal, import, however. Queen Anne had given her likeness to Parke to thank him for his role as aide-de-camp to the British commander in the victorious Battle of Blenheim in 1704.[1] As an emblem of political allegiance, this miniature anticipates less showy portraits of George Washington that were worn by Americans of both sexes later in the century. Here the expensive, gem-encrusted locket is only one element in a conspicuous display of wealth through costume that includes embroidered velvet, brocade, gold and silver buttons, rings, and chains.

In the later eighteenth and early nineteenth centuries, during the miniature's heyday, gentlemen's clothing became less ostentatious. As men of means developed an aesthetic of understatement, they wore progressively drabber colors, preferred fine tailoring to excessive ornament, and rejected nonfunctional jewelry, which increasingly was deemed effeminate. This gender-prescribed dress code generally prohibited gentlemen from wearing miniatures of private importance openly.[2] Men carried portraits of their lovers, wives, children, and friends in a coat, vest, or breeches pocket, at the waist in closed cases together with seals and watches, or as a pendant around their necks — but hidden under an intricately knotted cravat or other neckcloth. It was the lady's role to publicly

display on her person the family's wealth and affections embodied in one potent symbol, the miniature.

In England the earliest known painting of a miniature being worn by a woman dates from around 1560, during the reign of Queen Elizabeth, and the wearer was herself royalty—Lady Katherine Grey.[3] By the 1570s, miniatures in England had become available to the gentry and those of the "middling rank" as well. But even intimate portraits enclosed in jewels had state significance in the Elizabethan court, where secrecy fueled the intertwined games of political and sexual intrigue. In an oft-told tale, the queen herself snatched one of her ladies' jewels, an enclosed, decorative case that could have concealed a portrait. Discovering a young male courtier depicted within it, she pinned the jewel to her shoe buckle. After the man dedicated a poem to the Virgin Queen, she elevated his miniature from her foot to her elbow, nearer her heart.[4]

Such tales illuminate themes central to understanding the miniature's mystique: the owner has the option, which others may try to violate, of hiding or revealing a portrait; the sitter is presented on a scale that demands intimate viewing; where and how a miniature is worn says something about the relationship of owner, sitter, and beholder; and carrying or wearing a miniature implies possession. Who possesses whom is unknowable, however, and life teaches that the harder we try to possess someone, the more elusive that person can become. Yet it is the longing to hold on to another that made owning the miniature so desirable.

Some fifty years after Lady Katherine displayed her devotion to husband and child, Anne of Denmark, the wife of James I, further popularized the fashion of wearing miniatures. In picture after picture, she appears adorned with jewels, which often enshrine images of her son Henry, who died in infancy. Miniatures marked rites of passage, elements of the human condition that royalty shared with the rest of humanity.

In the mid- to late eighteenth century, Queen Charlotte was probably the English royal with the most publicized passion for wearing miniatures. In a 1763

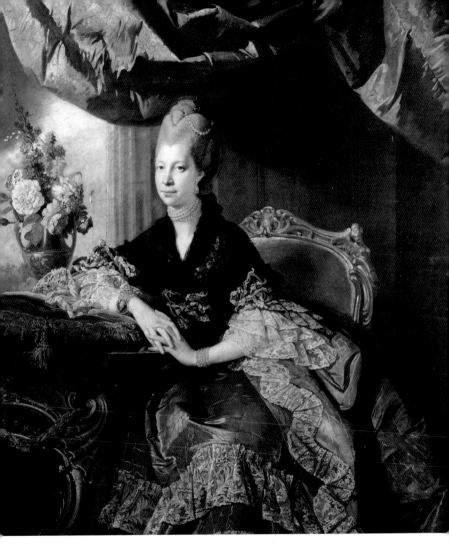

11. Johann Zoffany, *Queen Charlotte*, 1771, oil on canvas, The Royal Collection © 2000 Her Majesty Queen Elizabeth II.

painting (Holburne Museum, Bath), she wears a miniature of King George III, set in a bracelet of pearls, that she had just received from him as a wedding gift, while on her other wrist the impression of another miniature can be detected beneath her glove. The miniature of the king again graces the queen's arm in a portrait painted eight years later (fig. 11), demonstrating her continued fidelity to the sovereign who also demanded the allegiance of his subjects in England and the colonies. Such portraits were highly effective tools of propaganda: the miniatures helped create an image of the queen as a loyal wife that balanced the human and the regal.

This portrait of her adorned with the king's image most likely was distributed in the North American colonies by means of engravings, which by the mid-eighteenth century were being used to transmit European culture, in pictures as well as fashions, and by implication, European loyalties.[5] The popularity of the miniature as a predominantly female fashion accessory demonstrating fidelity traveled across the Atlantic but had less impact on political attitudes: colonists resisted their English rulers while embracing their sense of style.

In the years before the Revolution, portraiture was preeminent among the fine arts in the North American colonies. Large-scale paintings, miniatures in various media, drawings, and prints had been brought to the colonies by the first European settlers, who turned to fellow immigrants as well as American-born artists to create new images. During the war, the demand for large-scale portraits had understandably declined; it resumed in the more settled conditions and recovering economy of the 1780s. Charles Willson Peale, with John Singleton Copley the best of the American-born portraitists, continued to paint miniatures during the war, and in its aftermath recorded in full-scale paintings the miniature's role as a powerful form of female adornment — marking a renewal of both the economy and family life.

One of Peale's clients was Walter Stewart (fig. 12), an Irishman who immigrated to America in 1776 to receive a commission as captain of the Third Pennsylvania Battalion. By the time Peale painted his portrait in 1781, Stewart had risen rapidly to the position of colonel in charge of the Thirteenth and Third Regiments. Peale captures the confident air of the young man called by some

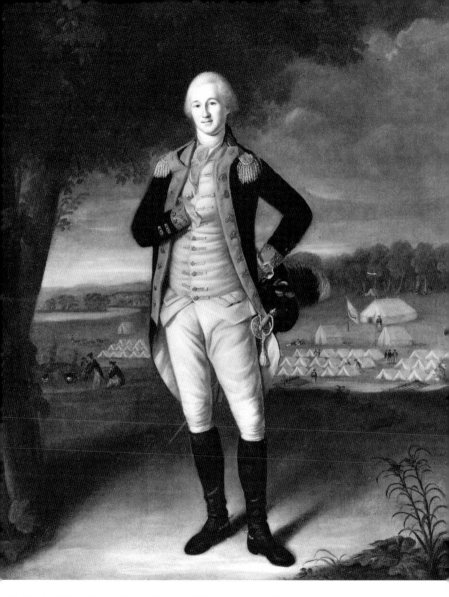

12. Charles Willson Peale, *Walter Stewart*, 1781, oil on canvas, Yale.

13. Charles Willson Peale, *Mrs. Walter Stewart (Deborah McClenachan)*, 1782, oil on canvas, Yale (detail).

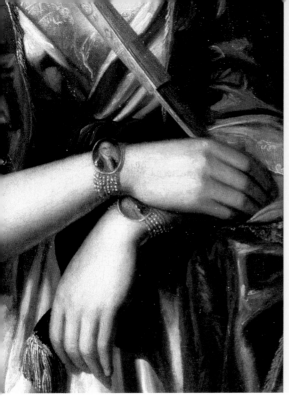

Detail of figure 13. The miniature on Deborah Stewart's proper left wrist is probably a picture of her father; the one on her right, her new husband. With her arms delicately crossed, it is the latter's portrait that overshadows the former, articulating the new allegiance of a woman upon marriage.

envious colleagues "the boy colonel," shown with the encampment of his regiments in the background and the congressional sword of honor worn prominently on his hip.

Stewart married eighteen-year-old Deborah McClenachan in April 1781. He marked the occasion by commissioning a full-scale portrait of her from Peale (fig. 13), completed in 1782, as well as miniatures of the two of them.[6] In the easel portrait we can see the role played by the miniature in verifying important social and personal traits of the sitter. Instruments from swords to quill pens celebrated male sitters' accomplishments in the world, but in portraits of women, artists extolled the sitters' affections at home through the selection of props,

notably miniatures worn as jewelry. In Peale's painting, Deborah Stewart wears miniatures set in pearl bracelets reminiscent of those worn by Queen Charlotte, jewelry that partook of a long English royal tradition, recorded in paintings at least as early as 1720.[7]

In Peale's portrait, the miniature on Deborah Stewart's proper left wrist is probably a picture of her father; the one on her right, her new husband. With her arms delicately crossed at the wrists, it is the latter's portrait that overshadows the former, articulating the new allegiance of a woman upon marriage. The nearly central placement of the miniature in the painting underscores Walter Stewart's central place in his wife's life. Whereas the oil painting would have adorned the home, the miniatures would have accompanied its inhabitants wherever they went. Walter Stewart may have kept his wife's likeness in his vest pocket, close to his heart, while her portrait of him would be displayed as a public declaration of love, wealth, and taste.

In *Mrs. Walter Stewart*, the miniatures are chief among many devices used by Peale to equate his sitter with an ideal of womanhood and define her husband as the perfect provider for such a lady. The fashionable paleness of her skin and ease with which she leans on a pier table convey feminine grace. The circular space behind her, oval frames on the wall, and fruit on the table echo the curvaceous forms of her body. The fine clothing and interior evoke Mrs. Stewart's social station; the paintings, sheets of music, and guitar, her cultured upbringing as the daughter of a well-to-do Philadelphia merchant who, like her husband, came to America from Ireland. Contrasting with the dark recess to her left, the cascading pearls in her hair, glimmering silk of her dress, and transparent lace cuffs and trim of her bodice favorably reflect her husband's wealth, as does his miniature portrait on ivory set in gold and pearls, precious commodities.[8] In their lineage, Revolutionary accomplishments, and mercantile occupation, the Stewarts, friends of George and Martha Washington, exemplified America's new aristocracy. Like others in their class, they adopted the miniature, a fashion born among the nobility in England.

Not only the elite of the new democracy but also its rising middle class were turning to portraits and portrait miniatures to define their members' new

status. Not surprisingly, these sitters, too, wished to be identified with the appropriate portrait symbolism. Mezzotint prints transmitted from Europe provided largely untutored painters with time-honored gestures and props. Throughout the seventeenth, eighteenth, and early nineteenth centuries, most couples desiring to be memorialized would commission paired portraits on canvas. Those of Dr. and Mrs. Hezekiah Beardsley (figs. 14 and 15) characteristically show the husband and wife equal in size and visual importance but differentiated by gender-specific attributes.

Fruit, a pervasive emblem of fertility (it appears in the portrait of Deborah Stewart as well), strikes a poignant chord in the portrait of Elizabeth Beardsley, the wife of a New Haven pediatrician who never bore children of her own, although she and her husband did raise her niece. The unidentified artist, known only as the Beardsley Limner, probably knew his patrons well, for Dr. Beardsley sold painters' colors at his drugstore on Chapel Street. Reflecting the artist's familiarity with his subjects, the attributes in their portraits are at once conventional for the era and particular to the couple. Alongside the familiar apples are pears, which were considered a luxury, like the miniature made of precious and perishable materials suspended from Mrs. Beardsley's neck on a simple black cord. The capable painter of the full-scale portraits may have also limned the actual miniature, which is recorded in Dr. Beardsley's will.[9]

Comparing the full-scale portrait of Mrs. Beardsley with that of her husband clarifies the significant part played by the depicted miniature in gender definition. The same table that supports fruit in her image in his holds a writing quill, paper, and volumes 4 and 5 of Edward Gibbon's *Decline and Fall of the Roman Empire*, recently published histories that were exciting controversy. Seated beside the table, Hezekiah Beardsley holds volume 3, signifying his involvement in contemporary intellectual issues debated by the larger community. Seen through the window, the distant landscape evokes the breadth of his accomplishments and interests, in contrast to the fenced garden in his wife's portrait that defines the limits of the domestic sphere.

While typical of parlor gardens of the 1780s, the enclosed garden is also conventionally associated in art and literature with the most sanctified image of

14. The Beardsley Limner, *Dr. Hezekiah Beardsley,* between 1788 and 1790, oil on canvas, Yale.

15. The Beardsley Limner, *Mrs. Hezekiah Beardsley (Elizabeth Davis)*, between 1788 and 1790, oil on canvas, Yale.

16. Philip Mercier, *A Woman in Love* (also known as *Peg Woffington*), c. 1735, oil on canvas, The Garrick Club, London.

woman in Western art, the Virgin Mary. Women, especially in their roles as wives and mothers, were regarded in the new republic as a primary civilizing force, as John Adams declared: "National Morality never was and never can be preserved without the utmost purity and chastity in women; and without national Morality, a Republican Government cannot be maintained."[10]

The Beardsley Limner reflects the assumptions of his time by presenting Mrs. Beardsley as a guardian of domestic industry and republican virtue. The nation — and particularly the state of Connecticut — was often compared to "a well cultivated garden, which, with that degree of industry that is necessary to happiness, produces the necessities and conveniences of life in great plenty."[11] To characterize those values in a universally understood language, the artist

colors his secularized vision of a contemporary domestic interior and exterior garden with muted quotations from religious paintings, particularly of the Madonna.

The open book on Mrs. Beardsley's lap may further recall scenes of the Virgin, who was usually depicted reading a devotional book in Annunciation paintings. While having no precise theological meaning in *Mrs. Beardsley*, the imagery of the book more generally links the sitter with such qualities as purity and dedication to all that is considered good, including the holiness of marriage. For innumerable artists and writers, the opening of a book also represents the opening of the self to another: as Orsino tells Viola in Shakespeare's *Twelfth Night*, "I have unclasp'd / To thee the book even of my secret soul" (1.4.13–14). In that sense, Mrs. Beardsley offers her whole person — body, mind, and spirit — not only to God but also to her husband, pictured in miniature over her heart.

The dog seated at her knees symbolizes fidelity. His gaze pointedly directs our attention to the miniature of Dr. Beardsley, to whom, along with God, Mrs. Beardsley has vowed her loyalty. The coupling of a miniature with a dog in images of eighteenth- and early nineteenth-century womanhood was a leitmotif reflecting the constancy in love required of both women and men (but perhaps less expected of the latter). In a British painting (fig. 16), a lady and sad-eyed dog pine together for an absent gentleman, whose portrait she holds in her hand. Like the dog, the miniature is an emblem of her faithfulness.

A miniature scene, painted with watercolor and chopped hair, of a lady carving in a tree while two dogs rest at her feet embodies this romantic sensibility (fig. 17). Declaring one's love by writing the beloved's name on a tree typifies youthful infatuation. The practice also has a venerable history in romantic art and literature. Perhaps the most frequently illustrated passage from the sixteenth through the nineteenth centuries comes from Ariosto's *Orlando Furioso*, an epic poem in which two lovers inscribe their names on every tree and stone they can find. Also popular was Shakespeare's *As You Like It*, in which Orlando confesses his secret love for the duke's daughter: "O Rosalind, these trees shall be my books, / And in their barks my thoughts I'll character" (3.2.5–6).[12] In the allegorical miniature, as in Shakespeare's play, the tree serves as the book of love —

ROMANTIC ALLEGORIES IN MINIATURE FREQUENTLY CELEBRATED
A SECRET LOVE. THE LOVERS SEALED THEIR COMMITMENT
NOT BY PUBLICLY EXCHANGING MARITAL VOWS BUT BY PRIVATELY
EXCHANGING MINIATURES.

17. Unidentified artist, *Romance Allegory*, c. 1795, Yale.
18. Unidentified artist, *Friendship or Romance Allegory*, c. 1785–90, Yale.

a natural equivalent to the open book on Mrs. Beardsley's lap. The tree also denotes the pastoral setting indispensable in art and literature for extolling the joys of true love, unlike the cultivated parlor garden in *Mrs. Beardsley* that suggests a passion constrained and sanctioned by social conventions.

Romantic allegories in miniature frequently celebrated a secret love. The lovers sealed their commitment not by publicly exchanging marital vows but by privately exchanging miniatures. The miniature of the woman carving her name is placed in a bracelet setting and therefore was worn by a woman. As the classically garbed figure may personify love, rather than serving as a stand-in for an individual, the bracelet might have been given by a man to a woman. Or a lady might have given it to a much-loved female friend. Similarly, a rose-gold stickpin showing two birds perched on a basin painted in dissolved hair on ivory (fig. 18) could have been exchanged between admiring friends or lovers of either sex. A comparable token (Victoria and Albert Museum) is explicitly labeled "LAMOUR."[13] In the scene of the woman carving initials in a tree, the faithful canine companions alone shared the secret held in the heart of their mistress.

In allegories of both romance and mourning limned in miniature, the image of a dog testifies to a couple's undying devotion (fig. 19). Such popular conceits inform each other, so that the presence of a dog in portraits of the living implies fidelity not only in this life but also in the hereafter. The dog in the companion portraits of Dr. and Mrs. Beardsley represents a mutual pledge. In fact, not long after these portraits were painted, husband and wife died, within two weeks of each other.[14]

Whereas the portraits of Mrs. Beardsley and Mrs. Stewart both celebrate marital intimacy, neither sitter relates intimately to the viewer. Neither beckons us forward, welcoming us as friend or family member, to see at close range the miniatures they wear of their husbands. By contrast, Charles Willson Peale invites us to become more intimately acquainted with Mary Tilghman, whom he was courting, for in his painting of her she has just removed the ribbon tied at her neck to hold up for our approval a locket portrait, recently limned by him, of her niece (fig. 20).[15] Personal jewelry frequently enshrined various family members, especially children, reflecting a new social attitude of the 1760s: an optimistic

19. Unidentified artist, Memorial on the reverse of *Gentleman*, c. 1810,
Promised Deutsch Bequest, Yale.

sense of the child as inherently good rather than tainted by original sin that expressed itself in more nurturing childrearing practices.[16]

With a growing awareness of the transience of each phase of child development, adults treasured the uniqueness of the moment in portable portraits. In Peale's painting, the child's figurative placement over her aunt's heart indicates a centrality in her affections. The artist conveys the rapport he felt with Mary Tilghman — or "Miss Molly" as he called her — who simultaneously shares her pride in Peale's talent and her feelings for her niece. The viewer experiences a moment of communion with the miniature's young subject as well as with the lady who cherishes her portrait — allowing us to trespass between public and private, a precarious terrain defined by the display in public of a private token of affection worn on the body.

Other wearers conceal the face on the miniature, valuing the power of possession afforded by smallness. In picture after picture, the lady intentionally excludes the viewer from her inner circle by showing only the miniature's covering case or its reverse, or hiding the whole locket beneath her clothing. In an early nineteenth-century pastel by an untrained artist working in Virginia (fig. 21), the miniature case worn by Sarah Bell on a gold chain is reversed to show an oval of blue glass surrounding the letter "C" fashioned in hairwork. Its significance remains a mystery, like an initial inscribed by a lover in a tree. Rather than falling naturally between the sitter's breasts, the pendant hangs awkwardly over the one closest to the viewer, tempting us to dare turn it over to unmask the face. The fragile rosebud held in Sarah Bell's hand equivocally alludes to both love and loss. In Peale's *Henrietta Maria Bordley* (1773, Honolulu Academy of Arts), depicting the sister of two boys who were represented in miniatures by him (see figs. 28 and 29), the teasing trail of a black ribbon disappears beneath the little girl's bodice. A scholar familiar with the family's history conjectures that the unseen miniature depicts the child's dying mother — but we can never know for certain. In many paintings of adult women, the black cord drawing the eye from an exposed throat to a lace-covered bosom concealing a portrait alluringly implies romance.[17]

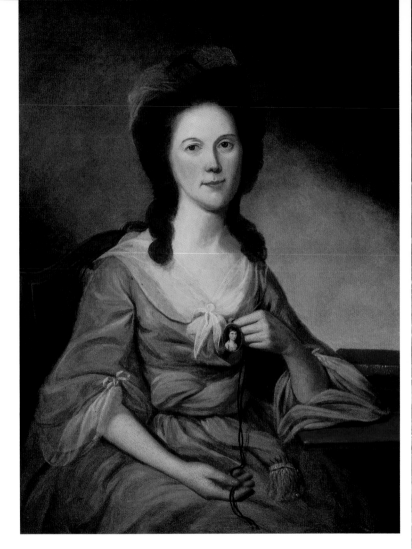

20. Charles Willson Peale, *Miss Mary Tilghman (Mrs. Edward Roberts)*, 1790, oil on canvas, The Maryland Historical Society, Baltimore.

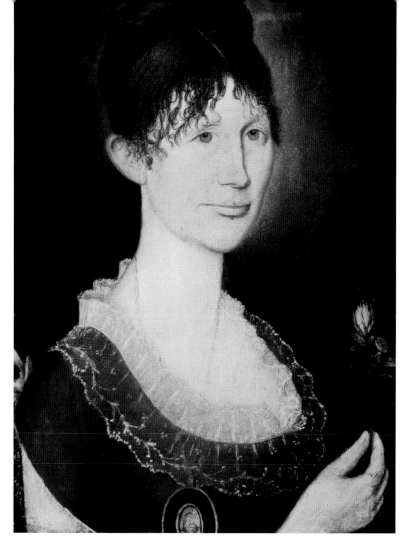

21. Aldridge (or Oldridge), *Sarah Bell,* c. 1808, pastel on paper, Abby Aldrich Rockefeller Folk Art Center, Williamsburg, Va.

More tantalizing than a full-scale portrait of a sitter protecting the identity of someone cherished in miniature is a miniature tempting the viewer with the same conceit (fig. 22). The diminutive size of the locket cupped in our hand intensifies the possessive power of the beholder's gaze. But the encoded information frustrates the voyeuristic impulse, for the secret was not meant to be decoded by someone unfamiliar with the players and the language that they speak. On one side of the locket, beneath the lens surrounded by a bright-cut fillet, a young lady with curly brown hair and blue eyes is pictured wearing a tiny necklace, its case decorated with a heart. In the fiction of the image, a portrait of the man for whom she feels such emotion lies on the hidden side of the depicted locket. His name and hers remain lost but, like Dr. and Mrs. Beardsley, they clearly hoped their love would outlive death.

Turn over the real locket (fig. 23), and that hope is carried through time by an image of a willow, below which a gentleman leans on a monument inscribed "OB/DEC.ᴿ/1792/AE/28/yrs." The initials "E. P." on the urn probably belonged to the lady, as did the brown hair surrounding the memorial scene. The gentleman who grieved for this lady was removed in time, place, and social stature from Queen Anne of Denmark, who also carried her broken heart in miniature form by wearing portraits of her much-mourned son. But the same longing to keep the dead within the circle of the living motivated both the queen and the anonymous owner of this simply limned American miniature.

Unlike many full-scale portraits, miniatures were intended for private viewing by the most intimate circle, the initiated who knew the story behind the portrait. A miniature usually descended in the family of the sitter: after the person who first held and wore it died, the miniature would be inherited, perpetuating family continuity and testifying to the devotion that by this means has outlasted a lifetime. Of course, portraits of any scale, including full-size oil portraits, serve to maintain memory. But the smallness of a miniature demands that it be viewed and exchanged in a way that enhances the bond between sitter and beholder not only at the moment it is first given and received but down through the generations.

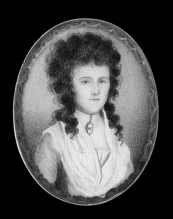

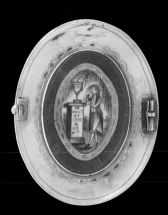

22. Unidentified artist, *Lady, probably with the initials E. P.*, 1792, Promised Deutsch Bequest, Yale.

23. *Memorial for E. P.*, reverse of figure 22.

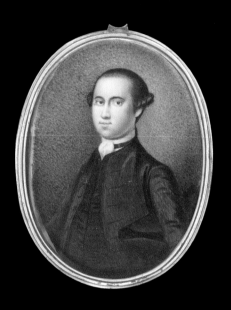

24. Benjamin West, *Self-Portrait,* 1758 or 1759, Yale.

In 1758 or 1759 Benjamin West, then a struggling young artist, limned his self-portrait, housed it in a silver locket, and offered it to Elizabeth Steele of Philadelphia, along with a proposal of marriage (fig. 24). She accepted the love token but not the hand of the man who painted it. Soon afterward, West left America for good, finally settling in London, where he became president of the Royal Academy in England and the most widely recognized American artist of his generation. Yet the tiny portrait he painted had significance beyond its purpose as a love token, for it is the first watercolor-on-ivory miniature known to have been made by an American-born artist, and it heralded an art that was to become increasingly popular in the North American colonies. Much of that popularity derived from the work of two other celebrated American-born artists, Charles Willson Peale, who painted some of his first miniatures under West's tutelage in London, and John Singleton Copley.

The story of West's miniature reveals much about the way early Americans viewed these personal tokens — and their makers. For West was to encounter his self-portrait again, more than sixty years after Elizabeth Steele rejected his proposal. In 1816 her son-in-law John Cook arrived at the London studio of the successful, happily married artist. West's studio had become a pilgrimage destination for American artists as well as other citizens for whom he embodied cultural attainment. Visitors from Philadelphia, like Cook and those accompanying him, were common. (West himself had been born in nearby Springfield, Pennsylvania.) By way of introduction, Cook presented the miniature.

The visitor recalled in his journal that West regarded the miniature as "a very great curiosity" and identified it as the self-portrait he had offered Elizabeth Steele. He declared, "Well I remember it. I was then 18 years old, and there is something more about [it] you may not know, and that is we were very much in

love with each other.... Rebecca Steele, her mother whose memory I honor, did not like my intended profession."[1] No father is mentioned in this account, perhaps indicating that Rebecca was a widow. Her concern for her daughter's future security was understandable at a time when portrait painters, like cabinetmakers and silversmiths, were perceived by society as mere tradesmen. A colonial painter often supplemented his income with mundane work in related fields and traveled from city to city, staying for months or longer in search of commissions. In fact, West explained to Cook that he had given the miniature to Elizabeth before leaving Philadelphia to paint portraits in New York.

In accordance with West's wishes, Cook had the silver case housing the portrait inscribed on the reverse: "Benj.ᵗ West./Aged 18./Painted by himself/in the year 1756./& presented to Miss Steele./of Philadelphia" (fig. 25). West incorrectly remembered the date of his New York trip, which is believed to have taken place in 1759, making the probable date of the miniature 1758 or 1759.[2] His love rejected, West traveled to Italy after his New York commissions before settling in England, where his meteoric career has been well documented.

Elizabeth Steele's life remains a mystery. Cook's account reveals only that she later married a Mr. Wallace, with whom she presumably had at least one daughter, who married Cook. In the absence of many civic and church records from mid-eighteenth-century Philadelphia, the diary of a local Quaker provides a rare glimpse into that city's social life. The entry for November 4, 1760, records that "Betsy Steel married on seventh day last to James Wallace, a Scotchman." However, the minutes of the Monthly Meeting of Friends for the "27th of 2nd mo. 1761" declare: "Elizabeth Wallace, late Steel, of this City, disowned, hath married contrary to Rules of Discipline."[3] During the same meeting, four other Friends met the same fate for breaches in marriage regulations. Disownment had become a common punishment for even minor transgressions of the rigorous codes during the years 1755 to 1774, the height of Quaker orthodoxy.

The fact that Elizabeth Steele was a Quaker at the time West presented his love token might have influenced the course of their romance. Scholarly controversy exists as to whether West was ever officially a Quaker. Some of that discussion revolves around interpretations of his modest attire in the miniature. In fact,

BENJAMIN WEST, THEN A STRUGGLING YOUNG ARTIST, LIMNED
HIS SELF-PORTRAIT, HOUSED IT IN A SILVER LOCKET, AND OFFERED
IT TO ELIZABETH STEELE OF PHILADELPHIA, ALONG WITH
A PROPOSAL OF MARRIAGE.

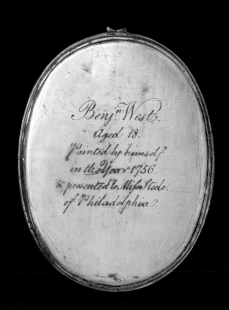

25. Benjamin West, reverse of *Self-Portrait*, 1758 or 1759, Yale.

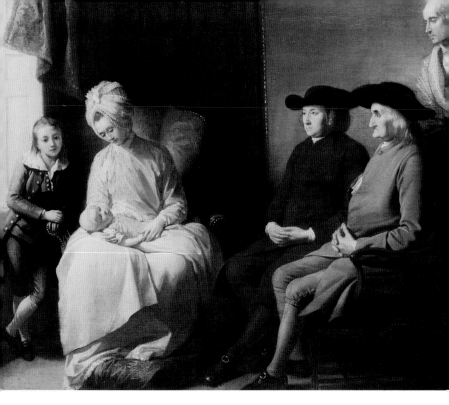

26. Benjamin West, *The Artist's Family*, 1772, oil on canvas, Yale Center for British Art, New Haven, Conn.

West depicted himself in respectable if subdued middle-class dress that might have been that of a Quaker, but not necessarily. True, he wears brown, rather than Quaker gray, but Quakers generally just chose simpler clothes than the fashion; they did not strictly prescribe dress. By appearing in his own hair, West conforms to social guidelines that suggested that craftsmen and artists, as men who worked with their hands, should not wear wigs.[4] However, he does sport a solitaire — the black ribbon around his neck that attached to the cloth bag covering his hair in back. This fashionable touch, practical for an artist, was probably atypical for a Quaker.

The Artist's Family (fig. 26) painted by West in London in 1772, offers clues to his past as well as his future and offers a sharp contrast to the miniature. West's father and brother represent the artist's Quaker past. Their restrained attitude combines with their clothing's sameness of color, lack of sleeve ruffles or ornament, and high-buttoned collars to define them more decisively as Quakers than West's equivocal dress in the miniature. In *The Artist's Family,* West now presents himself, on the far right, holding a palette while garbed in embroidered silks. Distinguished by his clothing as a gentleman-artist, his image accords with the idea promoted by Sir Joshua Reynolds that art was ennobled by "intellectual dignity" and served important social purposes.[5] West wears a changeable-silk loose dressing gown, an expensive, informal costume worn by gentlemen engaged at home in intellectual, spiritual, or creative pursuits.

In an image of womanhood that — like the portrait of Mrs. Beardsley (see fig. 15) — conflates secular domestic harmony with religious imagery, West shows his wife, Rachel, and their new child enthroned Madonna-like on a damask-covered chair and bathed in light as well as her husband and older son's devoted attention. She appears in a contemporary wrapping gown that a woman, especially soon after birth, would wear at home but not in public. By giving this ordinary garment thrown over a petticoat a religious resonance, West pays homage to his wife. Perhaps Elizabeth Steele, who disobeyed Quaker rules to marry James Wallace, should have overcome her mother's objections and married West instead.

Given the artist's relatively impoverished state when he proposed to Elizabeth, it is notable that he painted his self-portrait on ivory of a relatively large size for the period and housed it in a fine silver locket. Naturally, West hoped that she would cherish the miniature by wearing it close to her heart. The locket's hanger, now lost, may have broken from wear. Perhaps — as in many colonial paintings where the sitter conceals a miniature — she kept it hidden underneath her clothing, where James Wallace would not see her former beau's face. Eventually her family inherited the locket, leading to the revelation of her long-ago love as told to her son-in-law by West.

In 1816 West proudly observed to Cook that his self-portrait was not "a bad picture" for one who "had never seen a miniature." West must have had some guidance in the process, given the technical intricacies of painting in watercolor on ivory, the favored medium for English miniatures in London after 1720 but relatively uncommon in the colonies at mid-century. He may have seen examples brought by recent visitors, immigrants, or other artists, read manuals, or heard descriptions.[6] But compared to their European contemporaries, the pioneers of miniature painting in America like West were largely untutored, and their miniatures attest to their hard-won accomplishments.

A drawing (fig. 27) confirms that West planned the composition before he attempted to paint on ivory.[7] Although the self-portrait is the only miniature firmly attributed to him, there are drawings for additional miniatures throughout the sketchbook he used during the mid- to late 1750s in Philadelphia. One of the unidentified young ladies pictured may be Elizabeth Steele; the most likely candidate is the woman West drew directly below his self-portrait. In keeping with the custom of exchanging miniatures during courtship, West may have made a portrait of his beloved for himself.

West's finished *Self-Portrait* reveals his lack of experience in the technical processes of miniature painting. Visible through the lens covering the portrait, the ivory betrays a ragged left edge resulting from his unpracticed efforts to trim it. The ivory is thick when compared to the thin disks used by later miniaturists. The idea, often stated, that ivory replaced the earlier preferred support, vellum, because of its aesthetically pleasing transparency, contradicts the gradual

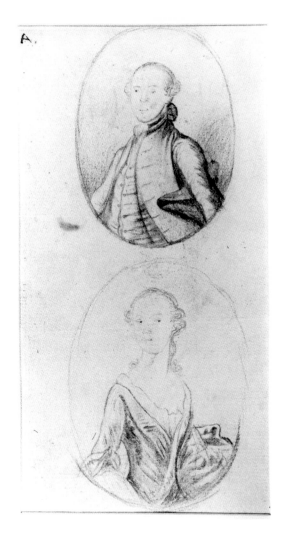

27. Benjamin West, *Self-Portrait Miniature/Miniature of a Woman*, c. 1755-60, pencil on paper, The Historical Society of Pennsylvania (HSP), Philadelphia.

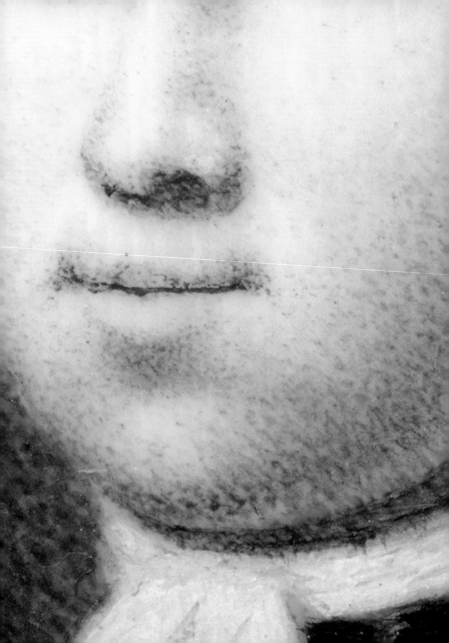

Detail of figure 24. When viewed under the microscope, West's portrait shows a heavy use of stippling, born of necessity. Lacking confidence in his ability to prevent the watercolor from forming puddles on the slippery surface and running, West cautiously applied individual dots. He did not mix colors but rather, as in the vermilion and gray in the cheek, juxtaposed them.

evolution of miniature painting first in England and then America. Initially, the ivory was so thickly cut that it was not transparent.

When viewed under the microscope, West's portrait also shows a heavy use of stippling, born of necessity. Lacking confidence in his ability to prevent the watercolor from forming puddles on the slippery surface and running, West cautiously applied individual dots. He did not mix colors but rather, as in the vermilion and gray in the cheek, juxtaposed them. He used single strokes to form the eyebrows and upper lids of the eyes and narrow, parallel strokes to define the hair and brown coat. Apparently with few tricks of the trade at his disposal, West created this image with painstaking work. His considerable effort resulted in a charming frankness that underscores the seriousness with which the youthful suitor took himself as a man and an artist. A potent symbol of thwarted love, the only miniature that West is known to have painted remained in the possession of only two families, the sitter's and then the artist's, for about 175 years.[8]

But if West painted no more miniatures himself, he was an important influence on another American artist who did. During West's lifetime, artists would escape the cultural backwater of America to flock to his studio for instruction and encouragement. One of these was Charles Willson Peale, who painted his miniature *Matthias and Thomas Bordley* (fig. 28) while he was a student of West's in London between 1767 and 1769.[9] Although only two and a half years older than Peale, West was already emerging as a major history painter and had played a prominent political role in the founding of the Royal Academy, an institution to promote English artists that was established with the approval of King George III in 1768.

Peale's London trip had been financed by eleven subscribers, all wealthy Maryland planters, many of them politically active, who shared a belief that the development of a promising artist's talent would benefit the colony by improving the cultural atmosphere. This subscription was instigated and organized by John Beale Bordley (1727–1804), a longstanding friend of the Peale family and the artist's most abiding patron as well as the father of the boys depicted in the miniature.[10]

West offered Peale access to leading artists and instruction in a variety of media, including etching, mezzotint, and modeling in clay, but from the beginning Peale demonstrated a preference for painting miniatures. One of Peale's patrons wrote from Philadelphia to warn him against concentrating on miniature painting, deeming it less profitable than larger scale portraiture.[11] Nonetheless, Peale persisted, mastering the difficult art well enough to submit pieces to exhibitions in London. Most of the works created by Peale under West's direction have disappeared, making those extant, such as *Matthias and Thomas Bordley*, invaluable to an understanding of Peale's London period.

In Peale's affectionate portrayal of brothers studying together, Thomas Bordley points to a line in an open book held by the younger Matthias. Their studies are watched over by a bust of Minerva, the Roman goddess of wisdom, in the left foreground. In the right background is a large building, perhaps an ancestral home in England.[12] Thomas was the first-born son and the second child, and Matthias the third child out of five born to John Beale Bordley, a Maryland lawyer, planter, and influential agronomist, and his first wife, Margaret Chew (1735–73). In 1767, when Bordley sent the ten-year-old Matthias and the twelve-year-old Thomas to London, he placed them in the guardianship of his younger half-brother Edmund Jenings (1731–1819). Jenings, a London lawyer and diplomat with an independent fortune, first retained a clergyman-tutor for the boys and then sent them to Eton, his own alma mater. In this miniature, the open book and sculptural bust of Minerva refer to their education. Peale combined an innovative informality of pose with an acknowledgment, through symbolism, of the sitters' personal circumstances.

Jenings was Peale's most important patron in London. Shortly after his arrival, Peale wrote to Bordley, "I have waited on Mr. Jenings who received me in a very courteous manner and promised to do me all the services he can." Jenings looked out not only for the Bordley children but also for Peale. In his "Autobiography" the artist recalled that the portrait of Thomas and Matthias was "done at the request of Mr. Edmond Jennings, who had the care of these Children while they were receiving their Education in England."[13]

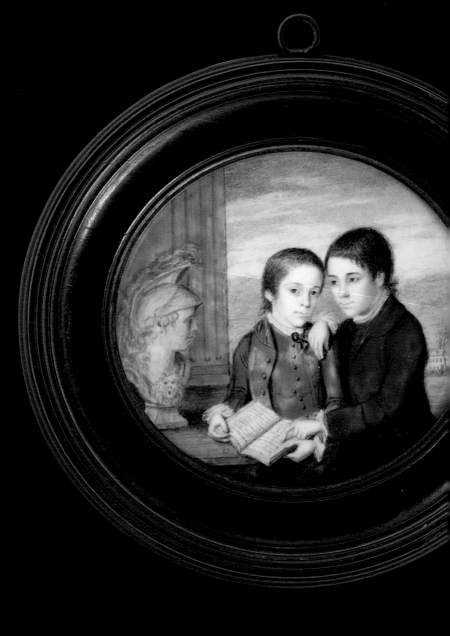

IVORIES OF THIS LARGE SIZE, AS WELL AS DOUBLE
PORTRAITS THAT SHOW THE SUBJECTS AS IF THEY WERE
ENGAGED IN CONVERSATION, ARE EXTREMELY RARE
IN AMERICAN MINIATURE PAINTING.

28. Charles Willson Peale, *Matthias and Thomas Bordley,* between
1767 and 1769, Yale.

In 1768 Peale submitted a miniature of *Two Young Gentlemen* to the Society of Artists' exhibition in London. The exhibited miniature may have been this one or it could have been the version now at the National Museum of American Art, Smithsonian Institution (NMAA) (fig. 29).[14] Miniatures were often commissioned for more than one relation of the sitter(s), and it is not unusual for several versions to exist. The NMAA miniature descended through the Bordley family in America; the other, now at Yale, apparently remained in England. Jenings probably commissioned it for himself or possibly as a gift to other relatives living in England, such as the boys' grandmother, Ariana Vanderhayden Jenings.

Although compositionally similar, the NMAA version has some color variations and differs in the placement of the boys' hands, details of clothing, the proportion and design of the bust of Minerva, and the background. (The miniatures are in nearly identical black-and-gold frames.) In the Yale miniature, graphite lines indicate that Peale considered placing Thomas' pointing finger in the same position as in the NMAA version but decided to move it slightly to the right so that the boy now directs his brother's attention to the beginning of a line of text. Both compositions testified that the boys were spending their time in dutiful and industrious pursuit of their studies and ably conducting themselves in a new environment.

Although Peale pictured both boys dressed elegantly in fine broadcloth, their clothing underscores the difference in their ages in accordance with a new awareness of the stages of child development. The older Thomas wears full adult dress, Matthias a child's neck ruffle. In the Yale version only, Peale further alluded to Matthias's youth by depicting a button on his vest left undone. Matthias may have unbuttoned his vest to allow his hand to slip underneath, a common posture during dance instruction, considered an essential part of an upper-class boy's education.[15] Those who loved him would have recognized the detail as a token of his youthful training for adult life as a gentleman.

Peale also made the bust of Minerva less dominating in the Yale portrait and gave the breastplate a whimsical expression. Such details support the hypothesis that this version was meant for their younger, less authoritarian uncle, whereas their father may have required a more disciplined image of his children.

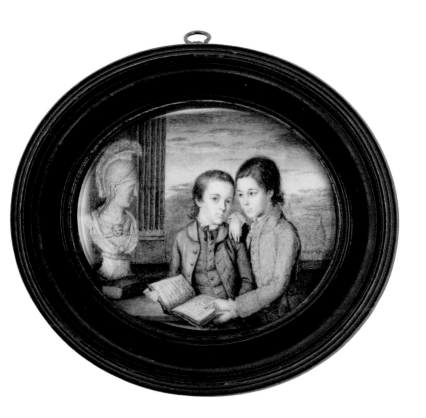

29. Charles Willson Peale, *Matthias and Thomas Bordley,* 1767, National Museum of American Art, Smithsonian Institution, Washington, D.C. (object reduced from actual size).

The variations in these miniatures appear consistent with an artist reinterpreting his own composition, perhaps in response to suggestions from a patron such as Jenings or a teacher, in this notable instance, Benjamin West.

In 1767 Peale wrote Bordley, "I have (God be Praised) Past through the Many Dangers of the Seas and am now at my Studies with Mr. West who... Promises me all the Instruction he is capable of giving.... Mr. West is intimate with the Best Miniature Painter [and] intends to borrow some Miniature Pieces for me to coppy privately as he does nothing in that Way himself."[16] In fact, Peale's ivory is thickly cut, like that of West's early *Self-Portrait* and unlike the thinner supports that were being used by leading miniaturists in London. Peale's double portrait also betrays a heavy reliance on stippling, especially in the features of the faces, comparable to West's technique. That stylistic similarity may owe as much to Peale's hesitancy to employ more refined techniques in this early stage of his training as to West's influence.

Ivories of this large size, as well as double portraits that show the subjects as if they were engaged in conversation, are extremely rare in American miniature painting. Both characteristics may owe something to Peale's exposure through West to "the Best Miniature Painter," who was most likely Jeremiah Meyer (1735–89), the only miniaturist involved in the establishment of the Royal Academy. Meyer's early works had been quite small, but around this time they increased in size to an average of about three inches, and were painted on a more thinly cut ivory with greater technical confidence in a varied linear style that Peale could not yet master.[17] Peale lacked technical experience, but not ambition, as his choice of such a large ivory and inclusion of both sitters in one miniature demonstrate.

In addition, Peale reported in a letter to John Beale Bordley that he had visited the studios of Joshua Reynolds and Francis Cotes, both of whose influence on the full-scale double and family group portraits he executed after his return to America has been noted by scholars.[18] The conversational tone of their paintings, however, is already apparent in the composition of this miniature.

Peale emulated the large-scale double portraits of husband and wife portrayed together on a single canvas, a genre not as common as paired portraits on

Details of figures 28 (far left) and 29 (left). In the Yale miniature, graphite lines indicate that Peale considered placing Thomas' pointing finger in the same position as in the NMAA version but decided to move it slightly to the right so that the boy now directs his brother's attention to the beginning of a line of text.

In the Yale version only, Peale further alluded to Matthias's youth by depicting a button on his vest left undone. Matthias may have unbuttoned his vest to allow his hand to slip underneath, a common posture during dance instruction, considered an essential part of an upper-class boy's education.

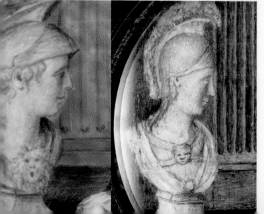

Peale also made the bust of Minerva less dominating in the Yale portrait and gave the breastplate a whimsical expression. Such details support the hypothesis that this version was meant for their younger, less authoritarian uncle, whereas their father may have required a more disciplined image of his children.

separate canvases in British and American eighteenth-century art. Here Peale captures a slice of life, with Matthias looking outward while his brother looks at him and keeps their place in the book, waiting to resume an exchange interrupted by the viewer. The feeling of unguardedness reflects a new trend toward informality in portraiture. In double portraits painted early in the century, the husband, usually standing, and the wife, usually seated, remain aloof. That stiffness lessens in portraits painted in the 1780s and 1790s, when husbands and wives touch and lean on one another.[19] Peale similarly poses the siblings as nearly equal partners in a mutual enterprise, with the older Thomas — like the husband in many double portraits — made slightly dominant by the protective placement of his arm in front of the younger boy and a deference suggested in Matthias's recession behind the table. This demonstration of affection between siblings captures the heart of the new modern family.

Peale's portrayal of the brothers studying illuminates new attitudes toward education in the eighteenth century as well as toward family life. An artist, saddler, soldier, naturalist, metalsmith, landscape architect, taxidermist, and inventor with an astonishingly inquiring mind, Peale himself became the patriarch of a clan devoted to artistic and scientific pursuits as well as a founder of a museum with wide-ranging collections. His dedication to learning was all the more admirable because his own educational opportunities had been restricted by the death of his schoolteacher father when he was only nine. His correspondence reflects both his intelligence and lack of academic training, of which he was aware, as when he told Bordley in March 1767, "I should apologize for my incorrected letter but . . . I lost the opportunity of Education and [am] but little acquainted with the Polite Word."[20] Peale's art makes palpable the hunger and respect he felt for education.

This miniature — his first composition depicting a boy actively pointing to a passage in an open book — is an early example of many works by him portraying harmonious domestic situations that inspire the young to emulate an older family member's devotion to learning. In later full-scale paintings, Peale united family members with an open book in an embracing gesture suggesting the linked joys of intimacy and education, as he did in a portrait of Mrs. James Smith instructing

her grandson — whose vest button is also undone (1775, NMAA). Here the book, like the book and the sculpture of Minerva in the miniature, symbolizes the body of past knowledge that the old must pass on to the young.

Matthias and Thomas Bordley is relatively unusual in featuring the bond between older and younger siblings, rather than family members of different generations, as instrumental in the learning process. However, the intimate scale of a miniature implies the presence of a beholder related to those depicted — in this instance, Edmund Jenings, who, with the commission of this double portrait, testified to his encouragement of his nephews' education. Peale links these participants, and reinforces their roles in the educational process, through gaze: Thomas points to the open book and looks at his younger brother; Matthias holds the book and gazes out at the beholder, his uncle.

Societal attitudes toward children's education had been shifting since about the mid-eighteenth century. Influenced by prevailing ideas of childrearing that were fostered by the philosophy of John Locke, adults were more inclined to use persuasion and example rather than punishment. Where before children, believed to be tainted from birth by original sin, were educated and disciplined with the sternest of methods, now a sense of the child as inherently good led to instruction designed to nurture the confident self-worth demonstrated in *Matthias and Thomas Bordley*.[21] The bond between the brothers, their dedication to their studies and to assisting one another, and their implied desire to please their father and uncle all convey this broadly endorsed, hopeful view of children.

Peale's decision to include a sculpture as well as a book in the miniature suggests that even before he had children of his own, many named after famous artists, the painter — and by extension his patrons, Bordley and Jenings — believed that exposure to art was an integral part of a boy's education. Perhaps these men believed, as Peale's entire life demonstrated, that art served valuable social and civic purposes. Customarily, fathers were responsible for training their sons for adult life. In Bordley's absence, Jenings, a successful lawyer and an art patron, had taken over this role. By extension, Peale further provided the boys with an example of professional accomplishment by painting their portraits, for they had to spend considerable time posing in his presence.

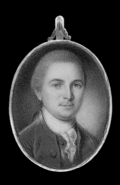

30. Charles Willson Peale, *George Walton*, c. 1781, Yale.

Peale's allusion to classical mythology also reflects West's admiration for the subject as a major source of inspiration. In the Society of Artists exhibition of 1768, where Peale showed a version of this miniature, West displayed *The Drummond Brothers* (Addison Gallery of American Art, Phillips Academy, Andover), an oil painting celebrating the education of two sons of the archbishop of York that also includes a sculpture of Athena/Minerva. More often, West employed mythological references in history paintings. Peale did not aspire to his mentor's lofty rank of history painter, but beginning with this miniature he did attempt to make portraiture approach the level of history painting by including classical symbols.[22] The bust of Minerva suggests Peale's pride in the importance of his profession to the American colony; he indirectly defines himself as an artist with the creative capacity that characterized artists of a glorious past. This lesson about the importance of art in society was not lost on the young Matthias, who

eventually returned to Maryland and became an amateur artist. He also managed the Bordley family's plantation on Wye Island after his father settled in Philadelphia.

After his return to Annapolis in 1769, Peale corresponded with Jenings, who continued to provide him with commissions. The artist often closed his letters with affectionate inquiries about the boys' health and studies. In response to seeing drawings by them, Peale shared Jenings's pride in his nephews' accomplishments and asked him to "pray give my love [to them] and till them I say, that there is no boys in this country can do the like." In 1771 a grieving Peale wrote to John Beale Bordley upon learning of Thomas's death from consumption at Eton: "The predominant subject of my Mind is too melancholy for me to say much, but if we are to be happy for having acted our parts well, Tommy must be without a remorse for I believe he has done all the duties of his age. How much I pity Mr. Jennings, this, I believe, is the most severe affliction he ever felt."[23] The miniature would have served Thomas's uncle by preserving the boy's memory and image. In an era when family members and friends were much more likely than now to die young, even miniatures that were not painted posthumously often played a role in mourning.

But Peale's comment that Thomas performed "all the duties of his age" has its counterpart in the function of the miniature as well. This double portrait would have instructed later generations in behavior worthy of emulation. It not only reminded mourners of Thomas's face but also characterized him through narration as a devoted student and caring older brother, qualities that marked him as a youth of great potential in an era newly enthralled with childhood.

Back in Annapolis, Peale continued to paint miniatures — although one of his earliest commissions was a full-length oil of the boys' father, *John Beale Bordley* (1769, National Gallery of Art, Washington, D.C.). Between 1770 and 1775, Peale often charged clients as much for miniatures as for small oil paintings. He continued to order supplies — from "Cammels hair pensils" to "Miniature pictures . . . chiefly of Bracelet size"— from London long after his return. But the simple locket housing *George Walton* (fig. 30) was probably made in America, not

England, for the edge of the bezel was rolled over the ivory, a process requiring the maker to have the portrait literally in hand. A multitalented craftsman, Peale ground lenses for cases, while Philadelphia jeweler Thomas Shields fashioned some of the lockets or brooches.[24] When compared to more elaborate contemporary English cases, most of Peale's small oval lockets, like the one encircling *Walton*, communicate a preference for simplicity in accordance with the identities of the politically revolutionary artist and his usually like-minded sitters.

In 1776 Peale found himself in Philadelphia at the center of the struggle for independence. He became active in politics, enrolled in the city militia, and was soon fighting in the area. Peale brought along his paintboxes to take miniature likenesses of officers who commanded regiments in the region. He wrote to Benjamin West in London: "You will naturally conclude that the arts must languish in a country imbbroiled in Civil Wars. [Y]et when I could disengage myself from military life I have not wanted employment, but have done more in miniature than in any other manner, because these are portable and therefore could be keep out of the way of a plundering Enemy." The vital role miniatures played during wartime was conveyed in a letter from an officer to a friend: "My compliments to Miss Nelly.... Tell her I cannot write; if she knew... with how much pain I now write she would excuse me for not doing it; tell her I am getting my picture drawn in miniature and as she may never have an opportunity of seeing the original again, I shall send her the copy when it is finished."[25]

Peale's revolutionary politics and participation on the battlefield, as well as the excellence of his portraits, created continued demand among officers, for example George Walton, commander of a Georgia regiment at the siege of Savannah in 1778. In the same year Walton married Dorothy Camber in Savannah. For Walton, as for others caught in this moment of upheaval, there was no time to separate the personal from the political. Unlike some military heroes who chose to present themselves in uniform even during peacetime, in his portrait Walton wears a superfine broadcloth suit and lace shirt ruffle. This miniature honored — in a private way that served his family during separation — the battles Walton led not in the field but rather in the Continental Congress as a fiery leader of the Whigs.

Like many of Peale's patrons, Walton played a prominent role in the republic he had fought to establish. A signer of the Declaration of Independence, he was twice governor of Georgia, chief justice of the state, and a U.S. Senator. According to family lore, the miniature was painted to mark the distinguished sitter's signing of the Declaration of Independence, but it probably was made later, during his service in the Congress, when he was again separated from his family. The keepsake descended in the family, worn by the aristocratic women who cherished his memory.

> Dorothy Walton, the widow of the signer, was an Englishwoman who had passed with her husband through the most stirring days of the Revolution, suffering the capture and imprisonment by her own people as penalty for her new loyalty. She preserved many souvenirs of her late husband's brilliant career — a miniature painted by Peale in Philadelphia the year of the signing; letters from Adams, Jefferson, Washington and Lafayette; commissions, appointments and resolutions from the Georgia assembly and the Continental Congress. These mementos, which later became [her granddaughter Madame] Octavia [Walton Le Vert]'s, early impressed upon her an ardent admiration for her grandfather and a militant pride in the nation he helped establish. . . . She wore the Peale miniature at the courts of Europe, and in the presence of kings was happy to be known as a revolutionist's granddaughter.[26]

Peale's portrait miniatures of Revolutionary-era heroes embodied and preserved on an intimate rather than a heroic scale the character of the new nation.

In the miniature Peale's stippling technique in the face and background has grown bolder since his more tentative touch in the large *Matthias and Thomas Bordley*. The small size and precise modeling of *Walton* are characteristic not only of Peale's work but also of most miniatures painted during the colonial period and young republic. The wavy strokes composing Walton's frizzed and powdered hair, and the dense coloration of the mauve jacket and blue-gray background typify Peale's mature style.

But the genius of colonial portraiture was John Singleton Copley, whose miniatures were the equal of his easel paintings. Unlike West and Peale, Copley made his first experiments in miniature in oil on copper rather than watercolor on ivory. Perhaps examples of the more fashionable English style were unavailable to him in Boston around 1755, when, at the age of seventeen, he began painting miniatures. Copley probably used as models seventeenth-century oil-on-copper miniatures—those paintings "in Littell" that the founding colonists had brought to New England as family heirlooms. Local colonial artist-craftsmen may have carried on the tradition of painting in oil on copper, logically leading Copley to adopt the practice. Even if more au courant watercolor-on-ivory miniatures were available, Copley's sitters, among them a high proportion of wealthy Tories,[27] may have valued traditional paintings "in Littell" because of their association with ancestral keepsakes. Such miniatures provided continuity with a home culture as it was remembered, preserving memory and asserting group identity through kinship ties.

Perhaps Copley also had firsthand knowledge of oil-on-copper miniatures painted by Scottish artist John Smibert, who had established a studio in Boston. Copley had been introduced to art by watching his stepfather Peter Pelham engrave mezzotint plates, many after large-scale portraits by Smibert. Smibert's own art as well as his copies after European paintings provided crucial models to colonial artists—and the inquisitive Copley would have been intrigued by the oil-on-copper technique if he did see miniatures by him. Patrons' demands for the comfortingly familiar and accessible works combined with purely practical considerations, for Copley's choice of medium benefited from both his experience with oils from painting large-scale portraits and the availability of metal plates for supports from his late stepfather's printing studio.[28]

Copley rapidly developed beyond the talents of those around him through an uncommon facility with a variety of media, the unflinching intensity of his eye, a hunger to try any method that might attract customers, and a curiosity that led him to daring experimentation. During the mid-1750s the youthful artist explored painting in oil on canvas, engraving, drawing in pastel on paper, and unconventional ways of working in miniature. Scrutiny of his earliest miniatures

recently led to the discovery by conservator Theresa Fairbanks that, probably to infuse some of his portraits with luminosity, he painted on a gold-leaf ground adhered to copper.

Possibly before he tried this unusual approach, around 1758 Copley painted a portrait of Andrew Oliver, the future lieutenant governor of Massachusetts, in the surprising and contradictory medium of oil on ivory, perhaps in response to his client's request for that support (fig. 31). The oil naturally blocked out any light from the ivory. But the miniature's existence underscores the unique complexity of Copley's technical evolution. His companion miniature in oil of Oliver's second wife Mary Sanford benefits from an evocative glow traced to a continuous layer of gold-leaf ground (fig. 32). Again Copley selected an unusual support — a slightly convex copper blank fabricated for enamel miniatures — suggesting that his innovative use of gold might have been inspired by European enamels, which were occasionally fired on gold rather than copper. The original appearance of the portrait of one of the Olivers' fourteen children cannot be fairly assessed, as the surface suffers from corrosion, in part attributable to Copley's atypical methods (fig. 33).[29]

Among Copley's most politically influential patrons, the Olivers commissioned almost two-thirds of his known miniatures, as well as many large-scale portraits. Based on technique and the probable age of the sitter, *Andrew Oliver* was painted around 1758, making it the first of several versions Copley painted of him. In June of that year his commission as province secretary was published with that of his wife's brother-in-law Thomas Hutchinson as lieutenant governor. Like Peale's miniatures, many of Copley's portraits in little acknowledge the sitters' impact through public service on political events that also had a profound effect on their private lives. When declining an earlier appointment, Oliver had protested that during prolonged public service, his "private Affairs had already suffered, and were in Danger of suffering so much."[30]

Although regarded as a master of verisimilitude, Copley painted fictions as convincingly as facts. For *Mrs. Andrew Oliver*, he borrowed fashion elements like the lace-edged neckline and conventionalized hair wisp from styles found in earlier art, especially English court portraits by Anthony Van Dyck and Godfrey

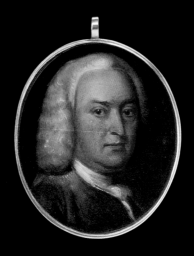

31. John Singleton Copley, *Andrew Oliver*, c. 1758, Yale.

32. John Singleton Copley, *Mrs. Andrew Oliver (Mary Sanford)*, c. 1758, Yale.

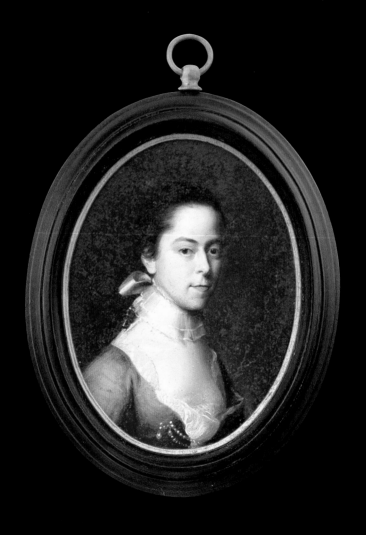

33. John Singleton Copley, *Mrs. Samuel C. Waldo (Grizzel Oliver)*, probably 1760, Yale.

Kneller painted in the previous century. For Copley, who was trying to elevate his own status by pleasing socially superior patrons, this kind of artistic cross-reference testified to the "educated taste of both artist and sitter and to their feeling that the dress of the past was more acceptable for representation in painting than constantly changing contemporary fashions were."[31]

It was not uncommon for artists to use historical dress and fashions found only in pictures to alter the attire of their female sitters; artists usually depicted gentlemen, however, in their own clothing. In his portrait, Andrew Oliver reveals his wealth as well as his age by wearing an expensive but old-fashioned velvet suit, as opposed to the fine broadcloth frock worn by younger gentlemen of similar prestige at this time. His wig, a heavily frizzed long bob with a smooth top, also would have been considered conservative.

These conventions underscore cultural attitudes about the relationship of the sexes to time: women, whose virtues and domestic role were deemed timeless, could be portrayed in fashions freed from the moment; men functioned in the constantly changing outside world and were bound to it, as their contemporary clothing revealed. Descriptions of the character of Mary Sanford Oliver accord with her plump and gentle countenance and the timeless quality of her costume in Copley's portrait: "Even in the evil days to come when Whigs searched the depths of their vocabularies for terms opprobrious enough to describe her husband, they paid tribute to her piety, charity, simplicity, and amiability. A woman who could bear fourteen children and still be good to her little stepson and amiable to the world in general was indeed a jewel."[32]

The portrait of the Olivers' daughter Grizzel probably marked her marriage at age twenty-six to Samuel Waldo, a Harvard graduate from Falmouth, Maine, in Boston, on August 11, 1760. Although she was the second oldest daughter, she was the first girl married. Her sadly brief union ended with her death seven months later. An obituary recalled her as an "affectionate and obliging" wife praised for "Delicacy of features," "Sweetness of Manners," and "graceful and virtuous Conduct." Copley dusted her image with sensual, invented touches. The ruff around her neck and bow at the nape could have been contemporary, but not the errant blue drapery or the seductive string of pearls unsuccessfully

keeping the front of her dress in place.[33] Copper corrosion has aged her portrait but we can still appreciate how Copley's symphony in pink, white, and brief notes of blue contributed to an illusion of enduring beauty.

Letters show that her parents bore their loss with deep religious faith.[34] It was one of many losses that plagued the family in the 1760s, for Andrew Oliver served as enforcer of the infamous Stamp Tax. On August 14, 1765, a Boston mob hung Oliver in effigy from the Liberty Tree. On the figure's right arm were the initials "A O," and on the left, this couplet: "What greater Joy did ever New England see / Than a Stampman hanging on a Tree." The crowd destroyed Oliver's place of business, sacked his house, and slashed family portraits. Even the patriot John Adams was appalled: "Has not the blind indistinguishing rage of the rabble done that gentleman irreparable injustice?"[35] Following the riot, Oliver resigned his office. Despite the suffering to himself and his family, when Thomas Hutchinson was appointed governor in 1770, Oliver accepted an appointment as lieutenant governor, dying while serving in that office before the Revolution.

Perhaps Copley's miniature of Andrew Oliver's brother Chief Justice Peter Oliver (fig. 34) survived the turmoil because of the protection afforded by the winged angel heads that decorate its frame. (It may also have been because miniatures, unlike easel portraits, are small enough to be secreted in times of upheaval.) The sitter's emblematic evocation of divine intervention and his weary facial expression betray his uncertainty. The existence of so many portraits of members of the related Oliver, Hutchinson, and Watson families limned by both American and British miniaturists but descending in the United States testify to how exchanges of miniatures were used to cement ties between relatives on either side of the Atlantic.[36] Families similarly used large-scale portraits to bridge distances, but the portability of miniatures made them particularly suitable during a time of increasing mobility and unprecedented social and political unrest.

Members of related social and kinship groups often chose to be represented by the same artist, and Copley was much in demand among the Boston elite. Reverend Samuel Fayerweather, who was also painted "in Littell" by Copley

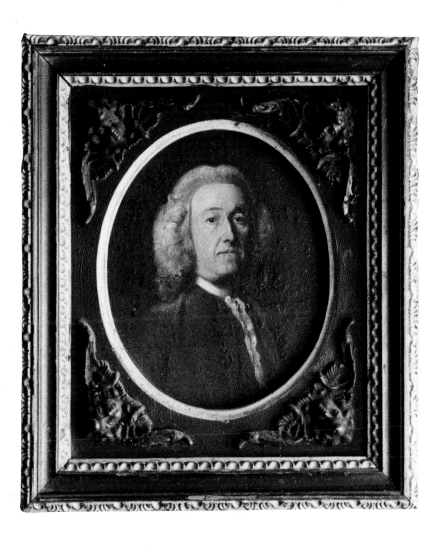

34. John Singleton Copley, *Peter Oliver*, c. 1760, Collection of Andrew Oliver, Jr.,
Daniel Oliver, and Ruth Morley Oliver (object reduced from actual size).

John Singleton Copley, *Reverend Samuel Fayerweather*, probably 1760 o

(fig. 35), was the grandson of Brigadier General Samuel Waldo, the father-in-law of Grizzel Oliver. Copley painted *Fayerweather* on a flat, heavy copper support; printmaking toolmarks indicate that he probably reused a plate from the studio of his deceased stepfather, Peter Pelham. By applying his oil paints more fluidly and thinly than in the Oliver portraits, in *Fayerweather* a maturing Copley exerted greater control over the gold ground, imparting warmth and radiance. Gold shines through the translucent red glaze around the minister's eyes with an other-worldly glow. Copley's inspired application of gold leaf suggests associations of the precious metal, in art and theology, with heavenly light. Even the silver gadrooned frame, possibly made by Paul Revere, had originally been gold-washed or plated, extending the sense of pure light to the entire object.[37]

Such heavenly allusions are appropriate to this miniature's meaning, for it honors Fayerweather's achievements as scholar and minister. A Bostonian by birth and a Harvard graduate, he had been ordained in the Episcopal Church in London and awarded a Master of Arts at Oxford. Recalling through dress that triumphant moment filled with "demonstrations of joy and respect," Copley presents him in Oxford regalia, complete with pink academic hood and board cap, and a linen tabbed collar denoting his clerical status. The portrait must have been painted after Fayerweather returned to New England in 1760; he previously served as a clergyman in South Carolina. Given his attire, it probably honored either the reverend's assumption of the ministry of St. Paul's Episcopal Church in North Kingston, Rhode Island, on August 24, 1760, or — another highlight of his career — his preaching to a packed congregation at King's Chapel in Boston before Governor Francis Bernard on December 2, 1761.[38]

This miniature represents an exception to the rule that oval shapes predom-inated during the eighteenth century. The unusual size, shape, and silver frame endow the object with an importance in keeping with the probable reason for the commission. In the absence of firsthand information, we can only speculate that a friend or family member chose the miniature rather than the more public format of the full-scale portrait because it better expressed the personal pride derived from the sitter's accomplishments. This miniature may have been given as a gift

Detail of figure 35. Gold shines through the translucent red glaze around the minister's eye with an otherworldly glow. Copley's inspired application of gold leaf suggests associations of the precious metal, in art and theology, with heavenly light.

to Reverend Fayerweather to be kept in a private place, perhaps a cabinet containing earlier miniatures of illustrious ancestors.

Portraits of any medium and scale communicate cultural values. At a time when the clergy were considered the primary pillars of the community, portraits of them were widely circulated in prints, among the best by Peter Pelham. Ministers commanded high esteem in their communities and families, so it is not surprising that Copley poured such technical effort into *Reverend Samuel Fayerweather*. But along with others in his generation, political turmoil marred Fayerweather's professional life: "Although he respected the warm rebel sympathies of his congregation, he did not feel that he could dispense with the reading of the prayers for the king, so he made his last entry in the church records on November 6, 1774, and ceased to officiate in St. Paul's."[39]

Having mastered the alchemy of gold beneath oil on copper, by about 1762 Copley had also taught himself how to paint in watercolor on ivory. His earliest untutored attempts at the demanding process thus predate Peale's supervised efforts in London between 1767 and 1769. Copley's transition from oil on copper to watercolor on ivory was gradual, with extant miniatures revealing overlapping interest in both approaches. Whereas Copley's palette in the portraits "in Littell" reflected that of his dense, opaque, large-scale oil portraits, his watercolor limnings mirrored the flickering, delicate handling of his pastels, made more incandescent by his shimmering stippling technique playing over the ivory surface.

Copley rendered many works, including his compelling self-portrait, in both media (figs. 36 and 37). The pastel is one of a pair he made of himself and his new bride Susannah (Sukey) Farnham Clarke, whom he wed in November 1769. Like West, he probably offered a keepsake to his beloved in the hope that she would wear it near her heart. The tiny love token was set in a gold locket probably crafted by Paul Revere. (In colonial America, class and commerce often superseded politics; Revere worked on miniatures for both Patriot and Tory artists and sitters.) The background, like that of Peale's *George Walton* and most colonial miniatures, is a subtly modulated, dark monotone. In translating and reducing his self-portrait from pastel on paper to watercolor on ivory, Copley

enriched the contrast by adding purple to the facing of the blue silk loose gown and gold stripes to the red embroidered waistcoat underneath it.

Copley conveyed his high level of attainment as a gentleman-artist not only by his sophisticated execution but also by his self-presentation as assured, fashionable, and wealthy. Similar to the garment worn by the successful West (see fig. 26), Copley's expensive gown lends an engaging informality to his self-portrait while also alluding to other eighteenth-century images of creative geniuses in the scholarly fields of religion, literature, science, and art — an endeavor that he believed deserved the lofty status of those other pursuits.[40] At the zenith of his American career, Copley had secured an enviable social and economic position never before achieved by an artist working in America.

The son of Anglo-Irish immigrants, he raised himself above his origins through his talent, business sense, and strategic marriage: his wife was the daughter of Richard Clarke, the influential Boston agent for the British East India Company. In the same year as Copley limned this miniature, the boy born into poverty on the docks of Boston's Long Wharf purchased an elegant home on Beacon Hill. The miniature he gave Sukey in celebration of their new life together was as precious in medium and minute in scale as those then worn in the most fashionable circles of London. Copley's efforts to make his miniature mimic English ones and himself appear not as an artist but as a gentleman indistinguishable in dress from his wealthy patrons reveal his internalization of their taste and values.

When political turmoil threatened the security of his wife's Tory family, concern for her and their children, as well as his ambition to compete in a more sophisticated art market, led an undoubtedly conflicted Copley to undertake the voyage across the Atlantic in 1774, never to return. He also turned his attention away from miniatures. Competition with accomplished masters in England and the largeness of his desire to become a history painter like West account for his decision. But returning the piercing gaze of this handsome young artist, who saw himself and his fellows with a clarity rare in the annals of portraiture, makes palpable the loss of all that he left undone in America.

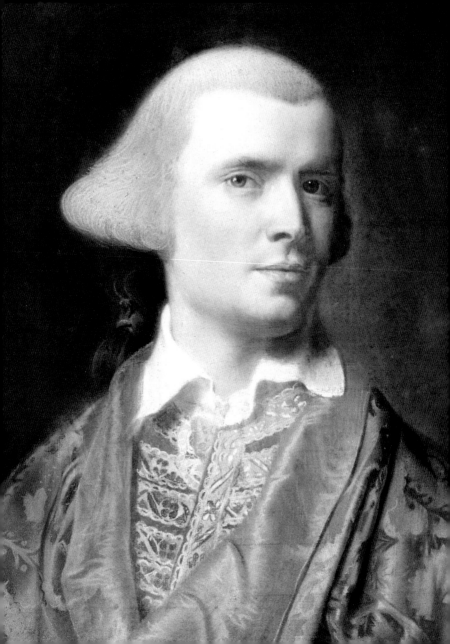

36. John Singleton Copley, *Portrait of the Artist*, 1769, pastel on paper, Winterthur
 Museum, Winterthur, Del.
37. John Singleton Copley, *Self-Portrait*, 1769, Gloria Manney Collection.

38. Joseph Dunkerley, *Ebenezer Storer II,* c. 1785, after a pastel by John Singleton Copley, c. 1767–69, attached to hairwork bracelet, c. 1850, Yale.

39. Joseph Dunkerley, *Mrs. Ebenezer Storer II (Elizabeth Green),* c. 1785, after a pastel by John Singleton Copley, c. 1767–69, attached to hairwork bracelet, c. 1850, Yale.

At about the time Copley was sailing to England, Joseph Dunkerley, whose works are sometimes confused with Copley's because of their delicacy, tiny size, and similar casework, was heading for the colonies, where he became one of the first important miniaturists of the new republic. He limned *Ebenezer Storer II* and *Mrs. Ebenezer Storer II* (figs. 38 and 39), a marital pair of miniatures, after pastels by Copley (1767–69, private collection). Housed in gold frames, the miniatures are set in bracelets of woven hair that symbolize the couple's devotion to each other — and, as we shall see, their descendants' dedication to their memories.

Unlike the Olivers, most members of the Green and Storer families of Boston were Whigs — in fact, for years following the Stamp Act, Ebenezer Storer II found himself in heated political and personal controversy with Governor Thomas Hutchinson and Lieutenant Governor Andrew Oliver. But Patriots and Loyalists alike were anxious to have their portraits painted by Copley. Commissions from the Green and Storer families, who were related (three Storer children married into the Green family), contributed to Copley's prolific production of pastel portraits during the mid- to late 1760s. With its virtuoso rendering of expression and costume, *Ebenezer Storer II* is among Copley's most successful works in this medium.[1] In translating Copley's pastels into watercolors, Dunkerley achieved a sketchy delicacy by allowing much of the ivory to show through. Less tentative in touch than many of his miniatures, this pair are among his most graceful achievements.

Dunkerley had come to America with the British army, which he deserted to serve as a lieutenant in a Massachusetts artillery regiment, resigning on May 20, 1778. In 1781 he rented a house in Boston from Patriot-silversmith Paul Revere, who did the casework for some of Dunkerley's miniatures. In December

1784, Dunkerley placed a notice in the local press advertising that he "still carries on his Profession of Painting in Miniature at his home in the North Square," implying that he had been active as a miniaturist previous to that date. The following year he also offered his services as a drawing instructor.[2]

Possibly through those notices, or earlier through his connections with Revere, Dunkerley was introduced to the Storers, who were among Boston's leading citizens. Ebenezer Storer II was a prosperous partner in his father's firm of Ebenezer Storer and Son, Merchants, and a Patriot who held local offices. In the pastel and miniature, his partially exposed scalp reveals that he shaved his head so that, as a dignified gentleman, he could wear a wig in public. For private relaxation, he would replace the heavy, uncomfortable wig with a cap. Like Copley in his self-portrait (see figs. 36 and 37), Storer has traded his suit coat for a damask gown worn over his waistcoat, removed his neckcloth, and unbuttoned his collar. The resulting freedom from the constraints of public dress codes, in short from outward body consciousness, allowed a gentleman to look inward: "Scholars and scientists, men of the mind who customarily worked in the privacy of the study or laboratory, frequently chose to have themselves presented in a portrait wearing a banyan [or gown] . . . and nightcap. This more informal at-home costume became the recognized uniform of the contemplative life."[3]

The "uniform" attests to Storer's affluence, which allowed him to pursue higher endeavors at home in his retreat "devoted to a valuable library, a philosophical apparatus, a collection of engravings, a solar microscope, a camera," and other scientific instruments including a "comet-catcher." Familiarly known as "Deacon," he held that position at Brattle Square Church until 1773 and used his influence to support charitable causes, especially the alleviation of poverty, and a crusade against "the progress of Vice and Immoralities."[4] Through costume, Copley (and Dunkerley after him) succeeded in conveying both the social status and introspective individuality of Ebenezer Storer II.

Whereas Mr. Storer dresses in contemporary clothing, Mrs. Storer wears a pleasing amalgam of current fashion, evidenced in the hair style and the lace shift ruffle, and invented details — the gown's full sleeve and pearl trim, and the shift's plunging neckline, emphasized by a pink rose — that refer to Van Dyck costume,

not unlike the portrait dress of Mrs. Oliver and her daughter Grizzel (see figs. 32 and 33). The resulting evocation of timelessness accords with descriptions in the sitter's obituary of her enduring feminine virtues: Mrs. Storer "excell'd in all the Characters of Wife, Parent, Friend, Mistress, and Benefactor. Those who knew her the most intimately, loved her the most sincerely. If she had a Fault, it was a *too tender Heart,* and *too great a fondness for her Friends,* which must make their Loss the more painful."[5]

In 1774, after nearly a quarter-century of married life, Ebenezer lost his wife, aged 41. By the time Dunkerley painted these miniatures, the widower had married Hannah Quincy, whose influential family "assumed the responsibility of finding a regular income for him" during a period of social unrest. In the same year as his marriage, 1777, Storer accepted the prestigious office of treasurer of Harvard College. Nonetheless, the Storer business suffered during the war and never fully recovered, leaving the family in difficult circumstances. Storer tried various jobs in turn, becoming a wine merchant and serving as paymaster and clothier of the 2nd Massachusetts Regiment, which may have been another connection between him and Dunkerley. In 1788 Storer was forced to sell off a great deal of his Boston real estate.[6]

He even sold and then shortly bought back his Sudbury Street mansion, inherited from his father, where the pastels by Copley are known to have hung in the dining room. In the 1780s, someone in the family, perhaps one of Ebenezer and Elizabeth Storer's three adult children, commissioned Dunkerley to limn miniatures after Copley's pastels.[7] These pictures recalled a time of greater stability, before Elizabeth's death, before the Revolution, when the Deacon, dressed in gown and cap, had the peace of mind to pursue studies in the comfort of his extensive library.

This marital portrait pair offers a palimpsest of family devotion through time: not only were the miniatures limned after pastels made a generation earlier, but the bracelets probably were updated by still later descendants. The clasps' multiple gold loops indicate that each portrait was originally set in a multistrand bracelet, perhaps composed either of pearls, such as those worn by contemporaries in paintings (see *Mrs. Walter Stewart,* fig. 13), or of less elaborately

A HEART PLAYING CARD FOUND INSIDE THIS LOCKET SUGGESTS THAT
IT MAY HAVE BEEN A LOVE TOKEN.

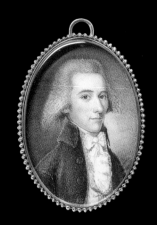

40. Nathaniel Hancock, *Self-Portrait*, c. 1792, Yale.

fashioned hair. Comparison to other hair bracelets suggests that the exceptionally intricate, braided bracelets now attached to the clasps are Victorian in sensibility and probably date to the mid-nineteenth century.[8]

The decision to modernize the bracelets testifies to the miniatures' continuing significance to family members. Around the time these bracelets were fashioned, a hairworker published a book detailing the process and urging people to do the work themselves rather than risk "hair jugglery." He cautioned that some unscrupulous hairworkers discarded the beloved's precious hair — even the irretrievable strands of the dead — and made decorative work from the more easily controlled hair of strangers.[9] Such "jugglery" robbed the hair of its mystical associations with a present or past love or with an ancestor still cherished through stories made more palpable by objects of devotion like miniatures.

Artists used convenient material — for example, the folded newspaper inside the disassembled miniature (fig. 5) — as packing to ensure a snug fit of all the parts within the case. The miniaturist usually chose the packing randomly, for it was meaningless to the sitter and beholder, who never saw it once the locket was sealed.

Except, of course, when the sitter is the artist. A heart playing card found inside the locket containing a self-portrait of the little-known miniaturist Nathaniel Hancock suggests that like the self-portraits of West and Copley, this may have been a love token (fig. 40). Perhaps Hancock limned it for his wife Elizabeth, whose death on May 3, 1792, was announced in the Boston *Independent Chronicle*. Her obituary is the first indication of Hancock's presence in America. Whether he initially intended the portrait for his wife, at some point he gave it as a gift to Nathaniel Foster of Framingham, Massachusetts. A descendant recalled that Hancock was a family friend, and Hancock's present reflects the tradition of giving miniatures to friends, although the exact meaning of the gesture is muted by the scarcity of information on both giver and receiver. Hancock's friendship with the family is further honored in the miniatures he painted of several family members.[10]

In the self-portrait, the artist's intense eyes are set in a face deftly modeled with tiny stippling, in contrast to the crimson coat and background composed of

larger adjacent, hatched strokes. At first the background appears to be a single color, but close examination reveals touches of red-brown and blue juxtaposed for opalescent effect. Hancock, who was probably an engraver,[11] may have incised the bright-cut pattern on the reverse of the distinctive "cartridge-edged" locket that houses his self-portrait.

This stylistically distinctive and assured miniature is the work of an artist with professional training. Hancock's first-known advertisement in America, published shortly after his wife's death, promised that "the Likenesses he has taken and finished, since his arrival in Boston will best speak his ability.... An European artist, who takes the most correct Likenesses ... and finish[ed] in an elegant style of painting; as miniatures at 2, 3, and 4 guineas; in a gilt frame and glass included, and elegant Devices in Hair on moderate terms." Such announcements allow us to track his vagabond existence searching for clients in Petersburg, Virginia, in 1796, in Richmond in late 1797 and early 1798, back to Boston in 1799, to Portsmouth and Exeter, New Hampshire, in 1801, and to Salem four years later, where he remained until 1809. Hancock's relationship with the Fosters may have given him contacts that led to commissions in Salem; Nathaniel Foster's wife Susannah was the sister of the port collector there.[12]

One of the miniatures by Hancock that is most admired today portrays Jedidiah Morse (fig. 41), a graduate of Yale College, a conservative Congregationalist minister in Charlestown, Massachusetts, and the leading American geographer of his generation. A fascinating participant in the struggle to establish the nation's identity after the Revolution, Morse occupies an ambivalent position in American history. As an orthodox cleric, his resistance to religious pluralism and tolerance closed the minds of many, but his geographies — the most widely read texts on the subject — expanded the horizons of thousands of citizens in the new republic.

The title of the first, *Geography Made Easy* (1784), conveys Morse's wish to make the science accessible to a youthful audience. He declared geography to be "no longer esteemed as a polite and agreeable Accomplishment only, but as a very necessary and important Part of Education" and dedicated his work to "the Young Gentlemen and Ladies, Throughout the United States."[13] Accordingly,

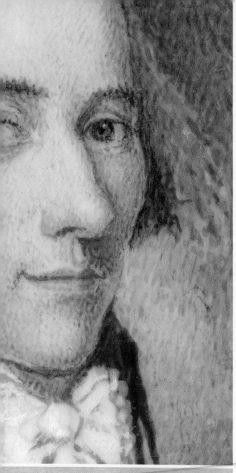

Detail of figure 40. Nathaniel Hancock's intense eyes are set in a face deftly modeled with tiny stippling, in contrast to the crimson coat and background composed of larger adjacent, hatched strokes.

Detail of reverse of figure 40. Hancock, who was probably an engraver, may have incised the bright-cut pattern on the reverse of the distinctive "cartridge-edged" locket that houses his self-portrait.

the diminutive yet detailed scene on the reverse of Hancock's portrait portrays the geographer as teacher (fig. 42). Notably, Morse's pupils are all young ladies, varying in age, chaperoned by the woman wearing a hat who is entering from the right.

In surrounding the geographer with women, Hancock was positioning Morse in one of the most hotly debated issues in the early republic—women's education. Morse's dedication to educating women in geography reflected a growing consensus that female literacy and learning in certain prescribed fields would serve American nationalism and republicanism. For Morse, one of those fields was geography. He exhorted "every citizen of the United States to be acquainted with the geography of his own country,"[14] and specifically marketed his books to a diverse audience of all ages and classes. The scientist-theologian proselytized on the power of geography to build a sense of nationhood.

Morse believed the study of geography could engender unity among the diverse citizens of the American states (although he favored his own New England over other regions). As part of this plan, he "radically" inverted the world order by "starting with the description of the United States and the Americas before delineating Europe, Africa, and Asia." He considered his publications a corrective to a British interpretation of the world: "Before the Revolution, Americans seldom pretended to write or think for themselves. We humbly received from Great Britain our laws, our manners, our books, and our modes of thinking; and our youth were educated as subjects of the British king; rather than as citizens of a free and independent republic."[15] It was in educating liberty-loving youth that the role of women—and therefore their early initiation into an American perspective of geography—was so crucial.

In the influential tract *Thoughts upon Female Education*, Benjamin Rush countered hostility toward educating girls by justifying the study of geography as indispensable to a girl's later domestic role: "An acquaintance with geography... will enable a young lady to read history, biography, and travels, with advantage; and thereby qualify her not only for a general intercourse with the world, but, to be an agreeable companion to a sensible man."[16] Morse believed

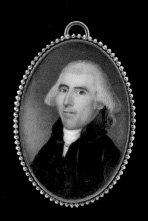

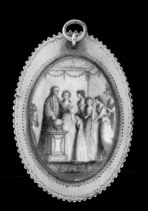

41. Nathaniel Hancock, *Jedediah Morse*, c. 1795, Yale.

42. Nathaniel Hancock, *Geographer Discoursing to a Group of Ladies*, reverse of figure 41.

that it would also dispose her, along with young gentlemen, to a proper view of the social hierarchy.

Near the close of his *Elements of Geography* (1792), the scientist-theologian exhorted his readers to repeat after the "Master": "I am truly delighted, Sir, with the account you have given of my country, and I am sure I shall love it more than I ever did before. I hope I shall always be disposed to respect and obey my rulers. The *Bible* tells me I must do this." The young ladies gathered around Morse in Hancock's miniature may have recited such a refrain at the close of the geographer's lecture. Like other federalists and fellow Congregationalist ministers, who rejected British rule but craved a firm social structure in its absence, Morse called for "deference and obedience to an elite; these calls were tinged by patriarchal and familial language."[17]

Morse appears in Hancock's miniature as a benevolent father figure to the admiring young ladies. Although he wears a frock coat in the portrait proper, on the reverse he dons a loose gown, a significant element in his presentation as a scholar in the realms of both theology and science. The long dignified robe visually complements the flowing chemise gowns of the ladies he addresses. One student, distracted by the viewer's entrance, engages us directly, pulling us into the miniaturized space made miraculously majestic by the high-ceilinged room decorated with a plaster medallion and neoclassical swags. The other women remain focused on the authoritative figure who, with one hand resting on the globe elevated by a podium, gestures with the other toward his rapt disciples. On Morse's left, the student gazing into his face seems most intimately drawn into his charismatic orbit.

The sashed dresses, fashionable in the mid-1790s, that the young women wear accord with Hancock's documented period of activity in Massachusetts from 1792 to 1796. This also was the time of Morse's greatest success as a businessman, about which he was deeply conflicted. Although as a minister he preached self-denial, as a geographer he capitalized on the growing interest Americans had in their newly independent country. By 1794 Morse's income from geography amounted to approximately five times his minister's salary. By 1795 his complete geographical system decorated the bookshelves of many a

Detail of figure 42. In surrounding the geographer with women, Hancock was positioning Morse in one of the most hotly debated issues in the early republic—women's education. Morse's dedication to educating women in geography reflected a growing consensus that female literacy and learning in certain prescribed fields would serve American nationalism and republicanism.

prosperous American. A proud family member, admiring colleague, or grateful student — like the mesmerized girl — may have given Morse the miniature to mark a specific lecture, best-selling publication, or the honorary degree of Doctor of Divinity conferred on him by the University of Edinburgh in 1794, in recognition of his geographical books.[18] The miniature, with its supportive testimonial to the reverend's true calling, may have had more personal import as a gift from his proud wife Elizabeth. The mid-1790s was a time of euphoria not only in Morse's professional life, but also in his personal one. Jedidiah and Elizabeth Morse, whose son Samuel had been born in 1791 — before Hancock arrived in Massachusetts — celebrated the birth of Sidney Edwards in 1794 and Richard in 1795.[19]

Of the European miniaturists like Dunkerley and Hancock who came to America toward the end of the eighteenth century, the most acclaimed portraitist and surely the most colorful character was John Ramage. An emigrant by way of London from Ireland, where he had trained at the Dublin Society Schools, Ramage hid a scandalous marital record behind a fashionable facade. He had left his first wife, by whom he had two children, in London and emigrated to Halifax, Nova Scotia, around 1772. A few years later he arrived as a miniaturist and goldsmith in Boston, where he married Maria Victoria Ball in 1776. That same year he fled Boston and returned to Halifax, where, as an Irish Protestant, he supported the British and enlisted in a Loyalist regiment. There he also married a "Mrs. Taylor." One biographer conjectured that this "third" wife was actually the same woman as his first, Elizabeth Liddell. Maria Victoria, having caught her husband in a bigamist union, obtained a divorce and "all the personal Satisfaction she wished for."[20]

In 1777 Ramage settled in British-occupied New York, where he rapidly became the city's leading miniaturist, painting all the "military heroes or beaux of the garrison and all the belles of the place." Nonetheless, by the time his wife Elizabeth died in 1784, his fortune was on the decline owing to his profligate lifestyle. In 1787 he married yet again, this time to Catherine Collins, the daughter of a New York merchant. But he left her and their children behind in 1794 when he escaped to Montreal to avoid debtors' prison. This was not a desertion,

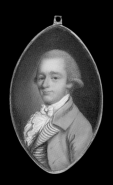

43. John Ramage, *New York Dandy*, c. 1785, Yale.

however; family correspondence reveals him to have been a passionate husband and affectionate father during his declining years, marred by illness and time in jail.[21]

At the height of his fame, according to America's first art historian, William Dunlap, Ramage was "a handsome man... with an intelligent countenance and lively eye. He dressed fashionably, and according to the time, beauishly."[22] And Ramage's portraits of gentlemen may on some level have been self-portraits, for Dunlap's verbal portrayal could equally fit the aptly named *New York Dandy* (fig. 43). The portrait exemplifies Ramage's masterful technique — delicate lines build convincing sculptural planes in the superbly modeled face. Ramage's sitters frequently turn slightly to the left, where a point of light against the dark background draws our eye to the face, which seems to be illuminated from within. And like most of Ramage's sitters, this one wears "beauish" clothing and a whimsical half-smile.

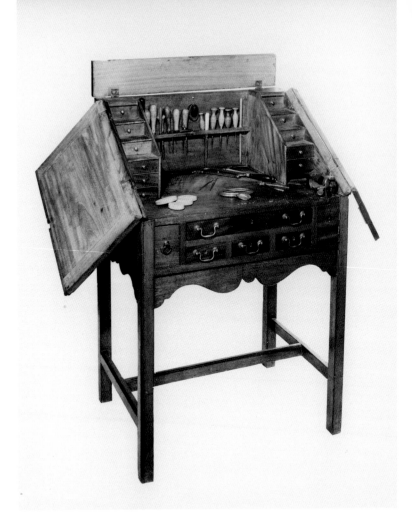

44. John Ramage's work desk and tools, The New-York Historical Society, New York.

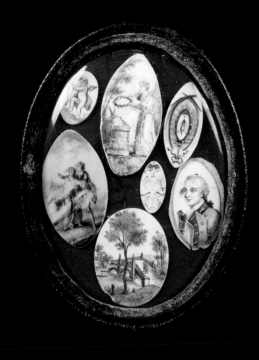

45. John Ramage's sample card, "Mourning, Love, and Fancy," The New-York Historical Society, New York (object reduced from actual size).
46. John Ramage, *Romantic Allegory*, c. 1785, Promised Deutsch Bequest, Yale.

Ramage probably fashioned the marquise locket himself, with its plaited hair on the reverse and intricately decorated rim. Still extant is the artist's desk (fig. 44), filled with the goldsmithing tools he used to create or enhance the incised and fluted cases that encircle many of his elegant portraits of affluent patrons. But he also offered his clients a number of options: "J. Ramage, Miniature Painter, Chappel Street, No. 77, begs leave to acquaint his friends he has received by the last vessels from England, a large assortment of Ivory, Chrystals, and Cases, with every other thing necessary in his branch of business."[23]

Another advertisement lured customers by referring to his "curious Devices in Hair" that "have been so much admired." Contained in Ramage's desk are sample "Devices" limned in watercolor and sometimes hair on a card (fig. 45). By choosing one of these designs, or a combination of motifs from several cards, a patron could express, in allegorical terms that were widely understood, individualized sentiments of love, loss, or longing.[24] The result was a personal form of adornment. An allegorical miniature (fig. 46) that resembles the image at the top of Ramage's sample card would have been offered as a token of love. The meaning of the two birds united on the altar is immediately intelligible more than two hundred years later. Harder for modern viewers to decipher is the woman who crowns them with a floral wreath. The theme, possibly taken from *Henry and Emma*, by the popular English poet Matthew Prior, is a famous rococo motif, the triumph of love. Emma's sacrifice, offered to Hymen, the god of marriage, is a wreath made of flowers and her lover's hair.

But a portrait gently limned by Ramage could also whisper love into the recipient's heart. That was the intention of Anthony Rutgers, who sat for Ramage at the height of the artist's New York career. The sitter appears elegant in a magnificently pleated double shirt ruffle, a striped waistcoat, and a frock coat with high collar (fig. 47). He was descended from a Dutch family that had settled in New Amsterdam in the 1630s and risen to affluence from brewery profits wisely invested in Manhattan real estate. A well-traveled merchant who at one time lived in Curaçao, Dutch Antilles, Rutgers was a founding shareholder in the lucrative Tontine Coffee House.

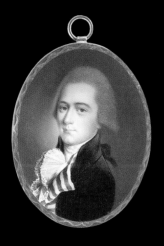

47. John Ramage, *Anthony Rutgers,* probably 1790, Yale.

The name "Cornelia M Rutgers," engraved on the locket's reverse, reveals that he gave his portrait to his new wife, Cornelia, the daughter of Hugh Gaines, an editor, publisher, and printer, probably on the day she took his name. When they were married on April 17, 1790, "The schooner which lay in the East River was decorated in honor of the occasion with a very numerous variety of the colors of all nations and exhibited a most beautiful appearance."[25] Increasingly by the turn of the century, a wedding on this scale would have been commemorated by the presentation of a miniature.

Though never signed, Ramage's miniatures are generally recognizable because of their high quality and distinctive style. A miniature of Mrs. Alexander Rose (Margaret Smith) has long been attributed to Ramage, in part because the fine hairwork on the reverse and the gold chasing on the rim resemble his workmanship (fig. 48). The portrait shares his typically rich coloring and high placement on the ivory. But the face of Anthony Rutgers is built from sculptural planes, with a slight softness around the edges of forms, in contrast to the overall flatness, extreme linearity, and charming stylistic quirkiness of *Mrs. Rose* (fig. 49).

Rutgers's eyes are convincingly rendered; Mrs. Rose's are not. Under raised eyebrows, her upper eyelids are strikingly thick toward the nose, then taper toward the outer corners and curl upward. No graphite underdrawing appears in his portrait; in hers graphite lines delineate the edge of the mouth, nose, and upper eyelids. Most distinctive is the coarse texture of her hair, unnatural in its geometric shape. However, the overall silhouette does relate to actual hairstyles of the early 1790s, as does her fitted dress with white braid edging and lace tucker. According to the U.S. Census of 1790, at that date Margaret Rose lived in Charleston, South Carolina, not New York, where Ramage worked. The eccentricities of the technique match those of Pierre Henri, a miniaturist from France who arrived in New York in 1788. Henri, who pursued an itinerant career in America, worked in Charleston from 1790 to 1793.[26]

It was love that brought Margaret Rose to Charleston. Born Margaret Smith on September 19, 1747, in New York City, the sitter was the daughter of Judge William Smith, a prominent Loyalist. The British appointed her brother chief justice of New York and subsequently of Canada. Yet despite her family's

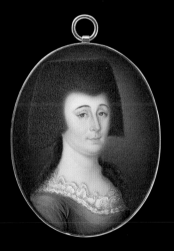

48. Brown hair plaid on reverse of figure 49.

49. Pierre Henri, *Mrs. Alexander Rose (Margaret Smith),* between 1790 and 1793, Yale.

Detail of figures 47 (top left) and 49 (bottom left). Rutgers's eyes are convincingly rendered; Mrs. Rose's are not. Under raised eyebrows, her upper eyelids are strikingly thick toward the nose, then taper toward the outer corners and curl upward. No graphite underdrawing appears in his portrait; in hers graphite lines delineate the edge of the mouth, nose, and upper eyelids.

ties to the crown and New York, Margaret Smith wed Alexander Rose, a Patriot serving in the South Carolina militia, in Charleston on January 21, 1779. The city was in the midst of war. Governor Rawlins Lowndes wrote from the Carolina capital on the very day Margaret and Alexander married: "Our situation is truly critical and without spirited and many Exertions we shall be disgraced in the eyes of America and dispersed by the enemy." In May 1779 besieged Charleston fell to the British, in whose hands it remained until the end of the war. Now, in calmer times, both Alexander and Margaret had miniatures painted by Henri, perhaps to send to relatives of hers in New York or to exchange with each other to ease their separations, for as a merchant and shipowner, Alexander traveled often. The miniature of Margaret Rose descended in the family, testifying to its continued personal significance.[27]

While the watercolor-on-ivory miniatures by Peale, Copley, Dunkerley, Hancock, and Ramage each bear the unique fingerprint of the individual artist, as a group these small, crisply modeled miniatures, generally executed in opaque colors with a stipple technique, reflected an English prototype transplanted to the New World and modified for a republican market. Henri was one of many Continental artists, whose works tended to be more decorative in effect, who immigrated to America toward the close of the eighteenth century. Both foreign and native-born artists offered clients greater embellishment of miniatures through inscriptions, hairwork, and allegorical scenes, reflecting the miniature's increasingly important role at the turn of the century as a means of expressing affection.

THE CULT OF WASHINGTON

During the turmoil of the Revolutionary era and after, the newborn nation's greatest love affair was with its founding father. Portraits had become a means of communicating political values through visages of statesmen and military leaders who represented the moral glue of a fractured social order. During the war, portraits of popular leaders, especially George Washington, conveyed allegiance not only to the individuals represented but also to the cause exemplified by the characters of those who led the fledgling nation into battle. After the peace of

1783, portraits of heroes honored men who had been willing to sacrifice their lives and celebrated the new nation they had brought into being.

When Washington was elected Commander in Chief in 1775, curiosity about the legendary Virginian — rumored to be uncommonly tall, dignified, and strong — was fed by printed images, many of them modeled after paintings from life by Charles Willson Peale, who painted his first portrait of the leader in 1772. Charles and his brother James, who both served in the war, also made miniatures after those paintings for clients who could afford to express their affection and admiration for Washington in a more personalized form. Among them was Anne White Constable, who treasured a miniature made around 1785 that portrayed Washington as a military hero, with an emphasis on the epaulette carrying the three stars indicating his general's rank (fig. 50).[28]

Attributed to Charles when it first entered the Yale collection, the miniature decisively reveals the hand of James in the bow-shaped mouth characteristic of his work.[29] James's dancing curvilinear line, so unlike his older brother's more rigorous touch, invades every part, from the eyes to the nostrils and buttonholes, endowing the whole with a compelling vivacity. After the death of the miniature's first owner, generations of descendants, many of whose names are engraved on the reverse, cherished this image of Washington. The rose-gold case records how they adapted the miniature to their various needs, for it is fitted out as a locket but also has a bracelet clasp — its fastener now lost — and a folding swivel hanger that acts as a stand.

By the time Washington was elected president, in 1789, his face had become a recognized symbol of victory and liberty. Given the public sale of Washington's likeness in full- and bust-length oil portraits during his presidency, miniatures painted from life and given by him as keepsakes to family and friends offer a rare glimpse of the private man. Yet even artists invited into his home and confronted with the flesh-and-blood individual could not resist creating an icon for posterity and profit. Miniaturists who painted personal mementos for the first family invariably made replicas for the public market.

The first two portraits of Washington painted during his presidency were both miniatures, limned on the same day, October 3, 1789. In the morning John

BY THE TIME WASHINGTON WAS ELECTED PRESIDENT, IN 1789, HIS FACE
HAD BECOME A RECOGNIZED SYMBOL OF VICTORY AND LIBERTY.

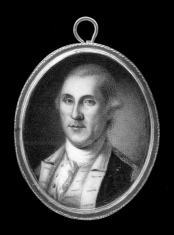

50. James Peale, *George Washington*, c. 1785, Yale.

Ramage depicted the president in military uniform as a gift for Washington's wife, Martha.[30] That afternoon he sat for the marquise de Bréhan, variously referred to as the sister or, more likely, sister-in-law of Eléanor-François-Elie, comte de Moustier, minister to the United States from France. Born Anne Flore Millet, she married the Marquis Jean-François-René-Almaire de Bréhan in 1766, and bore a son four years later. But only the marquise and her son traveled with Moustier to America, where rumors about them strained relations between the two nations. James Madison, the most forceful leader in the House of Representatives, bluntly advised Thomas Jefferson, minister to France:

> *Mou[s]tier proves a most unlucky appointment. He is unsocial, proud and niggardly and betrays a sort of fastidiousness toward this country. He also suffers from his illicit connection with Madame de Brehan which is universally known and offensive to American manners. She is perfectly soured toward this country. The ladies of New York (a few within the official circle excepted) have for some time withdrawn their attentions from her. She knows the cause, is deeply stung by it, views every thing thro the medium of rancor and conveys her impressions to her paramour over whom she exercises despotic sway.*[31]

More evenhanded in his evaluation, Secretary of Foreign Affairs John Jay wrote Jefferson:

> The Count de Moustier found in this Country the best Dispositions to make it agreable to him, but it seems he expected more ... flattering Marks of minute Respect than our People ... are either accustomed or inclined to pay anybody.... This added as I suspect ... to Insinuations ... have led him into Errors ... which naturally dispose him to give and receive Disgust. Appearances (whether well or ill founded is not important) have created and diffused an opinion that an improper Connection subsists between him and the Marchioness. You can easily conceive the Influence of such an opinion on the Minds and Feelings of such a People as ours. For my part I regret it; she seems to be an amiable woman; and I think if left to the Operation of his own Judgment and Disposition his Conduct would be friendly and useful.[32]

In the international arena of the 1780s, the United States was a weak nation that needed to remain on good terms with its former ally. Letters from Washington to Moustier attempt to assuage the diplomat's ruffled sensibilities by promoting commercial ties and a "friendly connection between our nations." For reasons of state, in November 1788 Washington welcomed the count to Mount Vernon, accompanied by "the Lady, who has taken so much interest in the new world," and her son. The president assured Moustier that "I shall cordially rejoice in an occasion of demonstrating how welcome she is."[33] Washington had that opportunity on the controversial couple's next trip to Mount Vernon on October 3, 1789, when he sat for Madame de Bréhan.

The president — who was certainly used to posing for artists — referred to himself as the "Original" in his diary entry: "Sat about two Oclock for Madam de Brehan to complete a Miniature profile of me which she had begun from Memory and which she had made exceedingly like the Original."[34] His comment seems surprising when we view the portrait: painted from life, it was executed in neoclassical profile en grisaille to recall a cameo (fig. 51). The features are distinctly Washington's — the high forehead, deep-set eyes, aquiline nose, hair tied back with a ribbon in a long queue — but Bréhan has transformed flesh into stone.

When Washington mentioned that she had begun the portrait "from Memory," he probably meant that she conceived it following her first visit the previous year. However, her likeness recalls not the man she met but rather the sculptures of him she might have seen: the bas-relief profile, crowned with a laurel wreath, by Joseph Wright, sculpted around 1784, or Jean-Antoine Houdon's iconic terra-cotta bust of 1785 (Mount Vernon Ladies' Association). With the spread of neoclassicism from the 1760s onward, the market for actual cameos and visual equivalents in other media spread. Even before Bréhan came to America, she may have been influenced by the cameo-style paintings of members of French royalty by Jacques-Joseph de Gault.[35]

During the same visit in 1789, Bréhan also painted a cameolike portrait of Eleanor (Nelly) Parke Custis (fig. 52), the daughter of Martha's son John Parke Custis, who, along with her brother, was unofficially adopted after their father's death by the Washingtons. Raising the children of relatives or even friends was

commonplace in the early republic, the result of high birth and death rates. Although Nelly still saw her older siblings and her mother, the girl who grew to womanhood during Washington's presidency adoringly called him "the General" and wrote to her best friend describing her grandmother: "She has been more than a Mother to me. It is impossible to love anyone more than I love her."[36] Bréhan's original portraits of Washington and the ten-year-old Nelly were set in a double-sided locket, no doubt as a token of affection for Martha Washington.

But first the artist used the original portrait of Washington to make replicas. Moustier sent a letter to the president from Paris in 1790, along with proofs of engravings: "Accept, with goodness, I pray, Sir, the homage which I have the honor to make in the accompanying proofs — Mad. De Brehan will profit of the first certain opportunity which presents to address to Madam Washington the medallion intended for her — in the mean time, She will make a copy of the original for herself." Clearly Washington liked Bréhan's profiles of him. Along with letters offering "his best regards," he gave watercolor, miniature, or engraved versions as gifts to friends, among them Deborah Stewart (see fig. 13), the wife of General Walter Stewart.[37]

A smaller grisaille profile by Bréhan — made more sculptural by the optical effect of the high-domed lens — was initially set in a pointed oval locket, then later mounted as a ring surrounded by graduated colorless paste gems (fig. 53). The gems allude, democratically, to diamonds, the hardest precious stone, which is equated with loyalty and therefore a fitting emblem of allegiance. The band's large size suggests that the ring belonged to a man. The ring, without beginning or end, associated with marital pledges, evokes constancy — a vow of devotion exchanged between Washington and the people of the United States.

By mimicking a cameo in these profiles, Bréhan alluded as well to the historical roots of the miniature, which grew not only from the small portraits in illuminated manuscripts but also from classical coins, medallions, and cameos. No other type of jewel has a history as distinguished as the cameo. First worn in signets by the Greeks and Romans, headstones carved in relief to be worn as jewelry often depicted heroes and divinities. And like a classical hero, Washington is

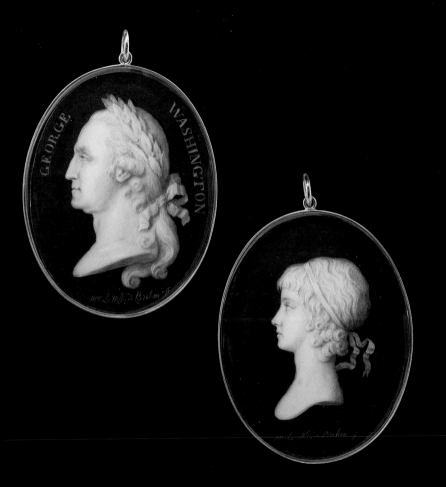

51. Marquise Jean-François-René-Almaire de Bréhan (Anne Flore Millet), *George Washington*, 1789, Yale.

52. Marquise Jean-François-René-Almaire de Bréhan (Anne Flore Millet), *Eleanor (Nelly) Parke Custis (Mrs. Lawrence Lewis)*, reverse of figure 51.

53. Marquise Jean-François-René-Almaire de Bréhan (Anne Flore Millet),
George Washington, 1789, Yale.

crowned with a laurel wreath, symbol of victory. Bréhan's portraits depict
Washington not as the doting husband of Martha or as the benign Father of His
Country but as an American Caesar or Cincinnatus. Contemporaries often
compared Washington to the legendary Roman citizen-soldier who, like him,
in a time of crisis reluctantly exchanged hearth and plow for sword and shield.

The inscription of Washington's name on the upper right and left of
Bréhan's original miniature (fig. 51) imitates the design of ancient coins and
Renaissance medallions honoring such cultural immortals. No longer an aging
man threatened by death, he becomes an icon of enduring power. This potent
symbol promises its wearer that the new nation General Washington's timeless
profile represents will endure, by might if necessary.

Miniatures of Washington recall jewels of allegiance to the monarch worn
in Europe and especially in England during the Elizabethan and Stuart periods.
Following in the tradition of a king rewarding a loyal subject, Washington

54. Unidentified artist, *George Washington*, between 1796 and 1799, Yale.

allegedly bestowed upon Patriot-artist John Trumbull, his former aide-de-camp, who recorded the nation's history in oil on canvas, a tiny, stippled bust portrait of himself elegantly set in a gold-and-diamond floral breast pin (fig. 54).[38] Washington's gesture recalls that of Queen Anne, who gave Daniel Parke her miniature in gratitude for military service (see fig. 10). The emblematic representative of a new nation, Washington was far less and yet far more than a king. Possessing his image expressed an awareness of being part of a new era and an optimistic faith in its future.

The exchange between Washington and Trumbull must have taken place in the last years of the leader's life, as the diminutive bust is ultimately modeled after the enormously popular oil portraits of 1796 painted by Gilbert Stuart, an American artist who two years earlier had returned from several years in Ireland.[39] Americans, many of whom had been reared to pledge allegiance to a revered king, craved an authoritative — but not autocratic — father figure to take

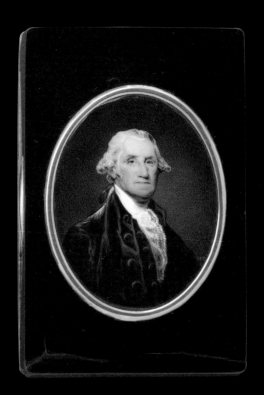

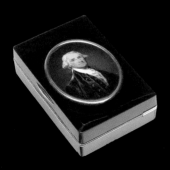

55. William Russell Birch, *George Washington*, c. 1796, set in gold snuff box covered in tortoiseshell, Yale.

56. Side view of figure 55 (object reduced from actual size).

his place. The miniature, a token of affectionate admiration within families, was the perfect vehicle for expressing personal respect for Washington as the new father figure. Miniatures derived from Stuart's pictorial image of Washington as an elder statesman, stern but wise, best characterized him as the country's benevolent patriarch.

British-born enamelist, painter, and engraver William Russell Birch modeled his approximately sixty enamel miniatures of Washington after Stuart's portraits, and charged from thirty to a hundred dollars each (fig. 55).[40] Enamel miniatures were relatively rare in America. In England, the fragile form of miniature painting in watercolor on vellum had been challenged during the seventeenth century by the introduction from the Continent of more durable enamel miniatures. First brought to England in the 1630s by the French miniaturist Jean Petitot, enamel miniatures remained popular in Britain through the early part of the eighteenth century, when watercolor-on-ivory miniatures largely eclipsed them.

A small number of primarily immigrant artists introduced enamels to America, with Birch being the most acclaimed. Successful in England, he had exhibited at the Society of Artists and the Royal Academy. When he settled with his family in Philadelphia in 1794, he advertised that he had "the honor of being recommended by Mr. West," Philadelphia's favorite son and president of the academy. Birch's autobiography includes an essay about the enamel process and a partial list of his works, including copies after old masters, landscapes, and portraits, the most lucrative being the pictures of Washington. It also includes this vivid account of the genesis of those portraits:

> When [Washington] was sitting to Stuart, he told him he had heard there was another Artist of merit from London, naming myself, that he would sit to me if I chose. Mr. Stuart brought me the message. I thanked Mr. Stuart, and told him that as he had painted his picture, it would be a mark of the highest imposition to trouble the Gen'l to sit to me, but that when I had copied his Picture of him in Enamel, which was my forte, that I would show it to the Gen., and thank him for his kind offer, which when I had done, I waited upon the Gen'l with a note....

57. Attributed to Ruth Henshaw Bascom, *Eliza Jane Fay,* 1840, pastel and graphite pencil on paper, New York State Historical Association, Cooperstown. Inscribed "In Memy / Geo. / Washingt" on the pendant.

When I saw the Gen'l I put the picture into his hands. [H]e looked at it stead-
fastly … till feeling myself awkward, I begun the History of Enamel Painting,
which by the time I got through, he complimented me upon the beauty of my work.
I then told him how much we was beholding to Mr. Stuart for the correctness of
his likeness.[41]

The endurance and brilliance of enamel made it the perfect medium for
Birch's iconic images of Washington. Composed of crushed glasses applied to a
usually white enamel ground fused on a support of gold, silver, or copper, their
pigments were made permanent by subsequent kiln firing. Birch incorporated his
popular portraits into brooches and pendants. But their jewel-like shine and rich
velvety colors are particularly appealing when the miniature is set into a gold oval
on the lid of a tortoiseshell-covered snuffbox (fig. 56). Whether the owner of this
snuffbox knew Washington personally or revered him at a distance, having a
small portrait of him emblazoned on an object for everyday use exemplifies how,
through home-oriented consumerism, Washington became ubiquitous in the
American domestic interior and psyche. Portrait miniatures of Washington
melded the public and private realms, helping to fashion an American character
based on the ownership and internalization of republican ideals.

The high-profile death of the country's father on December 14, 1799,
marked a watershed in communal mourning and in the powerful role of the
miniature in the process. Washington's demise inspired the frenzied, lucrative
commercial production of songs, poems, essays, prints, plays, and household
objects in his honor. But nothing so personally expressed the national grief
as the unprecedented display of portrait and allegorical miniatures worn by men,
women, and children well into the nineteenth century as a sign of respect and
of a deep and prolonged mourning. A pastel (fig. 57) made decades after his
death shows a young girl wearing a pendant inscribed in Washington's memory.
It is decorated with a pyramid, endowing the president with the grandeur of
the pharaohs.

In the late eighteenth through mid-nineteenth century, the miniature was a
visible, public family mourning device, and the first president's death united the

nation as one family. A miniature worn on the body displayed a citizen's bereavement for his or her Father. Typical of miniatures expressing national sorrow in the allegorical terms usually reserved for personal loss is the scene, housed in a locket, of a lone female mourner weeping below a willow tree beside Washington's tomb (fig. 58). The willow tree, urn, and Grecian mourning figure dressed in white were popular neoclassical symbols in the last quarter of the eighteenth century. Here the mourner at once personifies Virtue, Liberty, America, and the grieving individual who wore this locket. The motifs are painted in sepia and carmine watercolors—the colors of earth and blood, emblematic of the wounded country. Although carmine fades easily, touches of it remain most visible over the mourner's heart. The depicted earth itself is textured with chopped hair, as if symbolically joining the miniature's owner with the body politic, represented by the buried Washington.

This miniature is attributed to Samuel Folwell, a Philadelphia painter, engraver, hairworker, needlework designer, and drawing master. His memorials, often dedicated to Washington, frequently feature crossed trees and a curly-haired mourner with "flipperlike" hands,[42] as seen here and in a more elaborate, private family memorial (see fig. 63). Memorials designed by Folwell were also worked by the young women who attended his wife Ann Elizabeth's school of embroidery, which inculcated them in the fervor of patriotism surrounding Washington's death. Unlike the Peale family, who catered to the highest levels of society in Philadelphia, Folwell offered a wide range of services to the expanding middle class.

From the 1760s the vogue for memorials on ivory was especially strong in England, and similar work was produced on the Continent and in the United States, especially for the wealthy. The death of Washington gave impetus to a wider market for mourning iconography in America. Many echelons of society, including those who may have hesitated to commission a private watercolor-on-ivory portrait from a leading miniaturist, could afford to display their loyalty to Washington's memory.

Mourning iconography grew from a classical Arcadian root. Beyond this distant source, craftsmen like Folwell turned for inspiration to books, prints,

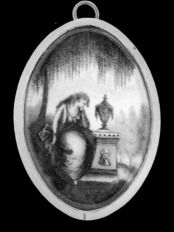

58. Attributed to Samuel Folwell, *Memorial for George Washington,* c. 1800, Yale.

portfolios of allegorical devices, and even, with regard to Washington, decorations for stage sets designed for monodies and eulogies hymning the president after his death. Memorials to Washington by Folwell and others in prints and needlework and painted on ivory reflected and fueled the heightened spirituality of the evangelical awakenings of the mid- and late eighteenth century. By combining patriotism and spirituality, mourning scenes conveyed the nation's vision of the dead Washington as the ultimate father, the immortal benefactor-savior of America.[43]

A uniquely private mourning miniature, however, allows us most tenderly to glimpse George and Martha Washington as a couple rather than as public,

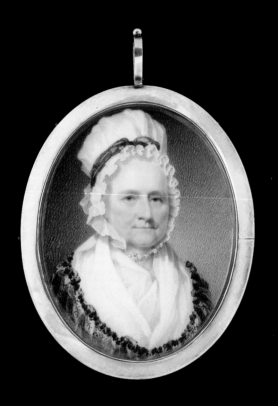

59. Robert Field, *Mrs. George Washington (Martha Dandridge, Mrs. Daniel Parke Custis)*,
1801, Yale.

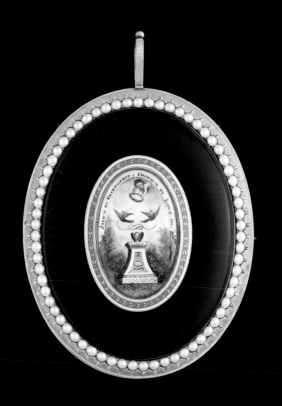

60. Robert Field, *JOIN'D BY FRIENDSHIP*, *CROWN'D BY LOVE*, reverse of *Mrs. George Washington*, 1801, Yale.

Detail of figure 59 (above). Field's characteristically refined strokes transcribe the curving contours of her flesh, made still paler by contrast with the brown hatchings in the background. Her eyes convey the universal sadness of someone who has lost a life's partner.

Detail of figure 60 (opposite). On the reverse, the widow's gray hair is probably intermingled with that of her deceased husband and ritually sprinkled over the earth beneath the altar, celebrating her undying love for him. The oval ivory wafer is encircled by a yellow-gold rim enameled in pale blue and white with bright-cut leaves and blue glass over embossed foil.

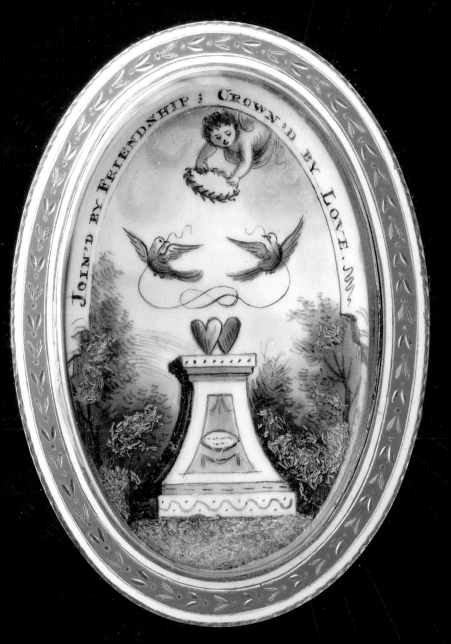

historical icons. Robert Field's informal portrait of Martha Washington, painted by him in 1801 at Mount Vernon, portrays her as a widow undergoing prolonged mourning, signified by the black ribbon on her cap (fig. 59).[44] Her suitably old-fashioned cap, double neckerchief, and black-lace shawl all encircle her gentle face, depicted by Field with affection and insight.

Among the most accomplished British-born miniaturists working in America, Field not only painted portraits of prominent citizens in Baltimore, Philadelphia, Washington, and Boston, he also socialized with them. In marked contrast to most American portraits, which were densely painted on small ivory disks, Field, who arrived in Baltimore in 1794, brought with him a more luminous technique for limnings on a thinner, larger ivory. Here, the result is a delicate fragility that underscores the reclusive widow's age and mood. His characteristically refined strokes transcribe the curving contours of her flesh, made still paler by contrast with the brown hatchings in the background. Her eyes convey the universal sadness of someone who has lost a life's partner. Field reveals the private person who disliked her public role, described by Abigail Adams as "unassuming, dignified and femenine, not the Tincture of ha'ture [haughtiness] about her."[45]

When a New York merchant visited Mount Vernon in 1801, he wrote in his diary that "a miniature drawn last winter or spring by a Mr. Robert Field, now in Washington, of Mrs. W., is a striking likeness. She is drawn to please her grand-children, in her usual long-earred cap and neckerchief, that they may see her, as she expressed it, in her everyday face." Two portrait miniatures by Field fitting this description are known to exist. One miniature, now at Mount Vernon, in fact descended directly from the widow's granddaughter Martha Parke Custis Peter. But the other, now at Yale, has a decorative reverse of highly personal import, revealing that Martha Washington kept it for herself before eventually giving it to Nelly's daughter Frances Parke Lewis, who was just an infant in 1801.[46]

On the miniature's significant reverse, the widow's gray hair is probably intermingled with that of her deceased husband and ritually sprinkled over the earth beneath the altar, celebrating her undying love for him (fig. 60). Their chopped hair is symbolic of their bodies, joined forever, like the two hearts

wedded on the altar to Hymen. Entering from above in the arms of a flying Cupid or Christian putto, the offering of a laurel wreath from heaven is a gesture of immortality. The gesture echoes the words recited at a monody staged days after Washington's death: "Glory, bring thy finest wreath, Place it on thy Hero's urn."[47]

Field's scene also recalls numerous romance allegories, like the one by John Ramage (see fig. 46) in which a pair of birds stand side by side, imitating a man and woman before the altar in a marriage ceremony. In Field's allegory the birds have taken flight in opposite directions, but they do so with regret, looking back toward each other and holding in their beaks a ribbon forming a lovers' knot that forever joins them. Interpreted in a book of emblems as meaning "The farther apart, the closer united,"[48] the conjoined birds articulate Martha Washington's longing for her husband's physical presence and belief that they are still together in spirit. Inscribed "JOIN'D BY FRIENDSHIP, CROWN'D BY LOVE," the tiny scene, possibly limned in dissolved hair, expresses the triumph of love over its most formidable foe, death. The oval ivory wafer is encircled by a yellow-gold rim enameled in pale blue and white with bright-cut leaves, blue glass over embossed foil, and, in the locket's rose-gold rim, sixty-seven prong-set, full pearls — one for each year of George Washington's life. The elaborately decorated reverse expresses his widow's aspiration that his death is only a prelude to their reunion in life everlasting.

61. Unidentified artist, *Mourning Ring for Thomas Clap*, 1767, Yale (object enlarged from actual size).

62. Attributed to John Brevoort, *Mourning Ring for John Brovort Hicks*, 1761, Yale (object enlarged from actual size).

Mourning rings, brooches, and lockets convey, in a different way from the written word, how much our understanding of death and our relationship to those who have died have changed over time. In mourning rings fashioned in America in the early and mid-eighteenth century, skulls or skeletons often appear entombed inside coffinlike crystals (fig. 61). These common artifacts, which strike modern sensibilities as morbid, have a long history. They have precedents in Memento Mori jewels of the Renaissance and in late seventeenth-century English mourning slides, which were frequently worn as pendants, depicting such motifs as skulls with cross-bones or skeletons holding hourglasses. The precursor of the figure of Death personified as a corpse or skeleton — ubiquitous in European art by the fifteenth century — was frequently illustrated in the *Legend of the Three Living and Three Dead*. In the tale, three foolish youths, or arrogant kings, encounter three corpses. "As you are, so once were we," they intone. "As we are, so you will be."[1]

Early and mid-eighteenth-century mourning rings in effect urge us, "Prepare for Death and Follow Me," to quote an injunction on countless colonial gravestones decorated with death's heads, skeletons, and hourglasses. Mourning rings with these symbols were given to the bereaved at funerals and bequeathed from generation to generation. It may be hard for modern readers to understand what comfort a ring adorned with a painted skull could offer a family mourning the death of a child, the hardest loss to bear. Yet the maker of one such ring was closely related to the deceased toddler.

In 1761 New York goldsmith John Brevoort fashioned a ring in memory of his grandson and godchild, John Brovort Hicks (fig. 62). Only two and a half years earlier young John had been baptized in the Dutch Reform Church. The child was the son of the goldsmith's daughter Charlotte and Whitehead Hicks,

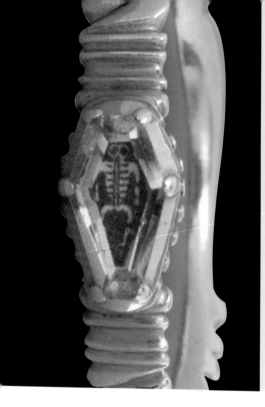

Detail of figure 61. In mid-eighteenth-century mourning rings, skeletons often appear entombed inside coffin-like crystals. These common artifacts convey how much our relationship to those who have died has changed over time.

mayor of New York City from 1766 to 1773. As in most rings dedicated to children, the inscription is in a white enamel infilling connoting innocence. Faced with the ever-present possibility that their children, especially infants, would die, family members wore such rings as a way to turn their minds from vanity toward an acceptance of death. The rings not only memorialized the child's death, they prepared the wearer for his or her own. The loss of a loved one thus became a contemplative lesson, a heaven-sent opportunity for developing a less worldly, more spiritual state of mind. As a father and clergyman wrote in his diary upon the sudden death of his infant daughter, "The will of the Lord be done!... O that we may have a due sense of the Divine Mind concerning us!"[2]

But mourning rings bearing skeletons became less common later in the eighteenth century. Now images of sorrowful mourners appeared on the rings, brooches, and lockets, and the change represented a new idea of death and our relationship toward loss (fig. 63). The shift from an emphasis on death itself to one on the lamentation for the dead developed in tandem with the new enthusiasm for family life being celebrated by portrait miniatures.[3]

One aspect of the development of more affectionate family relationships and the child-centered home was the greater expression of grief over loss. Mourning scenes, often limned on the reverse of portraits, kept the absent family member ever present. The increasingly popular *Elegy Written in a Country Churchyard*, by Thomas Gray, still invokes the "trembling hope" of the Christian in the face of Death, but the dominant idea is that we shall survive in the memories of those who mourn us:

> On some fond breast the parting soul relies,
> Some pious drops the closing eye requires;
> E'en from the tomb the voice of Nature cries,
> E'en in our Ashes lives their wonted Fires.

This idea, noted by contemporaries as novel in poetry, soon became commonplace. Of course, it is not the dead but the living that such sentiments serve. Visiting the grave, or keeping miniature reliquaries of the deceased adorned with a representation of that visit, fulfills what is now recognized by psychoanalysts as a fundamental need to imaginatively or tangibly locate the dead in a specific place.[4] These reliquaries are among the least understood but most compelling objects in American art.

The intimate experience of death in an era of high mortality rates formed a constant emotional landscape against which these tokens must be interpreted. Social historians view intense mourning as characteristic of the more closely bonded modern family.[5] The emphasis on weeping over loss reflects Enlightenment ideas about humankind's innate moral compassion. By the late eighteenth century, sentiment—the expression of feelings with open outbursts of emotion,

63. Attributed to Samuel Folwell, *Mourning Brooch for SP, ARP, and SP*, c. 1795,
Promised Deutsch Bequest, Yale.

especially tears — was seen as a desirable trait. The exaggerated rhetoric of the sentimental had a profound impact on mourning iconography.

Mourning is a culturally learned form of language. While some of the attitudes toward death, grief, and the deceased now seem odd, or so conventionalized as to appear insincere, still we miss a public language to express loss. If the ritual of grief must be performed — and personal experience, anthropology, and psychology all agree that it is essential — then it is most easily observed when the forms of expression are set and shared by a supportive community. Mourning miniatures express a private grief in a public language that was understood by the mourner's family, friends, and neighbors.

Classical forms, Christian iconography, moral philosophy, and personal feelings were layered over these incredibly small scenes of idealized simplicity, often painted with dissolved or chopped hair and adorned with tears in the form of seed pearls. The archetypal imagery of mourner, urn, tomb, plinth, and trees would be chosen from sample devices by maker and client and then arranged to fulfill an individual need.[6]

The most popular convention of mourning miniatures in the late eighteenth and early nineteenth century became the figure of a female mourner in a white neoclassical dress drooping over or beside an urn placed beneath a willow tree. The pastoral setting alludes to numerous biblical gardens, among them the Garden of Eden, where life began, and the Garden of Gethsemane, where Christ was arrested, leading to his Crucifixion and Resurrection, which brought the promise of eternal life. The weeping willow, which visually mirrors human grief in the natural world, has the power to grow again after it is cut, and thus symbolizes life-in-death. Drawn with a linear simplicity that recalls the grave steles of the ancient Greeks, the mourning figure, head covered with the veil of Aeternitas, signifying renunciation of the corporal, succinctly distilled classical and Christian ideals.[7]

The common choice of a female mourner with head bent and eyes downcast in selfless devotion also reflects the role of women as the symbolic embodiments of moral virtue, the keepers of the domestic sphere. As Americans began to move away from the emotionally restrained, father-dominated family of early

America, the tender mother emerged as the moral guardian in sermons, child-rearing manuals, prescriptive literature — and art.[8]

As part of a pedagogical approach enforcing moral values through domestic arts, the motif of a female mourner became a cliché on needlework and watercolors made by girls and women. The memorials decorated the home and recalled those who had departed from it but would be met again in heaven. A mother who lost her infant son in 1801 to an influenza epidemic consoled herself with this thought: "At bedtime, instead of my charming boy, ... I found a lifeless corpse — laid out in the white robes of innocence and death. Though I wept and pressed him, he could not look at me. How could I endure it — much less compose myself — but by believing him gone to perfect rest and happiness — there to wait for his father and mother."[9]

To us, it comes as some surprise that the ubiquitous maternal mourner does not usually dress in black. But the white drapery reflects the mourning personifications in antique sculpture, as well as the popularity in late eighteenth-century fashion of the white neoclassical Empire dress. White also was worn at funerals, in particular of unmarried women and bachelors, but above all for children.[10] The equation of white with innocence, purity, and spirituality makes it the appropriate choice for the ethereal mourner limned on white ivory.

Although somewhat less common, male mourners also appeared in allegorical scenes as stand-ins for the bereaved. For example, on the reverse of a portrait of Mary Otis Bull, the male mourner in reverie before her tomb on one level represents — but is not a portrait of — her grieving husband, Caleb Bull, Jr. (fig. 64). A former Revolutionary War captain, the first director of the Hartford Bank, and a business partner in the Hartford silversmith firm of Bull and Morrison, Caleb had married his second wife, Mary, on February 12, 1778. He lost her seven years later. Her portrait can be dated to around the time of her death on the basis of costume details: the white kerchief puffed up over the bust, the black neck ribbon, and the strikingly large cap that curves down from a bow at the top and leaves ample room for the built-up hair popular during the 1780s (fig. 65).[11]

Technical comparison to *Caleb Bull* (fig. 66), signed by William Verstille, suggests that the local limner also painted the previously unattributed *Mrs. Bull*

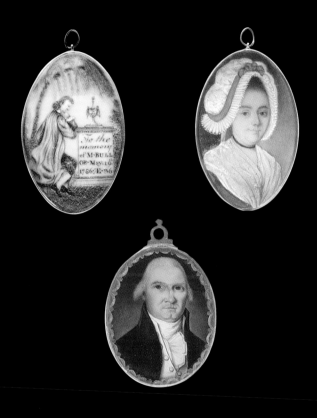

64. Attributed to William Verstille, *Memorial for M. Bull,* reverse of figure 65.
65. Attributed to William Verstille, *Mrs. Caleb Bull (Mary Otis),* c. 1786, Yale.
66. William Verstille, *Caleb Bull,* c. 1790–95, Yale.

before he left Connecticut in 1787 in search of commissions in New York. There he kept an account book recording not only portraits but also hairwork and "devices,"[12] indicating that he probably painted the memorial in watercolor and chopped hair on the reverse. Verstille might have limned Mary Bull's likeness posthumously but probably painted it shortly before her death in 1786. On the portrait, abrasion along the ivory's edges appears to be from an earlier fillet, supporting speculation that when Mary died the artist slightly trimmed his recent portrait miniature to create a mandorla shape associated with mourning, added the gravesite vigil on the reverse, and rehoused the disk.

The mourner, younger in appearance than Mary's husband, wears a minister's robe: an academic-style gown with full set-in sleeves gathered at the wrist and finished with a ruffle.[13] While embodying Caleb's bereavement, as a clergy-

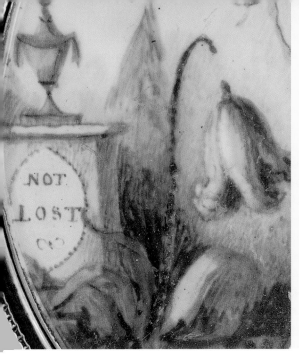

Detail of figure 67. During an era when parents faced births with the awareness that new life often meant death, "NOT LOST BUT GONE BEFORE"—a maxim offering consolation on gravestones and in poetically abridged form here—voiced faith in the family's future reunion.

man the mourner serves simultaneously as a spiritual conduit for Mary's passage from life to death. It is through his intervention that those who loved her will retain their connection with her beyond the grave.

Among the most poignant mourning miniatures are those dedicated to the very young. The words "NOT LOST" inscribed on a miniaturized tomb beside a soulful flower express the plaintive wish of the parents of Hannah Hodges, a twelve-year-old girl who died of consumption during a smallpox epidemic in Salem, Massachusetts, in 1792 (fig. 67). Hannah was the first-born daughter of Captain Benjamin Hodges, a merchant, shipmaster, and Freemason, and Hannah King Hodges of Salem. Two years after young Hannah's death, on June 5, 1794, her parents welcomed the birth of her namesake. Although that baby lived well into adulthood, Captain and Mrs. Hodges lost six of their nine children to

68. Unidentified artist, possibly Ezra
 Ames, *Memorial for Henry G. Staats,*
 c. 1802, Yale.
69. Reverse of figure 68.

consumption, which eventually claimed their lives as well. The winged angel's head at the top of the mourning miniature denotes the rapidity with which a human life passes, but it is also the guardian angel that watches over each soul at birth and calls it home to heaven. During an era when parents faced births with the awareness that new life often meant death, "NOT LOST BUT GONE BEFORE"—a maxim offering consolation on gravestones, mourning miniatures, and in poetically abridged form here—voiced faith in the family's future reunion.[14]

The longstanding attribution of the *Memorial for Hannah Hodges* to John Ramage appears less certain because he was in New York in 1792; however, the artist had Boston-area connections, and Hannah's father, as a shipmaster, traveled regularly.[15] Forms are more softly blended than in Ramage's sharply delineated *Romantic Allegory* (see fig. 46), but that stylistic change may have been deliberate, for the delicacy enhances the memorial's air of serenity. The memorial more closely resembles Ramage's portraits (for example, *Anthony Rutgers*, fig. 47), both in its lyrical mood and in its series of fine hatches. If Ramage, who never signed his miniatures, did limn this mourning scene, then the Irish-born goldsmith probably also fashioned the locket with fluted edges.

In a striking miniature, a weeping female figure dressed in black standing over a plinth is partially veiled by willow boughs painted on the reverse of the covering glass (fig. 68). In style and technique, it resembles others executed in the early nineteenth century around Albany, New York.[16] The memorial descended in the Albany-based Staats and Cuyler families. A comparison of the initials inscribed on the mourning locket to family genealogies seems to tell a familiar story of infant deaths. Henry Staats, born on January 16, 1802, and christened the following month at the First Dutch Reformed Church of Albany, figuratively rests in the tomb, inscribed on the plinth "HGS."

On the reverse (fig. 69), cut-gold initials probably stand for his brother Richard Cuyler, born earlier on July 16, 1800, and remembered by locks of plaited hair. The initials of their mother, Catherine Cuyler Staats, are engraved at the top of the locket's reverse. While no records of the boys' deaths have been found, the birth of a son christened Richard Henry in 1803 suggests that his parents bravely named him after his deceased brothers.[17]

Allegorical miniatures were pervasive as tokens of bereavement among Christian families, yet it appears that despite their association with Christian belief, some Jewish families also commissioned them. Three prominent New York City families, all descendants of founding members of Congregation Shearith Israel, chose the same miniaturist to fashion mourning jewelry in memory of family members. This unidentified craftsman's "signature" is the meticulous mastery of precious hairwork, beads, pearls, and wire. In a double memorial set in a simple circular locket (fig. 70), those skills poignantly perpetuate the memory of two infants, Solomon and Joseph Hays, who died in 1798 and 1801, respectively. The genealogy of any deceased infant, especially in the absence of baptismal records, is difficult to confirm. But it seems likely the boys were the sons of Jacob Hays, known as the "terror to evil-doers," who was appointed city marshal the year of Solomon's death and high constable (chief of police) by every New York City mayor from 1802, the year after Joseph's death, to 1849.[18]

In consultation with his grieving patrons, the miniaturist selected and adapted a design from a pattern book, then transformed the generalized sentiment into a personal relic. The centrally placed, veiled, maternal guardian protectively places her arms over the tombs of both children. In times of illness and death, faith in God was coupled with reliance on a watchful, loving mother. The records of Congregation Shearith Israel, largely concerned with practical issues, pause in 1798, the year of Solomon's death, to lament the human cost of a city-wide scarlet fever epidemic.[19]

Solomon may have been one of its young victims, although the cause of his death remains unverified. Our knowledge of Solomon and his younger brother is more visceral: his blond hair forms the abstracted willow on the left, Joseph's brown hair, the one on the right. Anyone who has ever touched an infant's hair and marveled at its softness reacts to these long strands, still alive with the silkiness and sheen possessed only by the very young. The boys' hair also appears to have been dissolved to paint the left and right portions of the scene, lending a golden and earthen tone to the background landscape symbolically inhabited by each infant. Chopped and cut blond hair fills the earth below Solomon's

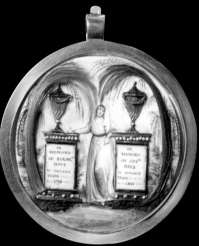

70. Unidentified artist, *Memorial
 for Solomon and Joseph Hays*, 1801,
 Promised Deutsch Bequest, Yale.
71. Reverse of figure 70.

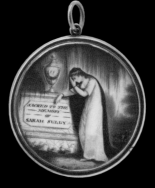

72. Thomas Sully, *Memorial to His Mother, Sarah Sully*, c. 1801, Yale.

monument and the urn above; brown hair similarly defines Joseph's place of rest. On the reverse, the two brothers' locks plaited together unite them forever beneath their conjoined initials (fig. 71).

The Hays memorial's circular shape, like that of painter Thomas Sully's memorial to his mother (fig. 72), evokes the continuity of familial affections. Born in England, Sully had spent most of his childhood with his maternal grandparents because his mother and father were itinerant actors. With his parents and eight siblings, he immigrated to the United States in 1792. The eleven-year-old boy was away at school in New York two years later when his mother died in Richmond, where she was performing. This miniature can be dated stylistically to the beginning of the artist's professional career, during which he would become the foremost portraitist working in Philadelphia.[20] Testifying to the difficulty of accepting the death of a parent, this homage was probably painted

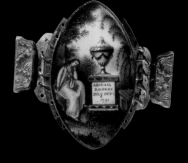

about seven years after Sarah Chester Sully's death. Perhaps the teenaged artist also lamented the time lost when she was still alive, for mother and son had often been apart.

Conventionalized imagery could be used to great effect, especially when the artist himself was grieving. The curve of the mourner's back is both echoed and answered by the willow. The yellow in the foreground earth, carmine in the flesh, and blue in the background sky act as foils for the drama in black and white of the sorrowful mourner beside the monument. Sully's sinuous line renders this formulaic scene with an inner grace.

Inscriptions dedicated to more than one generation attest to the significant role mourning miniatures played in cementing family ties through time. Housed in a marquise-shaped locket mounted in a bracelet clasp, a tiny scene shows a female mourner lamenting beside a three-dimensional urn above a plinth, both

formed out of minute ivory pieces attached to the ivory surface and decorated with pearl finials and engraved gold bands (fig. 73). The dedication painted on the plinth reads, "ABIGAIL/ROGERS/ OB. 7 OCTR./... 1791" But on the reverse, the engraving on the clasp reveals that this mourning scene was rededicated some fifty years later to "Martha Ann/[B.] Lovering/died Augt. 27. 1842/Aged 19 yrs." In addition to this engraving, recent analysis detected further modifications: the lens was removed and perhaps replaced, chopped hair was added, and the end caps of the bracelet clasp were altered. The changes suggest that the first bracelet was made of silk, the later one of hair, but both are now lost.[21]

These efforts to preserve and reuse the miniature honored the memories of both Abigail Rogers and Martha Ann Lovering, and compel us to reweave the threads that joined them in the hearts of those who owned this memorial. Born in 1753 into the colonial aristocracy, Abigail Rogers, née Bromfield, was the daughter of Boston merchant Henry Bromfield and Margaret Fayerweather, whose nephew Samuel was painted in miniature by John Singleton Copley (see fig. 35). (Henry Bromfield's second wife, Hannah Clarke, was the sister of Susannah Clarke, Copley's wealthy Tory wife.) Soon after Abigail married merchant Daniel Denison Rogers in 1781, her brother penned these optimistic lines: "I rejoice with our sister Abigail that she has found her Daniel and has so fair a Prospect of Happiness in the Society of a deserving Man."[22]

But only months later Abigail's father wrote to her new husband, who had taken his daughter abroad, "We are anxious to hear of our Daughter's health and to know whether the sea has proved beneficial.... I pray God we may have agreeable Tidings." This is just one of innumerable letters expressing concern for her health. When Abigail and Daniel were staying at Windsor with the Copleys while the artist painted a portrait of the daughters of King George III, Daniel confessed frankly, "Her dear Body [is] reduced to a perfect skeleton and her stomach extremely weak."[23] Yet around this time Copley painted a

74. (opposite) John Singleton Copley, *Mrs. Daniel Denison Rogers (Abigail Bromfield)*, c. 1784, oil on canvas, Fogg Art Museum, Harvard University Art Museums, Cambridge, Mass.

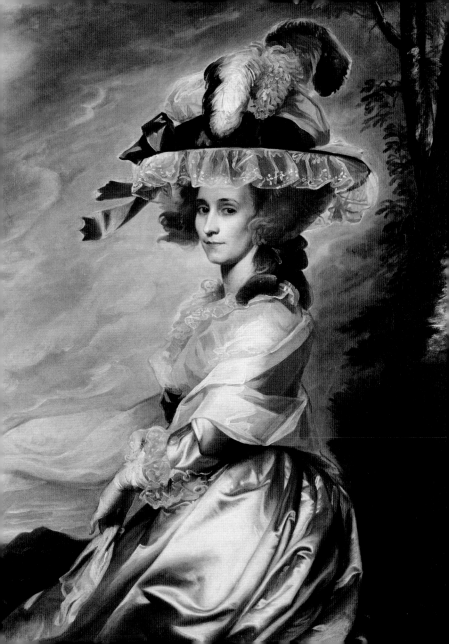

glamorous portrait of his step-niece, a breezy confection of prosperity, youth, and beauty (fig. 74).

Abigail Bromfield Rogers died after "a long and very painful illness," but her family never forgot her. In the mourning miniature, on the left the bushy elm or oak, emblematic of the fortitude she showed during her suffering on earth, is balanced on the right by the willow, symbolic of life everlasting in the gospel of Christ.[24] Trees are also signs of fertility in the midst of death. Though the chronically ill Abigail Rogers bore no children of her own, her husband's sister Elizabeth, who married Thomas Gilman, named her daughter, born in 1789, Abigail Bromfield Gilman in honor of her ailing sister-in-law. Abigail Gilman in turn married John Lovering. In 1837 their son John Gilman Lovering married Mary [Martha] Ann Martin, who died in 1841 soon after the birth of their son Henry.[25] By that time, the vogue for allegorical mourning miniatures had passed. Instead of commissioning a new one, the family rededicated an existing relic they still held sacred. One family heirloom tangibly commemorates Abigail Rogers and Martha Ann Lovering, two distant cousins who died more than half a century apart.

The pervasive elevation of the child, and the mother who risked her life to bear it, found succinct expression in miniatures extolling maternal devotion. In one, the mother holds a baby on her lap while addressing her standing son (fig. 75). This little homage reflects the position of women and children in the new modern family. The serious mood and the mother's lecturing of the older child can be linked to women's growing responsibility for the improvement of their children and, by implication, the improvement of society. Maternity had come to be valued as a contribution to the nation, an attitude that at once kept women in their place and elevated that place.

As in most allegories of love or death, the idyllic setting is pastoral. The miniature may have been given by a husband to his wife to celebrate the birth of their child, although the weeping willow suggests that this is a mourning minia-ture. In late eighteenth-century America, the importance of the mother's role was enhanced by religious imagery in childrearing publications, popular writings, poetry, and art. This miniature fits into contemporary interpretations of the

75. Unidentified artist, possibly Samuel Folwell, *Maternal Allegory,* c. 1795, Yale.

spiritual experience of mothering: although the poses of the figures could be taken from everyday life, they are as formal as if the three were engaged in a sacred rite. The miniaturist subtly evokes religious meaning in the placement of the baby on the mother's lap in relation to the standing child, a grouping reminiscent of the Virgin Mary, baby Jesus, and young John the Baptist.

After about 1760 many artists of larger paintings and prints used similar groupings to infuse the everyday gestures of family life with religious piety. Benjamin West's *The Artist's Family* (fig. 26) exemplifies such testaments to the enthronement of the mother as Madonna. In contrast to paintings earlier in the century in which the father generally dominated, in late eighteenth-century portrayals, he often recedes from view, as West himself does at the far right, focusing his and our attention on his wife, who is holding their younger child.[26]

In the allegorical miniature, the father's presence is merely implied as the possible giver or receiver of this token. The soft glow of the ivory beneath the brown and blue watercolors contributes to the spiritual overtones. The miniaturist sprinkled chopped hair over the watercolor delineating the earth at the base of the tree, suggesting the role of the mother as the source of the family. As in all miniatures of love and loss, the hair adds to the sacramental charge of the object as a kind of shrine.

A mourning miniature of a deceased teenaged girl breaking through an obelisk to reunite with her distraught mother embodies the power of maternal devotion (fig. 76). The evergreens pictured in the background reinforce the

Detail of figure 76. A mourning miniature of a deceased teenaged girl breaking through an obelisk to reunite with her distraught mother expresses the universal longing to keep the dead within the circle of the living. This tiny but powerful token of maternal devotion is fashioned from watercolor, chopped hair, gold wire, pearls, and minute pieces of ivory attached to the ivory surface.

Resurrection imagery. Their dark foliage symbolizes death, but their upward thrust — like the pyramidic form of the foreground obelisk — connotes hope, their greenery everlasting. The reverse of the locket bears an engraved dedication to S.C. Washington, who died at age nineteen in 1789. Inside the locket, a piece of cut paper attached to the back of the ivory contains a tiny remnant of a note, probably from the family who mourned her, instructing the artist on how they wanted their daughter memorialized. The powerful imagery they chose encapsulates the ultimate purpose of all miniatures, to hold onto the beloved. More than any other token of the time the mourning miniature expressed the universal longing to keep the dead within the circle of the living.

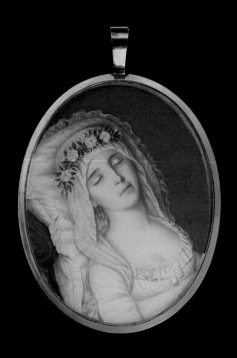

77. P. R. Vallée, *Harriet Mackie (The Dead Bride)*, 1804, Yale.

Few miniatures offer deeper insight into the early nineteenth-century American way of mourning than *Harriet Mackie (The Dead Bride)* (fig. 77).[27] Housed in a rose-gold locket, this portrait would have been worn close to the heart and looked at in private, as one would approach a secret. By commissioning this token, small enough to hold in the palm of the hand, someone in Charleston, South Carolina, in 1804 acquired a visible past — a tangible link with a teenaged girl both loved and mourned. By reconstructing as far as possible the history of her life and death, we restore to this miniature its power to suggest the intimate communion between the self and another.

The miniaturist's name has traditionally been given as Jean François de Vallée, purportedly a textile manufacturer who corresponded with Thomas Jefferson, but no documentary evidence supports this. However, advertisements in the local press reveal that between 1803 and 1806 one *P. R.* Vallée did work in Charleston, and his technical virtuosity reveals him to have been a mature miniaturist when he arrived. In the usual manner, he announced his availability in the *Times:* "Mr. P. Vallée, *Miniature Painter*, LATELY arrived from Paris, offers his services to the Ladies and Gentlemen of this City, in the line of his profession; he warrants the most correct LIKENESS."[28]

Vallée's likeness of Harriet Mackie was taken from her corpse. Although many mourning miniatures were copied from portraits made while the subject was alive — for example, Dunkerley's *Mrs. Ebenezer Storer II* (fig. 39), after Copley's pastel — others were painted directly from the body. Painting the dead cannot be easy. Here, as was customary, Vallée may have secured Harriet's slack jaw with a strap and continued to work as decomposition set in. But it was rare for a miniaturist to depict the dead with closed eyes, as Vallée did. Usually the eyes were shown open, so that the memory of the *living* person could be preserved. The decision to leave Harriet's long-lashed lids closed and record her pallor reveals a need not only to remember the features of a living person but to fix them in death.

Vallée's image likens death to a blissful sleep, recalling recumbent or reclining mortuary statues from the Middle Ages to the present. Harriet's repose

Detail of figure 77. Harriet Mackie's chaplet is adorned with roses, flowers that frequently appear on tombstones. A symbol of love and death, the rose would become the most common motif in American posthumous mourning paintings by the mid-nineteenth century. To the ancient Romans the rose was the flower of Venus, the goddess of love. Harriet, who died before being deflowered on her wedding night, is crowned with white roses, a symbol of purity since the earliest years of Christianity.

suggests the words used by Christ when raising the daughter of Jairus from the dead: "Dormit, non est mortua." The serenity of Harriet's expression, the comfortable pillow under her head, and the hint of domestic furniture at the lower left envision sleep as a state of transition between home as protective haven in life and heaven as protective home in the afterlife. Later in the century, this domesticated heaven would serve as a comfort in popular images and consolatory poetry. For the wearer of this locket, the visual metaphor suggests the place the deceased occupied in the mourner's mind: she sleeps until they shall meet again in their heavenly home.

Harriet rests, forever dressed in a white bridal gown, with a veil and garland of white roses crowning her head. Her close-fitting veil and chemise gown, with its lace frill softening the neckline, were fashionable bridal attire.[29] However, in this arresting scene, these celebratory contemporary garments take on an opposite aura of mournful eternity, for they allude as well to the ethereal veil and gown worn by the mourning Madonna on so many memorials.

Similarly, her bridal garland could also be interpreted as a funeral chaplet. The wreath of flowers was an ancient symbol that had been revived in Vallée's revolutionary France; it was given as an offering to the deceased in funerary monuments. Here the chaplet symbolizes the perpetuation of Harriet's memory by the person who commissioned the miniature. A traditional token of maidenly purity — in *Hamlet,* Ophelia is buried wearing her virgin's garland — floral bridal wreaths, worn by the corpse, carried by attendants, or left hanging in the church, were significant props in funeral ceremonies for unmarried girls until late in the nineteenth century.[30]

Harriet's chaplet is adorned with roses, flowers that frequently appear on tombstones. A symbol of love and death, the rose would become the most common motif in American posthumous mourning paintings by the mid-nineteenth century, when such easel portraits became more common. To the ancient Romans the rose was the flower of Venus, the goddess of love. Harriet Mackie, who died before being deflowered on her wedding night, is crowned with white roses, a symbol of purity since the earliest years of Christianity. A garland of roses, like those worn by the dead bride, also alludes to the rosary of the Blessed

78. Anne-Louis Girodet-Trioson, *Les Funérailles d'Atala (The Entombment of Atala)*, 1808, oil on canvas, Musée du Louvre, Paris.

Virgin. Harriet Mackie thus personifies the sweetness and grace of untainted womanhood. In Renaissance paintings, wreaths of roses are worn by angels, saints, or human souls who had entered into heaven, where the sleeping bride now blissfully resides.[31]

In Vallée's depiction, Harriet herself resembles a white rose: the lace edging her pillow, the ruffled neckline of her dress, and the gathered veil form "petals" around her pale-pink skin at the center. The diaphanous fabric and her exposed neck and bosom promise to be as soft to the touch as rose petals. She remains a fresh bud in the process of opening—that literary and artistic cliché of feminine purity and nascent eroticism. Vallée's pictorial analogy between feminine and floral beauty is evocative not only of sexuality but also of death, for the roses she wears and the rose she has become are doomed to fade. The artist's

79. P. A. Vafflard, *Young et sa fille*, 1804, oil on canvas, Musée des Beaux-Arts, Angoulême.

visual conflation of the elegiac and the erotic is appropriate to his subject, with its contradictory fusion of death and desire.

The closed eyes and languor of Harriet's body make this portrait unique among American posthumous miniatures, but it can be placed within a broader category of subtly erotic, large-scale images of death. At the end of the eighteenth century and the beginning of the nineteenth, "morbid" depictions of the "desirable corpse" were first detectable. No compunction was felt about representing physical contact between the living and the dead — as seen in the desperate embrace of the lover in *The Entombment of Atala*, painted in Vallée's native France in 1808 (fig. 78).[32] Cemetery scenes from the same period often showed a dead girl being exhumed by a father, husband, or lover — an idea that persisted in popular imagery throughout the nineteenth century (fig. 79). In *The Dead Bride*, the embrace of the bridegroom-lover is implied, for the lingeringly rendered sleeping beauty is meant to be contemplated in solitude and worn close to the mourner's heart.

That passionate need to break through the barrier between the living and the dead and keep the body of the beloved near is symbolically expressed on the locket's reverse, where a lock of Harriet's plaited hair — a residue of her identity — is preserved under glass (fig. 80). In the portrait, significantly, the hair is modestly covered, as befits a virgin bride. In fairy tales and myths, a young girl's hair can symbolize maidenhood — and its imminent loss — as is suggested by the cascades of hair Rapunzel let down to pull her lover up into the tower. Harriet's hair, a sexual charm, is revealed only to the wearer of this locket. Hair is magic: Harriet's locks have transcended her mortal condition. Here the dead bride's hair symbolically pledges eternal love — till we meet again in another life, where our wedding vows will at last be taken. This miniature possesses uncanny power, for Harriet's hair binds the living to the dead.

The factual story of Harriet's life and death has been cloaked in legend. We now know that her body was buried in St. Michael's churchyard, Charleston, under a gravestone bearing the inscription: "Departed/this life on the 4th./day of June Anno Domini/1804/MISS HARRIET MACKIE/In the seventeenth year of

her age./Beloved by all her acquaintance." But an obituary in the Charleston *Courier* focused on the *suddenness,* rather than the sadness, of her passing:

> Died, on Tuesday morning of an indisposition taken on Monday night, Miss Harriet Mackey, daughter of the late Doctor [James] Mackey, formerly of Georgetown. — She had been in perfect health and high spirits all Monday, and at night complained of an indisposition, which carried her off the succeeding morning.
>
> ...Few that have died had more cause to wish to live, than this excellent young lady. Possessed of wealth, youth, beauty, and blooming health, and surrounded by a large circle of tender and admiring friends, she was just within a few days of being united to a young gentleman of qualities fitted to her own, to ensure connubial happiness, and endear the both to society. The feelings of such a man for such a lady must be far beyond the reach of description.[33]

A personal glimpse into Harriet Mackie's last months can be found in the journal of John Blake White, a Charleston playwright and lawyer who was courting her cousin Elizabeth Allston. His account of that courtship portrays a sprawling clan of related families, Mackies (also spelled Mackey), Pawleys, and Allstons (or Alstons). The women saw each other often, traveling between Charleston and their families' thriving rice plantations near Georgetown. In January 1804, White was first introduced to Harriet, and was immediately struck by her "singular beauty and charm."[34]

A mere six months later, White was writing in his diary:

> June 5th 1804. After but a few short hours illness[,] death has snatched from our sight one to whom youth and health had promised length of days. But last evening I was at the house and in the society of Miss Harriott Mackey, and today I have beheld her a corpse! Mersiful God! is it possible, that a few hours shall have effected so great a change, as that the object which but yesterday seemed so lovely and so fair to view, should today appear disgusting and become the object of our aversion.

HAIR IS MAGIC: HARRIET'S LOCKS HAVE TRANSCENDED HER MORTAL CONDITION. HERE THE DEAD BRIDE'S HAIR SYMBOLICALLY PLEDGES ETERNAL LOVE — TILL WE MEET AGAIN IN ANOTHER LIFE.

80. Reverse of P. R. Vallée, *Harriet Mackie (The Dead Bride),* 1804, Yale.

It was this "disgusting" corpse that Vallée portrayed as forever lovely. When the artist was called in to immortalize her in death, Harriet's body would have been laid out on the bed, dressed in her bridal gown to receive visitors.[35]

White lamented: "I do participate most earnestly in the sorrows of this afflicted family. What appears to mark this sad circumstance more peculiarly with a mournful and deplorable aspect is her having been engaged to be married … to Mr. Wm. Rose[,] a young gentleman of this City, who, by this sad stroke is rendered indeed wretched." Some years later White added: "Poor Rose died … dejected and broken hearted."[36] So the rose garland in Vallée's portrait symbolizes not only the brevity of Harriet's life but also the name of her fiancé.

Harriet's apparent "perfect health" and the unexplained rapidity of its decline created a mysterious local legend that she was poisoned. Although no clear evidence of foul play exists, a motive for murder can be found in the will left by Harriet's father, Dr. James Mackie, who died when she was seven. He gave to his wife "a certain number of negroes, some cattle and horses and Fifty Pounds to buy a riding chair," and, as long as she remained his widow, "liberty to plant my land with her negroes under the direction of my Executors." Most important, his will made his daughter that rare phenomenon in early nineteenth-century Charleston society, a rich woman in her *own* right:

> I will and devise all the rest and residue of my Estate both real and personal consisting of negroes, horses, cattle, &c. to my daughter, Harriet Mackie[,] when she attains the age of 21 years or at the day of her marriage which ever shall happen first. But if my said daughter should die before the above mentioned periods, then I give that part of my Estate which I have given to my said daughter, to Captain Wm. Alston's two sons, John Alston and Wm. Alston.

In 1806, two years after Harriet's sudden death, her mother took William Alston to court, in an apparently vain attempt to retain her income: Sarah Mackie argued that "the devise to Harriet was a vested interest; that she [Mrs. Mackie] is entitled to the rents and profits of the residuary Estate during her lifetime."[37] Sarah died

the following year, and there is no record of her case against William Alston ever having been decided.

The Alston family, the largest of the Georgetown rice-planting factions, exerted considerable influence on the world in which Harriet Mackie lived — and died. William, perhaps "the largest slave owner in South Carolina," was referred to in awe as "King Billy." Dr. Mackie's will left his estate to King Billy's younger sons, John Ashe Alston and William Algernon Alston. John died young, but William prospered. Sometime between 1803 and 1805, Vallée painted a portrait miniature of him (Gibbes Museum of Art, Charleston), possibly to commemorate his acquisition of considerable property: Rose Hill plantation in 1803 and the Mackie estate following Harriet's death in 1804, all part of the rich rice-planting region along the Waccamaw and Pee Dee Rivers.[38]

Some fifty years after Harriet Mackie's death, a reviewer in the local press speculated that real-life models had inspired Susan Petigru King's novel *Lily*, about a "poisoned bride." The novelist probably had some knowledge of the actual events, for she was close to her aunt, who had married into the Allston family. In the opening paragraph, the will being read echoes that left by Dr. Mackie. The fictional child, Lily, "shall come into immediate and entire possession of my whole estate, without restriction" when she comes of age or marries. "In case of her death before either of these events come to pass, I hereby devise my whole estate to the said Hugh Clarendon and his heirs forever."[39] Thus, Hugh Clarendon is a fictional version of the elder William Alston — King Billy. *Lily* is largely set in Charleston and at Chicora Wood, the name in fact of the plantation owned by the novelist's uncle, Governor Robert F. W. Allston. So the story is played out in territory that would have been familiar to the real Harriet.

King chose to blame Lily's murder on Lorenza, a "sewing girl" of mixed race. Lorenza, who appears out of nowhere late in the story, is having an affair with Lily's fiancé. She gives Lily a glass of water poisoned with prussic acid before taking her own life. Given the mysterious circumstances of the real Harriet's death, the novel's improbable ending warrants scrutiny. For the person immediately suspected of Lily's murder is "the man who profits by her early death."

Dead! Lily, who but ten minutes previous stood, full of life and hope, in our midst!

A crowd gathered. They could not be kept out.

There, in that bridal chamber, with its pretty maidenly decorations, surrounded by all the thousand costly preparations for the approaching ceremony, wandered, wondered, suggested, rough men and careless speakers.

Glances were cast at Mr. Clarendon — whispers reached his ear.

He could not give himself up to his sorrow. "Justice" —"legal examination"— "Black business," were murmured all around.[40]

Perhaps King fabricated "Lorenza" in order to silence lingering gossip about Clarendon's counterpart William Alston — as well as calls for justice.

In the novel, the crowd finally makes way for Lily's fiancé to enter the bridal chamber. The vision he contemplates in solitude could have been illustrated by Vallée's portrait:

Not till this mob had been dismissed did he approach his bride. Not before them would he show his agony — agony not yet complete.

There she lay, white and beautiful,... her blue eyes closed, her snowy hands drooping at either side.[41]

The whiteness emphasized in both King's deathbed scene and Vallée's portrait signifies all that is good. Whiteness as a code in a value system has dire social implications, but it is deeply embedded in the artistic and literary iconography of the West. In the portrait, Harriet's white dress and pale skin, made luminous by the ivory beneath, connotes lack of exposure, in a double entendre, not only to the rays of the sun in outdoor work, from which she was protected by race and wealth, but to the touch of men.

When P. R. Vallée was commissioned to paint the corpse of Harriet Mackie, he dipped his watercolor brush into the cauldron of folklore. He drew his image not only from her body but also from myriad narrative and visual representations of the deathlike sleep of beautiful women. In particular, he may have

been thinking about Cupid and Psyche, for he had an engraving of these lovers with him in Charleston.[42] The Hellenistic tale by Apuleius had long been associated with marriage: in the fifteenth century, it was chosen by *cassone* painters as the most appropriate subject for adorning trousseau chests. In the story, Cupid's mother, Venus, orders her son to destroy her rival Psyche. But Cupid falls in love with his intended victim. His mother's antagonism necessitates furtive behavior: he makes love to the sleeping Psyche as an unseen presence. We can imagine such a presence hovering over Vallée's languid, sleeping bride, whose union in real life may have been thwarted by family members.

Like the heroines in so many myths of femininity, Harriet Mackie appears to have fallen under a spell. Looking at her closed eyes, holding the locket that contains her likeness in our hand, we cannot help but recall Snow White, Sleeping Beauty, and all the tales and pictures Western culture has given us of the beautiful female corpse, the object of male longing. This common cultural repertoire both articulates and represses desires and fears about sex, death, and women themselves. Knowing that Harriet Mackie was a real, historical woman may make us feel ambivalent about Vallée's transformation of her image into myth. At the same time, that transformation gives his representation the power to evoke a cultural dream of dead women who defied their fate. We will never know exactly how Harriet Mackie died; we will never know whether her ambiguous state in Vallée's portrait made mourning easier or harder for the person who commissioned this miniature. She sleeps, and she remains forever beautiful — Sleeping Beauty, awaiting her bridegroom's kiss.

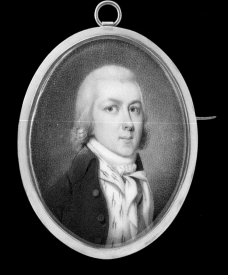

81. Archibald Robertson, *Gentleman*, c. 1795, Promised Deutsch Bequest, Yale.

Around the turn of the century, the demand for miniatures increased. The mood of the federal era can be seen in Robert Field's celebration of Martha Washington's undying love for her husband and P. R. Vallée's homage to a dead bride. The graceful aesthetics of these portraits, and the high level of private embellishment through hairwork and inscriptions on the reverse, reflect a growing American romanticism. Detailed examination of the physical characteristics of these ornaments and the stories behind them suggest that more couples were exchanging portrait miniatures directly. Along with the allegorical miniatures of love and loss that also flourished in this period, these personalized tokens helped express intimate sentiments.

Like Vallée and Field, scores of miniaturists from the Continent and Great Britain came to America to take advantage of the expanding market economy, including Archibald Robertson and Walter Robertson (no relation) from Great Britain, and Jean Pierre Henri Elouis from France. Continental artists like Vallée brought with them their own style of miniature, which employed a musically linear drawing technique against an opaque background. Sometimes circular in shape, Continental miniatures gained some popularity in the South but were not widely adopted by American-born miniaturists. These artists emulated new trends brought by the immigrants from Great Britain.

Most of the miniatures painted in the colonial and early republican periods had been small, densely colored, and limned on an ivory too thick to take full advantage of its luminous potential. British miniaturists like Field, on the other hand, painted portraits in more translucent strokes against a paler ground on larger, thinner wafers. Now American-born artists, including Edward Greene Malbone, Charles Fraser, Benjamin Trott, Anson Dickinson, and members of the Peale artistic dynasty, contributed to the flowering of the miniature in their home

country. Their lighter, more luminous miniatures floated in large lockets worn with diaphanous Empire-style dresses. These jewels adorned cultivated women, exuding a graceful air in harmony with the spacious and elegant rooms of the federal era.

Among the most influential miniaturists to cross the Atlantic was Archibald Robertson, the oldest of three brothers, all miniature painters born in Scotland. Dubbed "the Reynolds of Scotland," the successful artist was lured to New York in 1791 by an offer to open a school of drawing, the Columbian Academy of Painting, which he founded with his brother Alexander. He promulgated the new British miniature through teachings, writings, and the portraits he limned. A miniature of a dandified gentleman painted around 1795 illustrates Archibald's characteristic style: elongated heads modeled with short hatchings through which the ivory glows, in contrast to the smoother, more opaquely painted clothing (fig. 81).[1]

In 1800 Archibald described his approach in "A Treatise on Miniature Painting," written in the form of a letter for the instruction of his youngest brother, Andrew, in Aberdeen. In contrast to a heavy use of opaque paint even in facial areas, he advised applying thicker paint with discretion, primarily for costume, and asserted that "it ought to be an universal rule that the fewer colors you use the better — the greater simplicity the better."[2] Individual variants on this new style soon dominated miniature painting in the major cities.

Although not a miniaturist himself, leading American oil portraitist Gilbert Stuart acted as a catalyst for change in the genre: miniaturists Robert Field and William Russell Birch made copies of his Washington portraits; Walter Robertson and Benjamin Trott benefited directly from his friendship and promotion; Sarah Goodridge received personal instruction from him; and many other miniaturists emulated his style. Born in North Kingston, Rhode Island, the nearly destitute Stuart arrived in London in 1775, where he was taken in by the generous Benjamin West. The precocious artist soon rejected the precise modeling, painstaking realism, and linear vision of the straightforward American tradition in favor of the more painterly technique, shimmering grace, and three-dimensional form of younger British portraitists like John Hoppner, George Romney,

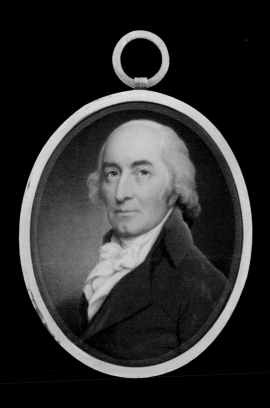

82. Walter Robertson, *Gentleman*, c. 1795, Yale.

and Henry Raeburn. Stuart borrowed only what he wanted from the idealized formulas of these fashionable portraitists, for his own genius lay in his ability to capture an animated personality rather than mere outward appearance. Finding great success, but also amassing considerable debt from his profligate lifestyle, Stuart left England for Ireland before returning to America.

With him in 1793 came Irish miniaturist Walter Robertson, who had forged a lucrative friendship with Stuart in Dublin. Upon his arrival in New York Robertson began making miniature copies of Stuart's portraits. Ambitious to establish a practice among the political and mercantile elite, in 1794 Robertson moved to Philadelphia, then the nation's capital and cultural center, where he roomed with Robert Field. Stuart soon followed, now accompanied by the miniaturist Benjamin Trott. Like Field and Archibald Robertson, as well as Trott, Walter Robertson was among the many artists who profited from painting miniatures of George and Martha Washington.

But even when he was not directly translating the oils of the popular Stuart into watercolor on ivory, Robertson's miniatures evoked Stuart's feathery brushstrokes (fig. 82). In a portrait of an unknown gentleman Robertson achieved an illusion of immediacy through intricately interwoven, long, gummy strokes that followed the contours of the face. On the dark coat, floated on with confidence, he used lines of shaded gum to indicate texture and body form, and white stipple on the collar and shoulders to simulate the powder falling from the gentleman's hair, fashionably tied back in a queue. Many of Robertson's elegant, solemn sitters have a certain sameness: posed against brownish backgrounds they appear to be members of one family, sharing the genetic traits of rounded, usually blue eyes set into deep sockets and elongated noses.

While maintaining these formal characteristics, Robertson's miniatures grew in scale and assurance by the time he left the United States around 1796. The height of his achievement can be seen in a miniature probably limned shortly after his arrival in India (fig. 83). The story behind this miniature underscores the fluidity with which the new British style traveled, along with culture and commerce, throughout the Empire at the turn of the century. Robertson's Scottish sitter, Dr. Alexander Gray, spent more than twenty years of his life in Bengal as a

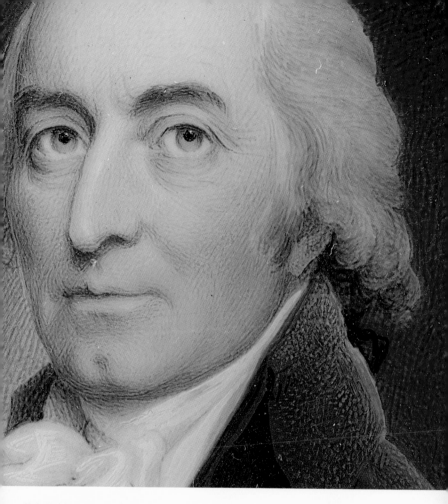

Detail of figure 82. Robertson achieved an illusion of immediacy through intricately interwoven, long, gummy strokes that followed the contours of the face. On the dark coat, floated on with confidence, he used lines of shaded gum to indicate texture and body form, and white stipple on the collar and shoulders to simulate the powder falling from the gentleman's hair, fashionably tied back in a queue.

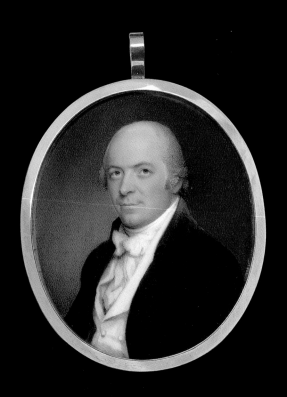

83. Walter Robertson, *Dr. Alexander Gray*, c. 1797, Promised Deutsch Bequest, Yale.

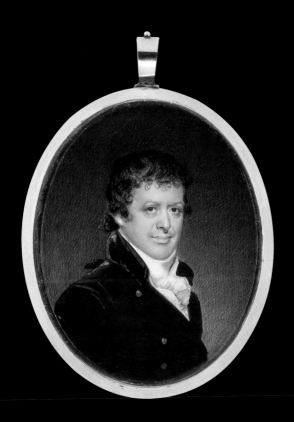

84. Benjamin Trott, *Joseph Anthony, Jr.*, c. 1794–95, Yale.

surgeon for the East India Company. He took advantage of trading opportunities to amass a fortune, the bulk of which he bequeathed to his hometown of Elgin for the establishment of a hospital to serve the poor. Both artist and sitter died in India, Robertson in 1801 or 1802 and Gray in 1807. The miniature, with its reverse adorned with purple glass surrounding a hair loop over a mother-of-pearl plaque, may have been made for the much younger woman Gray married — and soon divorced — late in life. Or it might have been a token sent to his only remaining family member, a sister, back home in Elgin, for a later handwritten inscription reveals that the locket descended through the family.[3]

Boston-born Benjamin Trott, like his rival Walter Robertson, frequently painted miniatures after oil portraits by Stuart, whom he met in New York and accompanied to Philadelphia. Although Trott traveled extensively after 1794 in search of commissions, Philadelphia was to remain his center of activity for some thirty years. According to William Dunlap, the opinionated contemporary chronicler of artistic friendships and rivalries, the obsessively jealous Trott found both Robert Field and Walter Robertson "annoying," irrationally claiming that the latter's "excellence depended upon the secret he possessed — the chemical compound with which he mixed and used his colours." Dunlap even recalled seeing in Trott's possession "one of the Irishman's miniatures, half obliterated by the Yankee's experiments, who, to dive into the secret, made his way beneath the surface like a mole, and in equal darkness."[4]

Initially Trott imitated Robertson's coloring, even adopting the other's interwoven, hatched brownish backgrounds, as seen in *Joseph Anthony, Jr.* (fig. 84), although in later miniatures his portraits are set against thin, pale washes with areas of ivory left unpainted. In the relatively early portrait of Anthony, Trott's colors are remarkably fresh — especially the opalescent flesh tones with subtle blue shadows in the face. The long strokes modeling facial contours, on close examination, seem surprisingly straight or angular rather than curved. Although tighter in execution than his later works, which capture Stuart's dashing fluidity, this miniature already exhibits Trott's vigor and command of the medium and explains one reason Trott attracted Stuart's attention in the first

place. According to Dunlap, the master "assisted [Trott] by advice, and recommended him. Trott's blunt and caustic manner was probably to Stuart's taste."[5]

It must have been through Stuart that Trott met Joseph Anthony, Jr., for the Philadelphia silversmith was Stuart's first cousin. Joseph's aunt Elizabeth Anthony married Gilbert Stuart, Sr., in 1751. Stuart is known to have painted several portraits of Anthony family members, including three versions of Joseph's father. A Newport, Rhode Island, sea captain and tradesman, Joseph Anthony, Sr., relocated his family to Philadelphia around 1783 to escape the depression that had been strangling Newport ever since the British occupation during the Revolution. The mercantile family prospered in Philadelphia, where his father's connections helped Joseph, Jr., establish a profitable shop. His newspaper advertisements catalogue the silver manufactured there as well as an extensive array of wares imported from London.[6]

Anthony successfully made the transition from craftsman to prominent entrepreneur through his talent, business acumen, family connections, and marriage on December 29, 1785, to Henrietta Hillegas, the daughter of Michael Hillegas, a merchant who became the first treasurer of the United States. Stuart painted oil portraits of Joseph and Henrietta in the later 1790s (Metropolitan Museum of Art).[7] Based on the slightly more youthful appearance of the sitter in the miniature, Trott probably painted the silversmith from life a couple of years before Stuart. The animated features and penetrating eye contact create a rapport between the affable sitter and the artist, felt in turn by the viewer and the first owner — probably Henrietta. On the reverse, a now empty aperture undoubtedly contained a lock of hair.

An impressive contingent of American talent resided in the nation's capital in the 1790s, including one of the most popular miniaturists of the federal era, James Peale. His patrons, like those of his brother before him and his competitor Trott, were generally drawn from the established mercantile and government elite, families who had dominated the city and state in the eighteenth century. Later in this chapter these miniatures will be discussed as part of the story of the Peale family's unparalleled contributions to miniature painting. But the

miniatures of James Peale, best exemplified by his portraits of the 1790s, represent more than a link in a strong familial chain. Just as Charles Willson Peale was one of the best practitioners of miniature painting in the colonial period, James, with his less restrained, more vivacious ivories, figured as one of the most outstanding miniaturists of the closing decade of the eighteenth century.

News that a possible Peale rival had arrived in town prompted Charles Willson to wonder whether a "Mr. Loise," said to paint "in a new stile," would justify his "cried up" reputation. Peale was referring to Jean Pierre Henri Elouis, a Frenchman who often called himself Henry Elouis. Born in Caen and trained in Paris, Elouis chose to paint miniatures in the translucent British mode, reflecting the years he spent in London, where he entered the Royal Academy in 1784. He immigrated to America near the outset of the French Revolution, working from 1791 to 1792 in Alexandria, Annapolis, and Baltimore, before settling in Philadelphia until 1799. There he ran a school "to teach young Ladies in the art of Drawing" and attracted an illustrious clientele for his portraits in "Oil or Miniature Painting" by advertising his "long experience in business, and the many opportunities he has had in the Academies both of London and Paris."[8]

Elouis may have brought or ordered his cases from France, for the harmonious case in rose-gold over copper with three-color enamel encircling a portrait of Hore Browse Trist appears Continental (fig. 85). That decorative sensibility also informs the refined reverse, where braided brown hair, set in the glass-covered aperture, is overlaid with the sitter's initials gracefully formed in script from graduated seed pearls (fig. 86). In the portrait, painted with short, broad strokes, the handsome sitter's naturally curly brown hair is worn in a Brutus crop. Philadelphia was the seat of fashion, and the sitter well represents his native city: immaculately dressed in the latest style, he wears a white waistcoat over a red-flannel underwaistcoat faced with black taffeta underlining and a double-breasted jacket.[9] Elouis's prodigious gifts are evident in the rich color contrasts of the clothing, delicately modulated skin tones, and fine draftsmanship.

Lost in thought, the handsome young man seems quite unaware of the viewer, lending his portrait a dreamy intimacy. Hore Browse Trist was the product of a "love match," the only son of Lieutenant Nicholas Trist, a British soldier

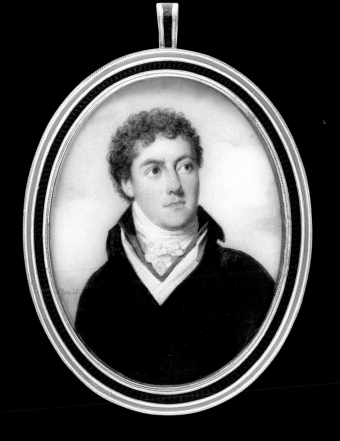

85. Jean Pierre Henri Elouis, *Hore Browse Trist*, probably 1798 or 1799, Yale.

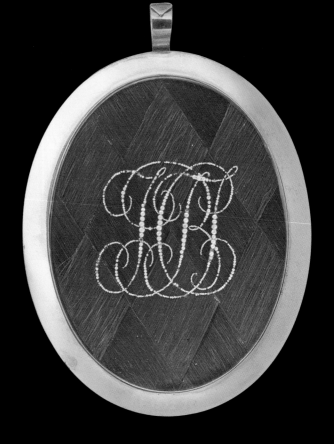

86. Reverse of Jean Pierre Henri Elouis, *Hore Browse Trist*, probably 1798 or 1799, Yale.

stationed in Philadelphia during the Revolutionary War, and Elizabeth House, the daughter of Quakers who ran a boardinghouse that provided hospitality to Patriots, among them Thomas Jefferson. Shortly after his son's birth in 1775, Nicholas went to Louisiana, then part of British West Florida, where he received a land grant that his son would later try to reclaim. Nicholas sent for his wife to join him in 1784 but died while she was journeying to meet him.[10]

Elizabeth returned to Philadelphia, where, with the continued assistance of Thomas Jefferson, Hore graduated from the University of Pennsylvania in 1792 and began to practice law. On Jefferson's advice, he made two trips to England to claim an inheritance through his father's estate, conduct business, and add polish to his education. Back from his second trip in 1797, "he was conversant in French, an avid reader of both classics and modern literature, and a popular figure on the Philadelphia social scene."[11]

This image accords with the dandified gentleman limned by Elouis. At the urging of Jefferson, in 1798 Trist decided to buy 575 acres in Virginia near Charlottesville, a move that nearly bankrupted him. By March of that year, Trist was engaged to be married to Mary Brown. The miniature was probably commissioned from Elouis either to mark their betrothal or at the time of their wedding in Philadelphia on April 27, 1799.[12]

This miniature's romantic mood anticipates the tone of the young couple's letters written over the years following their union. Hore's letters to Mary while he pursued business interests away from home also offer an intimate glimpse inside one of the "companionate marriages" at the turn of the century. Although only his side of the correspondence is available, hers can be gleaned from his responses. True partners, they share financial concerns, gossip about friends, state strong antifederalist political opinions, and make tender confessions of love, friendship, and loneliness. Along with their endless pages of correspondence, this miniature must have helped Mary bridge the distance between them.

By 1800 they were plagued with financial worries, worsened by the banking panic. In June their son Nicholas was born in their rented house in Charlottesville. By December finances allowed the delayed purchase of the Virginia land, Birdwood, and in April 1801 the extended family moved into a humble

"cabbin," described by Hore's mother in a letter to Jefferson as saved from hail damage by "its humility not its strength." Sometime after March 1802, Hore and Mary had another son, Clement. Aware of the family's financial plight and Trist's desire to start over by reclaiming his father's land, Jefferson appointed him customs collector at Natchez in the Louisiana territory.[13] Until they could afford to move west, Mary remained in Charlottesville with her mother-in-law and young sons while their father moved to Louisiana to assume his post and establish a plantation near Natchez. The two kept close by exchanges of letters, which tell much about their relationship.

Complaining that he has not received mail from her, Hore reminds Mary that "the family Group are constantly present to my imagination & fancy warmly colours the scene of domestic employments & domestic happiness." It was the distance born of absence that colored the female domestic sphere, seen through male eyes, with such a rhetorical rosy glow. But other times the pain is expressed in more particularized terms, as when Hore imagines walking with his wife through the streets of Philadelphia where they met, and shares his dreams, confessing, "I had you in my arms the other night." And he sends love to his mother and children: "Kiss him [son Nicholas] and let him know that not an hour passes in which he & my cherub [Clement] are absent from my mind." He tells Mary that the letter he received from her when he finally arrived in Natchez, "gave me a new existence.... You have caught the warmest feelings of my heart — tis sympathy arising from a union of souls that is not confined by space or measured by time, that induces you to pant for a reunion — but you have our Cherubs. I am solitary."[14]

The power of locks of hair to evoke an absent loved one — integral to the tradition of sentimental jewelry of which miniatures are a part — is invoked by Mary's "gratifying" gift to her husband of "little ringlets of my boys." Reflecting his era's awareness of the stages of child development, Hore wonders what changes he is missing as his sons grow up and marvels, "What a consolation you must receive and great delight in observing the dawn and graduation of reason in them."[15]

In one particularly poignant letter, Hore writes that he "cannot sleep" until he acknowledges the receipt of his wife's love letter. His metaphor reflects his understanding of the miniature as his era's most powerful emblem of love: "[Your letter] came by Express Mail yesterday & was so much like yourself that the sensations it exerted left an indelible impression not only of your amiability, but of your very looks & person in miniature on my heart."[16]

In December 1803, when Louisiana was ceded to the United States, Jefferson promoted Trist to Collector of the Port of New Orleans. The Trists were finally reunited early in 1804, but on August 29, Hore Browse Trist died in New Orleans of yellow fever. Two days later, his mother informed her "dear friend" Jefferson, "My Son, my support, my protector, my all in life, was wrested from me." Mary changed the name of their younger son, Clement, to Hore Browse Trist in his father's memory. The note in which she arranged for the change contains locks of hair belonging to their two sons, perhaps the same "ringlets" her husband had treasured during his separation from them.[17]

Mary raised the boys with the support of two successive stepfathers, as well as that of Thomas Jefferson. The young Hore Browse Trist married Rosella Bringier and managed the family sugar plantation in Louisiana. Nicholas moved to Monticello in 1817 at the invitation of Jefferson to study law. There he fell in love with Jefferson's granddaughter Virginia Jefferson Randolph, whom he married when finances permitted in 1824.[18] Thus the family connection with Jefferson, dating back to the sitter's boyhood, changed the lives of the next generation that cherished this portrait miniature.

The story behind the portrait of Hore Browse Trist makes palpable the need for miniatures at a time when husbands often left home for long periods to pursue careers that might offer their family financial security. Along with statesmen, merchants, salesmen, and soldiers, American portrait painters and others in the arts led peripatetic lives that equally affected their families.

William Dunlap, who recorded the artistic worlds of Philadelphia and elsewhere, is known to posterity as both the "father of the American theater" and the "American Vasari"; nonetheless, his long and varied career proved

DUNLAP'S PORTRAITS OF HIMSELF AND HIS WIFE SERVED FOR
EACH OF THEM AS A SURROGATE FOR THE OTHER DURING HIS LONG
ABSENCES IN SEARCH OF COMMISSIONS.

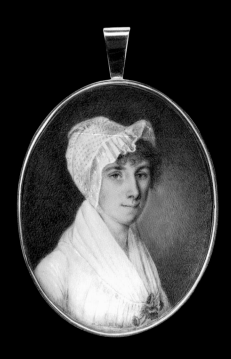

87. William Dunlap, *Mrs. William Dunlap (Elizabeth Woolsey)*, c. 1805, Yale.

HAVING TRAVELED CONTINUOUSLY FOR TWO MONTHS, ON FEBRUARY 19, 1806, HE OBSERVED THAT IT WAS HIS FORTIETH BIRTHDAY AND HE WAS AWAY FROM HOME.

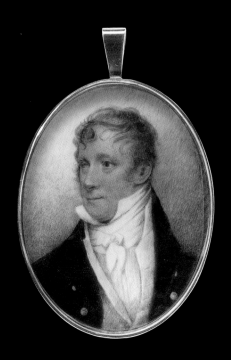

88. William Dunlap, *Self-Portrait,* c. 1805, Yale.

financially unrewarding. In his diary, the multi-faceted playwright, theater manager, art historian, and portrait painter recounts a life spent wandering in pursuit of social contacts and commissions, time spent sleeping in rented rooms away from home. His *Self-Portrait* (fig. 88), later selected as the model for the frontispiece of his published diary,[19] may have comforted his wife and children during absences, or it may have served him as a calling card advertising his abilities in his pressing search for clients. The miniature displays a use of strong color, a sophisticated softening of strokes to blend forms, and attention to true likeness — including a realistic rendering of the artist's right eye damaged in a childhood accident.

Dunlap's less accomplished portrait of his wife (fig. 87),[20] whom he married in 1789 when his first plays were produced, may well have remained with him during his journeys throughout the eastern seaboard, travels that took him as far as Montreal. In 1805, the year he went bankrupt as a theater manager in New York City, he settled his wife and family in his hometown of Perth Amboy, New Jersey, and focused on portrait painting to make ends meet. Dunlap's marriage to Elizabeth (Bess) Woolsey allied him to an old, conservative New York family; Timothy Dwight, future president of Yale College, became his brother-in-law. Dunlap's diary records his own less orthodox views of politics and religion and his disagreements with Dwight, as well as the pleasure he nonetheless took in the intellectual company of his wife's family.[21]

His memoir is more silent on his relationship with Bess, although their marriage appears to have been a good one, and she stuck with him through many professional disappointments. He may have gazed at her informal portrait when he wrote letters to her detailing his hard-won earnings: in the five weeks spent in Philadelphia during the winter of 1806 he painted six miniatures at between $20 and $25 apiece, as well as others he hoped to sell on his next stop in New York. Having traveled continuously for two months, on February 19, 1806, he observed that it was his fortieth birthday and he was away from home.[22]

Dunlap is best remembered as the author of the *History of the Rise and Progress of the Arts of Design in the United States*, published in 1834, which along with his *Diary* offers firsthand insight into the travails of portrait-making in early

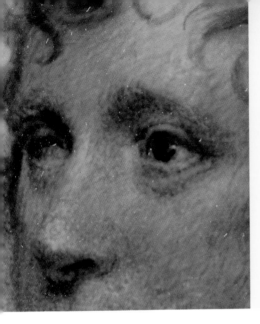

Detail of figure 88. Dunlap's *Self-Portrait* displays a use of strong color, a sophisticated softening of strokes to blend forms, and attention to true likeness—including a realistic rendering of the artist's right eye damaged in a childhood accident.

America. One of the heroes of Dunlap's *History* is Edward Greene Malbone, a miniaturist whose arduous journey to success destroyed his health but left to posterity miniatures exemplifying America's golden age.

Edward Greene Malbone's premature death at age twenty-nine cut short the brilliant career of a painter widely considered—in his lifetime by critics like Dunlap and even today—to be America's most accomplished miniaturist. His cylindrical, elegantly monogrammed painting case of ivory, containing eighteen tiny ivory dishes still filled with traces of pigment, conveys the artist's legendary refinement (fig. 89). He began life inauspiciously as an illegitimate son born into modest surroundings but only a generation removed from the luxury most of his future clients enjoyed. His grandfather Godfrey Malbone was born in Virginia but settled in Newport, Rhode Island, in 1718, where, with wealth procured from trade in rum, molasses, and African slaves, he acquired an imposing mansion on Thames Street. The following year he married Catherine Scott. Their son John, a merchant, in turn fathered six children by Patience Greene, including the future

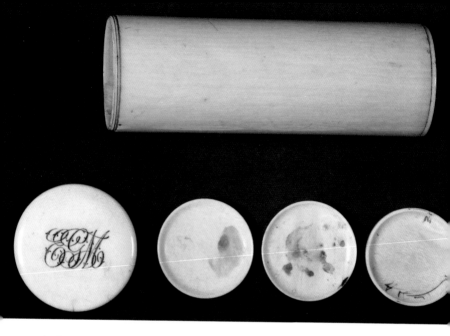

89. Edward Greene Malbone's ivory painting case, c. 1800, Museum of Fine Arts, Boston.

artist (known as Edward Greene in his youth), though he never married her. By this time, the Malbone family fortune had been greatly reduced, in part as a result of the British occupation of Newport.[23]

The young Edward expressed an interest in drawing at an early age, after observing scenery painters at a local theater. He may have received limited, informal instruction from Samuel King (1748/9–1819), a Newport painter and instrument maker, but he was largely self-taught. At seventeen Edward Greene ran away to nearby Providence and established himself as a miniaturist. In a letter dated October 11, 1794, he "dutifully" advised his father, whom he addressed formally as "Honored Sire," of his whereabouts and announced that he wished to use the surname "Malbone," which he promised "never to dishonor."[24] A desire to appeal to an affluent, influential clientele probably motivated Malbone to add

his father's more well-established surname to his mother's when he launched his career.

Malbone's talent, charm, and professional bearing contributed to his rapid entrepreneurial success, and soon after the death of his father, in 1795, the industrious artist proved able to support both himself and his sisters. But accounts by his sister Henrietta Whithorne, in a letter to Dunlap describing her brother's professional life, also reveal that the lot of an itinerant miniaturist was a difficult one, involving long periods of overwork and constant travel from city to city in search of commissions.[25]

In 1796 the teenaged Malbone was working in Boston, a prosperous urban center with a long-standing portrait tradition, where he placed this notice in the local press:

Malbone, Edward G., Miniature Painting and Hair Work, From Newport, takes this method to inform the Public that he intends to practice the above during his stay in this town. As he has hitherto been uniformly successful in his Likenesses, he flatters himself he shall be able to give satisfaction to his employers. N.B. Likenesses are warranted. Specimens of his work to be seen at his lodgings, at Mrs. Hatch's, Federal-Street.

Perhaps the prominent Russell and Sullivan families saw the itinerant artist's advertisement and were favorably impressed with his "specimens," for among the miniatures Malbone is known to have painted in Boston are a group of portraits of these related families.[26]

The accomplished *Thomas Russell* (fig. 90, below) in the Yale collection can now be securely identified as being painted by Malbone in Boston in 1796. Recent conservation treatment led to the discovery on the backing paper of his unmistakable signature, "EG Malbone/[?] July 1796," inscribed in highly soluble red paint: significantly, the same generously gummed watercolor used to execute areas of the portrait itself. Malbone occasionally signed his miniatures on the backing paper — in fact, he signed and dated three other Russell-Sullivan portraits there.[27] The July 1796 date reveals that Malbone painted this miniature

shortly after his arrival in Boston, and well before most — and probably all — of the other Russell-Sullivan portraits.

The heavy application of opaque rather than transparent watercolor in *Thomas Russell* is consistent with Malbone's works executed before about 1800–1801. However, the technical sophistication is not. Although noteworthy for a self-taught teenager, his miniatures of circa 1796 were usually more tightly outlined, less painterly, and more linear. Yet if Malbone painted the miniature much later, he would have used transparent washes, characteristic of his later style, to take advantage of the ivory's luminosity, in accordance with the new British fashion just taking hold in America. *Thomas Russell* has puzzled previous scholars, who could not fit it into Malbone's stylistic development.[28] As we shall see, the missing puzzle piece was found in a reconstruction of how the miniaturist was called upon to fulfill the needs of the Russell and Sullivan families.

Like most of Boston's first families, the Russell family owed its position to maritime success. When Thomas Russell, the owner of an extensive shipping and marine insurance business, died at the age of fifty-six, he was a highly respected citizen who, as a tax collector of the Port of Boston, had made a fortune speculating in Continental money. He had held several political offices, serving from 1789 to 1794 as a member of the State Council. Praised in an obituary as a "generous public-spirited citizen," Russell had dedicated considerable time and resources to charitable causes, most notably as vice president and later president of the Humane Society. He had actively participated in organizations favored by the Boston patriciate, including the Society for Propagating the Gospel Among the Indians, the Agricultural Society, the Society for Advice to Immigrants, the Boston Chamber of Commerce, and the National Bank of Boston.[29]

Russell's name is still invoked by social historians of the urban establishment as an "idol of the genteel set" — proper Bostonians whose "shared interests and beliefs and participation in the same institutions created a characteristic lifestyle that, in turn, helped unify the interrelated upper class clans."[30] Group cohesion among the rich merchants came about through joint commercial enterprises, common organizational and social institutions, and marriages that perpetuated the genteel outlook as well as consolidated political and economic power.

Through their patronage of Malbone, the Russell family satisfied individual and group needs for miniatures, from an artist whose personal demeanor and gracious style were rapidly becoming identified with a social elite.

Thomas Russell married three times: in 1765 to Elizabeth Henley, daughter of Captain Samuel and Elizabeth Cheever Henley of Charlestown, Massachusetts; in 1784 to Sarah Sever, daughter of the Hon. William and Sarah Warren Sever of Kingston; and in 1788 to Elizabeth Watson, daughter of George and Elizabeth Oliver Watson of Plymouth.[31] Thomas Russell's wives were descendants of the colonial ruling class anointed by the British. Thomas and his first wife Elizabeth had six children, four of whom survived into adulthood. Their daughter Elizabeth married into the socially prominent Sullivan family, as did her half-sister Sarah, the only daughter of Thomas and Sarah and the subject of a miniature painted by Malbone on a later trip to Boston (see fig. 97).[32]

There are eight known miniatures of the Russell and Sullivan families painted during Malbone's stay in Boston from 1796 to 1797: four of the family patriarch Thomas Russell, one of his son Daniel, one of Elizabeth, and two of John Langdon Sullivan, who married Elizabeth on October 10, 1797.[33] One portrait of the groom is specifically dated November 1797, the month after the wedding.

Thomas Russell died on April 8, 1796, almost three months before Malbone arrived in Boston; therefore, his family must have commissioned the portrait miniatures of him to eternalize his memory. As we have seen, posthumous miniatures served several important purposes. In addition to providing keepsakes for those left behind, miniatures of the departed, handed down within families, played an indispensable and at times intimidating role in family memory as heirlooms of a distinguished line well into the nineteenth century. In George Eliot's novel *Middlemarch* (1871), Dorothea Brooke is struck by the imposing cabinet display in her fiancé's home of his forebears, "miniatures of ladies and gentlemen with powdered hair hanging in a group."[34]

In all four of Malbone's extant miniatures of Thomas Russell the serene sitter is depicted with powdered hair, his head turned slightly to the left (his proper right), his brown eyes under heavy brows gazing in that direction, and the

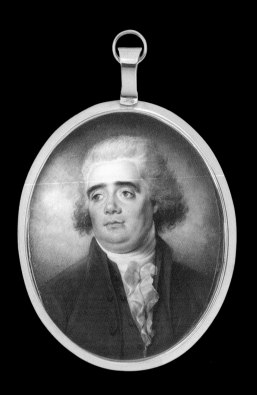

90. Edward Greene Malbone, *Thomas Russell*, 1796, Yale.

91. (top) Edward Greene Malbone, *Thomas Russell*, c. 1797, private collection
(object reduced from actual size).

92. (above left) Edward Greene Malbone, *Thomas Russell*, 1797, private collection
(object reduced from actual size).

93. (above right) Edward Greene Malbone, *Thomas Russell*, c. 1796, Cincinnati Art
Museum (object reduced from actual size).

bare hint of a smile on his mouth. Yet each of the portraits differs slightly, possibly reflecting the desires of individual family members who wished to remember him in their own way.

In comparison to the Yale portrait (fig. 90), the smallest miniature (fig. 91) shows less of Russell's upper torso; the heavyset sitter even seems slimmer, as if to accommodate the reduced format, and his complexion is ruddier. Yet Malbone depicted Russell against a skylike background as in the Yale miniature, wearing the same unbuttoned, plum-colored jacket and plum waistcoat with a white jabot. The largest version (fig. 92) is bust-length, like Yale's, but differs in clothing and background: the sitter wears a buttoned black coat with lapels, and a hint of a chair appears in the lower left below heavy red drapery that sweeps diagonally from the upper right. Malbone had used this conventional English curtain background in many early miniatures.[35]

The curtained *Thomas Russell* is signed and faintly dated at the upper left, "E. G. Malbone/1797," indicating that the artist painted it in the same year as the portraits of Elizabeth and her new husband, both of which are signed and dated 1797 on the backing paper. As these three portraits apparently descended in the family together, it is possible that Elizabeth commissioned this particular posthumous portrait of her father when she felt her separation from him most, as she was leaving her family home to marry. When examined under the microscope, the three miniatures of Thomas Russell reveal the same hand, although the brushwork in the Yale portrait is more modulated — composed of varied rather than elongated strokes, as if the artist had taken greater pains to build up the forms.[36]

A fourth portrait of Thomas Russell, now at the Cincinnati Art Museum (fig. 93), most closely resembles the Yale version in pose, costume, background, size, and accomplished technique. In fact, the sophistication, combined with the miniature's provenance in a private English collection, led to scholarly speculation that it was an English prototype for Malbone's miniatures. Now recognized as another version of *Thomas Russell* by the young American, the portrait is, in fact, signed by him in the lower right. Furthermore, research into Russell family history offers a logical explanation for its appearance in England. The portable

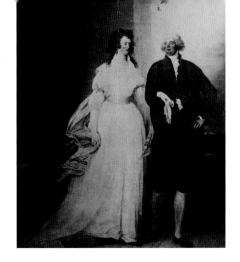

94. John Trumbull, *Hon. Thomas Russell and Mrs. Thomas Russell (Elizabeth Watson)*, between 1789 and 1794, oil on canvas, location unknown.

portrait was probably carried there by a member of the sitter's family: perhaps his widow Elizabeth, who married an Englishman, Sir Grenville Temple, on March 20, 1797, or his daughter Sarah, who went abroad for three years following her marriage in 1804.[37]

Since Thomas Russell died before Malbone arrived in Boston, Ruel Pardee Tolman, the late Malbone scholar, plausibly conjectured that "at least the first of Thomas' miniatures" may have been painted "during an unrecorded visit by the artist to Boston before he opened his studio there." Alternatively, Malbone could have copied Russell's posthumous likeness from an existing portrait by another artist. Examination of the Yale miniature under the microscope reveals dense, opaque watercolors and quantities of gum arabic that make the surface shiny like a varnished oil painting.[38] While the opacity is characteristic of Malbone's early work, the color's depth and richness combined with the painterly quality and skillful, assured brushwork suggested that the young artist might have modeled Russell's likeness after an oil portrait by a more established painter.

We can now assert on the basis of visual comparison that Malbone used as his model an oil painting by the Patriot-artist John Trumbull of Thomas and his third wife, Elizabeth Watson Russell, executed between 1789 and 1794 (fig. 94).

95. Reverse of Edward Greene Malbone, *Thomas Russell*, 1796, Yale.

This portrait served as the source of Russell's features and pose in all four miniatures, as well as of the clothing and skylike background in three of them, including Yale's. The provenance of this now unlocated Trumbull painting, known only from an archival photograph, indicates that it descended in the Sullivan family for generations, testifying to its significance as a family heirloom.[39] At the time of Russell's death, family members probably asked Malbone to model his miniature after this treasured portrait.

In the painting, the sitter looks at his wife, making the direction of his gaze in the miniatures more meaningful to family members familiar with the visual source. The precociously talented young artist was able not only to translate Trumbull's oil painting into watercolor on ivory but also to infuse it with his rare gift for characterization. His brilliancy of color and fluency of form convey the sitter's formidable presence, as if in direct response to the man himself.

When the Yale Art Gallery acquired this miniature, it was housed in a relatively modern, leather-covered pocket case, with an ill-fitting, gilt-painted cardboard mat. The unsafe housing was disassembled during conservation treatment, and important component parts were found hidden between the ivory and the leather case: a blue-glass oval, with an inset smaller rose-gold-over-copper rim securing a convex glass containing a lock of hair that rests on a card covered with old white silk. These precious, meaningful materials, once hidden from view, have now been reincorporated into a more appropriate reproduction locket so that they can be seen and appreciated (fig. 95).[40] The resulting presentation is far more sympathetic to the painting and stylistically consistent with the late eighteenth century. Indeed, the miniature probably appears much as it did in 1796.

The shape and size of the blue-glass oval and related materials, as well as their condition and style, all attest to their originality to the painting. The gold and glass, like the ivory on which the portrait itself is painted, are beautiful, costly materials that would have contributed to the miniature's preciousness as a commodity. On the other hand, the hair — in this instance a simple, unadorned lock — suggests not the secular but the sacred role of the miniature as a private, wearable shrine. In the original locket, the hair would have been seen only by

the wearer and those intimates she chose to reveal it to. The complexity and assurance of this portrait, the early July 1796 date carefully recorded on the signed backing, and the presence of hair in only this miniature, all combine to suggest that Malbone painted this version first, directly from Trumbull's painting. Its owner may have been Thomas Russell's widow Elizabeth, or his orphaned ten-year-old daughter Sarah, the only child of his second wife Sarah Sever. The miniature entered Yale's collection with one of her by Malbone, which will be discussed later.

While in Boston, Malbone renewed an earlier friendship with the painter Washington Allston (1779–1843). Malbone worked in New York in 1797, Philadelphia in 1798, and, two years later, made the first of several trips to Charleston, South Carolina, where he befriended Charles Fraser (1782–1860), a lawyer, whose later work as a miniaturist he strongly influenced. In May 1801 Malbone and Allston journeyed to London. As most American artists inevitably did, they visited Benjamin West. Malbone wrote to Fraser that West "told me I must not look forward to anything short of the highest excellence. He was surprised to see how far I had advanced without instruction." In London, Malbone admired miniatures by Samuel Shelley (1750–1808) and Richard Cosway (1742–1821), whose airy and elegant styles confirmed the direction in which his own art was already moving.[41] However, true to an American sensibility apparent in miniatures dating back to John Singleton Copley and Charles Willson Peale, Malbone's renderings were more direct than those of his English counterparts.

A confident artist, Malbone returned from London to Charleston in late 1801, when he began his most prolific period, documented in his account book, which records only a portion of his prodigious output. During a brief respite at home in Newport, around September or October 1802, Malbone recorded painting Archibald Taylor for $50. Among the wealthiest planters and slaveholders from the coastal region of Georgetown county, Taylor might have been passing through Newport on mercantile business (fig. 96).[42]

Placed against a carmine-tinged sky, the portrait of Taylor exemplifies Malbone's mature, transparent style of delicate cross-hatching, creating form by

means of fine interwoven lines. He strongly lit the sitter from the left, and used the device of bringing forward the far side of the face to engage the viewer through forceful eye contact. Two distinct shades of brown hair are plaited on the reverse. Perhaps Taylor's hair is entwined with that of his wife Mary Man, of Mansfield Plantation, who had died the year before in Boston, where she had gone in hopes of recovering from illness by escaping the heat of Charleston.[43] The miniature, which descended in the family, might also have been a gift for their son, John Man Taylor, a student at Harvard, or their daughter Anne Marie, back home in Charleston, where she would soon marry a member of the powerful Alston family, although the groom died three days after the wedding.

Malbone spent the remainder of his brief life traveling between Boston, Providence, New York, Philadelphia, Charleston, and his home in Newport. His growing reputation resulted in numerous commissions. Among his most masterly portraits, often larger in scale, are those executed in Boston around 1804 and 1805, his last period of major artistic activity. During this time he painted *Mrs. Richard Sullivan* (Sarah Russell) (fig. 97).

The Russell-Sullivan family must have been pleased with their portraits of Thomas Russell, for when Sarah married her half-sister Elizabeth's brother-in-law Richard Sullivan in 1804, Malbone was chosen to mark the occasion with a pair of marital miniatures. Malbone's account book records painting portraits of both bride and groom in December 1804, for which Richard Sullivan paid $55 and $56, respectively.[44] Regrettably, his portrait is unlocated.

The vogue for exchanging miniatures around the time of a wedding reflected an increased romantic sensibility at the turn of the century, the culmination of decades of change in the ways husbands and wives interacted.[45] When choosing a partner for life, compatibility and affection weighed increasingly heavily in the decision, balanced by economic and social considerations. In the patriarchal model that long held sway in the colonies, the selection of marriage partners was made to the advantage of both families by the fathers, with social and economic considerations given priority. The young couple probably had some veto power, but their feelings were not the major factor. By the late eighteenth century, priorities had largely reversed. Romantic love was seen as the

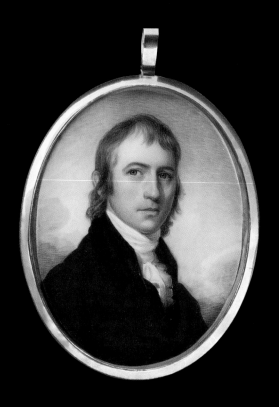

96 Edward Greene Malbone, *Archibald Taylor*, 1802, Yale

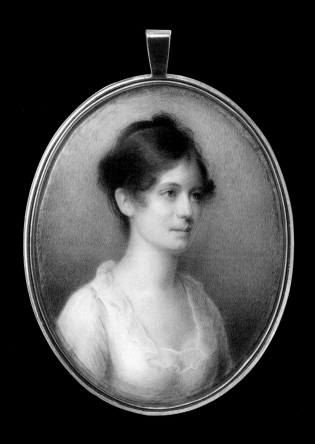

97. Edward Greene Malbone, *Mrs. Richard Sullivan (Sarah Russell)*, 1804, Yale.

Detail of figure 90.

Detail of figure 97. Comparing *Mrs. Richard Sullivan* to the earlier portraits of her father reveals that only in this miniature does the luminosity of the ivory emerge through delicate lines and pale washes of color. The introspective mood, the slight melancholy of Sarah's features, reflects the lasting poetic appeal of Malbone's art.

most significant consideration, at least ideally, with familial advantage playing a secondary role.

For the intermarried Russell and Sullivan families, affection and interest coalesced. The connection between the families that ultimately brought Sarah and Richard together began with "an abiding friendship" forged at Harvard by Sarah's older half-brother Thomas-Graves with his classmate James Sullivan, Richard's older brother. Soon after graduating James and Thomas-Graves both held office in a Massachusetts cavalry corps ordered to put down Shays's Rebellion in 1786. While making his preparations for the campaign Thomas-Graves Russell fell in love with his friend's fifteen-year-old sister Hetty Sullivan, who "helped her brother and their friends in filling cartridges." Family descendants recalled that despite the fact that their parents felt Thomas-Graves and Hetty were "hardly old enough," their "mutual interest" blossomed into engagement, with "miniatures interchanged."[46]

But before their marriage could take place, Thomas-Graves died of "lung complaints brought on by exposure" to severe cold while serving in the cavalry that crushed Shays's Rebellion.[47] The families were forever joined by the betrothal, however, and the losses and loves they shared continued to be marked by miniatures: first, Malbone's memorial miniatures for Thomas Russell in 1796 and 1797, and then his wedding portraits for the marriage of John Langdon Sullivan and Elizabeth Russell in 1797.

Sarah Russell had been an infant when her mother died, and only ten when her father followed. In a short time, her widowed stepmother married an Englishman and went abroad. Sarah resided with aunts in Charleston but, as a descendant recalled, "was often enough with her own sister [Elizabeth] to give Richard abundant opportunities of meeting her. That this acquaintance rapidly ripened into mutual devotion could not surprise those who knew them." Sarah and Richard were married on May 22, 1804.[48] The miniature was painted December 4, three days after the newly married Mrs. Richard Sullivan's eighteenth birthday.

Comparing this miniature to the earlier portraits of her father reveals that only in *Mrs. Richard Sullivan* does the luminosity of the ivory emerge through delicate lines and pale washes of color. Malbone's thin, misty veils are especially

appropriate for conveying the sitter's diaphanous dress and wispy hairstyle, fashionable at the turn of the century. He captured Sarah Sullivan's sensuous beauty with a relaxed immediacy and a rare combination of flamboyance and restraint, of amazing technical skills and self-effacing empathy with his sitter. What makes Malbone's progression in so short a period astonishing is that as his skills became more assured, his subjects are never burdened with a facile display of technique or temperament. The introspective mood, the slight melancholy of Sarah's features, reflects the lasting poetic appeal of Malbone's art. Sarah Sullivan's new husband could hold this locket close and hear her beating heart.

By the time Malbone painted this portrait, tuberculosis had slowed his astounding productivity. Nearly too weak to paint, he returned to Newport in March 1806 but on the advice of a doctor sought the warmer climate of Jamaica in December. A month later, en route home to Newport, he arrived at his cousin Robert Mackay's home in Savannah, Georgia, where he died four months later. At the time, Mrs. Mackay was in London with her young son John; she wrote her husband about the miniature by Malbone that she had carried with her on her journey: "I am glad you gratified me by letting him take your picture when you did — for even your likeness done by anyone else could not afford me the same pleasure.... John will know you by it for he often begs for a sight of it and never fails to take a tiss as he calls it."[49]

After Malbone's death, laudatory obituaries appeared in newspapers of all the cities where he had worked. So great was his fame that nearly half a century later, Nathaniel Hawthorne invoked his name in *The House of Seven Gables* to explain the uncommon power of a miniature to conjure the presence of an absent loved one:

We heard the turning of a key in a small lock; she has opened a secret drawer of an escritoir, and is probably looking at a certain miniature, done in Malbone's most perfect style, and representing a face worthy of no less delicate a pencil. It was once our good fortune to see this picture. It is the likeness of a young man, in a silken dressing-gown of an old fashion, the soft richness of which is well adapted to the countenance of reveries, with its full, tender lips, and beautiful eyes, that seem to indicate

not as much capacity of thought, as gentle and voluptuous emotion. Of the possessor of such features we should have a right to ask nothing, except that he would take the rude world easily, and make himself happy in it. . . . And yet, her undying faith and trust, her fresh remembrance, and continual devotedness towards the original of that miniature, have been the only substance for her heart to feed upon.[50]

Malbone's brief life span occurred during the heyday of the miniature in America. Although his commissions came from the upper and upper-middle urban classes, the demand for miniatures now spread to other social groups, as well as to rural areas, where they frequently were produced by "folk" artisans. In urban areas, numerous miniaturists adopted the delicate English style, combining it with a directness that was American in spirit.

A prolific, somewhat uneven Boston miniaturist who catered to a wider clientele than Malbone was William M. S. Doyle. Following an American precedent dating back to Charles Willson Peale, Doyle emerged from the craftsman tradition. In the 1796 directory he listed himself as a "paper stainer," indicating that he manufactured wallpaper. By 1803 he was calling himself a miniature painter.[51]

Like many American miniaturists Doyle possessed an entrepreneurial spirit. He made silhouettes and death masks while serving as proprietor with Daniel Bowen of Boston's Columbian Museum, which, in the true tradition of museums as venues for popular entertainment, displayed natural history curiosities and wax figures as well as art. Beginning in 1806 the more accomplished miniaturist Henry Williams (1787–1830) joined the business, and in 1812 a broadside proclaimed: "Doyle and Williams, miniature and portrait painters at the museum."[52] Some of Doyle's early miniatures lacked modeling, but his collaboration with Williams resulted in more convincing likenesses. Among the tricks he might have learned from Williams was how to exploit the transparent support by painting on the back of a thin wafer of ivory to subtly reinforce the glow of the fleshtones and the contours of the portrait on the front, a technique Doyle used to advantage in both *David Bradlee* and *Young Lady in a Sheer White Dress* (see fig. 101).[53]

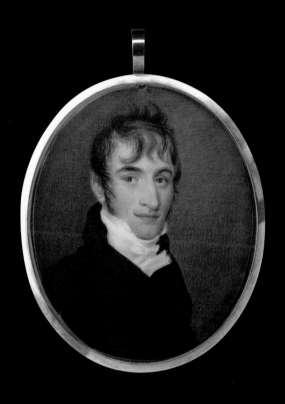

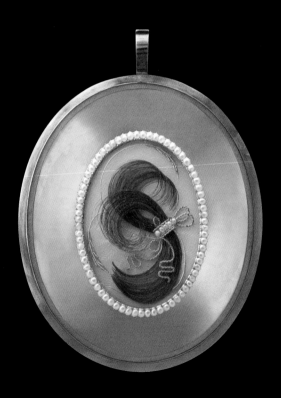

Signed and dated 1813 by Doyle, *David Bradlee* (fig. 98) stylistically resembles Williams's fluid style. In that year the occupation and address of the sitter, the son of Samuel and Ann Dunlop Bradlee, was listed in the *Boston Directory* as "hardware 4 South row." On the locket's reverse are two plumes of dark and light hair belonging to Bradlee and a now unidentified sweetheart, decorated with half-pearls and gold wire on an opal-glass plaque over embossed foil (fig. 99). Lovers frequently exchanged locks of hair to be set in their miniatures, and this is a particularly romantic example: not long after this love token was painted, but before a marriage was recorded, David Bradlee died, on April 3, 1814.[54]

Although Doyle seems to have painted more portraits of men than women,[55] a signed portrait attests to his ability to create a sensuous image of the opposite sex (figs. 100 and 101). Any gentleman receiving this miniature would have been love-struck. Glowing skin tones achieved by transparent washes are set against a deeply colored opaque background — a stylistic trend in the nineteenth century visible, for example, in the miniatures of Anna Claypoole Peale, which will be discussed below. The young lady's upswept brown hair and the dark pools of her eyes are the only other areas not suffused with light. Even her dress is transparent, exposing pale flesh and pink nipples beneath sheer white fabric.

Teenaged girls embracing French fashion and exhibitionist social norms are known to have worn such dresses at the beginning of the nineteenth century. But such flimsy fabric could never have supported the weight of a pin like the one pictured between this sitter's breasts. She must have asked Doyle to paint her wearing it; perhaps the pin was a love token from the gentleman to whom she gave this miniature. By offering such a scandalous presentation of herself, this young lady made a power play — the receiver might possess the locket, but in some sense she possessed him.

The appearance of the young woman in Doyle's miniature matches descriptions of Madame Jerome Bonaparte, sister-in-law of the emperor (who had her marriage to his brother annulled) and the most prominent society woman to attract gossip by appearing in public in a sheer dress. Madame Bonaparte's "scanty draperies" are mentioned in letters from Americans visiting Paris; her hair, without cap or bonnet, like the sitter's featured "curls on each side of the

TO DON ALMOST NOTHING, A LADY HAD TO BE AS LOVELY AND
CONFIDENT AS DOYLE'S SITTER, WHO MAY HAVE DRESSED
PROVOCATIVELY FOR EVERYONE TO SEE OR SAVED HER DISPLAY
FOR THE MAN WHO CARRIED HER PORTRAIT MINIATURE.

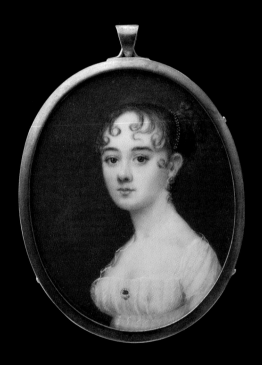

100. William M. S. Doyle, *Young Lady in a Sheer White Dress*, c. 1805,
Promised Deutsch Bequest, Yale.

DOYLE EXPLOITED THE TRANSPARENT SUPPORT BY PAINTING ON
THE BACK OF THE THIN WAFER OF IVORY TO SUBTLY REINFORCE THE
GLOW OF THE FLESHTONES AND THE CONTOURS OF THE PORTRAIT
ON THE FRONT.

101. William M. S. Doyle, Painting on back of ivory of *Young Lady in a Sheer White Dress*,
c. 1805, Promised Deutsch Bequest, Yale.

face greasy with *huile antique*." Her famous wedding gown of India muslin and old lace was so skimpy that "one of the guests declared he could have easily put it in his pocket." Some daring Americans, including Doyle's sitter in proper Boston, imitated the scandalous Bonaparte. A letter of 1804 graphically describes the disruption precipitated by a scantily attired lady at an "elegant and select party" in more fashionable Philadelphia:

> She has made a great noise here and mobs of boys have crowded round her splendid equipage to see what I hope will not often be seen in this country, an almost naked woman.... Her appearance was such that it threw all the company into confusion, and no one dared to look at her but by stealth; the window shutters being open a crowd assembled round the windows to get a look at this beautiful little creature, for every one allows that she is extremely beautiful. Her dress was the thinnest sarsnet and white crape without the least stiffening in it.... Her arms were uncovered and the rest of her form visible. She was engaged the next evening at Madam P.'s.... Several other ladies sent her word if she wished to meet them there she must promise to have more clothes on.[56]

Such excited commentary confirms that sheer dresses were in fact worn, but not so often that they went unnoticed, even in fashionable gatherings. To don almost nothing, a lady had to be as lovely and confident as Doyle's sitter, who may have dressed provocatively for everyone to see or saved her display for the eyes of the man who carried her portrait miniature.

Many miniaturists established in the major cities, including those who emerged from an artisan tradition like William Doyle, aspired to a cosmopolitan style that followed in modified form the most current trends in oil painting. However, the so-called folk portrait tradition also persisted, manifesting itself in both easel and miniature portraits. In America, where most miniaturists were self-taught or apprenticed rather than academically trained, the distinction between a cosmopolitan and an artisan aesthetic is not absolute. The term "folk portrait" is a problematic twentieth-century construction used here loosely to refer to flatly rendered, fully lit rather than modeled likenesses made by artists emerging from a

102. Mary Way, *Gentleman*, c. 1800, Yale.

craft background who worked primarily in rural communities. The artisan spirit promised that any citizen, by dint of hard work, could learn a skill and advance himself—or herself—in society.

Proving the saying that "Anonymous is a woman," a group of formerly unattributed profile likenesses can now be identified as being by Mary Way of New London, Connecticut. Way charged between $10 and $20 a miniature and struggled financially throughout her career. Beginning around 1790, this versatile artist used her conventional female training in sewing to create an original variation on the silhouette, a "dressed" miniature (fig. 102).[57] She assembled this particular gentleman from a cutout paper profile attached to black fabric, with facial

features rendered in watercolor and fabric stitched and glued onto the background. The figure, like a paper doll, literally wears an ivory stock, shell-colored waistcoat, and dark coat with shiny silver "buttons" pasted to it. Way achieved the effect of relief by leaving unattached the edges of the fabric and queue, with its sheath and bow. Although this sitter's identity is unknown, dressed miniatures of identified sitters attest to how Way individualized her portraits.

Profiles capture a likeness without foreshortening or shading, making them the preferred choice of self-taught artists. Way's manner of noting facial features — the exacting curve of the nostril, the wide-opened eye, the arched eyebrow close above the eyelid — also characterize her miniatures limned in watercolor on paper or ivory. In her dressed miniatures she used dark background fabric to emphasize the silhouette; in her painted miniatures, a dark wash highlights the pale profiles, as in the family group of Charles and Eliza Briggs and their toddler (figs. 103–105). The couple, housed in identical wood frames made to hang on a wall or in a cabinet, face each other. In Eliza's portrait, the delicately limned standing neck ruff dates her image to around 1820. Significantly, the ruff's black color is indicative of mourning.[58] Perhaps the child, whose individual presence on this earth is captured in exacting profile, has been taken from his or her parents too soon. On the reverse of the portrait set into a locket, the child's curl of blond hair rests unadorned.

Off-the-shoulder dresses, related to fashions for lady's eveningwear, came into vogue for children of both sexes around 1820. The minimal clothing could be explained by two impulses then current in childrearing — the desire to increase children's physical stamina by adapting them to cold and the wish to offer them unrestricted freedom of movement during play. Such chemises, worn by children of all classes, sometimes appear in posthumous large-scale portraits, underscoring the age and innocence of the departed, as the dress does in this sweetly limned miniature by Mary Way.[59] Her patrons probably were largely drawn from the middle class, a group whose tastes would increasingly influence miniature production in the Jacksonian period.

Love — quietly enshrined in the family group by Mary Way and loudly flaunted in *Lady in a Sheer Dress* by William Doyle — was memorably expressed

103. Mary Way, *Child of the Briggs Family,* c. 1820, Yale.

104. Mary Way, *Mrs. Charles Briggs (Eliza Bassal Meiller)*, c. 1820. Yale

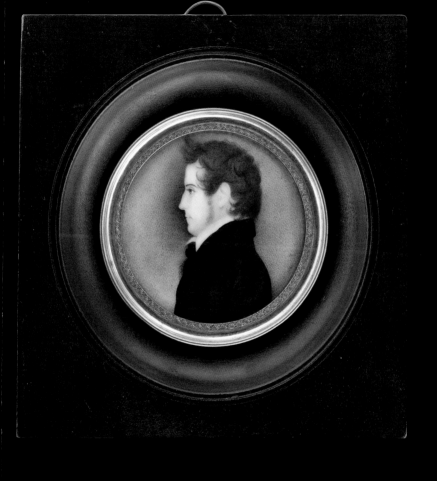

105. Mary Way, *Charles Briggs*, c. 1820, Yale.

in miniatures made in the late eighteenth and early nineteenth centuries, the heyday of American miniature painting. The artists we have examined tended to model their styles on freely brushed, translucent oval miniatures brought by British émigrés. But in the 1820s a new style emphasizing tighter execution, bolder color, and frequently a rectangular format appeared, as a younger generation of American artists, like James Peale's daughter Anna Claypoole Peale, turned their attention to the popular form. The story of the Peale artistic dynasty encapsulates the richly complex evolution of miniatures to suit the changing tastes of a new elite emerging from the growing middle class as the country moved from the federal to the Jacksonian era.

THE PEALE LEGACY

Considered one of the finest miniaturists of the federal era, James Peale also practiced landscape painting a generation before the beginnings of the Hudson River School and was one of the founders of the still life tradition in America. James so often collaborated on miniatures with his older brother Charles Willson Peale, who had trained him, that it is at first difficult to distinguish their separate hands. However, James's characteristically curvilinear line distinguishes his miniatures, like his *George Washington* (see fig. 50), which resembles his brother's work in its small size, dense coloring, finely stippled face, and longer, wiry strokes in the hair.

Close in date to that portrait, in 1786, a broadside proclaimed that "MR. CHARLES W. PEALE Being desirous of leaving off the business of Miniature Painting, and wishing to find full employment in painting the larger pictures, hereby acquaints his fellow citizens that he will paint Portraits in Oil." This declaration was followed by a list of prices ranging from five guineas to thirty, depending on size, and the announcement that "Mr. James Peale informs the ladies and gentlemen of Philadelphia, that he paints portraits in miniature at the moderate price of Three Guineas each." The brothers' business division was not rigorously adhered to, for Charles noted two years later that he "worked … a little on a miniature of my Brothers painted by himself," and also experimented with pigments in his own miniatures, although few created after 1786 remain extant.[60]

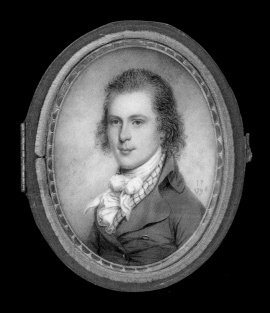

106. James Peale, *Rembrandt Peale*, 1795, Yale (case lid not shown).

Liberated from his brother's dominating shadow, James achieves a new delicacy and lightness as well as greater insight into character in a portrait of his nephew Rembrandt, limned in 1795 on the now fashionable larger ivory (fig. 106). Like many miniatures made after the announcement of the family division of labor, this one is signed "IP" (for James Peale), followed by the date. James splendidly detailed his nephew's costume: the modish puffed-up full chest is created by the high-buttoned coat, which pushes up the elaborately knotted cravat, shirt ruffle, and crossbar-patterned shawl collar of the waistcoat. As teacher and promoter of the next generation, James depicts Rembrandt as a young gentleman whose fine clothing could attract an affluent clientele. But the costume does not detract from the sensitive face, framed by wispy, unpowdered curls. As an uncle, James also conveys Rembrandt's introspective personality, which found expression in serious attention to artistic studies and a passion for writing romantic verse.

The year James painted this portrait was a pivotal one in his seventeen-year-old nephew's life. In 1795 Charles Willson Peale founded the Columbianum, a museum which later became the Pennsylvania Academy of the Fine Arts, and turned over his practice in oil portraits and silhouettes to his two oldest sons, Raphaelle and Rembrandt. In the critical eyes of the elder generation of Peales, both young men showed artistic promise. But Rembrandt demonstrated greater maturity than the older but temperamental and restless Raphaelle. Rembrandt signed his name as an artist to the charter establishing the Columbianum and undertook professional commissions.[61]

Of singular import in 1795 was a commission from Henry William DeSaussure, at the time of his resignation as director of the U.S. Mint, to paint a portrait from life of George Washington. Rembrandt's father and uncle knew the president personally — but that did not calm the artistic heir's trepidation. On the morning of the sitting, he panicked: "I was up before day-light putting everything in the best condition for the sitting with which I was about to be honored; but before the hour arrived, became so agitated that I could scarcely mix my colours, and was conscious that . . . I should fail in my purpose, unless my father would agree to take a canvas alongside of me." During a subsequent sitting,

Uncle James joined Charles and his sons Raphaelle, Rembrandt, and even fifteen-year-old Titian, leading an astonished Gilbert Stuart to joke, "They were peeling him."[62] Following this amusing demonstration of family solidarity and ambition, Raphaelle and Rembrandt embarked on a tour of southern cities, fulfilling their father's business expectations but also enjoying freedom far from watchful adults.

Familial pride suffuses James's portrait of his nephew. Groomed from birth by name and training to be a great artist, in 1795 Rembrandt was poised at the brink of his professional career when his Uncle James captured him, part boy, part man. Perhaps father Charles, James himself, or a member of their extended family kept this miniature to ease the separation when Rembrandt began his travels that year. Alternatively, it may have served as a token of affectionate encouragement for Rembrandt from his uncle — the older man who had experienced firsthand the pleasures and pressures of being trained by the affectionate but authoritarian Charles. In a family so dedicated to education, watching his uncle limn his portrait was no doubt also intended as a lesson for Rembrandt in the art of miniature painting — a field his older brother Raphaelle embraced for a time while Rembrandt, who probably made some miniatures, concentrated on larger works.[63]

Raphaelle apprenticed in his father's studio, where he studied miniature painting with James. Plagued by financial problems and having a family to support, he advertised "ASTONISHING LIKENESSES" and, under the heading "Still Life," offered to paint portraits "from the corpse." The son had a notoriously difficult relationship with his father, whom he assisted in his natural history museum. Charles urged Raphaelle to concentrate on portraiture, an art form he valued.[64] But Raphaelle turned to the less social, noncommissioned art of still life around 1815, when his health began to fail because of crippling episodes of gout, possibly compounded by arsenic poisoning from the preservatives he had used in the museum, as well as personal problems and alcoholism. He exhibited miniatures for the last time at the Academy in 1819.

Three miniatures allow us to trace Raphaelle Peale's stylistic evolution. *Robert Kennedy* (fig. 107) of 1799 exemplifies his early miniatures in its blue-gray tonality and dependence on his uncle's tutelage, particularly in details such as the

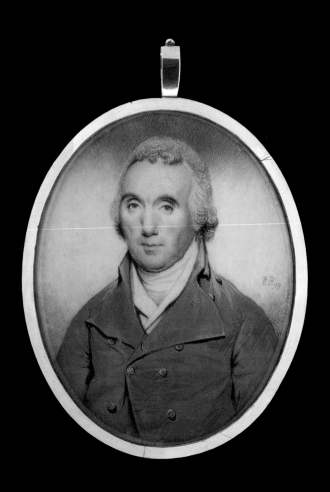

107. Raphaelle Peale, *Robert Kennedy*, 1799, Yale.

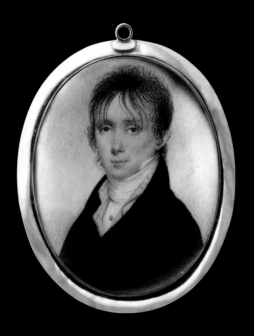

108. Raphaelle Peale, *John Frederick Rohr*, c. 1805, Promised Deutsch Bequest, Yale.

sweet-bow mouth. Later Raphaelle used a varied palette, as seen in *John Frederick Rohr* and *Samuel Woodhouse* (figs. 108 and 109), both attributed to him on the basis of stylistic and technical examination.[65] *Samuel Woodhouse* was painted shortly after the artist had turned much of his attention to still life and achieves a delicacy of color admired in those larger works.

In the portrait of Rohr, the serpentine strands of hair fashionably falling over the sitter's forehead lend him a romantic air. That mood is enhanced by a detail of dress: the deliberate placement of the pin between the folds of the cravat suggests it was a gift of personal import, like the miniature itself. In this portrait, probably painted around 1805–10, Raphaelle used more delicate cross-hatching, although he still retained a linear emphasis and the cupid-bow mouth seen in *Robert Kennedy*.[66] Typical of his mature works is the rainbow-blended sky, often enhanced by bands of color painted on the reverse of the thin ivory.

Commander Samuel Woodhouse exhibits more varied brushstrokes and techniques: subtraction to uncover the luminous ivory beneath the watercolor, sgraffito in the hair to create a lively wiriness, subtle blending of carmine and vermilion in the slightly more individualized lips that have faded somewhat with time. Most memorable are the deep-set blue eyes of the debonair, uniformed sitter, whose ship, waving the American flag, appears over his proper left shoulder against a wash of blue and white, touched with lavender and yellow, evoking water and sky.

In contrast to Charles Willson Peale's portrait of military leader George Walton (see fig. 30), who chose to be depicted as a civilian, in this miniature the naval uniform provides the key to its significance and date. A comparison of the sitter's uniform to official navy guidelines, specifically noting "one epaulette on the right shoulder" and "no button on the collar," matches dress authorized in late 1813 to signify a rank of masters commandant. Having entered the navy as a midshipman in 1801 and risen to lieutenant in 1808, Woodhouse achieved the rank of masters commandant on April 27, 1816.[67] Raphaelle Peale probably painted the miniature that year, or in 1817 during Commander Woodhouse's furlough in Philadelphia before the artist left that city for Norfolk during the summer.

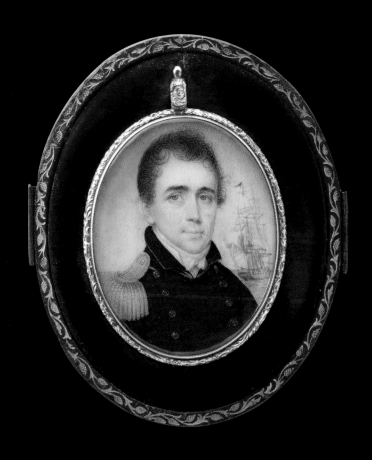

109. Raphaelle Peale, *Commander Samuel Woodhouse,* 1816 or 1817,
 Promised Deutsch Bequest, Yale (case lid not shown).

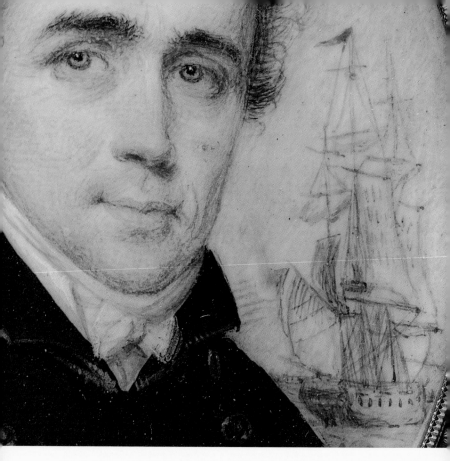

Detail of figure 109. *Commander Samuel Woodhouse* exhibits varied brushstrokes and techniques: subtraction to uncover the luminous ivory beneath the watercolor, sgraffito in the hair to create a lively wiriness, subtle blending of carmine and vermilion in the lips that have faded somewhat with time. Most memorable are the deep-set blue eyes of the debonair, uniformed sitter, whose ship, waving the American flag, appears over his proper left shoulder against a wash of blue and white, touched with lavender and yellow, evoking water and sky.

On the locket's reverse, the inscription, "com.ᴿ sam.ᴸ woodhouse/U.S. Navy," reflects a pride in the promotion that was shared with the miniature's likely owner, his wife Mathilda. In both civilian and military conventions, a standing collar is more formal than the rolling collar worn by Woodhouse, which defines his appearance here in naval terms as "undress" rather than "full dress." This relative informality is in keeping with the miniature's personal nature. While her absent husband served his country, Mathilda could look at his portrait and imagine him aboard the ship pictured in the background. Identifying that ship with certainty has proved difficult. According to naval records, Woodhouse was assigned to the *Constitution* on May 28, 1810, but by 1816 he probably commanded an undocumented private vessel because of a shortage of navy ships.[68]

During the War of 1812, the American press exulted over victories at sea by the *Constitution*. Then a lieutenant, Woodhouse was aboard that ship when, cruising off the coast of Brazil in company with the American sloop *Hornet*, they encountered a large British frigate, the *Java*. The *Constitution* fired the first shot of engagement, but in the maneuvering that followed, the *Java*'s return volley "carried away the *Constitution*'s wheel." Nonetheless, "superior American shiphandling and firepower soon began to take their toll. The British fired faster, but within two hours the *Java* was a wreck. Twenty-two of her crew were killed and another 102 wounded. The *Java* was so battered that she had to be scuttled."[69] Lieutenant Woodhouse's involvement in a series of stunning victories by the *Constitution* probably led to the promotion commemorated by the miniature.

Commander Woodhouse took charge of the *Hornet*, in 1826, and was promoted to captain the following year. Fortunately he was on leave two years later when the *Hornet* foundered in a gale "with the loss of all hands." Like many military leaders, Captain Woodhouse died peacefully in his sleep on his farm in Chester County, Pennsylvania in 1843.[70]

In *Commander Woodhouse*, Raphaelle Peale miniaturized full-scale portraits of mariners in which a background view often depicts a ship from the sitter's seafaring days. Another miniature exemplifying this tradition can be attributed to Thomas Birch (fig. 110), recognized as America's first marine painter, on the basis of comparison to known paintings and miniatures by him.[71] The

English-born Birch — who, like Raphaelle Peale, worked in Philadelphia and was the son of an artist (enamellist William Russell Birch) — specialized in seascapes, patriotic paintings of naval battles of the War of 1812, and portraits of sea captains. This expertise informs his miniature, in which the tilted head of the gentleman mirrors the rocking suggested by the boat in the background seascape, creating a satisfyingly unified image. The precision reflects the artist's training as an engraver, while the painterly, abstracted quality of the seascape explains why Birch's daring foray into marine art in an age of portraiture was praised in Philadelphia by collectors, critics, and fellow artists, including Rembrandt Peale.[72]

While a distant ship in a full-scale portrait may recall past exploits in the military or mercantile world, in a miniature it more likely alludes to the sitter's present absence at sea, and serves to console those left behind with a promise of safe return. In some instances, such a miniature may be a memorial to a loved one lost at sea, a scenario suggested by the hairwork on the reverse of the portrait by Birch. Over the plaid of hair, the monogram "JL," in combination with comparisons to other likenesses, identifies the previously unknown sitter as Captain James Lawrence, naval officer and hero of the War of 1812.[73] Born in Burlington, New Jersey, Lawrence joined the navy at age seventeen, serving under Commodore Stephen Decatur in 1804–5. He was second in command of the *Constitution* (on which Woodhouse served) and the *Wasp*. In command of the *Hornet* in 1812–13, he defeated the British brig *Peacock*. As commander of the *Chesapeake* on June 1, 1813, he lost his life and gained immortality when, wounded in battle with the British frigate *Shannon*, Lawrence directed, "Don't give up the ship."

In painting *Commander Woodhouse*, Raphaelle Peale participated in the Philadelphia marine tradition best exemplified by Thomas Birch, but he also continued the Peale family tradition, begun by Raphaelle's own father during the Revolutionary War, of portraying military officers of the current generation. The portraits Charles Willson and James Peale had painted during the war and in its aftermath celebrating military and political leaders — including George Washington — expressed the social values and allegiances of their era. During and after the War of 1812, reproductive print technology permitted wide circulation of

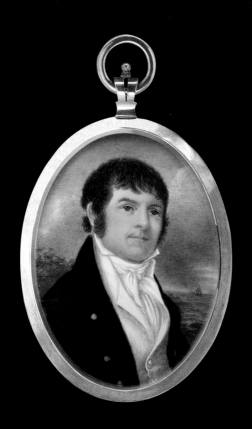

110. Attributed to Thomas Birch, *Captain James Lawrence*, c. 1810–13,
 Promised Deutsch Bequest, Yale.

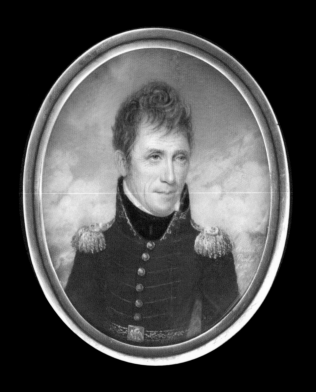

111. Anna Claypoole Peale, *Andrew Jackson,* 1819, Yale (frame not shown).

engraved and later lithographed images of military heroes and statesmen in such collections as *Delaplaine's Repository of the Lives and Portraits of Distinguished Americans,* published in Philadelphia in 1816–18. But the wide circulation of such images did not dampen the desire of individuals to have more personal and precious tokens of national leaders.

Raphaelle Peale's cousin Anna Claypoole Peale limned one of the best-known miniatures ever made of a military leader. She painted *Andrew Jackson* (fig. 111) in early 1819, while accompanying her uncle Charles on a painting expedition to Washington, where he arranged sittings with statesmen whose portraits he wanted to display in his Philadelphia museum. The aging artist, who also painted Jackson's portrait, in oil on canvas (Masonic Library and Museum of Pennsylvania), recorded in his diary on January 29: "This morning I rose before day to make my fire and prepare my Colours for taking my last setting of Genl. Jackson—being the 3rd morning which he has sat for Anna & myself before Breakfast, I should have considered his setting sufficient to finish it, had not Anna required more time to finish her Miniature likeness."[74]

It is Anna's portrait of Old Hickory that is widely considered the finest image of the sitter. This miniature can be understood in the context of the innumerable images of Washington as honoring a great person who led an exemplary public life—although Jackson remains a more controversial figure. The planter-politician from Tennessee had risen to prominence as a ferocious "Indian fighter." But it was General Jackson's smashing victory on January 8, 1815, in the Battle of New Orleans that spelled the end of British influence in Louisiana, concluded the War of 1812, and sparked a spirit of nationalism in the postwar years.

At the time of this portrait, however, the popular Jackson was in Washington to defend himself. He was under investigation by Congress for his brutal treatment in 1818 of the Seminoles in Spanish-held West Florida and his reckless execution of two British subjects who aided the Native Americans. In his final sitting before the two artists, Peale recalled in his diary that Jackson, stung by the accusations against him, conversed with supportive friends who had come to the studio to keep him company. Perceived by some as a tyrant, he was nonetheless celebrated as a hero in song and legend, and that is how Anna Claypoole Peale

presented him. On February 8, 1819, the full House vindicated his conduct in the Seminole War. That same year, as part of the Peale family strategy to attract patrons, Anna Claypoole Peale's gallant portrait miniature of the general was exhibited at the Pennsylvania Academy of Fine Arts.[75]

Two of the five daughters of James and Mary Claypoole Peale, Anna Claypoole and Sarah Miriam, pursued careers in portraiture that through commissions propelled them into the public realm and beyond the typical domestic confines of women's lives in the nineteenth century.[76] Anna trained in her father's studio, following an apprenticeship similar to James's a generation earlier under his brother Charles. The closeness of James's relationship with his daughter is reflected in early miniatures by her that recall his hand, and later ones by him that betray hers.

Not as tightly detailed as her father's earlier portrait of her cousin Rembrandt, Anna's *Andrew Jackson* declares her own theatrical voice. The cloud-filled sky, while common as a generalized portrait backdrop, here possesses an uncommon dynamism, a drama of shifting wind and light evocative of the battles fought by the sitter as well as of his mercurial personality. That background movement is carried forward by the wind-tossed hair and contrapposto pose. As he turns away from the viewer toward distant horizons, only the creases in Jackson's face — especially around his eyes — hint at the strain that he was experiencing during his contest with Congress.

The trip to Washington inaugurated Anna Claypoole Peale's most productive period. Even before their departure, her uncle recognized her growing prominence in a letter to his son Raphaelle: "Anna Peale in Miniature is becoming excellent, she has an abundance of work at an advanced price."[77] *Andrew Jackson* is signed "Anna C./Peale/1819." Later her work was signed and exhibited under various names, for she was married twice: in 1829 to Reverend William Staughton, who died the same year; and in 1841 to General William Duncan, after which her production significantly declined as she took up what was considered a married woman's primary role, that of homemaker.

But during her heyday, Anna shared a studio in Philadelphia with her sister Sarah Miriam and there trained her niece, Mary Jane Simes. Anna also

Detail of figure 111. In *Andrew Jackson* , the cloud-filled sky possesses an uncommon dynamism, a drama of shifting wind and light evocative of the battles fought by the sitter as well as of his mercurial personality. That background movement is carried forward by the wind-tossed hair and contrapposto pose. As he turns away from the viewer toward distant horizons, only the creases in Jackson's face—especially around his eyes—hint at the strain that he was experiencing during his contest with Congress.

maintained a studio at the Peale Museum in Baltimore and additionally made trips to Washington, New York, and Boston. Although most accomplished as a miniaturist, she painted easel portraits, landscapes, and still lifes, just as her male counterparts in the Peale family did. In 1824 she was elected an academician at the Pennsylvania Academy of the Fine Arts, where she showed miniatures in the annual exhibitions in 1814, and then continuously from 1818 to 1832.[78]

Anna Claypoole Peale's distinguished sitters included senators, an ambassador, scientists, and presidents. The miniature of Andrew Jackson, later the seventh president, is thus significant not only because of the sitter's fame but also because it resulted from Charles Willson Peale's promotion of his niece's career. In helping Anna to an important commission, Peale ensured that his family's remarkable dynasty, which was in large measure responsible for giving a face to a nation, would continue. Equally important, he helped place Peales among the first professional women artists to emerge in the new republic.

Charles Willson Peale's oil painting *James Peale By Lamplight* (fig. 112) poetically pays tribute to three generations of that close-knit family. The brothers were remarkable in their generation for their longevity. In this gentle portrayal of his younger brother, the eighty-two-year-old Charles depicts the seventy-three-year-old James contemplating a miniature. A medal on James's lapel alludes to his military service during the Revolution. It was following the war that James began painting miniatures; he largely took over that aspect of the painting trade from his brother in 1786. James trained the next generation of Peales — most notably Raphaelle and Anna — in miniature painting, helping to free Charles to turn over most of the portrait business and pursue his career as a museum entrepreneur. Around 1795 Charles had first celebrated James's career by portraying him limning a miniature (see fig. 4). At that time Charles also paid tribute to the role of miniatures in preserving family continuity, for the image coming to life through James's art probably represented Rachel Brewer, Charles's first wife.[79]

In this oil portrait of James, painted nearly thirty years later, a similar tiny palette and brush lie idly on the table. The tools' presence recalls James' accomplishments in miniatures. But working constantly on a diminutive scale gradually

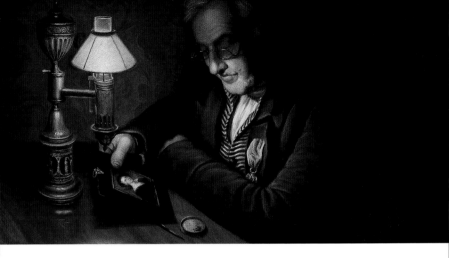

112. Charles Willson Peale, *James Peale by Lamplight,* 1822, oil on canvas, The Detroit Institute of Arts.

113. Anna Claypoole Peale, *Rosalba Peale,* 1822, The Detroit Institute of Arts
(frame not shown).

caused his eyesight to fail, and about 1820 he turned to still life painting. In this homage, the dim lamplight sympathetically evokes fading vision. But the brush and palette do not belong to James, and it is not his achievement with them that holds him spellbound.

In the miniature he contemplates, the dark opaque background and the sitter's sloping shoulders and elegantly elongated neck reveal the distinctive style of James's daughter Anna. By making the miniature James holds a superb example of her art, Charles extolled his brother's roles as teacher and as proud father. By selecting a miniature that portrays Charles's granddaughter Rosalba Peale (fig. 113), a still younger member of the clan, who was named after a Venetian miniaturist, he expressed his faith in the continuity of both family and art.[80] This painting at once celebrates the contributions by the Peale family to the art of the miniature and the intimate role that miniatures played as tokens of affection in family life.

Vivacious portraits such as *Rosalba Peale*, painted in 1820, and *Eleanor Britton* and a portrait of a lady, both painted in 1821 (figs. 114 and 115), illustrate why Anna Claypoole Peale received a steady stream of commissions. Perhaps Charles chose to illustrate *Rosalba* in the *Lamplight* painting not only because it depicted his granddaughter but also because, as an agent for his niece's advancement, he wanted to market her new style. In the possibly unfinished portrait of her younger cousin, Anna experimented with "a new palette" that culminated in the more refined portraits painted soon afterward.[81]

In these portraits, the gleaming, rich color, enhanced by large amounts of gum arabic, and the skillfully blended, varied brushstrokes produce the effect of tiny oil paintings. Anna used intricate cross-hatching to create transparent shadows in the pale faces, in opposition to the more broadly treated black dresses and dark backgrounds. In the two later portraits, that background, painted in horizontal strokes to emphatically distinguish it from the foreground, becomes more opaque and opalescent, setting off the delicate flesh tones, transparent lace collars and, in the portrait of the unidentified lady, the vivid colors of the cashmere shawl. These three portraits demonstrate that Anna's sitters sometimes resemble one another, all possessing long necks and narrow shoulders — traits reflective

of current ideals of beauty and posture to which a female artist may have been especially attuned.[82]

She also astutely responded to her patrons' needs. Her client base, although largely drawn from the established mercantile elite that her father and uncle had served, also included increasingly diverse segments of the rising upper-middle class in Philadelphia and Baltimore.[83] And she offered them a number of options. Oval portraits in varied housings, such as *Eleanor Britton*, set in a traditional rose-gold locket, and the *Lady*, set in a red-leather covered pocket case, persisted along with rectangular portraits like *Rosalba Peale*, set in a frame made of lacquered wood or papier-maché with an acorn hanger. The variety of formats offered by Anna Claypoole Peale and other artists acknowledged the multiple functions of the miniature as it reached a wider audience on the verge of the more democratic Jacksonian era.

In the portrait of her younger cousin, Anna freely experimented with the "cabinet miniature" in vogue in England but not yet widely accepted in America. She pointedly imitated oil painting by showing Rosalba in a three-quarter, half-length pose with domestic props of table and drapery. In fact, Anna's portrait of Rosalba heralds a fundamental modification in the American miniature tradition: the introduction of a larger, more opaque, rectangular portrait framed for display on a tabletop easel, inside a cabinet, or on a wall, where it functioned as a smaller version of a larger painting. This presentation suited artists who desired to take advantage of growing opportunities to exhibit their miniatures alongside oils, as Anna did at the Pennsylvania Academy, the Peale Museum in Baltimore, and the Artists' Fund Society. However, this new format did not — as is often assumed — *replace* the smaller, oval, and presumably more private portrait worn as jewelry but rather coexisted with it as well as with other alternatives, such as leather cases. What is most striking in the 1820s and 1830s is the plurality of miniature sizes, formats, and housings. *Eleanor Britton* simultaneously looks forward and back, combining a contemporary mode of depiction with a locket recalling the colonial tradition.

Furthermore, the changes in format and size did not signal a change in the miniature's time-honored role as a token of affection, including romantic, even

114. Anna Claypoole Peale, *Eleanor Britton (Mrs. William Musgrave),* 1821, Yale.

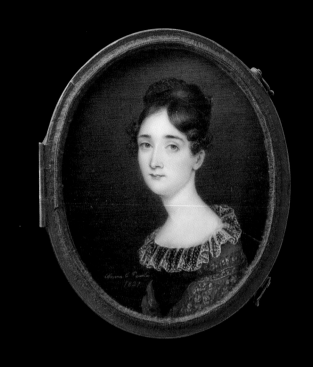

115. Anna Claypoole Peale, *Lady with a Shawl*, 1821, Yale (case lid not shown).

secret, love. In fact, Anna painted the rectangular portrait of Rosalba while the two cousins were visiting their aunt Angelica Robinson and her husband Henry. Rosalba apparently intended to give the miniature to him, but her grandfather Charles learned of her plan, and — deeming the gift most inappropriate — felt bound to inform her father and demand, "Why give her picture to any married gentleman?"[84] Its presence in Charles's portrait of James attests to his continued influence over family matters, as well as to the miniature's continued significance as a family heirloom.

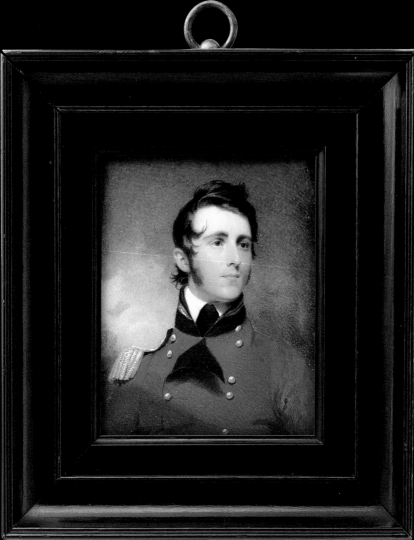

A sea change in public taste had taken place when the small, densely painted miniatures of the colonial era were overtaken by the large, transparent ivories of the federal era, heralded by British miniaturists like Archibald Robertson and exemplified in America by the work of Edward Greene Malbone. Now a new tide washed across the Atlantic, presaged in a letter written from London by Andrew Robertson to his brother Archibald, who was working in New York. Andrew dismissed the pale, serene portraits by Richard Cosway, whom Malbone admired, as merely "pretty things, but not pictures. No nature, colouring, or force." And Benjamin West, still an arbiter of artistic taste, had complimented Andrew's own darker, bolder pictures: they had, he remarked, "none of the trifling insignificance of miniatures."[1] At a time when public exhibitions increasingly placed miniatures in competition with oil paintings, Robertson's tiny portraits had the force to command public attention. It took several years for this trend to travel to America, but as Anna Claypoole Peale's works demonstrated, by the 1820s miniatures in the new mode had become popular there.

Andrew Robertson's portrait of a handsome young British lieutenant posed against an opaquely rendered sky (fig. 116), limned in 1814 in England for an illustrious American client, is a harbinger of the new miniature.[2] Robertson employed an exceptionally accomplished technique: a soft, gummy stipple for the face, guided by a few barely discernible graphite lines, seen, for example, at the edge of the nose, shaded with a characteristically dark wash. To create the brightly colored coat, Robertson first laid down red watercolor, then built form through cross-hatching in gum arabic mixed with a hint of gray. He achieves a three-dimensional effect in the buttons — white with gum for highlights over gray crescents.

A shadow slanting across the bottom of the image suggests a barrier between viewer and sitter, a spatial distancing at odds with the intimate proximity invited by most earlier miniatures, which brought the face close to the beholder. Although he uses a miniaturist's technique, Robertson rejects the delicacy of these earlier works in favor of the boldness of contemporary oil painting. Miniatures by Robertson and his followers on both sides of the Atlantic were often — but not exclusively — painted on large rectangular pieces of ivory and framed for hanging on a wall, frequently as part of a cluster of family images. In this instance, however, the secret behind Robertson's rectangular miniature makes it difficult to imagine its owner displaying it where others might have been tempted to probe the sitter's identity.

Robertson's miniature descended in the family of Colonel John Trumbull, the American artist and Patriot who served as an aide-de-camp to General Washington, as a diplomat, and perhaps even as a spy in the service of his country. After his death, the miniature was sold at auction along with other personal effects as a portrait of a "British Officer," an odd possession for a man with Trumbull's political convictions. But Trumbull had a secret interest in the youth, one which he chose not to reveal directly, not even in the autobiography he left to be published posthumously.[3]

It was in 1953, when Theodore Sizer published an edition of Trumbull's autobiography, that the colonel's secret became public. Although Trumbull had made no mention of "those matters which lay closest to his heart," he *had* saved correspondence "of the most intimate — and damning — nature": it revealed that he had fathered an illegitimate son, John Trumbull Ray, by a "servant girl." Few of Trumbull's friends knew about the child; some in his circle, like the inveterate gossip William Dunlap, suspected "concealed complications" — and a number of people spread rumors.[4] But those "damning" letters tell the story of a tortured relationship between the legendary Patriot-artist and his son, whose portrait miniature the colonel cherished, probably revealing it to only a few intimates, until his death at age eighty-seven.

116. (overleaf) Andrew Robertson, *Lieutenant John Trumbull Ray*, 1814, Yale.

For the socially conscious Trumbull, a Harvard graduate and the son of a governor of Connecticut, the embarrassment of the situation was intensified by the difference in class between himself and the child's mother. The close friend he took into his confidence when he was forced to ask for help was James Wadsworth, to whom Trumbull wrote from London in 1799. In his confession, Trumbull defensively presented his own version of his conduct toward Temperance Ray, a servant in his brother's house, and their son:

> When I was last in America an accident befel me, to which young Men are often exposed; — I was a little too intimate with a Girl who lived at my brother's.... The natural consequence followed, and in due time a fine Boy was born; — the number of Fellow labourers rendered it a little difficult to ascertain precisely who was the Father; but, as I was able to pay the Bill, the Mother using her legal right, judiciously chose me; — I was absent at the time; — the Business was ill-managed, — became public....
>
> But, having committed the Folly, and acquired the name of Father, I must now do the Duty of one, by providing for the education of the Child, to whoever he may belong: — I did not mean to have troubled any of my friends with this awkward business; — but as it is very uncertain how long I may be detained in Europe, and the Child who was born in 1792 is now seven years old, an Age when the impression of good or evil habits is deep and lasting, it is necessary that his Education should be attended to without delay; May I then beg of you who are so good a Negotiator, to undertake this Business for me? — The Mother's name was Temperance Ray. She lived at Haddam.... I could wish you to see both Child and Mother, if they are living.... I wish him to be kept constantly at a good common School, and taught reading, writing and Arithmetic, so as to fit him to make a good Farmer....
>
> It is bad enough to be called the Father of a Child whose Mother is little worth; — but, to be called the Father of a worthless illiterate profligate wretch (as He may prove to be, if left uneducated) is a disgrace to which it is criminal to expose oneself, when it may be avoided by a little Care and Expence.[5]

A year after writing this letter, the forty-four-year-old Trumbull married Sarah Hope Harvey, a beautiful twenty-six-year-old Englishwoman, who was herself of uncertain social background. It wasn't until early 1801, while the Trumbulls were on a belated honeymoon, that Wadsworth gave a full report: Temperance Ray had married "a sea-faring man, by whom she had several children," but Wadsworth had difficulty locating the boy, who had been placed with a family named Smith. He finally met up with Ray "out tending cows":

> The Boy is called after You — and I shall in future mention him by the name which he bears — I found that John was a favorite and tho a lad they thought him of some consequence — John came home with the cows — I viewed him with much attention — His clothes were dirty and ragged & his hair in every direction. I perceived however a fine countenance, hazel eyes, with ruby cheeks — After conversing with him a few minutes I asked him if he would go home with me & go to school — John with some interest asked me if I knew his Father — I waved the question — [6]

Wadsworth assured Trumbull that "on viewing him I have no doubt but he is your son — his forehead in particular and the upper part of his face resembles yours — his rosy cheeks indicate the finest health — in short he is an uncommonly fine looking boy." Wadsworth took the lad "from a house where his manners morals and education had been totally neglected" and apparently placed him first with one John R. Murray and then with a Reverend Mitchell, where he was to receive a country education. The Trumbulls, who remained in England until 1804, apparently first met Ray at the Mitchells' home when he was twelve years old.[7] John was led to believe that his benefactors were his aunt and uncle, and he sent them grateful letters about his progress in school. In 1808 the Trumbulls returned to London in search of both treatment for the artist's deteriorating eyesight, and a boost to his flagging portrait commissions. Their "nephew" accompanied them, and the colonel placed him with "a respectable farmer in Northumberland" for instruction in agriculture.

But Ray, like Trumbull himself, had no interest in farming, and declared in a letter of June 22, 1811: "I thought the best way was to tell you honestly at once

Details of figure 116. Robertson employed an exceptionally accomplished technique: a soft, gummy stipple for the face, guided by a few barely discernible graphite lines, seen, for example, at the edge of the nose, shaded with a characteristically dark wash.

To create the brightly colored coat, Robertson first laid down red watercolor, then built form through cross-hatching in gum arabic mixed with a hint of gray. He achieves a three-dimensional effect in the buttons—white with gum for highlights over gray crescents.

what I wish, that is to go into the [British] army. I should rather do that than to go back to America." After several heated letters were exchanged, the colonel sent this volley: "Permit me to state another objection: — you have chosen, of all times, to enter the British Army at the moment when a war with America is almost inevitable: and when of course your entering the military service of this Country may be regarded, & perhaps justly[,] as an Act of Treason to your native Country."[8] Nevertheless, on the eve of the War of 1812, Ray entered the 45th (Nottinghampshire) Regiment as a volunteer, where he ended up serving in the Peninsular War rather than fighting against the United States.

The tension between "uncle" and "nephew" apparently abated with time, for a letter from Trumbull to a confidant betrays an understanding of Ray's decision, and even pride in his military accomplishments:

> About a year ago he explained himself to me & begged permission to go into the British Army, and make War his profession, rather than return to a Country, where his Origins & connexions would ensure him Enemies and Insults & where his whole life must be a series of petty and disgusting squabbles. I made all the opposition in my power short of absolute prohibition but, finding argument useless, I at length consented to his going to Portugal as a Volunteer.... To have been wounded at the Storming of Badajor & again at the battle of Salamanca, secures him the respect of his comrades thro' life & from such a beginning I cannot but hope that he will make a distinguished Officer.

Following these engagements Ray was commissioned ensign on March 30, 1812, and promoted to lieutenant on March 30, 1814.[9]

During this period of rapprochement, a proud Trumbull commissioned for himself a miniature of the young man honoring Ray's promotion, and further ordered a gift for Ray. While on leave in London on August 16, 1814, Lieutenant Ray wrote his "uncle": "I have... seen Mr. Robonson who is to let me know tomorrow morning when I am to sit for my Miniature.... I am extreemly obliged to Aunt and yourself for your Miniatures which I saw to day." Trumbull, who was living in Bath, which was safer for an enemy alien than London, replied,

"Make our best respects to Mr. Robertson — & beg to have the picture in your uniform." A few days later Ray reported that Robertson had "nearly finished my Miniature."[10]

The exchange of miniatures between the generations in essence legitimized their familial relationship through art. But strains soon arose between Ray and his benefactors, aggravated by economic privation and bitter disappointment: Trumbull's dreams of becoming a successful portrait painter in London dimmed, Ray was placed on half pay by the War Department on Christmas Day 1814, and Sarah Trumbull, who suffered from alcoholism, began behaving in an increasingly erratic manner. Some unspecified incident led the colonel to punish Ray in 1815 by revoking the promised present, which had meant so much to him: "Your Aunt — and best benefactress, is so much dissatisfied with your unkind conduct that She has taken her miniature from Mr. Robertson & will keep it until She has reason to believe that you know how to value it."[11]

In the same letter, written shortly before the Trumbulls returned to America, the colonel, who had on occasion given Ray small sums of money, informed him that he could not leave Ray any, and that "it is well you should feel the value of [money] by privation." In the story of John Trumbull's relationship with his illegitimate son, money and miniatures are linked as emblems of reward and punishment in the conflict of wills.

Sporadic letters chart the course of their relationship from bad to worse. On August 17, 1817, Ray addressed a letter to his "aunt" only, confessing, "I suppose that Mr. Robertson has informed you of my being married ... and doubtless has put the worst construction upon it as she has no money, but although poor she has a good education ... and is a virtuous and careful wife. Unfortunately for us, I have not been able to get any employment as yet." Trumbull, who had himself impulsively married a woman considered socially unacceptable by family and friends, responded with condemnation: "We are not much surprised that you have taken the most important Step in Human Life, without asking our Opinion: for it is not the first instance of your independence. [B]ut, we are a little surprised that it did not occur to Mrs. Ray, (who we understand was a Widow) that *Family wants* might arise which would require more than your half pay to provide for."[12]

Apparently in a letter announcing the birth of his daughter, Ray affronted the Trumbulls by addressing them "for the first time" as mother and father. In anger, Trumbull cruelly informed Ray of the circumstances of his birth as the son of a "Servant," emphasizing the "looseness" of Temperance Ray's conduct as opposed to the goodness of his own wife, whom he credited with persuading him to give the boy an education. Perceiving that Ray's wife must have been pregnant when he married her, Trumbull, ironically, condemned his son's behavior. In debt himself, he refused Ray's request for financial assistance. A final letter, written in 1829 from Ray to Trumbull, attests that fate had not been kind: "It is with shame for my long silence that I attempt to address you again.... I am only employed about Nine Months out of 12: I was last year employed to ship & lend their Goods at Blackwalls.... As for the Army there is no prospect of any employment. Mrs. R. continues to have very bad health & unable to do anything, but thank God my Children are all better provided for in another World."[13]

In his will John Trumbull bequeathed "to John T. Ray, a Lieutenant in the British army, a miniature likeness of himself painted by Robertson," but apparently Ray, who may have died before then, never received it.[14] Trumbull did not indicate that the lieutenant's middle initial stood for his own name, or leave to him anything else of value, financial or familial. Nonetheless, the colonel had apparently kept the portrait of his son wearing the uniform of the British nation he himself had fought. We are left to wonder whether Trumbull read in the miniature the virtue of military heroism he admired or the vices of sexual indiscretion and financial insolvency he disdained — in both Ray and himself.

Long before John Trumbull hurtfully revoked the gift to his son of a portrait miniature of the young man's stepmother, Shakespeare had shown the power of miniatures as symbols of family conflict in *Hamlet*. When Hamlet confronts his mother, Gertrude, in her bedchamber, he uses miniatures to add force to his accusations of treachery and licentiousness. Placing the miniature he wears of his father next to the one she now wears of his stepfather-uncle, Hamlet commands, "Look here upon this picture and on this," and notes that Claudius's likeness reveals corruption, his father's, virtue: "Here is your husband, like a mildew'd ear/Blasting his wholesome brother" (3.4.54, 65–66). Miniatures were

117. Anson Dickinson's trade card, found on the reverse of his *Gentleman of the Dunlap Family*, 1819, Yale.

thus not only tokens of love but also time-honored weapons in the war of the generations. Long after the deaths of those who understood its power, Robertson's miniature of Colonel Trumbull's illegitimate son remains as testimony to squandered opportunities for reconciliation.[15]

The new miniature style illustrated by Robertson's *Lieutenant John Trumbull Ray* affected not only the emerging generation of American artists, among them Anna Claypoole Peale, but also older members of Malbone's generation, notably Anson Dickinson and Charles Fraser. Dickinson was one of the few portraitists who benefited from brief instruction by Malbone, who limned a luminous miniature of him in New York in 1804 (Stamford Historical Society, Connecticut). Although he never possessed Malbone's power, Dickinson's technique initially displayed a delicacy associated with the master of federal-era miniatures — a delicacy he never abandoned even as his colors gradually grew darker in response to changing fashions in both clothing and art.

Dickinson's portraits reject the bold color contrasts, opacity, and sheen evident in Robertson's miniatures, while adopting the larger rectangular format. The itinerant Dickinson inserted his trade card on the back of many of his miniature cases to serve as an advertisement (fig. 117).[16] His portable paintbox, brushes (called pencils), and reducing glass (to determine the correct proportions for translating a face from life to art), document how little the painstaking elements of the craft, at least, had changed (fig. 118). The artist would have used a magnifying glass for detail work.

The relatively soft, washy palette and intimate mood in a marital portrait pair of General and Mrs. Epaphroditus Champion (figs. 119 – 20) aesthetically look backward while the rectangular red-leather cases look forward, anticipating the daguerreotype cases of later decades. Such cases could be carried, displayed closed or open on a table, or hidden in a drawer or other container, retaining the possibility of privacy. But they could not be worn, and they do not offer the option of an allegorical scene or hairwork on the reverse that made the miniature a kind of personal reliquary and was an essential part of its early appeal.

Still the miniature's traditional role as a family heirloom remained unchallenged. This pair form part of a larger group of family members whom

122. Anson Dickinson, *Epaphroditus Champion Bacon*, c. 1835, Yale (case lid not shown).

Dickinson probably knew through his strong ties to his native Litchfield County, Connecticut. Born in Milton, the son of a carpenter, Dickinson—like so many miniaturists before him—began working in the craft tradition, apprenticing as a silversmith in Litchfield, then working as an enamelist and sign painter before establishing himself in New Haven as a miniaturist. By the time he limned these portraits of the Champions in 1825, Dickinson had established a home base in New York, where he settled with his wife, Sarah, and two adopted children. But he traveled constantly in search of work, from 1824 through 1825 moving through Baltimore, Washington, New York, Montreal, Quebec, and Litchfield County to fill local commissions.[17]

Typical of Dickinson's Connecticut patrons, the Champions of East Haddam represented the distinguished men and women who had contributed to the area's prominence during the Revolutionary era, a time marked by extensive participation in the war and by a bustling social, political, and cultural atmosphere in its aftermath. But by the 1820s Litchfield County had become a more culturally conservative place, whose citizens appreciated Dickinson's sensitivity to their old-fashioned values, expressed in his modified stylistic adherence to earlier miniature conventions. In addition to the tenderness of touch, the high placement of the sitters on the ivory harks back to colonial portraits on smaller ivories—but in this generous format the placement seems confining. Nonetheless, the way Dickinson fills the space with the figure brings the sitter closer to the beholder, creating an emotional rapport reminiscent of the earlier tradition.

General Champion fought in the Revolutionary War, serving briefly with Colonel John Trumbull. He later held local political offices before being elected to the U.S. House of Representatives from 1807 through 1817. As a successful businessman he was engaged in local real estate and shipping to the West Indies. Both the general and his wife, Lucretia, dress in a conservative manner appropriate to their status and age: his shirt collar does not show, as it would in the latest style; her eyelet cap and ruff, while consistent with the date of 1825, reflect trends dating back to 1819.[18]

In addition to the miniatures of Epaphroditus and Lucretia, Dickinson also limned a matching marital pair of the younger generation: the Champions' oldest

daughter Lucretia (unlocated), and her husband, the Honorable Asa Bacon (fig. 121). A Yale graduate, Bacon contributed to the earlier intellectual cosmopolitanism of Litchfield through his association with America's first law school, established there in 1784. Although never elected to office, he was a Federalist candidate for Congress from 1806 to 1818. He married Lucretia in 1807, a marriage marred by the losses of three daughters in early infancy. Whereas in their portraits the older couple turn their bodies toward one another but look at the viewer, Asa Bacon's gaze appears to have been directed toward the portrait of the wife with whom he shared so much heartache, with more to come.

One of their sons, named Epaphroditus Champion Bacon in honor of his grandfather, studied at Yale Law School and was admitted to the Bar in 1835. Dickinson commemorated that occasion with a portrait in the same format as those of the youth's elders (fig. 122). Young Bacon established a successful law practice in Mobile, Alabama, but pulmonary problems forced him to return home. After serving in the State House of Representatives in the early 1840s and devoting time to heraldic and antiquarian studies, he died suddenly on a trip to Spain, where he had gone for his health.[19] One of three sons his parents buried in early adulthood, Epaphroditus remained in their hearts through this keepsake. The scale and format of the miniature had changed, but its familiar meaning as an emblem of present achievement and future promise transformed too soon into a memorial remained a constant in a society still marked by high mortality rates.

Like Anson Dickinson, Charles Fraser, a direct heir to the Malbone tradition, selectively adopted aspects of the newer aesthetic that defined the miniature as a small oil painting. A many-faceted man, Fraser was a lawyer, author, poet, and orator, but today he remains most celebrated as Charleston's finest miniaturist. He was the youngest of fourteen children born to Mary Grimké and Alexander Fraser, who died when Charles was nine. The boy studied drawing briefly around 1795 with local engraver and landscape painter Thomas Coram (1757–1811) until his guardians discouraged his inclination toward art. He then took up law at the College of Charleston and was admitted to the Bar in 1807.

But his first love remained art, and he retired from the law in 1818 to devote himself to painting, concentrating on portrait miniatures of the city's leading

123. Charles Fraser, *Self-Portrait,* 1823, Carolina Art Association, Gibbes Museum of Art, Charleston, S.C. (case not shown).

citizens. In a letter to the ubiquitous William Dunlap, Fraser lamented his lack of formal art education: "This unfortunate error by which the destiny of my life was directed, or rather *misdirected[,]* will ever be, as it has always been, a source of regret to me." Only a year later, however, Fraser's reputation was so well established that Dunlap wrote in his diary: "[Samuel F. B.] Morse is the oil painter of Charleston, Fraser the Miniature." By 1846, Fraser had entered 633 works in his account book.[20]

Fraser's early work was strongly influenced by Malbone, who made several visits to Charleston between 1801 and 1807. At first Fraser adopted Malbone's luminous style and delicate cross-hatching, but he eventually developed an energetic technique at odds with his mentor's calm elegance, more in accordance with the boldness of contemporary oil paintings and miniatures. His now coarser stipple, however, never imitated the richness and glazing of oils but rather retained its earlier sensitivity to the watercolor medium.

That stipple flickers over Fraser's *Self-Portrait* (fig. 123), in which he chose to depict himself not as an artist with palette in hand but as an educated gentleman holding a book. Fraser associated his miniature with the grand manner in full-scale painting through the inclusion of a column with a monumental base. Painted on a large, rectangular ivory, the composition of a remarkably life-like head and bust placed against an unspecified background anchored by a silhouetted column, recalls popular easel paintings by Gilbert Stuart from his later years in Boston. In fact, Fraser boasted to family members that Stuart admired his *Self-Portrait*.[21]

Fraser's signature style appears most notably in portraits from the 1820s through the early 1830s; for example, *H. F. Plowden Weston*, *Young Lady in White*, *Mrs. Theodore Gourdin*, and *Mrs. John LaBruce*. In these mature works, he employed an insistent, mosaiclike stippling to define areas of the composition and create chromatic harmonies. His pointillism obscures contours; a dark, single curved stroke delineates the upper eyelid; and rhythmic patterns of dots become horizontal hatches in the background. But though Fraser's emphatic style calls attention to his miniatures as art, on another level his approach satisfied the demand in Jacksonian America for a kind of blatant realism in large- and small-

scale portraiture. Whereas Malbone's portraits had a lingering trace of romantic idealization, Fraser's sitters appeared in a light that was sympathetic yet uncompromisingly frank. In the words of one historian, "Fraser was not a prettifier of faces."[22]

His portrait of H. F. Plowden Weston (fig. 124), a planter and rare-book collector,[23] offers an empathetic but forthright depiction of the weariness of old age. Vigorous touches of watercolor fall into place next to one another, shifting into a recognizable image. In Fraser's best portraits, like this one, the vibrating face conveys a powerfully realized individuality, not only in appearance but also in characterization. This miniature offers a rare example of a sitter posed looking down, the upright back of the chair emphasizing the stoop of his shoulders. Fraser captured the eighty-five-year-old gentleman lost in thought, withdrawn into a past filled with memories shared by few among those still living.

In one of his strongest touches, Fraser introduced the element of light as an active ingredient in the composition. It enters diagonally from the upper right, seemingly lightening the rough stipple behind the sitter, bleaching his pale face and white hair, emphasizing the creases on his face, and expressively serving as a metaphor for contemplation. The averted gaze, twisted mouth, rumpled coat, and neglected cravat create an impression of a man who is no longer fully aware of those around him — yet the miniature's existence affirms that someone did want to remember Weston, as he really was, before he slipped away. Weston died three years later; consecutive entries in Fraser's account book seem to indicate that he made a copy of this portrait and also painted one of Weston's son Plowden.[24]

Fraser, whose portrayals of old age have been praised by scholars, also adeptly conveyed the sensuality of youth, as exemplified by his portrait of a young lady in white (fig. 125). Close examination reveals that sometime during the creative process the artist changed his mind: minimizing the sitter's chignon, he focused more attention on her face, neck, and bosom. He achieved a harmony of white and rose in her dress and shawl, echoed in the tones of her flesh, which are made luminous by the ivory's surface. Surrounding the wide neckline of the sitter's dress and her exposed bosom, the gentle folds of a rose-colored shawl suggest the opening of a flower, an evocation of dawning female sexuality that

124. Charles Fraser, *H. F. Plowden Weston,* 1824, Carolina Art Association, Gibbes
Museum of Art, Charleston, S.C.

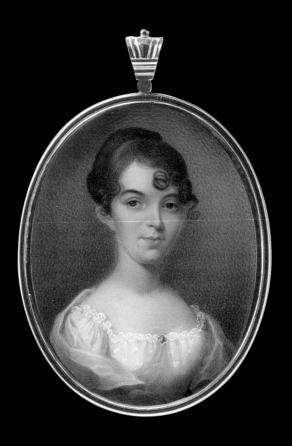

125. Charles Fraser, *Young Lady in White*, c. 1820–25, Yale.

we saw tragically portrayed in *The Dead Bride*. Like most of Fraser's early minia-tures, this portrait is housed in an oval locket, whose basket-weave, engine-turned reverse contributes to the miniature's charm. Just a decade earlier, there would probably have been a compartment containing hairwork.

Characteristic of Fraser's patronage was the wealthy Gourdin family. A member of the agrarian aristocracy, Theodore Gourdin was a planter, born near Kingstree in Williamsburg County, South Carolina, and active in local politics. Educated in Charleston and Europe, he was described by contemporaries as "a public spirited citizen" who "served the district in many capacities" and "a man of culture" who "owned a large library." A descendant of Louis Gourdin of Artois, an émigré to South Carolina, Theodore Gourdin was a French Huguenot, as was his wife Elizabeth. Their ancestors were among the many who had fled from their native land to Charleston in 1685 after the revocation of the Edict of Nantes and had gradually migrated northward along the Santee River. In the Carolinas the new landowners eventually established plantation systems on the mainland; when they realized that sugar would not grow there, they planted rice.[25]

The prosperity of Charleston — and of plantation families like the Gour-dins and LaBruces as well as the Mackies and Allstons — was linked to the bustling harbor, from which were shipped exports of South Carolina's staple crops of rice, indigo, and cotton. The port city owed its urbanity to the desire of English descendants to emulate cosmopolitan London, as well as to the vitality of a diverse population, including the Huguenots, who had emigrated from France in search of religious tolerance, and found it. By the time Fraser painted these portraits of Theodore and Elizabeth Gourdin (figs. 126 and 127), Charleston's reputation for luxury was unsurpassed in America. But those who enjoyed it were supported by the labor of African slaves, who made up 51 percent of the popula-tion in 1820.

In 1774, upon probate of his father's will, Theodore Gourdin became heir to a considerable legacy of land and slaves, with the stipulation made by his father that the "negroes families should not be separated." Less than twenty years later, he was the largest slaveowner in Williamsburg County, with a total of 150 slaves. And at the time of his death in 1826, "Theodore Gourdin was

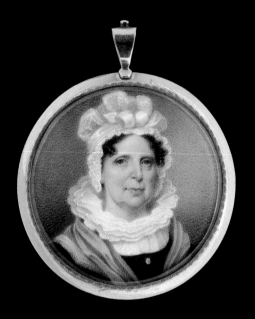

126. Charles Fraser, *Mrs. Theodore Gourdin (Elizabeth Gaillard)*, 1826, Yale.

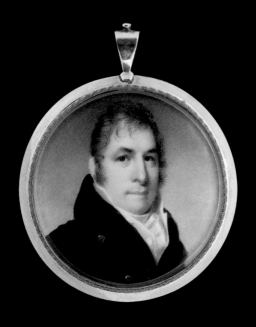

127. Unidentified artist (formerly attributed to Fraser), *Theodore Gourdin*, probably 1813–15, reverse of Charles Fraser, *Mrs. Theodore Gourdin*, Yale.

probably the wealthiest man in Williamsburg.... He could walk from Lower Saint Mark's Church on the Clarendon-Williamsburg line to the town clock in Georgetown, a distance of about seventy-five miles, without stepping off his own land."[26]

In a double-sided locket that contains the portraits of both Theodore and Elizabeth Gourdin, the precious materials of gold and ivory as well as the painstaking workmanship testify to the couple's wealth. But the story of how their portraits came to be set back to back testifies to the love of a wife for her husband. To unlock the meanings of this highly personal possession, the technical aspects of the miniature, its history, and the lives of the Gourdin family need to be investigated.

Theodore Gourdin married Elizabeth Gaillard on October 20, 1785, when she was nineteen and he twenty-one. They had ten children, of whom two sons, Robert Marion and John Gaillard Keith, died in infancy, while the youngest, Hamilton Couturier, died in 1809 at the age of six. Seven children survived into adulthood. After the death of the sitters, the double-sided locket long remained a treasured token of remembrance, descending in the family through their son Peter Gaillard Gourdin. In 1911, when Peter's daughter Martha G. DeSaussure inscribed on a card "For my daughter Isabelle," she identified this special gift as "Fraser's miniatures of / My Grandfather & Grandmother."[27]

In spite of the family tradition that Fraser painted both portraits, recently uncovered facts indicate that someone else painted *Theodore Gourdin*. In his account book, Fraser listed "Mrs Gourdine" as the first entry in 1826, and noted a charge of $40. Fraser's entries reveal that many of his miniatures were commissioned through kinship ties; he painted other members of the sitter's birth family, the Gaillards, later in 1826. However, he did not record Mr. Gourdin's portrait in his account book at any time. Like many other prominent citizens of Charleston, the family lent works by Fraser, including this miniature, to the exhibition in the artist's honor held during his lifetime in 1857; notably, only *Mrs. Theodore Gourdin* is specifically listed as being by the artist.[28]

Close examination reveals that the two portraits are technically distinct. Even if *Mrs. Theodore Gourdin* were not documented in Fraser's account book,

the compelling characterization and signature technique would identify this portrait as being by him. As in other mature works, Fraser used a separate pattern of brushstrokes rather than lines to define each element of the composition, executed contours and shadowing of the flesh with a mosaiclike stippling, and rhythmically hatched the background with a swirl of horizontal strokes.

Theodore Gourdin, based on a careful comparison to the technical handling of *Mrs. Gourdin*, cannot be attributed to Fraser. The shorter, choppier strokes in her portrait epitomize the artist's style; the less emphatically stippled face of *Mr. Gourdin* is composed of delicate hatching and more elongated strokes. Fraser applied a single curved line to define the crease above Elizabeth Gourdin's eye; several strokes define the crease above her husband's. In her portrait, forms blend into one another; for example, when seen under magnification, pointillist dots of color flow from the edges of her proper left cheek into her bonnet and hair. A markedly dissimilar effect is achieved in Theodore Gourdin's portrait, where facial contours and features are contained, often with graphite lines. Graphite, visible in his hair, does not appear in hers. Fraser used blue tones in Mrs. Gourdin's face, especially noticeable in the shadows around the eyes, proper left cheek, and chin, to integrate the head with the background. This device is not used in the face and background of *Mr. Gourdin*.

Fraser rendered the textured fabric in Elizabeth Gourdin's white bonnet and ruffled collar with an additive technique, so that the brightest whites appear to be raised. In Theodore Gourdin's white collar, a subtractive technique is used to allow the ivory itself to form the highlights — the opposite approach. In fact, everything about the technique in *Mr. Gourdin* points to an earlier style of miniature painting. Technical analysis, however, rules out the possibility that Fraser himself painted *Mr. Gourdin* before he retired from law and began documenting commissions in his account book in 1818. True, in his early, Malbone-influenced works, Fraser modeled faces with calmer, directional, longer strokes more akin to those used to form *Mr. Gourdin*. But as early as 1803 Fraser's characteristic crease above the eye, the blue tonalities in shading, and hatched blue-gray background darkening around the shoulders betrayed his hand — and none of that appears in *Mr. Gourdin*.[29]

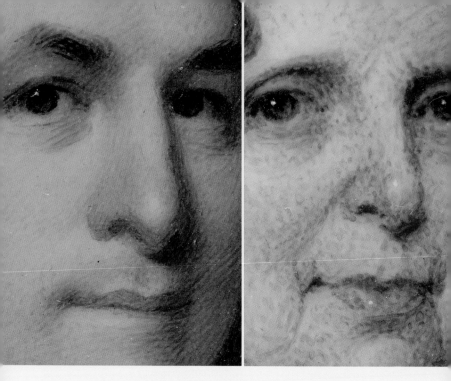

Details of figures 127 (above left) and 126 (above right). *Theodore Gourdin,* based on a careful comparison to the technical handling of *Mrs. Gourdin,* cannot be attributed to Fraser. The shorter, choppier strokes in her portrait epitomize the artist's style; the less emphatically stippled face of *Mr. Gourdin* is composed of delicate hatching and more elongated strokes. Fraser applied a single curved line to define the crease above Elizabeth Gourdin's eye; several strokes define the crease above her husband's. In her portrait, forms blend into one another. A markedly dissimilar effect is achieved in Theodore Gourdin's portrait, where features are contained, often with graphite lines.

Nonetheless, the overall designs of the portraits complement each other, implying that one was conceived at a later date with the other in mind. In both a light source, which emanates from the upper left, starkly models the face. The two sitters, shown in three-quarter view, look out quietly from the same angle. Fraser frequently depicted older women wearing white bonnets and scarves or ruffled collars, a device that accentuates their sensitively painted faces. In *Mrs. Gourdin*, the artist relieved the white and black clothing with a blue shawl that draws us back to the sitter's blue eyes. The shawl's placement creates a ∨-shape, which not only directs our gaze to her face but also echoes the ∨-shape formed by her husband's white waistcoat and pleated white stock.

Fraser's early miniatures were oval in shape, the later ones rectangular; however, this double-sided portrait is round. He thus probably painted *Mrs. Gourdin* in a circular format to match an existing miniature of Mr. Gourdin. Circular miniatures are generally associated with the Continent, suggesting that the artist who limned *Mr. Gourdin* either was of French descent or had agreed to a circular format at the request of his patron, an assertion through style of Mr. Gourdin's French heritage. In the portraits, the apparent age difference between husband and wife supports the hypothesis that Fraser painted *Mrs. Gourdin* years after her husband's portrait was painted. Her sagging cheeks and jowls, honestly delineated, make her appear older than Mr. Gourdin, who was actually three years older than his wife.

The exquisitely rendered portrait of Theodore Gourdin must have been commissioned for some special reason. We know that he served as a Republican member of the U.S. House of Representatives from South Carolina from March 4, 1813, to March 3, 1815. This accomplishment would be deemed worthy of celebration in a portrait showing his public face. In fact, Thomas Sully, a childhood friend of Fraser's, painted an easel portrait in 1815 of Theodore Gourdin (Mead Art Museum, Amherst College, Massachusetts), who appears to be around the same age as the sitter in the miniature, and to be dressed in a similar fashion.[30] Therefore, the portrait miniature may have been commissioned between 1813 and 1815 as a substitute for the man himself when he

left his large family — and especially his wife, whose children now had families of their own — to perform his public duties.

Theodore Gourdin died on January 17, 1826; Fraser entered Mrs. Gourdin's name in his account book as the first entry for that year. His widow apparently commissioned her portrait immediately following her husband's death and requested a round format to match the earlier portrait of him. Like a wedding band, this circular, double-sided locket is a tangible testament of their undying love.

We have seen that posthumous miniatures like Malbone's *Thomas Russell* were often modeled on full-scale, existing oil portraits to provide portable, visual reminders of the deceased for family and close friends. In 1828 Fraser recorded in his Account Book "Mrs Lebruce, a copy" for which he charged $40. The painter whose oil portrait Fraser copied for *Mrs. John LaBruce* (fig. 128) can now be identified as Samuel F. B. Morse, who was among Fraser's numerous artist friends. In 1819 Morse had made a pair of oil portraits of the sitter (fig. 129) and her grown son, Joseph Percival LaBruce. Perhaps Joseph later commissioned this keepsake of his mother. He may also have requested a portrait miniature of himself or of his deceased father based on an earlier portrait, for on the line following the entry for Mrs. LaBruce, Fraser wrote "Mr LaBruce — do —." Another charge of $40, jotted down and then added into the final sum, indicates that Fraser completed a miniature of a Mr. LaBruce, although it remains unlocated.[31]

Morse's, and in turn Fraser's, portrait of Martha Pawley LaBruce is distinguished by a sober absence of flattery and a painterly style influenced by portraitist Gilbert Stuart. Following Stuart's legendary example, Morse and Fraser abandoned drawing in favor of brushwork. Morse's "soft massings of transparent, liquid color" and contours that are "merely the indistinct boundaries of these areas" are confidently translated by Fraser into fluid patterns of stippling, although those dots are somewhat more methodically applied than in *Mrs. Gourdin*, painted from life.[32] Even the monumentality achieved in Morse's portrait is captured by Fraser in miniature form through the sitter's upright bearing and iconic placement on the ivory. Painted by Morse at the time of her husband's death, Martha LaBruce wears a black dress as a sign of her widowhood.

Morse alleviates the black with a paisley shawl and sunset background, while Fraser heightens the somber mood by using a more restrained palette and eliminating accessories.

While reducing Morse's portrait of Martha LaBruce in scale and changing the shape to an oval, Fraser considerably edited the composition, in the process focusing greater attention on the sitter's face. Fraser's rapport with his sitter makes this miniature a classic example of his mature art. Responding to his sensitive characterization of old age, even when copying a portrait by another artist rather than painting directly from life, a critic in 1934 remarked of *Mrs. LaBruce* that "the glow and sparkle of her eyes catch you, arrest you, — you are face to face with a personality." That strong character was probably helped by circumstance. Martha Pawley LaBruce came from two families who held sizable grants of land on the Waccamaw dating back to 1733. She was related through the Pawleys to the Mackies and through the LaBruces to the Allstons, the wealthy and powerful families who were so tragically linked in the death of Harriet Mackie.[33]

By the 1840s Fraser's technical abilities had declined; his stippling usually became more uniform in shape and less responsive to form and character. Widely respected during his lifetime, in 1857 Fraser was honored by a group of prominent citizens of Charleston, who mounted a retrospective exhibition comprised of landscapes and still lifes as well as more than three hundred miniatures. A reviewer observed that Fraser painted "heads of not a few of the most distinguished persons in southern history...These miniatures were arranged in family groups, and ... the dead and the living, were thus reunited again by the magic of Art." A descendant of a "leading tidewater" family, who belonged to Charleston's exclusive cultural and social institutions, Fraser chronicled this elite so vividly because many of his patrons were his social equals and friends.[34]

The miniature had now taken its place on the walls of exhibition halls. Yet in spite of its changing format, its small scale continued to offer lovers the possibility of revealing their love only to the beloved. Inside a lidded rectangular case, a pair of beautiful breasts glowingly rendered in watercolor on ivory confront the beholder (fig. 130). Chief among the fascinating glimpses into individual lives that miniatures teasingly unveil is that of Sarah Goodridge, the miniaturist

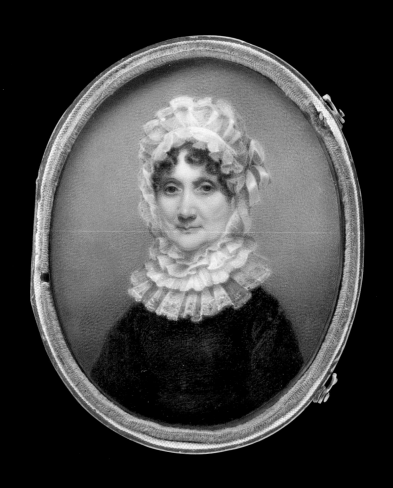

128. Charles Fraser, *Mrs. John LaBruce (Martha Pawley)*, 1828, Yale.

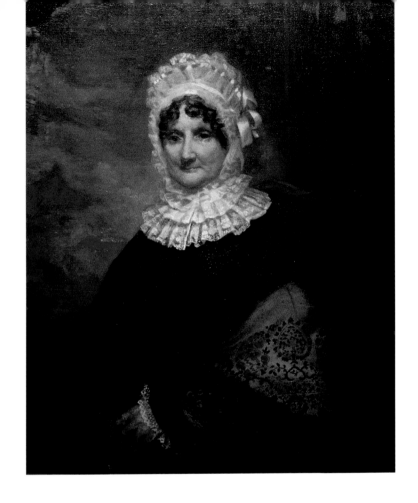

129. Samuel F. B. Morse, *Mrs. John LaBruce (Martha Pawley)*, c. 1819, oil on canvas, Private Collection.

130. Sarah Goodridge, *Beauty Revealed (Self-Portrait)*, 1828, Gloria Manney Collection.

who limned this image of vibrant sensuality as a gift to the statesman Daniel Webster. Goodridge never married and lived her entire life in the Boston area, residing with her father or various siblings. She left home only twice, for two trips to Washington in the winters of 1828 and 1841, presumably to visit Webster when his first wife died and after he had separated from his second. On a now lost backing paper, an inscription dated this miniature to the first visit, in 1828.[35]

Although Webster, then a senator, accepted Goodridge's gift, he married someone wealthier and better suited to support his extravagant lifestyle and his unrealized ambition to become president. But Goodridge's unusual *Self-Portrait*

descended in the Webster family, along with the easel and paintbox used during a prolific artistic career in which she painted Webster's portrait at least twelve times over two decades. His descendants referred to her as his fiancée.[36]

Sarah Goodridge's provocative gift to Daniel Webster remains a striking sign that boundaries of conduct were never as narrow as we sometimes believe. More evocatively than words, this miniature attests to the fact that a forty-year-old woman in the early nineteenth century could enjoy her sexuality. The forty-four carefully worded letters from Webster that document their growing friendship, as well as the pressures of professional commitments, financial problems, and family concerns, do not articulate the erotic life the couple shared — whether briefly, intermittently, or over a long period of time — but this portrait tells us all we need to know. In a rhapsodic response to seeing this miniature on exhibition, the novelist John Updike wove one possible scenario of their affair.[37]

Regardless of the romance's outward course, this image offers an unparalleled view into the miniaturist's inner life as a woman and an artist. As in William Doyle's portrait miniature of a young lady wearing a sheer dress (see fig. 100), a woman is making a sexual overture to a man during an era that valued female modesty and passivity. Because Goodridge is both lover and artist, no intermediary is necessary. But whereas Doyle's lady reveals her face, Goodridge's breasts hide her identity; the deliberately placed mole is a clue that has meaning only to her lover. In an age still shy about painting the nude, Goodridge painted a private part of her own body, unclothed in moral or religious interpretation. Unlike some of her contemporaries, who tentatively ventured into depictions of the nude as personifications of virtue or vice, Sarah Goodridge did not aim her picture at the public art world. She meant it for private contemplation by one man. Understanding this does not diminish the implications of her gesture, for surely as an artist and a woman she appreciated the potency of her imagery. It still surprises viewers today.

Breasts in Western art evoke conflicting sexual and sacred associations as attributes of love, nourishment, and protection, most often articulated by the Virgin's baring of one breast to feed the infant Christ, or of sex, sin, and death, exemplified by Eve's nakedness in the Garden of Eden. Breasts have occupied a

131. Unidentified artist, probably British, *Eye*, c. 1805–10, Yale.

central place in the visual arts from the prehistoric Venus of Willendorf to the countless representations of nymphs, goddesses, and odalisques, down to the commercial advertisements today that sell a wide assortment of commodities through sex. Men created the majority of these images, using the female body as subject. But Goodridge's *Self-Portrait* is a rare instance of a female artist in the nineteenth century taking ownership through art of her own body as subject. Or rather part of her body, offered to another as if in a box, swathed in gauzy wrapping pulled aside to unveil its contents. The disembodied breasts allude to precious objects wrapped for protection — perhaps fragile jewels, exotic fruit, or actual body parts like the bones, fingers, or hair of saints kept in reliquaries since the earliest days of Christianity.

The idea of using a part of the body to stand for the whole as a way of hiding a lover's identity has a history in English miniature painting. The vogue for miniatures detailing an eye as a token of love — perhaps an illicit affair — took hold during the late eighteenth and early nineteenth centuries. In one disconcerting image, the sitter's eye, particularized by locks of brown hair on the upper left that suggest a woman, is painted in watercolor on ivory and set in a circular gold brooch (fig. 131). Scratches on the covering crystal indicate that it was worn frequently, perhaps on the underside of a gentleman's lapel. Such a personal object

is a domestic adaptation of one of the most potent devices of devotional art, the disembodied eye of God. In fact, the sight of the eye of the Almighty gazing down from the copula of a church in Rome is said to have inspired a British woman to commission a miniature of her own eye.[38] But the disembodied eye is also an erotic image. It reminds us that love enters through the eyes, which first caress the object of desire, then possess it. The unblinking stare of a jealous lover or the all-seeing God unnerves the beholder, keeping him or her from straying from the path dictated by the ever-present watcher.

As the gift of an eye miniature from one lover to another was almost always meant to remain a secret, documented examples are rare. Probably the most famous such miniature is *Mrs. Fitzherbert's Eye*, housed in a pearl crest-shaped setting, which was painted by Richard Cosway as a love token for the Prince of Wales, later George IV. An American example allegedly was painted by Edward Greene Malbone, renowned for his sensitivity to the nuances of romance.[39] Goodridge's technique in her remarkable *Self-Portrait* recalls the tradition of Cosway and Malbone both in its romantic impulse and its use of transparent veils of delicate color. Her luminous stipple and hatch achieve a three-dimensional quality, combining ethereality with realistic form that enhances the ambivalently hallowed and profane connotations of her subject.

Throughout the 1820s, even while traces of the luminous style practiced in modified form by Dickinson, Fraser, and Goodridge continued to thrive, most miniaturists — notably Henry Inman and Thomas Seir Cummings — more fully embraced the painterly, glistening, deeply colored aesthetics of contemporary oil painting. This is hardly surprising, as both men apprenticed as oil painters: Inman under distinguished portraitist John Wesley Jarvis, and Cummings, in turn, under Inman himself. Late in his seventeen-year association with Jarvis, Inman began to specialize in miniatures. Shortly after he opened his own studio in 1822 on Vesey Street in New York, Cummings became his pupil, and then his partner from 1824 to 1827 — a collaboration documented by stylistic similarities that make it hard to distinguish an individual hand and by some jointly signed miniatures. After 1827 the two divided their business, with Inman specializing in painting oils and Cummings in miniatures. Inman became the leading oil

Details of figures 132 (top) and 133 (above). Enlarged details of Inman's portraits limned around the time of the marriage of Laura Woolsey to William Samuel Johnson on April 20, 1824, show carmine, vermillion, and blue hatching resembling engraving in the face, with sgraffitto giving delineation to brows and eyelids.

portraitist in New York, his work valued for its fluid brushstroke, detailing of material stuffs, and highly finished, forceful style that still bore a trace of idealization in images of women.

Those same qualities make Inman's miniatures, at first glance, appear to be small versions of his oils, but closer examination reveals a flawless miniaturist's technique. Enlarged details of his portraits limned around the time of the marriage of Laura Woolsey to William Samuel Johnson on April 20, 1824, show stippling in the background and carmine, vermillion, and blue hatching resembling engraving in the face, with sgraffitto giving delineation to brows and eyelids (figs. 132 and 133). In the portrait of the new Mrs. Johnson, violet dusted over the eyelids and hinted at in shadows explodes in an elegantly draped shawl.[40]

The plurality of housing choices during this period, discussed above specifically in relation to Anna Claypoole Peale's miniatures, gave clients options regarding the function of their miniatures. Inman's marital portrait pair demonstrates that those decisions could be based on gender roles. Mrs. Johnson's portrait is housed in a large rectangular lidded red-leather case, Mr. Johnson's in a small oval rose-gold-over-copper locket, with a tiny compartment in the reverse for a lock of hair, now lost. A member of the same Connecticut-based Woolsey family as the wife of William Dunlap, Laura Johnson frequently stayed in New Haven while her husband worked at his legal firm in New York. Most plausibly, when Laura left home she openly wore her affection for her husband in miniature, while William carried her closed portrait to work or displayed it like a small oil painting in the home that was defined as her sphere.

Inman's darker, bolder miniatures were compatible with the heavier black dresses then in fashion — as opposed to the gossamer white of Malbone's era — and with the ornate, overstuffed finery of the Victorian parlors and boudoirs in which they were shown. In part because rectangular ivories afforded artists the space to depict sitters supporting their heads on their hands, Laura Woolsey Johnson appears more informally posed than most of her predecessors — as if she were seated near William in their parlor. Their tender correspondence records their affection throughout a marriage of more than fifty years, during which they lost two children in infancy and raised four to adulthood.[41]

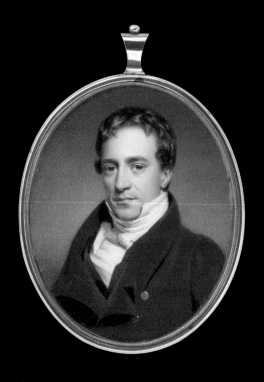

132. Henry Inman, *William Samuel Johnson*, probably 1823–24, Yale.

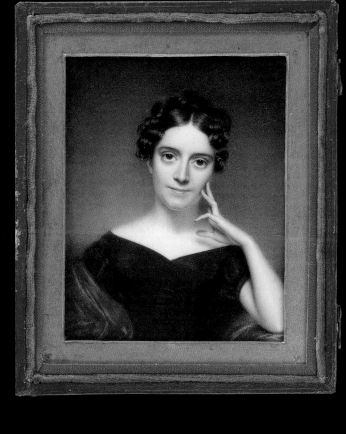

Henry Inman, *Mrs. William Samuel Johnson (Laura Woolsey)*, probably 1823–24, Yale
(case lid not shown).

The contemplative gaze, tilted head, and hand-to-head gesture that make Inman's sitter appear to be an intimate of the beholder's appear in Cummings's *Thomas Cole* (fig. 134). In fact, the artist and sitter were close friends, whose professional associations and ambitions further linked them around the time Cummings painted this miniature. Born in England, the self-taught Cole came to America with his parents in 1818 and discovered in the wilderness an inspiration bordering on religious devotion. The meaning with which Cole invested the land struck a chord with Cummings, who likened his friend's "sublimely beautiful" paintings to a "moral poem."[42]

Such responses among critics and the public eventually dubbed this Englishman the founder of the American school of landscape painting. By 1825 Cole's journeys had brought him back to New York City. With Inman, Cummings and Cole were among the fifteen original members of the National Academy of Design, founded in 1826 in reaction against the antiquated teaching policies of the American Academy of the Fine Arts. They also socialized

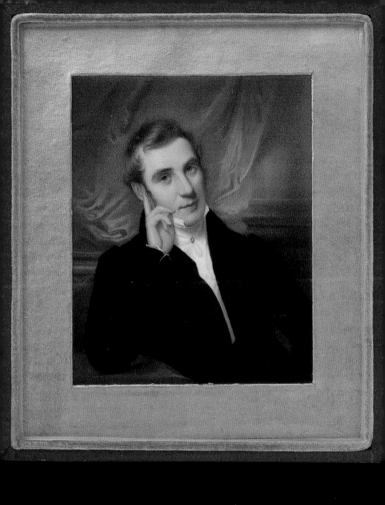

84. Thomas Seir Cummings, *Thomas Cole*, probably 1828 or 1829, Yale (case lid not shown)

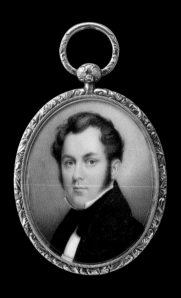

135. James Passmore Smith, *Self-Portrait*, c. 1830–35. Promised Deutsch Bequest, Yale

regularly with a like-minded coterie of artists at the Sketch Club, which held its first meeting at Cole's rooms at 2 Greene Street in 1827. In the annual National Academy exhibition of 1828 Cummings exhibited an oil portrait of Cole painting a landscape (Albany Institute of History and Art) and the following year showed this more personal portrait miniature of his friend, which descended in the sitter's family.[43]

Cummings's ambitious composition in the miniature mirrors oil painting in its striking color contrasts, rectangular format, and inclusion of props: the foreground table and background drape and column. Much like his friend Cole, who elevated landscape to the level of history painting, Cummings desired to raise miniatures in the estimation of critics to the status of oil portraits. One of the most prolific miniaturists and influential teachers of his generation, Cummings argued in a published essay that miniatures "should possess the same beauty of composition, correctness of drawing, breadth of light and shade, brilliancy, truth of colour, and firmness of touch, as works executed on a larger scale."[44] Amazingly, in *Thomas Cole,* Cummings achieves this parity by using a precise stipple technique that gives his flesh tones a porcelainlike quality.

An extremely fine stipple skillfully models the face of James Passmore Smith in a *Self-Portrait* set in a small locket that differs from earlier examples in its foliate design and large ring hanger, which allows it to be worn or hung on a wall (fig. 135). Lifelong Philadelphia residents, Smith and his wife, Mary Adams, had five children. His close friends included artists Thomas Sully, John Neagle, John Henry Brown, and Jacob Eichholtz. Smith's *Self-Portrait,* along with Eichholtz's oil portrait of the artist interrupted while limning a miniature (fig. 136), descended in the Smith family.[45] They were painted around the same time — possibly at the same session.

In both, the subject wears his hair combed to the side, a high black stock, and waistcoat with rolling collar; however the sameness of men's styles during the 1830s should be noted. Both images achieve the naturalism demanded of portraiture at the time and capture Smith's penetrating gaze. Interestingly, the miniaturist's palette depicted in Eichholtz's picture resembles that used by oil painters, not the tiny ivory palettes generally favored by earlier practitioners and visible in

Charles Willson Peale's portrait of his brother James (see fig. 4). Smith's palette choice may subtly signify the closer association between the arts of miniature and large-scale painting. Fewer than fifteen of his miniatures have been identified, many of them copies after larger works. All are unsigned, but some carry a trade card advertising his services as a miniature painter and teacher of drawing and painting.[46]

Even before the introduction of photography, competition in the Jacksonian era with large-scale painting altered the aesthetics, marketing, and social function of the miniature. The generally increased opacity, often heavily gummed surface, and, most important, greater diversity of housing formats changed the way miniatures were viewed, exchanged, and held. Frequently painted in a bolder style on large rectangles framed to be displayed alongside oils in an exhibition or hung at home in a cabinet, boudoir, or parlor, miniatures of this scale and shape were no longer meant to be worn. Smaller miniatures set in lockets sometimes had a tiny reverse compartment for a lock of hair, but not for the elaborate designs or allegorical scenes that had enriched the meanings of many federal-era miniatures. Nonetheless, the stories behind Jacksonian-era miniatures attest to their continued value as the most personal form of artistic expression — at least until little portraits drawn by the sun challenged their monopoly of the small face.

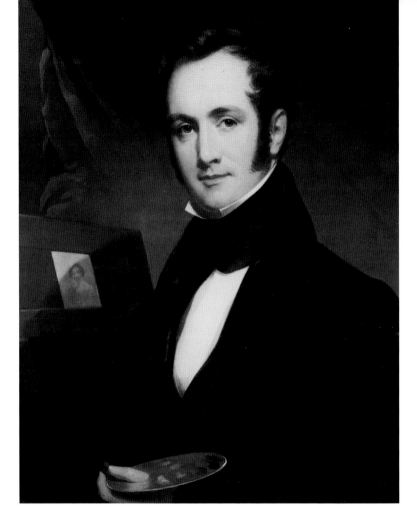

136. Jacob Eichholtz, *James P. Smith*, c. 1835, oil on canvas, National Gallery of Art, Smithsonian Institution, Washington, D.C.

137. Lid, by Littlefield and Parsons, of gutta percha Union case containing
Mrs. Moses B. Russell (Clarissa Peters), *Child in a Pink Dress*, c. 1850, Promised
Deutsch Bequest, Yale.

One of the first scholars of miniature painting in America observed in 1927, "The miniature in the presence of the photograph was like a bird before a snake: it was fascinated—even to the fatal point of imitation—and then it was swallowed."[1] In fact, the invention of photography did not herald the immediate death of the miniature but rather its continued transformation. Beginning around 1820, the American miniature's flirtation with oil painting had altered its style and format. Two decades later, painted and photographic portraiture became integrally intertwined.

Enamored by the seemingly objective accuracy of the "pencil of light," as opposed to the allegedly more subjective painter's eye, the American public saw the photograph as a truer likeness than the painted portrait in all respects except color. The precision, sharp contrasts, and blatant realism of photography had crucial effects on painted portraits, just as the expressions, poses, and props used in paintings influenced photography. Thus painters modified an older art form in response to new ways of seeing, and photographers adopted painting conventions to make the strange seem familiar.

Although the photograph affected both large and small painted portraits, its similarity to the miniature in scale, housing alternatives, propensity to serve a private function, and portability intensified the competition and correspondence of the two media. After Samuel F. B. Morse—himself a portraitist—brought daguerreian art to the United States in 1839, miniaturists scrambled not only to compete but also to experiment with this mesmerizing new way of reproducing the small face. Novelty, low price, relative speed of production, "scientific" accuracy, and availability created a demand for daguerreotypes after 1839 and ambrotypes (essentially, negative transparencies on glass) after 1854. To pursue their livelihood, miniaturists met their clients' altered expectations for acquiring a

true likeness in less time by mirroring the meticulous aesthetics of the photograph in watercolor-on-ivory portraits painted exclusively from or aided by a photographic image: "One novelty in portrait painting, and a most acceptable one ... [is] the taking of a portrait from the Daguerreotype.... A single sitting produces a perfect facsimile of the features from which a most accurate miniature is painted."[2]

Entrepreneurs, many of them miniaturists turned photographers, painted directly over various photographic bases, thereby guaranteeing accuracy while softening unflattering blemishes, adding lifelike color, and mimicking the more expensive and genteel miniature. Miniaturists and photographers also formed partnerships to satisfy the growing demand for varied likenesses. The complexity of responses to sun-drawn pictures, as photographs were called, created some surprising results.

Along with hybrid painted photographs, the watercolor-on-ivory miniature not only persisted but also continued to find growing patronage among members of the middle class, with whom the older establishment, the traditional owners of miniatures, increasingly shared economic and political power. For reasons of taste and custom, many clients from the established elite preferred to commemorate kinship ties in an art form valued by their ancestors. Conversely, commissioning such traditional mementos in America signaled that those who had struggled for economic and social status — some of them immigrants — had succeeded. They had established their families and secured stability not only for themselves but for the future generations they hoped would remember them.

A wide, comparative sampling of documented patronage for miniatures and photographs, beyond the scope of this study and difficult to achieve, is needed to explain the longevity of the miniature. But certainly the patina of age that still attracts Americans entering the twenty-first century to antiques, reproductions of antiques, and revivals of earlier styles and art forms played a role.[3] Through its historical associations and precious materials, the miniature retained an aura of aristocratic lineage and timeless beauty craved during a period of rapid change. Satisfying the consumer's desire for something old and something

TO PORTRAITS LIKE THIS. DAGUERR
HE DECEASED, BUT MINIATURES ALS
EED FOR TOKENS OF MOURNING.

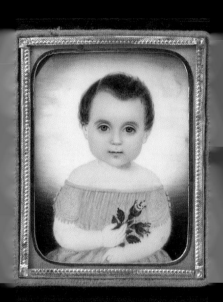

sell (Clarissa Peters), *Child in a Pink Dress*, c
ale (case lid not shown)

new, the antebellum miniature maintained its link with the past while alluding to the taste of the present.

Daguerreotype cases open like books, and the old cliché "Don't judge a book by its cover" applies. When opening a case like the one concealing the picture of a little girl in a pink dress (fig. 137), it is impossible to know whether a miniature or a daguerreotype will be found inside. That fact attests to the intimate connection in format and function between the two art forms at mid-century. Instead of the watercolor-on-ivory portrait (fig. 138), a face shining as if in a mirror from a metal plate might be discovered; either image would be protected under glass and held there by a gilded metal liner.

Beneath the glass, the child in the pink dress poses with the unblinking frontality characteristic of sitters in early daguerreotypes. But that aesthetic had a longer history in American so-called folk portraits, which exalted the frontal, flat, fully lit face, without shading, in part because light "served as a metaphor for whatever a particular group considered to be the appropriate combination of rational understanding and divine inspiration." In fact, one daguerreotypist serving a market accustomed to folk portraiture complained, "I can't sell a picture . . . where one side of the face is darker than the other, although it seems to stand out better and look richer."[4]

The evenly illuminated, naively painted face enshrined in this daguerreotype packaging does not reflect the realism of photography. Typical of Boston-based Mrs. Moses B. Russell (Clarissa Peters)'s ethereal images of children, this little girl stares out of large, limpid, round eyes, the top eyelids fringed with clearly delineated lashes, set into an excessively pale face created by delicate, gummed lines.[5]

The harsh reality of high infant mortality lends an air of sad urgency to portraits like this. Daguerreotypes often were taken of the deceased, but miniatures also continued to fulfill the need for tokens of mourning. This may be a posthumous portrait, for an angelic halo of pink and blue sky surrounds the child's head. Following a long tradition associating childhood innocence with closed blossoms, the girl holds two fragile rosebuds in her hand. Artists used

139. Lid, engraved "MAS," of gold locket containing Unidentified artist, *Lady of the Sully Family*, c. 1844, Yale.

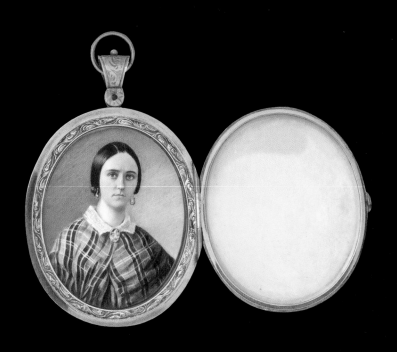

140. Unidentified artist, *Lady of the Sully Family*, c. 1844, Yale.

roses at every stage of growth, from buds of hope to open flowers of maturity, to denote the transience of life.

The daguerreotype case sheltering the child's portrait promised one thing and delivered something else. The ornately engraved cover of a yellow-gold locket (fig. 139), crafted by George W. Webb in Baltimore in 1844, promises a watercolor-on-ivory portrait inside (fig. 140). Yet daguerreotypists also advertised that they could provide bracelets, lockets, and rings, allowing the individual portraits to be worn as personal jewelry (fig. 141).[6] Opening the Webb case reveals the serious countenance of a young lady in fact limned in the traditional medium—but with such sharply focused precision that her image appears to be painted over a photograph. But examination under high magnification indicates that the watercolor stipple is applied confidently, with no marks that could not have been made with a brush, and no traces of a photographic image or emulsion beneath the paint on the ivory support.

The miniaturist's process has not changed but rather his or her way of seeing. Perhaps the artist painted this portrait from a photograph rather than from life—or maybe looking at photographs had altered the way he or she interpreted life. The sitter's expression, or lack of it, even mimics the frozen solemnity of being "daguerreotyped," as Ralph Waldo Emerson described it in 1841:

> And did you look with all vigor at the lens of the camera, or rather, by direction of the operator, at the brass peg a little below it, to give the picture the full benefit of your expanded and flashing eye? . . . And in your resolution to keep your face still, did you feel every muscle become every moment more rigid; the brows contracted into a Tartarean frown, and the eyes fixed as they are in a fit, in madness, or in death?[7]

The severity of this miniature mirrors early photography, with color added. Ironically, as the century progressed, some hand-colored photographs imitated the look of miniatures. Dated 1896, this opalotype (fig. 142), a photograph on opal (white) glass that was sensitized with gelatin-bromide and then tinted with pale washes of colors, is now disfigured by peeling emulsion, but its

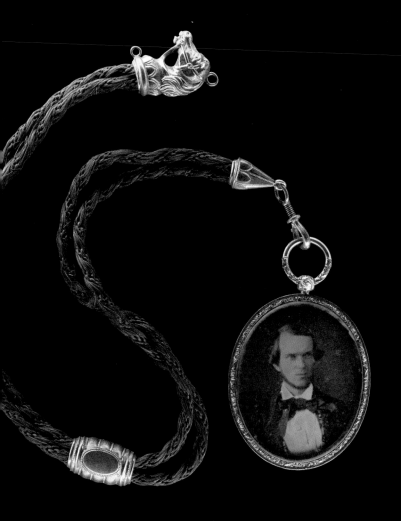

141. Unidentified artist, *Gentleman*, c. 1850–52, hand-tinted daguerreotype set
in yellow-gold locket with hanger attached to hairwork watch chain with metal
findings, private collection (object reduced from actual size).

Unidentified artist with the initials J. H., *Anne Sherman*, 1896, opalotype, Yale

143. Albert Sands Southworth and Josiah Johnson Hawes, *Young Girl, Hand on Shoulder*, hand-tinted whole-plate daguerreotype, Matthew R. Isenburg Collection (case not shown).

maker's aims are still apparent. Made some fifty years later than the woman in the locket, the opalotype alludes to watercolor or even pastel in its softer coloring and tender mood. Such crosscurrents underscore the connections between the art forms throughout the second half of the nineteenth century.

The sitter for the locket miniature remains unidentified, but some clues suggest that she represents a clientele not drawn from the economic and social elite. She wears a plaid dress with matching pelerine cape held closed with a brooch — a costume similar to one deemed "conservative," with a certain "home-made" quality, on an older sitter in a daguerreotype dated circa 1845 – 47.[8] Inside the locket, a card advertises "YOUNG CATHOLIC'S / LECTURE / COURSE." Such signs appearing around mid-century indicate a greater inclusiveness in miniature patronage in response to America's changing face through immigration, as well as to market competition for the broad clientele served by photographers.

Silhouettes, often made with a physiognotrace, had offered inexpensive profiles to many before the age of the camera. Yet the camera could also render shadow at a price affordable to the middle class. In advertisements photographers quoted Shakespeare: "Secure the shadow / Ere its substance fade."[9] Such copy tapped into hopes and fears about the camera's power to capture the soul — beliefs that mirrored and intensified older perceptions about the revelatory power of portraiture in general.

Leading daguerreotypists like M. A. Root of Philadelphia and the partner-ship of Albert Sands Southworth and Josiah Hawes in Boston used the expressive vocabulary of high art to record something beyond surface resemblance, an interpretation of the inner life of the subject (fig. 143). Late in his career, South-worth described the dialogue between photographer and sitter in transcendental-ist terms: "The artist is conscious of something besides the mere physical, in every object in nature. He feels its expression, he sympathizes with its character, he is impressed with its language; his heart, mind, and soul are stirred in its con-templation. It is the life, the feeling, the mind, the soul of the subject itself."[10] As Shakespeare knew, the "substance and shadow" endowed by nature or God had long been the true subject of art.

Housed inside a daguerreotype case and resembling photography in its precision, the watercolor-on-ivory portrait of Susan Wetherill by Philadelphia miniaturist George Hewitt Cushman dramatically uses light and shadow to reveal and conceal in an attempt to capture the heart and mind of the sitter (fig. 144). In *The House of Seven Gables,* Nathaniel Hawthorne had likened daguerreotypists to magicians, with a power over the spirits of others.[11] Cushman may have wished for those powers when he painted this miniature, possibly using a daguerreotype as a model, and incorporating his unrequited feelings for the introspective sitter, his future wife, who withdraws into herself.

Cushman painted the oval portrait on a rectangular ivory. Under the preserver on the blank ivory, zigzag strokes trace the artist wiping his brush as he used a typically mid-nineteenth-century technique of saliva-working to gain the control needed to soften and blend colors, creating a polished finish that could compete with photography (fig. 145). The exacting aesthetic also reflects the Connecticut-born Cushman's experience as an engraver under Asaph Willard in Hartford and John and L. W. Cheney in Boston before he moved in 1842 to Philadelphia, where for the next twenty years he engraved banknotes and book illustrations.

Cushman first exhibited miniatures in that year at the Artists' Fund Society. His technique, honed as an engraver and appreciated in the era of the daguerreotype, is tempered by a refined poetry, suggestive of his early instruction in drawing from Washington Allston, a painter of the federal era admired for his Rembrandtesque chiaroscuro. Romantic portraits by Allston also influenced the style of Southworth and Hawes, who daguerreotyped his sketches for a publication of engravings by Cheney, Cushman's employer in Boston.[12] The methods and materials used by daguerreotypists and miniaturists differed; their aesthetic influences, aims, and results could be remarkably similar.

The moodiness projected by Cushman in his portrait of Susan Wetherill echoes the tone of their letters, exchanged during a long courtship. Based on the proportions of the sitter's V-shaped neckline, this portrait can be dated to circa 1843, making it early in Cushman's career as a miniaturist. As he generally only painted portraits for friends, the date indicates that his acquaintance with Susan

R, CUSHMAN DECLARED, "WHEN I MET YOU THIS [...]
D MYSELF ALONE WITH YOU — I RESOLVED TO CONF[...]
[...]AT HAS [BEEN] PLEADING AT MY HEART FOR A LO[...]
[...]T I *LOVE* YOU *DEEPLY TENDERLY WHOLLY*..."

[...]tt Cushman, *Susan Wetherill (Mrs. George Hewitt Cushman)*

145. George Hewitt Cushman, *Susan Wetherill (Mrs. George Hewitt Cushman),* c. 1843–45, uncased, showing artist's brushstrokes on ivory, Yale (object enlarged from actual size).

Wetherill began soon after his arrival in Philadelphia. If he limned her portrait from an earlier daguerreotype, the miniature may have been commissioned around 1845, when his first extant letter to her begins with a formal salutation: "Miss Susan Wetherill." But the opening sentence betrays the power she already held over his heart: "I can scarcely say whether your letter gave me more pleasure or pain."[13]

Members of the established elite, the prominent Wetherill family emigrated from England in the late seventeenth century. They contributed to Philadelphia society as founders of the Free Quaker religious movement, which approved of bearing arms in support of the Revolution, and as pioneers in the combined fields of manufacturing and science.[14] Susan was the oldest daughter of John Wetherill and Susan Garrison. Her brother Edward was an active abolitionist, as was her sister Rebecca, a professional musician and vocalist who never married. A later miniature (Historical Society of Pennsylvania) by Cushman showing a transfixed Susan playing the harp suggests that she, too, had musical talent.

Inheriting wealth and an independent spirit, Susan resisted George's cautious but persistent pursuit. On November 19, 1847, he uncharacteristically blurted out, "When I met you this morning and found myself alone with you — I resolved to confess to you what has [been] pleading at my heart for a long, *long* time — That I *love* you *deeply tenderly wholly* — and have done so almost from the first of our acquaintance." When she did not respond as he hoped, he respectfully accepted a relationship on her terms, reluctantly defined by him as "the most perfect friendship."[15]

Along with their letters, miniatures negotiated the emotional distance between them. Knowing the romantic significance of receiving a miniature as a gift, Susan responded to his offer to paint her portrait: "I thank you but hope you will excuse me if I refuse to accept it." But by the summer of 1848 — when his salutation of "Dear Susan" had progressed to "My own dearest" — George wrote from his birthplace in Windham, Connecticut: "I received your picture on Tuesday and right glad I was to get it. I had no idea before that I could enjoy looking at a work of mine with so much relish — the truth is I began to realize,

that three hundred long miles separates us — and the want of those *little nothings* that you don't think worth mentioning but are *much* to me."[16]

Perhaps as long as five years after first limning her miniature, Cushman wrote to Susan Wetherill's father advising him of the "warm attachment" Cushman felt for Wetherill's daughter, her "full return" of his affections, and his urgent request for "*the sanction of your approval and consent to our union.*" George and Susan were married on October 31, 1849. Many years later, the Cushmans' daughter Alice remembered this miniature, probably made during the early years of her parents' courtship, being referred to at home as "Mama in the Black Dress."[17] In the age of photography, Cushman's miniatures of his wife still served as traditional love tokens and family heirlooms.

Because Cushman's patronage was confined largely to his family and friends, his career does not illuminate the standard reception of antebellum miniatures. The history of the prolific John Henry Brown does. Born in Lancaster, Pennsylvania, he began an apprenticeship in 1836 to the painter Arthur Armstrong (1798–1851) while working as a clerk in the Recorder's Office. In 1839 Brown established himself as a professional portraitist and sign painter, but in 1844 he began devoting himself exclusively to miniature painting, initially with enormous success. The following year he settled in Philadelphia, where he exhibited his miniatures frequently at the Pennsylvania Academy of Fine Arts and at the Artists' Fund Society until 1864.

The humble artist often found himself astonished at his backlog of commissions: "I am blessed beyond my deserts. As an Artist I believe myself much overrated. My least price now is one hundred dollars for a picture, however small. I have at present, at least two years work engaged, and have within the last four months refused about a years work. If God continues my good health, I will have abundant cause, to be Grateful for many mercies." In a major overview of American artists, an influential critic of the late nineteenth century not only called Brown one of the "best miniature painters in the country" but also marveled at his ability to be "constantly employed" at a time when miniature painting was being eclipsed by photography.[18]

Catherine Bohlen epitomizes his forceful portraits, which updated the tradition of miniature painting by borrowing elements from both oil painting and photography (fig. 146). Brown's portraits are particularly useful to an assessment of the antebellum demand for miniatures after the introduction of the daguerreotype because his career is better documented than that of most other artists who painted watercolor-on-ivory miniatures during this period. In fact, that documentation led to the correct identification of the sitter, who had originally been misidentified as Jane G. Bohlen in the auction catalogue that provided the only information available on the miniature.[19] This catalogue dated the miniature to 1849; however, when the portrait was removed from its locket for conservation treatment, the date 1850 was discovered inscribed on the ivory. Comparison of the artist's entries for that year in his journal and account book with evidence gleaned from genealogical research, city directories, and census records identified the sitter as Catherine, the twenty-year-old daughter of Jane G. and John Bohlen, a Philadelphia merchant born in Germany.

Catherine Bohlen is one of Brown's most exacting likenesses, painted using a saliva-working technique similar to Cushman's to control and blend strokes and create a rich array of contrasting textures and colors on a small scale. Seated in profile, the homely yet imposing sitter wears a blue brocade dress with lace pelerine and cameo at her corsage and an ermine stole draped over her shoulders. She holds a bouquet in a silver container called a tussy-mussy. Brown achieves a subtle transcription of surface texture, especially in the exquisitely defined lace. As a miniaturist who valued sharp detail, he must have empathized with the skilled hand that fashioned its delicate tracery.

The complexity of the composition, poetic mood, and striking color contrasts rival full-size oil portraits. Brown's emphasis on the sitter's profile and the textures of lace and brocade recall Renaissance portraiture, giving Catherine's vividly individualistic profile a hieratic quality. He posed her seated with one arm resting on a table and the other on her lap, and combined a frontal body with a profile head to lend drama to the characterization. The tension of the pose and array of textures suggest Brown's familiarity with the portraiture of the French

neoclassical painter Jean-Auguste-Dominique Ingres. Brown's choice of props may have been familiar to his Philadelphia clientele from the paintings of the much sought-after portraitist Sarah Miriam Peale, who exhibited at the Pennsylvania Academy of the Fine Arts annual exhibitions until 1831 and frequently posed her female sitters wearing an ermine stole.[20]

Catherine's elaborate afternoon attire is fairly expensive, without being au courant, although the blue color of her dress was popular around 1850. Ermine, though still desirable, had been at the height of fashion in the early to mid-1840s. Her conspicuous hair, brought down along the face, back under the ears, and up to meet the knot at the nape of her neck in a Victorian loop, was most popular in the mid-1840s.[21] Brown may have modeled this miniature on an earlier painting or photograph, or artist and sitter may have selected finery not quite of the moment for dramatic effect.

The sitter herself might have wanted a miniature that imitated the oil portrait tradition. She may even have collaborated with the artist in the choice of pose and props, for Catherine Bohlen was knowledgeable about art. "Miss Bohlen" is regularly listed as the owner in sources relating to family art collections exhibited at various institutions and charity events in Philadelphia at least into the 1860s. The Bohlen family collections included paintings by European, primarily French, artists as well as leading American landscapists, including Asher B. Durand, Sanford Robinson Gifford, Thomas Moran, and William Trost Richards, and the American genre, portrait, and floral painter George Cochran Lambdin.[22] At mid-century, many painters matched the tints and tones of flowers in their portraits to the complexions and clothing of the young woman being depicted. Although his sitter is not beautiful, Brown similarly compares feminine and floral charm in this miniature, for Catherine holds a small bouquet — a hint of romance.

Catherine Bohlen illustrates the effects of not only oil painting but also photography on miniature painting in the antebellum period. For at the same time that Brown refers to the poetic aspects of the oil painting tradition, he also captures the presence of a flesh-and-blood woman, recording her plain features and recessed chin with a frankness often reserved for the new medium of photography.

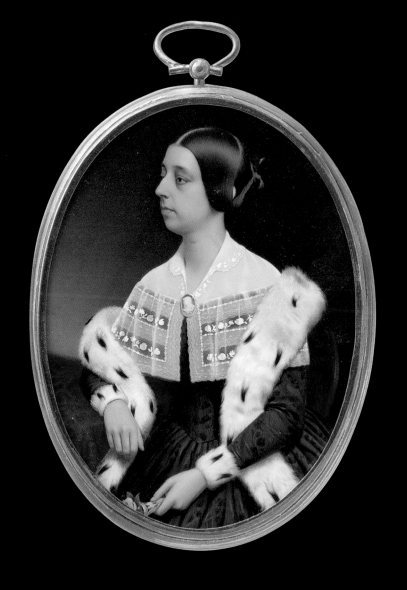

146. John Henry Brown, *Catherine Bohlen*, 1850, Yale.

Even when the artist painted directly and exclusively from life, as he may have done in this instance, the daguerreotype had crucial effects on his portraiture. In *Catherine Bohlen*, he achieved considerable success painting in a painstaking manner that imitated and even rivaled photography in its attention to detail.

Miniature production declined in the 1820s and dropped even more significantly after the introduction of the daguerreotype, yet some artists — notably Brown — continued to produce miniatures for a large clientele late into the nineteenth century. Philadelphians had many portrait options in 1850, including oil paintings by leading portraitists like Thomas Sully, John Neagle, and Henry Inman, and daguerreotypes by leading studios, including that of M. A. Root, one of the best known in the nation. Like Sully, who advertised paintings from daguerreotypes,[23] Brown readily acknowledged his use of photography, citing Root's portraits as a specific source, and later ambrotypes by others as models for some of his portrait miniatures.

By 1850 miniatures often were painted on rectangular ivory supports and housed in lidded cases like daguerreotypes; however, the extant miniatures by Brown reveal that his clients also remained loyal to the past by choosing the traditional oval format set into a locket. The oval miniature of Catherine Bohlen appears to have been slightly trimmed, probably to fit the locket it is now housed in, which dates from the 1910s to 1920s, when the portrait still belonged to a member of the Bohlen family.[24] Decades after it was commissioned, therefore, when rehousing the miniature, the sitter's descendants decided to retain the associations of a now venerable artistic form, the wearable portrait miniature.

Ironically, *Catherine Bohlen*, executed in Brown's largest and most expensive size, is too heavy to wear comfortably as a locket. The vibrancy of its color, which shows almost no signs of fading from exposure to light, suggests that it was not worn but rather secreted away for much of its history. In fact, the locket rests in the fitted compartment of a hinged leather case. In that sense, the portrait functioned like a daguerreotype, kept hidden in a closed case and revealed only to those related by friendship or kinship.

Miniatures, however, usually were substantially more expensive than daguerreotypes. In 1855 a daguerreotype with hand coloring might cost from

$3 to $6, although daguerreotype prices, not unlike those of miniatures, varied widely, depending upon the photographer, size, and degree of embellishment. Between 1846 and 1850, Brown's miniatures ranged in price from $50 to $218; after 1850 he charged up to $500, although rarely more than $250.[25]

Catherine Bohlen and other clients painted by Brown reflect a widening of the patronage for miniatures from the time of colonial artists like Charles Willson Peale and John Singleton Copley, who generally painted portraits of the American aristocracy. In this private portrait, the sitter projects an awareness of her public position in Philadelphia, a position she cultivated through the exhibition of works of art from her collection in support of charitable causes. The Bohlens were not members of Philadelphia's established elite but rather of the new elite, the growing merchant community.

From existing primary sources, it can be deduced that her father, John Bohlen, was born in Germany and became an eminent shipping merchant and importer in Philadelphia.[26] He may have been involved in business with Henry Bohlen, a relative who lived on the same street and is described in various sources as a wealthy liquor merchant. Given that the family cultivated an interest in art, they may have possessed miniature portraits of earlier family members.

Brown's journal and account book reveal that Catherine's portrait was one of many painted by him of members of the extended Bohlen family in 1849–50. Among them, Brown records painting a miniature portrait of Mrs. John Bohlen, Catherine's mother, whose first name was Jane. He began a "large size picture" of her on March 2, 1849, and although he was interrupted on March 16 "in consequence of Mrs Bohlen not being able to sit, on account of the death of a nephew's child," he "finished" it the following day. The delay was caused by the death on March 15 of Henry Bohl Bohlen, the fifteen-year-old son of Henry Bohlen, the liquor merchant; Brown began painting a posthumous portrait of the teenager "from a daguerreotype" on April 7 and completed it in nine days. Henry's death was followed a year later by the death of John, Jane's husband and Catherine's father, on March 11, 1850; Brown painted his portrait in July.[27]

Perhaps these recent deaths in the family motivated someone who loved Catherine to preserve her *living* likeness in the precious medium of watercolor

Detail of figure 146. In *Catherine Bohlen,* Brown achieves a subtle transcription of surface texture, especially in the exquisitely defined lace. As a miniaturist who valued sharp detail, he must have empathized with the skilled hand that fashioned its delicate tracery.

on ivory. In this instance, Brown's achievement and fee for a Bohlen family portrait were hard won: his journal entries reveal that he spent nearly an entire month, November 2–27, painting this exceptionally convincing likeness. Yet Catherine, or whoever commissioned her portrait, was still not satisfied, for on December 2 Brown made "a slight alteration." Catherine's portrait, which is the same size but more detailed and compositionally challenging than that of her mother, took him nearly twice as long to paint. He charged accordingly: *Catherine Bohlen* cost $210; *Mrs. John Bohlen* only $138.

Census records for 1850 confirm that when Brown painted Catherine, she was living with her newly widowed mother and brother John, Jr., along with three domestic servants from Ireland. The census taken ten years later reveals changes in the family structure. Jane's name, which disappeared from city directories in 1855, is not recorded in the 1860 census, indicating that she had died in the intervening years. John, who now had his own household, is listed first, with his profession specified as Attorney at Law, his real estate valued at $60,000 and his personal estate at $40,000. Ann Bohlen, most likely John's wife, is listed directly after him — the place Catherine's name had held in the 1850 census. But a decade later, Catherine's name is buried among those of the now much more numerous domestic servants.[28] This placement of her name poignantly suggests the diminished status over time of unmarried women like Catherine. If the miniature of her by Brown, with its lace-and-roses allusions to romance, had been commissioned because of a love interest, the relationship had not led to marriage.

A decade after he painted this tour-de-force, Brown's level of patronage began to decline. In his journal and account book, he recorded his growing anxiety about reduced commissions. He attributed his situation to the impending war and the growing preference for photographic images. In October 1864, he joined the already existing photography practice of Frederick August Wenderoth and William Curtis Taylor, forming Wenderoth, Taylor, and Brown, located on Chestnut Street in Philadelphia. Public enthusiasm for photography was dampened by its failure to render the world — and especially the human face — in color,

but the firm of Wenderoth, Taylor, and Brown was among the pioneers in overcoming this obstacle.

In 1875 Taylor defended the role of those who added brushwork to photography: "In retouching a negative and in painting over a photograph the artists... see before them not what is but what is meant to be." According to practical handbooks like "How to Paint Photographs," the enterprising Wenderoth had introduced the Ivorytype, "a photograph, colored and sealed upon plate-glass," to America in 1855. The firm also produced opalotypes and in 1868 introduced "the New Crayon," both forms of photographic images that Brown then tinted with washes of color in imitation of miniature portraits. Brown confided in his journal in 1876 that "after a lapse of 12 years, I have returned to miniature painting on ivory." In fact, during the intervening years the firm had continued to offer their clientele a choice of media by advertising "Fine Photographs and Paintings of every Description."[29]

Brown's career as a miniature painter was revived in the 1870s: he exhibited at the National Academy in 1875, received a medal for the miniatures he showed at the Centennial Exhibition in 1876, and continued to paint miniatures until 1890. He owed his popularity to an uncanny ability to imitate photography in his attention to detail and high degree of contrast, yet also to imitate oil painting in his brilliant, opaque colors and complex compositions, all while still remaining true to the miniature tradition in feeling and format. He embraced the new photographic medium by acknowledging his debt to daguerreotypes and later ambrotypes for many of his miniature portraits, including one of Abraham Lincoln in 1860.[30]

A scrutiny of his journal and account book reveals that many of his miniatures painted after photographs were posthumous portraits, reflecting an increased demand for mourning miniatures around mid-century. He painted miniatures for a broad clientele, including members of Philadelphia's established as well as new merchant elite and others who traveled to the city from considerable distances for his services. In addition to Lincoln, patrons included such prominent sitters as James Buchanan and Stonewall Jackson. For clients

demanding both the traditional and contemporary, Brown's distinctive miniatures seamlessly combined the longevity of the miniature format, and its associations with social refinement, with the popular aesthetics of photography.

Like Brown, many miniaturists flirted with the profession of photographer; unlike him, many of them never returned to limning in watercolor on ivory. In 1856 a New York City art critic lamented the fate of the miniature, its once luminous light overpowered by sun-drawn pictures: "Among miniature painters, the photographic art has had the effect to benefit and signalize the few, while it annihilates the many. In fact, the Sun is so soulless an artist that a revival of the old, gentle art in question may be looked for ere long."[31]

That revival arrived at the turn of the century. Although many female miniaturists — from the pioneering Mary Roberts in the colonial era, through Anna Claypoole Peale, Sarah Goodridge, and Mary Way, to Mrs. Moses B. Russell in the antebellum period — had enriched the profession during its heyday, women now entered the field in far greater numbers. But their contributions, and those of their male colleagues, are beyond the scope of this book. However vital their art, the miniature as an emblem of love and loss no longer played an essential, exclusive role in American private life.

Photographic images had eclipsed the miniature as the primary means of expressing private relationships and perpetuating memory in portable form. In *The Camera and the Pencil*, published in 1864, Philadelphia's leading practitioner of the "heliographic art," M. A. Root, described the daguerreotype's role in words that once could have applied to the miniature, with the significant difference of wider accessibility through lower cost:

> In the order of nature, families are dispersed, by death or other causes; friends are severed; and the "old familiar faces" are no longer seen in our daily haunts. By heliography, our loved ones, dead or distant; our friends or acquaintances, however far removed, are retained within daily and hourly vision. To what extent domestic and social affections and sentiments are conserved and perpetuated by these "shadows" of the loved and valued originals, every one may judge. The cheapness of these pictures brings them within reach, substantially, of all.[32]

The more democratic daguerreotype shared with the miniature an emotional preciousness because it was a positive image that could not be readily duplicated. Over time, however, the reproducibility of the photograph from a negative, as opposed to the singularity of the painted portrait miniature, would diminish its power as an intimate keepsake.

The very function of miniatures as familial and loving tokens frustrates an evaluation of their importance in the evolution of portraiture, material culture, and social history in America. Small, private, fragile, and portable, miniatures were easily damaged or lost as they accompanied family members through the dislocations of revolution, immigration, migration, the Civil War, and the passage of time. Looking at an exhibition of miniatures in 1934, a reviewer observed: "Most of them have had adventurous existences, surviving war and fire and flood, treasured, but sharing the family fortunes almost like individuals and possibly all the more loved for any resulting blemish."[33]

People no longer commemorate friendship, seduction, betrothal, marriage, or the death of a loved one with portrait and mourning miniatures. During a time of high birth and death rates, these tiny objects expressed what has become inexpressible at the beginning of the twenty-first century, when medical advances and institutions push an intimate understanding of life and death out of the home, and out of common discourse.

The miniature's language of sentiment belonged to an age that at first seems incomprehensible to skeptical modern minds. But once the private stories behind the miniatures are known, the loves and losses they honor strike a familiar chord, in part because the heyday of the American miniature coincides with the advent of the modern family. Families have changed, but the hopes that bind them and the hurts that tear them apart remain the same. Holding these tokens of undying devotion today elicits a kinship with both giver and receiver, and a longing for such potent, tangible emblems to mark life's passages.

NOTES

Frequently Cited Sources

Aiken 1995
Carol Aiken, "The Emergence of the Portrait Miniature in New England," in Peter Benes, ed., *Painting and Portrait Making in the American Northeast*, The Dublin Seminar for New England Folklife, Annual Proceedings, vol. 19 (Boston: Boston University, 1995), 30–45.

Bolton 1921
Theodore Bolton, *Early American Portrait Painters in Miniature* (New York: Frederic Fairchild Sherman, 1921).

Bolton-Smith 1984
Robin Bolton-Smith, *Portrait Miniatures in the National Museum of American Art* (Chicago: University of Chicago Press, 1984).

Deutsch 1999
Davida Tenenbaum Deutsch, "Jewelry for Mourning, Love, and Fancy, 1770–1830," *Antiques* 155 (April 1999): 566–75.

Dunlap 1834
William Dunlap, *History of the Rise and Progress of the Arts of Design in the United States*, 2 vols. (New York: George P. Scott, 1834).

Foskett 1987
Daphne Foskett, *Miniatures: A Dictionary and Guide* (Woodbridge, Suffolk: Antique Collectors Club, 1987).

IGI
International Genealogical Index (Salt Lake City, Utah: Genealogical Department of the Church of Latter Day Saints). On the web at www.familysearch.com.

Johnson 1990
Dale T. Johnson, *American Portrait Miniatures in the Manney Collection*, exh. cat. (New York: Metropolitan Museum of Art, 1990).

Miller, Hart, and Appel 1983
Lillian B. Miller, Sidney Hart, and Toby A. Appel, eds., *The Selected Papers of Charles Willson Peale and His Family*, vol. 1: *Charles Willson Peale: Artist in Revolutionary America, 1735–1791* (New Haven: Yale University Press, 1983).

Miller, Hart, and Ward 1988
Lillian B. Miller, Sidney Hart, and David C. Ward, eds., *The Selected Papers of Charles Willson Peale and His Family*, vol. 2: *Charles Willson Peale: The Artist as Museum Keeper, 1791–1810*, pts. 1 and 2 (New Haven: Yale University Press, 1988).

Miller, Hart, Ward, and Emerick 1992
Lillian B. Miller, Sidney Hart, David C. Ward, and Rose S. Emerick, eds., *The Selected Papers of Charles Willson Peale and His Family*, vol. 3: *The Belfield Farm Years, 1810–1820* (New Haven: Yale University Press, 1992).

Rebora and Staiti 1995
Carrie Rebora and Paul Staiti, with Erica E. Hirshler, Theodore E. Stebbins, Jr., and Carol Troyen, with contributions by Morrison H. Heckscher, Aileen Ribeiro, and Marjorie Shelley, *John Singleton Copley in America*, exh. cat. (New York: Metropolitan Museum of Art, 1995).

Sellers 1952
Charles Coleman Sellers, *Portraits and Miniatures by Charles Willson Peale*, Transactions of the American Philosophical Society, vol. 42, pt. 1 (Philadelphia: American Philosophical Society, 1952).

Severens 1984
Martha R. Severens, *The Miniature Portrait Collection of the Carolina Art Association* (Charleston, S.C.: Gibbes Art Gallery, 1984).

Severens and Wyrick, Jr., 1983
Martha R. Severens and Charles L. Wyrick, Jr., eds., *Charles Fraser of Charleston: Essays on the Man, His Art, and His Times* (Charleston, S.C.: Carolina Art Association and Gibbes Art Gallery, 1983).

Stebbins, Jr., and Gorokhoff 1982

Theodore E. Stebbins, Jr., and Galina Gorokhoff, *A Checklist of American Paintings at Yale University* (New Haven: Yale University Art Gallery, 1982).

Strickler 1989

Susan Strickler, assisted by Marianne E. Gibson, *American Portrait Miniatures: The Worcester Art Museum Collection* (Worcester, Mass.: Worcester Art Museum, 1989).

Tolman 1958

Ruel Pardee Tolman, *The Life and Works of Edward Greene Malbone, 1777–1807* (New York: New-York Historical Society, 1958).

Verplanck 1996

Anne Ayer Verplanck, "Facing Philadelphia: The Social Functions of Silhouettes, Miniatures, and Daguerreotypes, 1760–1860" (Ph.D. diss., College of William and Mary, 1996).

Wehle 1927

Harry B. Wehle, *American Miniatures, 1730–1850* (Garden City, N.Y.: Garden City Publishing, 1927).

Introduction

1. Graham Reynolds, with the assistance of Katherine Baetjer, *European Miniatures in the Metropolitan Museum of Art* (New York: Metropolitan Museum of Art, 1996), 67.

2. Hilliard's treatises on the miniature found their way to the New World, where they may have served as instruction manuals. See Jonathan L. Fairbanks, "Portrait Painting in Seventeenth-Century Boston: Its History, Methods, and Materials," in *New England Begins: The Seventeenth Century* (Boston: Museum of Fine Arts, 1982), 3:413–14.

3. The miniature portrayed in *Elizabeth Eggington* (fig. 1) is discussed in Aiken 1995, 37–39. Among the English miniatures documented as being in the colonies are a watercolor-on-vellum portrait of Puritan leader John

Winthrop (Massachusetts Historical Society, Boston) and an oil-on-copper portrait of Daniel Oliver, Jr., sent from London in 1727 to his parents in Boston, illustrated in Andrew Oliver, *Faces of a Family: An Illustrated Catalogue of Portraits . . . Made Between 1727 and 1850* (Portland, Maine, 1960), no. 4. For comprehensive histories of the English miniature, see Katherine Coombs, *The Portrait Miniature in England* (London: Victoria and Albert Publications, 1998); John Murdoch et al, *The English Miniature* (New Haven: Yale University Press, 1981); Graham Reynolds, *English Portrait Miniatures*, rev. ed. (New York: Cambridge University Press, 1988); Roy Strong, *The English Icon: Elizabethan and Jacobean Portraiture* (London: Routledge and Kegan Paul, 1969); and Strong, *Artists of the Tudor Court: The Portrait Miniature Rediscovered, 1520–1620* (London: Victoria and Albert Museum, 1983).

4. On Mary Roberts, see Richard H. Saunders and Ellen G. Miles, *American Colonial Portraits: 1700–1776*, exh. cat. (Washington, D.C.: Smithsonian Institution Press for the National Portrait Gallery, 1987), p. 163, cat. 40. For a discussion of the origins of the American portrait miniature, see Aiken 1995, 30–45. On the general history of American miniatures, see Robin Bolton-Smith and Dale T. Johnson, "The Miniature in America," *Antiques* 138 (November 1990): 1042–54; Johnson 1990, 13–26; and Strickler 1989, 13–19.

5. Although they have not specifically focused on miniatures, many scholars have perceptively discussed the demand for portraiture in the late eighteenth century among the upper and upper-middle classes in the context of an expanding market economy. See, for example, Rebora and Staiti 1995; Timothy H. Breen, "The Meaning of 'Likeness': American Portrait Painting in an Eighteenth-Century Consumer Society," *Word and Image* 6 (October–December 1990): 325–30; Jack Larkin, Elizabeth Mankin

Kornhauser, and David Jaffee, *Meet Your Neighbors: New England Portraits, Painters, and Society, 1790–1850* (Sturbridge, Mass.: Old Sturbridge Village, 1992; distributed by University of Massachusetts Press, Amherst); and Margaretta M. Lovell, "Painters and Their Customers: Aspects of Art and Money in Eighteenth-Century America," in *Of Consuming Interest: The Style of Life in the Eighteenth Century*, ed. Cary Carson et al. (Charlottesville: University Press of Virginia, 1994), 284–306. I am also indebted to the application of this approach to the demand for miniatures in Philadelphia, in Verplanck 1996. The social groups listed reflect an ongoing database study of the collection at Yale University and is therefore not statistically a reflection of a broad sampling of American miniatures. It does, however, appear to be generally consistent with the biographies of sitters published in miniatures collections catalogues such as Severens 1984, Strickler 1989, and Johnson 1990.

6. Lawrence Stone, *Family, Sex and Marriage in England, 1500–1800* (London: Weidenfeld and Nicolson, 1977), cited in Margaretta M. Lovell, "Reading Eighteenth-Century American Family Portraits: Social Images and Self-Images," *Winterthur Portfolio* 22 (Winter 1987): 251–52. I am indebted to Lovell's application of social history to large-scale portraiture. On changing family life, also see Nancy F. Cott, *The Bonds of Womanhood: "Women's Sphere" in New England, 1780–1815* (New Haven: Yale University Press, 1977); and Steven Mintz and Susan Kellogg, *Domestic Revolutions: A Social History of American Family Life* (New York: Free Press, 1988).

7. On the technical process of painting miniatures on ivory, see Carol Aiken, "Materials and Techniques of the American Portrait Miniature," in Johnson 1990, 27–37.

8. Contemporary advertisements offered hairwork with natural or dissolved hair. "Natural" hair was used in sentimental designs that have small sections of chopped hair sprinkled over wet paint or strands worked into designs as part of the painted scene or decoratively arranged. But "dissolved" hair was for a time more difficult to define because, in fact, hair, however finely chopped, does not dissolve; rather it forms a suspension of particles in a liquid. Intrigued by the problem, Ruel Pardee Tolman performed an experiment that he described in two brief articles: "Human Hair as a Pigment," *Antiques* 8 (December 1925): 353, and "A Document on Hair Painting," *Antiques* 17 (May 1930): 231. Conservator Katherine G. Eirk recently repeated Tolman's experiment, demonstrating that hair, macerated in distilled water in a mortar with a pestle, produces a "dirty water" that can then be mixed with gum arabic to produce a pigment.

9. Charles Fraser, remarking on the power of miniatures by his colleague Edward Greene Malbone in *Charleston Times*, May 27, 1807; cited in Tolman 1958, 62.

Chapter 1: Public Display of Private Devotion

1. Ellen G. Miles identified the miniature in Richard H. Saunders and Ellen G. Miles, *American Colonial Portraits: 1700–1776*, exh. cat. (Washington, D.C.: Smithsonian Institution Press for the National Portrait Gallery, 1987), p. 83, cat. 4.

2. Although miniatures are not mentioned, Karin Calvert discusses the trend toward gentlemanly understatement in "The Function of Fashion in Eighteenth-Century America," in *Of Consuming Interest: The Style of Life in the Eighteenth Century*, ed. Cary Carson et al. (Charlottesville: University Press of Virginia, 1994), 283. Male artists, however, were occasionally depicted wearing miniatures openly; see, for example, Jonathan Adams Bartlett, *Self-Portrait*, probably 1841 (Abby Aldrich Rockefeller Folk Art Museum, Williamsburg, Virginia).

3. The portrait of Katherine Grey is attributed to Levina Teerlinc. Elizabeth I imprisoned Grey, who had a claim to the throne, for marrying Edward Seymour. The miniature shows her wearing his portrait and holding their child, a focus for attempts to usurp Elizabeth. See Katherine Coombs, *The Portrait Miniature in England* (London: Victoria and Albert Publications, 1998), 26. For the miniature as a fashion accessory in England, see Ann Sumner, "The Changing Role of the Portrait Miniature," in Ann Sumner and Richard Walker, *Secret Passion to Noble Fashion: The World of the Portrait Miniature* (Bath: Holburne Museum of Art, 1999), 11–35.

4. On the miniature in Elizabethan court culture, see Patricia Fumerton, "'Secret Arts': Elizabethan Miniatures and Sonnets," *Representations* 15 (Summer 1986): 57–97.

5. Painted by Johann Zoffany in 1771, *Queen Charlotte* (Windsor Castle) was engraved in 1772 by R. Houston "from the Original Picture in the Possession of his Majesty" and by R. Laurie with a simpler background: Oliver Millar, *The Later Georgian Pictures in the Collection of Her Majesty the Queen* (London: Phaidon, 1969), cat. 1196.

6. The miniatures (location unknown; cost 8 guineas each) are itemized in the Peale-Stewart Bill of Sale, reproduced in Sellers 1952, 201.

7. See Bernard Lens's *Sarah Churchill, Duchess of Marlborough*, 1720 (Victoria and Albert Museum, London), which probably was a copy after a still earlier painting; Ann Sumner and Richard Walker, *Secret Passion to Noble Fashion: The World of the Portrait Miniature* (Bath: Holburne Museum of Art, 1999), 22.

8. Perhaps subtly suggesting her new husband's future role as father, the miniature of Walter Stewart appears in front of his wife's belly, directly to the left of the apples associated with sexuality and fertility through the biblical story of Eve. The Stewarts did indeed have chil-

dren: George Washington was godfather to their oldest son and gave their daughter Anna away in marriage to a relative of Alexander Hamilton.

9. Will of Dr. Hezekiah Beardsley and codicils, 1790, Connecticut State Library, cited in Christine Skeeles Schloss, *The Beardsley Limner and Some Contemporaries: Revolutionary Portraiture in New England, 1785–1805* (Williamsburg, Va.: Colonial Williamsburg Foundation, 1972), 23. *Dr. and Mrs. Hezekiah Beardsley* are discussed on 19–23. The Beardsley Limner, an unidentified artist named after the sitters in the portraits at Yale, was active in New England after the Revolution. Stylistically related works were first attributed to him in 1957 by Nina Fletcher Little in "Little-Known Connecticut Artists, 1790–1810," *Connecticut Historical Society Bulletin* 22 (October 1957): 99–100.

10. John Adams to Benjamin Rush, quoted in John A. Schutz and Douglas Adair, eds., *The Spur of Fame: Dialogues of John Adams and Benjamin Rush, 1805–1813* (San Marino, Calif.: Huntington Library, 1966), 76. For similar sentiments expressed by Adams as early as 1778, see Charles F. Adams, ed., *The Works of John Adams* (Boston: Little, Brown, 1851), 3:171. On early American parlor gardens, see Rudy J. Favretti, *Early New England Gardens, 1620–1840*, 2d ed. (Sturbridge, Mass.: Old Sturbridge Village, 1966), 9–11, as discussed in Schloss, *Beardsley Limner*, 23.

11. Jedidiah Morse, *American Geography; or, A View of the Present Situation of the United States of America* (Elizabeth, N.J., 1789), 218–19; Morse sees New England, particularly his native Connecticut, as the best "garden" for the growth of republican government.

12. For a discussion of *Orlando Furioso* to which I am indebted, see Rensselaer W. Lee, *Names on Trees: Ariosto into Art* (Princeton: Princeton University Press, 1975). On page 76, Lee reproduces Fragonard's *Chiffre d'amour*

(also called *The Souvenir*) (Wallace Collection, London), which, like the miniature but without overt reference to a literary source, shows a young lady accompanied by a dog, carving in a tree. The fanciful dress of the lady in figure 17 alludes to classical sources without any overt literary reference. The unidentified miniaturist may have been familiar with numerous pictorial variations, among them Joshua Reynolds's *Mrs. Lloyd* (private collection), a widely copied painting of the subject in fanciful dress carving her new husband's name in a tree. For a discussion of this popular painting and possible sources, including Shakespeare's *As You Like It*, see Algernon Graves and William Vine Cronin, *A History of the Works of Sir Joshua Reynolds, P.R.A.* (London: Henry Graves, 1899), 2: cat. 103.

13. Victoria and Albert Museum, London, 970-1888, described in Shirley Bury, *An Introduction to Sentimental Jewellery* (London: HMSO, 1985), p. 19, fig. 13a.

14. On their deaths, see Schloss, *The Beardsley Limner*, 20, 23.

15. In the possibly biased view of a Peale descendant and scholar, Mary Tilghman would have married Peale if her wealthy family had accepted a union below her social station; see Sellers 1952, p. 21, cat. 867.

16. For insight into how this social change manifested itself in full-scale portraiture, see Karin Calvert, "Children in American Family Portraiture, 1670 to 1810," *William and Mary Quarterly*, 3d ser., 39 (January 1982): 87–113; and Margaretta M. Lovell, "Reading Eighteenth-Century American Family Portraits: Social Images and Self-Images," *Winterthur Portfolio* 22 (Winter 1987): 243–64. On the social shift itself, see Philip J. Greven, Jr., *The Protestant Temperament: Patterns of Child-Rearing, Religious Experience and the Self in Early America* (New York: Knopf, 1977).

17. Charles Coleman Sellers suggests that the portrait is of the mother in "The Portrait of a Little Lady, Charles Willson Peale's *Henrietta Maria Bordley*," in Lillian B. Miller and David C. Ward, eds., *New Perspectives on Charles Willson Peale* (Pittsburgh: University of Pittsburgh Press, 1991), 87. For adult women wearing concealed miniatures, see, for example, *Mrs. Charles Ridgely* and *Mrs. Thomas Bartow* in Sellers 1952, 286, 288.

Chapter 2: The First American Miniaturists

1. Excerpt from the journal of John Cook. In the American Arts Office files at Yale is a handwritten copy made in 1848 by Preston C. F. West of a transcription of the relevant portion of Cook's journal made by *his* son William Wallace Cook. A letter from Preston C. F. West's son-in-law Edward Willcox to Andre E. Rueff, Esq., dated Feb. 23, 1924, identifies Preston C. F. West as a collateral descendant of the artist and later owner of the miniature. A grammatically corrected version of this transcription of Cook's journal appears to be the basis for the entry on the miniature in the Pennsylvania Academy of Fine Arts exhibition catalogue of 1817, which is quoted in full in Helmut von Erffa and Allen Staley, *The Paintings of Benjamin West* (New Haven: Yale University Press, 1986), p. 450, cat. 524.

2. See von Erffa and Staley, *Paintings of Benjamin West*, p. 450, cat. 524.

3. Elizabeth Sandwith Drinker, *The Diary of Elizabeth Drinker: The Life Cycle of an Eighteenth-Century Woman*, ed. and abridged Elaine Forman Crane (Boston: Northeastern University Press, 1994), 17; *Publications of the Genealogical Society of Pennsylvania* 12 (March 1933): 33. Thanks to Dennis A. Carr for research assistance on the Steel[e] family.

4. See von Erffa and Staley, *Paintings of Benjamin West*, p. 450, cat. 524; and Karin Calvert,

"The Function of Fashion in Eighteenth-Century America," in *Of Consuming Interest: The Style of Life in the Eighteenth Century*, ed. Cary Carson et al. (Charlottesville: University Press of Virginia, 1994), 267, 269. Claudia Brush Kidwell noted in discussion with me that some artists and craftsmen did in fact wear wigs.

5. Sir Joshua Reynolds, *Discourses on Art*, ed. Robert R. Wark (San Marino, Calif.: Huntington Library, 1959), 43. For generously sharing information on the dress depicted in West's miniature and painting, my thanks to Claudia Brush Kidwell and Nancy Rexford.

6. Journal of John Cook. For conjecture on West's sources of inspiration for painting in watercolor on ivory, as opposed to Copley's reasons for painting in oil on copper, see Aiken 1995, 33–34; and Erica E. Hirshler, "Copley in Miniature," in Rebora and Staiti 1995, 122.

7. On the drawing and sketchbook, see Richard H. Saunders and Ellen G. Miles, *American Colonial Portraits: 1700–1776*, exh. cat. (Washington, D.C.: Smithsonian Institution Press for the National Portrait Gallery, 1987), 199; and William Sawitzky, "The American Work of Benjamin West," *Pennsylvania Magazine of History and Biography* 62 (October 1938): 438–39 and 448–49.

8. Letter from Edward Willcox to Andre E. Rueff, Esq., Feb. 23, 1924, American Arts Office.

9. I would like to acknowledge my profound debt to the dedicated teaching and formidable scholarship of Jules David Prown, Paul Mellon Professor of the History of Art Emeritus, who is an expert on innumerable subjects, including Peale's London training. This miniature was acquired for the Yale University Art Gallery in his honor on the occasion of his retirement. I thank Amy Kurtz for her research assistance on this miniature.

10. See Robert J. H. Janson-LaPalme, "Generous Marylanders: Paying for Peale's Study in England," in Lillian B. Miller and David C. Ward, eds., *New Perspectives on Charles Willson Peale* (Pittsburgh: University of Pittsburgh Press, 1991), 11–27. On Bordley, see Sellers 1952, 36.

Bordley's close association with the Peale family dated back to his own childhood. After his mother moved to London with her third husband, Edmund Jenings, Sr., Bordley lived with relatives in Chestertown, where Charles Willson Peale's father was the boy's schoolteacher. Sellers, a Peale family descendant, called Bordley Charles Willson Peale's "dearest friend. No other had so profound an influence upon his career." Family history no doubt gave Peale a sense of personal commitment to the children that affected his depiction of them. Also see his portrait of *Henrietta Maria Bordley* (1773, Honolulu Academy of Arts), which depicts the younger sister of Matthias and Thomas. In tribute to the Bordley family, Peale named one of his own daughters Margaret Bordley Peale.

11. See Charles Carroll, barrister, to Charles Willson Peale, Oct. 29, 1767, in Miller, Hart, and Appel 1983, 70–71.

12. To date, the building has not been identified; however, it has been determined that it is not a building at Eton, where the boys attended school. Background views of specific buildings of significance to the sitter can be found in European painting from the late fifteenth century onward, but mid-eighteenth century portraitists in America and England tended to prefer imaginary garden backdrops. However, this building, if identified, would probably prove to be meaningful to the sitters, since particular buildings in backgrounds of other portraits by Peale have often proved significant. For example, the presence of St. Paul's Cathedral in the background of the NMAA version of this miniature (fig. 29) refers to the boys' location in London and religious training.

13. Sellers 1952; Charles Willson Peale, "Autobiography," 38, *Peale Family Papers*, microfiche IIC/2, quoted in Saunders and Miles, *American Colonial Portraits*, p. 238, cat. 97. Peale's spelling, as of Jening's name, was even more individual than that of most eighteenth-century gentlemen.

14. For the NMAA miniature, see Saunders and Miles, *American Colonial Portraits*, pp. 282–83, cat. 97. Peale, who exhibited three miniatures and an oil portrait, was listed in the catalogue as a "Miniature Painter."

15. On costume, I consulted with Claudia Brush Kidwell.

16. Peale, quoted in Miller, Hart, and Appel 1983, 48. Peale does not state whose work he actually studied.

17. Jules David Prown asserts that Meyer is "the most likely candidate" in "Charles Willson Peale in London," in Miller and Ward, eds., *New Perspectives on Peale*, 35. See Katherine Coombs, *The Portrait Miniature in England* (London: Victoria and Albert Publications, 1998), 84–86 on Meyer, and 95–99 on the influence of Joshua Reynolds on portrait miniatures. The miniatures of other English artists also were becoming grander in scale and in compositional complexity, influenced by tastes in full-scale oil painting and in particular by the art of Reynolds, the leader of the new Royal Academy.

18. For the best discussion of the artistic influences Peale was exposed to in London, see Prown, "Charles Willson Peale in London," 29–50; letter from Peale to Bordley cited on 35; on the influence of Francis Cotes' paintings on Peale, see 43–44.

19. I am indebted to the excellent discussion of double portraits in Margaretta M. Lovell, "Reading Eighteenth-Century American Family Portraits: Social Images and Self-Images," *Winterthur Portfolio* 22 (Winter 1987): 247–52.

20. Charles Willson Peale to John Beale Bordley, London, March 1767, in Miller, Hart, and Appel 1983, 48.

21. See Philip J. Greven, Jr., *The Protestant Temperament: Patterns of Child-Rearing, Religious Experience and the Self in Early America* (New York: Knopf, 1977). In large-scale family portraits after 1760, playful children often disrupt the decorum evident in earlier portraiture; see Karin Calvert, "Children in American Family Portraiture, 1670 to 1810," *William and Mary Quarterly*, 3d ser., 39 (January 1982): 87–113.

22. West also showed the neoclassical masterpiece *Agrippina Landing at Brundisium with the Ashes of Germanicus* (Yale University Art Gallery) at that same exhibition; the picture led to King George's commission of *The Departure of Regulus*, for which Peale posed as Regulus. Peale's full-scale portraits that incorporate classical symbols, often alluding to the British and American ideals of liberty, include *William Pitt* (1778, Westmoreland County Museum, Montross, Virginia), *John Beale Bordley* (1770, National Gallery of Art, Washington, D.C.), various versions of *Washington at Princeton*, and *Conrad Alexandre Gérard* (1779, Independence National Historical Park, Philadelphia). Peale did not use classical symbols frequently because, as he explained to John Beale Bordley, he did not have the opportunity to become "well acquainted with the Gresian and Roman statues to be able to draw them at pleasure by memory" (Peale to Bordley, November 1772, in Miller, Hart, and Appel 1983, 126–28).

23. Miller, Hart, and Appel 1983, 101, 104–5.

24. Miller, Hart, and Appel 1983, 341. Peale charged £5.5.0 for miniatures and £5.5.0 for a "head-sized" oil portrait; he charged £22.1.0 for a "whole length" oil. See Sellers 1952, 19. On other details of Peale's technique, see Miller,

Hart, and Appel 1983, 150–51, 172; and Miller, Hart, and Appel 1983, 561–62.

25. Peale, quoted in Miller, Hart and Appel 1983, 387–88; Joseph Hewes to James Iredell, Philadelphia, Mar. 26, 1776, in Griffith McKee, *The Life and Correspondence of James Iredell* (New York: Appleton, 1857), 274–75, cited in Verplanck 1996, 50. For a study of Peale's patronage, especially among officers, see Verplanck 1996, 23–65.

26. Sellers 1952, p. 215, cat. 892 (as late as 1792, Peale was still attempting to collect the eight guineas Walton owed him for the miniature); Caldwell Delaney, "A Mobile Sextet," Bay House, Hollingers Island, Nov. 19, 1980, sent with a letter dated May 17, 1994, from Mary Harper Speed to Robin Jaffee Frank, American Arts Office files. Family lore dates the miniature to 1776, but it may have been painted "shortly before Walton left the Continental Congress in 1781," according to Edgar P. Richardson, Brooke Hindle, and Lillian B. Miller, *Charles Willson Peale and His World* (New York: Abrams, 1983), p. 53, cat. 22.

27. For an indispensable inventory of Copley's miniatures, a statistical analysis of Copley's sitters, and a contextual understanding of his larger achievement, see Jules David Prown, *John Singleton Copley*, 2 vols. (Cambridge: Harvard University Press, 1966). For an important evaluation of Copley's work in miniature, see Hirshler, "Copley in Miniature," 117–25. The idea that Copley may have followed local practices in choosing his medium is convincingly postulated in Aiken 1995, see especially 33–34, 41–45.

28. For Smibert's possible influence on Copley, see Aiken 1995, 41–42; Hirshler, "Copley in Miniature," 118–19; and Theresa Fairbanks, "Gold Discovered: John Singleton Copley's Portrait Miniatures on Copper," *Yale University Art Gallery Bulletin* (1999): 76. Smibert's oil-on-copper *Samuel Browne* of 1734 is the earliest

portrait miniature documented as having been painted in North America: see *The Notebooks of John Smibert*, with essays by Sir David Evans, John Kerslake, and Andrew Oliver (Boston: Massachusetts Historical Society, 1969), p. 92, cat. 101. Marks left by printmaking tools on at least half of the fourteen flat copper plates used by Copley for miniatures suggest that he sawed up his late stepfather's supply of copper plates, Fairbanks, "Gold Discovered," 75–79.

29. Analysis of paint samples by James Martin, director of Analytical Services and Research, Williamstown Art Conservation Center, Massachusetts; my gratitude to the Getty Grant Program for funding conservation-related research, and to Mark Aronson for overseeing the process. For insights into Copley's technique, my thanks to Theresa Fairbanks; see Fairbanks, "Gold Discovered," 75–91.

30. Journal of the House of Representatives of Massachusetts (Boston, 1755), Nov. 5, 1755. One version of *Andrew Oliver* remains in the Oliver family, another at the National Portrait Gallery, Smithsonian Institution. For Oliver's and Hutchinson's commissions, see *Sibley's Harvard Graduates, Biographical Sketches of Those Who Attended Harvard College*, with biographical and other notes by Clifford K. Shipton, 17 vols. (Boston: Massachusetts Historical Society, 1873–1975), 7:391. For research assistance on the Oliver-Hutchinson families, my thanks to Jennifer L. Roberts and Sarah K. Rich.

31. Aileen Ribeiro, "'The Whole Art of Dress': Costume in the Work of John Singleton Copley," in Rebora and Staiti 1995, 106.

32. *Sibley's Harvard Graduates*, 7:384, based on the "very ornate" account of Mrs. Oliver's character in the Boston *News-Letter*, Mar. 25, 1773.

33. The sitter's name has been given in many previous publications as Griselda, not Grizzel. However, the wedding announcement in *The Boston News-Letter*, Aug. 14, 1760, lists her as

Grizzel, not Griselda, as does her obituary in the same paper, Mar. 5, 1761, 1, and *Sibley's Harvard Graduates*, 11:323. The date of the miniature has been changed from c. 1758 (Stebbins, Jr., and Gorokhoff 1982, cat. 341M) to 1760 based on biographical research and a better understanding of Copley's technique. On costume, I consulted with Claudia Brush Kidwell.

34. *Sibley's Harvard Graduates*, 7:391–92.

35. Franklin Bowditch Dexter, ed., *Extracts from the Itineraries and Other Miscellanies of Ezra Stiles . . . with a Selection from His Correspondence* (New Haven: Yale University Press, 1916), 436; John Adams's diary entry for Aug. 15, 1765, cited in James Henry Stark, *The Loyalists of Massachusetts and the Other Side of the American Revolution* (Boston: Stark, 1910), 181.

36. Theresa Fairbanks, "Gold Discovered," 80, further speculates that the frame may have been made by Thomas Johnston of Boston. See also Andrew Oliver, *Faces of a Family: An Illustrated Catalogue of Portraits . . . Made Between 1727 and 1850* (Portland, Maine, 1960).

37. This information appeared in X-ray fluorescence analysis by Janice Carlson, Winterthur Museum Analytical Laboratory. I thank Patricia Kane for initiating this analysis, and the Getty Grant Program for funding conservation-related research. Katherine Eirk identified the printmaker's toolmarks on the support during a conservation examination. Revere often provided cases for Copley's miniatures, as evidenced by extant account books (Massachusetts Historical Society); see Prown, *John Singleton Copley*, 1:30n2; and Hirshler, "Copley in Miniature," 123, 192.

38. Description of Fayerweather's experience in Oxford in *Sibley's Harvard Graduates*, 11:224; information on these events in John B. Carney, "In Search of Fayerweather: The Fayerweather Family of Boston," *New England Historical and Genealogical Register* 44 (January, April, and

July 1990): 229–30. In her informed discussion, to which I am indebted, Erica Hirshler, "Copley in Miniature," p. 192, cat. 14, correctly observes that this miniature, previously dated c. 1758, must have been made after Fayerweather's return to New England in 1760. She dates it to c. 1763 to coincide with his marriage; however, the sitter's costume seems more appropriate to a professional occasion.

39. *Sibley's Harvard Graduates*, 9:228.

40. I am indebted to discussions of this work in Prown, *John Singleton Copley*, 1:68, 1:212; Johnson 1990, 98–100; Hirshler, "Copley in Miniature," 123, 252–53. For an excellent discussion of such gowns depicted in portraits see "Banyans and the Scholarly Image," in Brandon Brame Fortune with Deborah J. Warner, *Benjamin Franklin and His Friends: Portraying the Man of Science in Eighteenth-Century America* (Washington, D.C., and Philadelphia: Smithsonian, National Portrait Gallery in association with University of Pennsylvania Press, 1999), 51–65. Per my consultation with Claudia Brush Kidwell, a banyan is one of several types of informal housegown whose precise contemporary names may be confusing or subject to scholarly debate.

Chapter 3:
Miniatures and the Young Republic

1. On the Storers and Copley's commissions, see Jules David Prown, *John Singleton Copley*, 2 vols. (Cambridge: Harvard University Press, 1966), 1:192; Ezra Stiles, *Literary Diary* (New York, 1901), 1:380–81; and Rebora and Staiti 1995, cats. 26–27 and 41–44.

2. Notices in *Independent Chronicle* for December 1784 and February 17, 1785, cited in Bolton 1921, 38. Information on Dunkerley's military service is in Society of the Commonwealth, *Massachusetts Soldiers and Sailors of the Revolutionary War* (Boston: Wright and Potter, 1899), 54; Francis Heitman, *Historical Register of*

Officers of the Continental Army During the War of Independence (Baltimore: Genealogical Publication, 1982), 207. For Dunkerley's house rental see Robin Bolton-Smith and Dale T. Johnson, "The Miniature in America," *Antiques* 138 (November 1990): 1045. For research assistance on Dunkerley, my thanks to Sarah K. Rich.

3. Karin Calvert, "The Function of Fashion in Eighteenth-Century America," in *Of Consuming Interest: The Style of Life in the Eighteenth Century*, ed. Cary Carson et al. (Charlottesville: University Press of Virginia, 1994), 267, 269. On the use of the term banyan, see above, Chapter 2, note 40.

4. E. E. M. Quincy, *Memoir of the Life of Eliza Susan Morton Quincy* (Boston, 1861), 90; *Sibley's Harvard Graduates, Biographical Sketches of Those Who Attended Harvard College*, with biographical and other notes by Clifford K. Shipton, 17 vols. (Boston: Massachusetts Historical Society, 1873–1975), 12:209. The connotations of the banyan in defining Storer are discussed in Brandon Brame Fortune with Deborah J. Warner, *Benjamin Franklin and His Friends: Portraying the Man of Science in Eighteenth-Century America* (Washington, D.C., and Philadelphia: Smithsonian, National Portrait Gallery in association with University of Pennsylvania Press, 1999), 61.

5. Obituary, *Boston Evening Post*, Dec. 12, 1774, 3. On costume I consulted with Claudia Brush Kidwell and Nancy Rexford.

6. *Sibley's Harvard Graduates*, 12:211–12.

7. Quincy, *Memoir of Eliza Susan Morton Quincy*, 90. Ebenezer, b. 1754, married Eunice Brewster in 1780; Charles, b. 1761, a diplomat in Paris, remained single; Mary, b. 1758, married Seth Johnson in 1796. IGI and Malcolm Storer, *Annals of the Storer Family Together with Notes on the Ayrault Family* (Boston: Wright and Patter, 1972), 49–50.

8. The miniatures still belonged to a descendant, Mrs. William Walker Orr, when they were discussed in Hermann Warner Williams, Jr., "Two Early Pastels By Copley," *Bulletin of the Metropolitan Museum of Art* 36 (June 1941): 138. On dating hair bracelets, see, for example, the bracelet dated c. 1850 illustrated in Martha Gandy Fales, "Jewelry in Charleston," *Antiques* 138 (December 1990): 1227, and hair bracelets illustrated in C. Jeanne Bell, *Collector's Encyclopedia of Hairwork Jewelry: Identification and Values* (Paducah, Ky.: Collector Books, 1998), 154–78.

9. See Alexanna Speight, *The Lock of Hair: Its History, Ancient and Modern* (London: Goubaud and Son, 1872), preface and 84. My thanks to Katherine G. Eirk for this source, and for discussions on the dating of hair bracelets.

10. *The Independent Chronicle and the Universal Advertiser* [Boston], May 10, 1792: "On Thursday last, *Mrs. Elizabeth Hancock*, consort of Mr. *Nathaniel Hancock*, Miniature Painter.—Her Remains were respectfully entombed, on Tuesday afternoon." On Foster see the letter, circa 1940, from Ann Regina Foster, donor, in the files of the Peabody Essex Museum, Salem, Massachusetts. There are four Foster family miniatures, including a double-sided portrait of Nathaniel Foster and his children, by Hancock at the Peabody Essex Museum. My thanks to Kristen Weiss, Collections Manager, for generously sharing information on these miniatures.

11. See Bolton 1921, 148.

12. Notice in the *Independent Chronicle* [Boston], June 28, 1792; cited in Johnson 1990, 130; notices in *Virginia Gazette and Petersburg Intelligencer*, July 5, 1796; *Virginia Gazette and General Advertiser* [Richmond], Nov. 22, 1797, and Jan. 10, 1798; *Columbian Centinel* [Boston], June 8, 1799. The diary of a doctor residing in Exeter, New Hampshire, places the miniaturist there in 1801, and in Salem four years later, where he remained until 1809 (*Diary of William*

Bentley [Salem, Mass.: Essex Institute, 1911], 2:392, 3:250; cited in Bolton 1921, 79). In Salem, Hancock advertised for sitters from Mrs. Buffington's, Court Street, on Nov. 5, 1805; and in 1808 he advertised that he was about to depart (Henry Wyckoff Belknap, *Artists and Craftsmen of Essex County Massachusetts* [Salem, Mass.: Essex Institute, 1927], 10). That Susannah (Hiller) Foster was the sister of Joseph Hiller is noted in the card files of the Peabody Essex Museum, Salem, Massachusetts.

13. Jedidiah Morse, *Geography Made Easy. Being a Short, but Comprehensive System of that very Useful and Agreeable Science* (New Haven, Conn. 1784), dedication page. For research assistance on Jedidiah Morse, I thank Jennifer L. Roberts and Tavia Nyong'o Turkish.

14. Jedidiah Morse, *The American Universal Geography* (Boston, 1793), 8.

15. Martin Brückner, "Lessons in Geography: Maps, Spellers, and Other Grammars of Nationalism in the Early Republic," *American Quarterly* 51, no. 2 (1999): 326 (My thanks to Tavia Nyong'o Turkish for calling this article to my attention); Jedidiah Morse, *Universal Geography, or, A View of the Present State of All the Empires, Kingdoms, States and Republics in the Known World, and of the United States of America in Particular* (Boston: Isaiah Thomas and Ebenezer T. Andrews, 1796), A-4.

16. Benjamin Rush, *Thoughts upon Female Education, Accommodated to the Present State of Society, Manners, Government, in the United States of America* (Philadelphia: Prichard and Hall, 1787), 9. Sewing, an accomplishment deemed essential for all women, was integrally intertwined with geography in the early republic. Artifacts from the period attest that young ladies sewed images of maps and globes on silk, linen, or wool, simultaneously demonstrating their skill in embroidery and their knowledge of geography. Their accomplishments, fashioned

from expensive materials, hung in homes as testimonials to their education and their family's prosperity. See Betty Ring, *Girlhood Embroidery: American Samplers and Pictorial Needlework 1650–1850* (New York: Knopf, 1993), esp. 312–17.

17. Jedidiah Morse, *Elements of Geography* (Boston, 1792), 121; Richard J. Moss, *The Life of Jedidiah Morse: A Station of Peculiar Exposure* (Knoxville: University of Tennessee Press, 1995), x–xi.

18. On Morse's career see Moss, *Life of Jedidiah Morse*, 49; and Franklin Bowditch Dexter, *Biographical Sketches of the Graduates of Yale College, with Annals of the College History*, 6 vols. (New York: Henry Holt, 1885–1912), 4:295–96. I am indebted to Moss for his discussion of Morse's conflicted identity in the context of the early republic. On costume, I consulted with Claudia Brush Kidwell.

19. Although widely remembered for his invention of the telegraph, Jedidiah and Elizabeth's son Samuel F. B. Morse — who had begun limning watercolor-on-vellum miniatures of his classmates at Yale for cigar money — aspired to be a painter in the grand manner, like West. After graduating from Yale and before traveling to Europe to study under West, Morse painted a family scene (c. 1810, watercolor on paper, National Museum of American History, Smithsonian Institution) showing the study of geography as integral to life in the Morse household. The globe takes center stage, with the patriarch towering above it, in a gathering that equates familial intimacy with education, much as Charles Willson Peale had done in his miniature *Matthias and Thomas Bordley* (figs. 29 and 30). The reverend's three sons listen as attentively to the learned patriarch's words as the young ladies do in Hancock's miniature. Elizabeth leans forward, her attention diverted from a sewing basket and scissors on the left in favor of the

globe in the center and her husband's geography book with extended map on the right.

20. Mather Byles, Jr., to the Rev. William Walter, June 19, 1777, quoted in John Hill Morgan, *A Sketch of the Life of John Ramage, Miniature Painter* (New York: New-York Historical Society, 1930), 6. For Morgan's speculations about Elizabeth Liddell, see 10.

21. Dunlap 1834, 1:226; Morgan, *Sketch of the Life of Ramage,* 33–44.

22. Dunlap 1834, 1:227.

23. Notice, *Royal Gazette,* Nov. 15, 1780, quoted in Rita Susswein Gottesman, comp., *The Arts and Crafts in New York, 1777–1799* (New York: New-York Historical Society, 1954), 16.

24. Notice, *Independent Journal: or, the General Advertiser,* Jan. 24, 1784, quoted in Gottesman, *Arts and Crafts in New York,* 16. For more on the "individualizing" of jewelry, see Deutsch 1999.

25. Ernest H. Crosby, "The Rutgers Family of New York," *New York Genealogical and Biographical Record* 17 (April 1886): 86. Anthony's brother Harmon G. Rutgers married Sarah, another daughter of Hugh Gaines.

26. The miniature is attributed to Ramage in Morgan, *Sketch of the Life of Ramage,* facing p. 25. But Alexander J. Wall, then librarian at the New-York Historical Society, stated in a letter dated Jan. 30, 1930, to John Hill Morgan at Yale, that the South Carolina Census of 1790 lists an Alexander Rose as living in Charleston. The miniature is now attributed to Henri on the basis of close examination and technical comparison by the author and Katherine G. Eirk to known works by Henri in other collections. For confirming the attribution, I thank Sarah Coffin and Elle Shushan. For access to objects in their care, my thanks to Angela Mack, Gibbes Museum of Art, Charleston, and Andrew Connors, National Museum of American Art, Smithsonian Institution. Costume dating is from my consultation with Claudia Brush Kidwell and

Nancy Rexford. *Mrs. Rose* is unsigned. This dates it to prior to July 26, 1793, when Henri declared in the *City Gazette and Daily Advertiser* that because he suspected someone was exhibiting inferior works in his name, he would in the future prick "two initials of his name (P.H.) with the year in a manner conspicuous enough to be noticed" (Severens 1984, quoted on p. 80); for stylistic comparison of *Mrs. Rose* to Henri's work, see especially colorplates 7, *Mrs. John Faucheraud Grimké,* and 81, *John Stanyarne.* The portrait was attributed to Ramage and dated circa 1780 in Stebbins, Jr., and Gorokhoff 1982, cat. 1215M.

27. Miniatures of Mr. and Mrs. Alexander Rose in the collection of the National Museum of American Art, Smithsonian Institution, formerly attributed to John Johnson by Theodore Bolton, independent of research at Yale, have been reattributed by Robin Bolton Smith to Pierre Henri; I thank Andrew Connors for sharing file information and for allowing me to examine these miniatures. *Margaret Rose,* a miniature of Alexander Rose's sister (Museum of Fine Arts, Boston), has a provenance similar to Yale's miniature, and also was attributed to Ramage. I attribute it to Henri based on technique; I thank Erica E. Hirshler for the opportunity to examine this miniature. Information on the Smith family is in the Jan. 30, 1930, letter from Wall to Morgan and *The South Carolina Historical and Genealogical Magazine* 3 (January 1902): 226. For the marriage of Alexander and Margaret Rose, see A. S. Salley, Jr., comp., *Marriage Notices in* The South-Carolina and American General Gazette *and in Its Successor* The Royal Gazette (Columbia, S.C.: State Company, 1914), 32. The letter of Rawlins Lowndes is reprinted in Walter J. Fraser, Jr., *Patriots, Pistols and Petticoats: "Poor Sinful Charles Town" During the American Revolution,* 2d ed. (Columbia: University of South Carolina Press, 1993), 110.

28. The engraved inscription on the reverse states: "Geo. Washington/A.D. 1785./Painted by Peal./Presented by Washington./to/→Anna Constable. 1785. . . ." However, Charles Coleman Sellers asserted that the presentation of the miniature by Washington is "belied by its resemblance to the earlier portraits and the fact that the General was not in Philadelphia in 1785" (Sellers 1952, p. 234, cat. 931). The date of 1785 given in the inscription accords with the general's uniform.

29. Attribution to Charles Willson Peale in "The Minutes of the Governing Board of the Art Gallery," Nov. 7, 1951, American Arts Office files. Sellers 1952, p. 234, cat. 931, attributed the portrait to Charles but did note the "stylized mouth" of James. Stebbins, Jr., and Gorokhoff 1982, cat. 1160M, list the artist as James Peale, an attribution confirmed by comparative technical examination of the miniatures of both artists by the author and Katherine G. Eirk.

30. Collection of Mr. and Mrs. E. G. Nicholson; Ramage also made duplicates. See Ellen G. Miles, *George and Martha Washington, Portraits from the Presidential Years*, exh. cat. (Washington, D.C., and Charlottesville: Smithsonian Institution, National Portrait Gallery, in association with the University Press of Virginia, 1999), 18–19.

31. James Madison to Thomas Jefferson, Dec. 8, 1788, in Julian P. Boyd, ed., *The Papers of Thomas Jefferson*, 27 vols. (Princeton: Princeton University Press, 1950–97), 15:340–41 (underlined in original). Many sources refer to the marquise as Moustier's sister, but she is called his "Belle-soeur," a term for sister-in-law, in Gilbert Chinard, *Trois Amitiés françaises de Jefferson d'après sa correspondance inédite avec Madame de Bréhan, Madame de Tessé et Madame de Comy* (Paris: Société d'Edition "Les Belles Lettres," 1927), p.13. See also Prosper Jean Levot, *Biographie bretonne* (1852–57; rpt. Geneva: Slatkine,

1971), s.v. "Bréhan, Bréhand, Bréhant." On the son, Amand-Louis-Fidèle, marquis de Bréhan (1770–1828), see *Dictionnaire de biographie française*, s.v. "Bréhan, Bréhand, ou Bréhant." Sources from the online catalogue of the Bibliothèque nationale française. For research assistance on Bréhan, my thanks to Amy Kurtz and Sarah K. Rich.

32. John Jay to Thomas Jefferson, Nov. 25, 1788, in *Jefferson Papers*, 15:291.

33. George Washington to comte de Moustier, Aug. 17, 1788, and Oct. 18, 1788, in *The Writings of George Washington; Being His Correspondence . . . with a Life of the Author*, by Jared Sparks (Boston: Russell, Shattuck, and Williams, and Hilliard, Gray, 1836), 417, 438.

34. Donald Jackson and Dorothy Twohig, eds., *The Diaries of George Washington*, 6 vols. (Charlottesville: University Press of Virginia, 1976–1979), 5:451.

35. Wendy C. Wick, *George Washington, an American Icon: The Eighteenth-Century Graphic Portraits* (Washington, D.C.: A Barra Foundation Book, 1982), 48–49, suggests Houdon and Wright as inspirations. Bréhan might have seen de Gault's work in exhibitions in the early 1780s; see Carlo Jeannerat, "De Gault et Gault de Saint-Germain," *Bulletin de la Société de l'Histoire de l'Art Français* (1935): 221–35.

36. Patricia Brady, ed., *George Washington's Beautiful Nelly: The Letters of Eleanor Parke Custis Lewis to Elizabeth Bordley Gibson, 1794–1851* (Columbia: University of South Carolina Press, 1991), 2–3. The date of the sitting is from C. H. Hart, "Original Portraits of Washington," *The Century* 21 (February 1892): 593.

37. Moustier to Washington, May 11, 1790, in Dorothy Twohig et al., eds., *The Papers of George Washington: Presidential Series*, 8 vols. to date (Charlottesville: University Press of Virginia, 1987–), 5:392; Washington to Mrs. Stewart, quoted, and "Miniature . . . exquisitely

drawn in grayish sepia by Madame de Brehan
... On bluish gray background" reproduced in
facsimile, in "Historical Sale, Portraits and Auto-
graphs, Revolutionary and Other Letters, the
Alexander Hamilton Family Papers," Stan V.
Henkels auction house, Philadelphia. Sale date:
May 15, 1931, catalogue 1454, lot A.

38. See Ezra P. Prentice, Jr., Trumbull descen-
dant, to Helen A. Cooper, Oct. 31, 1980, Ameri-
can Arts Office files.

39. On the dissemination through copies
of the "Lansdowne" and "Athenaeum" portraits,
named after their owners, see Wick, *George
Washington*, 58–63.

40. W. M. Horner, Jr., "William Russell Birch,
Versatile Craftsman," *Antiquarian* 14 (February
1930): 44.

41. Notice in *Pennsylvania Packet*, Oct. 28,
1794; *The Life of William Russell Birch, Enamel
Painter, Written By Himself*, Historical Society
of Pennsylvania, Philadelphia, quoted in Anne
Hollingsworth Wharton, *Salons Colonial and
Republican* (Philadelphia: Lippincott, 1900),
221–22. See also Horner, "William Russell
Birch," 44.

42. My thanks to Davida Tenenbaum Deutsch,
an authority on mourning and women's educa-
tion in early America, and on Folwell in particu-
lar, for confirming this attribution. See Deutsch,
"Washington Memorial Prints," *Antiques* 111
(February 1977): 324–31; Deutsch and Betty
Ring, "Homage to Washington in Needlework
and Prints," *Antiques* 119 (February 1981):
402–19, esp. pls. 11 and 12; Deutsch, "Samuel
Folwell of Philadelphia: An Artist for the
Needleworker," *Antiques* 119 (February 1981):
420–23; Eleanor H. Gustafson, ed., "Collectors'
Notes," *Antiques* 128 (September 1985): 526–27;
and Eleanor H. Gustafson, ed., "Collectors'
Notes," *Antiques* 155 (April 1999): 502–504.

43. I am indebted to Anita Schorsch, "A Key to
the Kingdom: The Iconography of a Mourning
Picture," *Winterthur Portfolio* 14 (Spring 1979):
41–71.

44. On costume, I consulted with Claudia
Brush Kidwell and Nancy Rexford.

45. Abigail Adams to Mary Cranch, June 28,
1789, in Stewart Mitchell, ed., *New Letters of
Abigail Adams, 1788–1801* (Boston: Houghton
Mifflin, 1947), 13.

46. Diary of John Pintard, quoted in Robert G.
Stewart, "Portraits of George and Martha Wash-
ington," *Antiques* 135 (February 1989): 34. On
the early history of these two miniatures, see
Harry Piers, *Robert Field: Portrait Painter in Oils,
Miniature and Water-Colours and Engraver* (New
York: Frederic Fairchild Sherman, 1927),
168–70.

47. Monody presented by Thomas Wignell,
True American, Dec. 24, 1799; discussed in rela-
tion to memorial prints, in Deutsch, "Washing-
ton Memorial Prints"; and Wick, *George Wash-
ington*, 140.

48. *Emblematic Devices with Appropriate Mottos
Collected by Samuel Fletcher* (London, 1810), 28.
Quoted and device reproduced in Deutsch 1999,
574. Similar devices and meanings are found in
earlier books. For a historical discussion of
inscriptions, iconography, and the history of
English love and mourning jewelry, see Shirley
Bury, *An Introduction to Sentimental Jewellery*
(London: HMSO, 1985); on Fletcher, see
pp. 9–10.

Chapter 4: "Not Lost but Gone Before"

1. Quoted in Alice K. Turner, *The History of
Hell* (San Diego, Calif.: Harcourt Brace, 1993),
123. Another famous visual precedent for the
figure of Death as a skeleton was the Dance of
Death, best remembered from Hans Holbein's
sixteenth-century interpretation, based on
medieval models. On English mourning slides,

see Shirley Bury, *An Introduction to Sentimental Jewellery* (London: HMSO, 1985), 36, and plates 3a,b,d.

2. Francis G. Walett, ed., "The Diary of Ebenezer Parkman," *Proceedings of the American Antiquarian Society*, 72 (part 1, 1962), on infant death see 31, 33, 36, 50. Quoted and discussed in the context of changing attitudes toward infant death in Nancy Schrom Dye and Daniel Blake Smith, "Mother Love and Infant Death, 1750–1920," *Journal of American History* 73 (September 1986), 332. On the ring for John Brovort Hicks, see Peter J. Bohan, *American Gold, 1700–1860*, exh. cat. (New Haven: Yale University Art Gallery, 1963), pp. 44–45, cat. 115.

3. While not specifically addressing miniatures, Philippe Ariès asserts that Western attitudes toward death developed in stages, in tandem with new ideas about family; see *Western Attitudes Toward Death from the Middle Ages to the Present* (Baltimore: Johns Hopkins University Press, 1974). Also see Dye and Smith, "Mother Love and Infant Death," 329–53.

4. Gray's elegy, quoted in Nicholas Penny, *Mourning, the Arts and Living* (London: Victoria and Albert Museum and HMSO, 1981), 49. Penny likens the progression in baroque monuments from skeletons to figures of mourners to the changes in conventional imagery on mourning rings and allegorical miniatures. For modern views see Colin Murray Parker, *Bereavement: Studies of Grief in Adult Life* (London: Tavistock, 1986), 6off.

5. Lawrence Stone, *Family, Sex and Marriage in England, 1500–1800* (London: Weidenfeld and Nicolson, 1977), 246–53.

6. See Deutsch 1999.

7. I am indebted to the iconographic discussion in Anita Schorsch, *Mourning Becomes America: Mourning Art in the New Nation*, exh. cat. (Clinton, N.J.: Main Street Press, 1976), which concentrates on mourning art in needlework.

8. For an interpretive study of prescriptive feminine and maternal values, see Nancy F. Cott, *The Bonds of Womanhood: "Woman's Sphere" in New England, 1780–1835* (New Haven: Yale University Press, 1977); and Ruth H. Bloch, "American Feminine Ideals in Transition: The Rise of the Moral Mother, 1785–1815," *Feminist Studies* 4 (June 1978): 101–26.

9. Diary of Louisa Park, entries for Dec. 14 and 24, 1800 (American Antiquarian Society, Worcester, Mass.), quoted in Dye and Smith, "Mother Love and Infant Death," 337.

10. Penny, *Mourning*, 57. For the ritual of mourning dress see Phyllis Cunnington and Catherine Lucas, *Costumes for Births, Marriages and Deaths* (New York: Barnes and Noble Books, 1972), 71.

11. See Mary Louise B. Todd, *Thomas and Susannah Bull of Hartford, Connecticut, and Some of Their Descendants* (Lake Forest, Ill.: Heitman, 1981), n.p. The miniature is dated c. 1770–75 in Stebbins, Jr., and Gorokhoff 1982, cat. 1846M. I revise the date based on my consultation on costume with Nancy Rexford; for costume comparison see Elizabeth Mankin Kornhauser, *Ralph Earl: The Face of the Young Republic* (New Haven and Hartford: Yale University Press and Wadsworth Atheneum, 1991), portraits of *Mrs. Oliver Wolcott (Laura Collins)* (c. 1789, Virginia Museum of Fine Arts, Richmond), cat. 26, and *Angus Nickelson and Family* (c. 1790, Museum of Fine Arts, Springfield, Mass.), cat. 35.

12. "Accounts of William Verstille," *Connecticut Historical Society Bulletin* 25 (January 1960): 25–31. Attribution to Verstille, in consultation with Katherine G. Eirk, based on the following observations typical of his hand seen under the microscope: an offset philtrum not aligned with the septum; short upper lip; thin lips curled at the corners; iris outlined in darker shade and opaque white in scelera; combined hatch and stipple;

minimal modeling. These characteristics are also evident in *Caleb Bull*. However, Verstille's style was still under the influence of Joseph Dunkerley when he painted *Mrs. Bull*, whereas *Caleb Bull* reflects the influence of New York artist John Ramage in technique as well as casework.

13. On costume, I consulted with Claudia Brush Kidwell and Nancy Rexford.

14. See IGI and *Genealogical Record of the Hodges Family of New England, Ending December 31, 1894*, comp. Almon D. Hodges, Jr. (Boston: Printed for the family by Frank H. Hodges, 1894), 42–43. For research assistance on Hannah Hodges, I thank Diane Waggoner. The words "NOT LOST BUT GONE BEFORE" are inscribed, for example, on an English miniature, c. 1790–95, illustrated in Bury, *Sentimental Jewellery*, p. 38, fig. 27b.

15. Attribution by John Hill Morgan, noted Ramage scholar, American Arts Office files.

16. For sharing information on the Albany miniatures, my thanks to Davida Tenenbaum Deutsch and Mary Alice Mackay, Albany Institute of History and Art. The Yale miniature compares closely with *Ludlow Mourning Locket* and *Egberts Mourning Locket*, discussed by Carol Aiken, who states that they are "possibly by Ezra Ames," in Tammis K. Groft and Mary Alice Mackay, eds., *Albany Institute of History and Art: Two Hundred Years of Collecting* (New York: Hudson Hills Press in association with Albany Institute of History and Art, 1998), 148–49. However, neither the Staats nor the Cuyler family, who owned the memorial now at Yale, is listed in Ezra Ames's work log: see Theodore Bolton and Irwin F. Cortelyou, *Ezra Ames of Albany* (New York: New-York Historical Society, 1955). Research is ongoing. For sharing information on the Albany miniatures, my thanks to Davida Tenenbaum Deutsch and Mary Alice Mackay, Research Curator, Albany Institute of History and Art.

17. IGI. For research assistance, I thank Tavia Nyong'o Turkish and Jennifer L. Roberts.

18. Once again, I thank Davida Tenenbaum Deutsch, an expert on mourning miniatures, who advised me that this miniature is by the same hand as two others in private collections, both memorializing members of prominent New York Jewish families who founded Congregation Shearith Israel. Based on the ages and locations of descendants of the Hays family, also founding members, at the time of the infants' deaths, research to date suggests that their father was Jacob Hays (1772–1849). On Jacob Hays, see Isaac Landman, ed., *The Universal Jewish Encyclopedia*, 10 vols. (New York: Universal Jewish Encyclopedia, 1939-43), 5:255–56.

19. Deutsch 1999, 574, notes that the "design is akin to design no. 9 on p. 3 of *A Book of New and Allegorical Devices … designed and Engraved by Garnet Terry*." See David de Sola Pool and Tamar de Sola Pool, *An Old Faith in the New World: Portrait of Shearith Israel, 1654–1954* (New York: Columbia University Press, 1955), 353, 455n211.

20. On dating, see John Hill Morgan, "Memento Mori: Mourning Rings, Memorial Miniatures, and Hair Devices," *Antiques* 17 (March 1930): 228.

21. Examination by the author with Katherine G. Eirk; report in conservation files, American Arts Office.

22. Letter from Henry Bromfield to Sarah Bromfield, March 30, 1782, Bromfield Family Papers, Manuscripts and Archives, Yale University Library. On the relationship to Copley, see Jules David Prown, *John Singleton Copley*, 2 vols. (Cambridge: Harvard University Press, 1966), 1:184–85.

23. Letters from Henry Bromfield to Daniel Denison Rogers, October 2, 1782, and Daniel Denison Rogers to Henry Bromfield, September 9, 1784, Bromfield Family Papers.

24. Obituary in a Boston newspaper, quoted in Daniel Denison Sade, "The Bromfields," *The New England Historical and Genealogical Register* 25 (1871): 42. On the iconology of the miniature see George Ferguson, *Signs and Symbols in Christian Art* (London: Oxford University Press, 1961), 35 and 40.

25. Information compiled from IGI records and Bromfield and Gilman Family Papers, Manuscripts and Archives, Yale University Library. The entry for Mary [Martha] Ann Lovering's son Henry Bacon Lovering in *The Twentieth Century Biographical Dictionary of Notable Americans* (Boston: Biographical Society, 1904) states that his mother died in 1844, but such sources often prove inexact, and Mary Ann remains the most likely subject of the 1842 inscription. For genealogical detective work, my warmest thanks to Diane Waggoner.

26. See Margaretta M. Lovell, "Reading Eighteenth-Century American Family Portraits: Social Images and Self-Images," *Winterthur Portfolio* 22 (Winter 1987): 247–52.

27. An earlier version of this section was published as "The Dead Bride," *Yale Journal of Criticism* 11 (Spring 1998): 69–78.

28. Charleston *Times*, October 22, 1803, in A. W. Rutledge files, South Carolina Historical Society. *The Dead Bride* was attributed to Edward Greene Malbone (see Chapter 5) until Ruel Pardee Tolman discovered Vallée's signature on it in 1929: see Tolman 1958, 47. Bolton 1921, 166, claimed "Vallée was a Frenchman who came to the United States to start a cotton mill near Alexandria, Virginia. A letter from Jefferson to Vallée written previous to the artist's departure is dated Paris[,] September, 1785." However, the French textile manufacturer with whom Jefferson corresponded is Gilles de Lavallée: see Julian P. Boyd, ed., *The Papers of Thomas Jefferson*, 27 vols. (Princeton: Princeton University Press, 1950–97), 8: February 25 to

October 31, 1785. Anna Wells Rutledge uses the name Jean François de Vallée in *Artists in the Life of Charleston: Through Colony and State from Restoration to Reconstruction*, Transactions of the American Philosophical Society, new ser., vol. 39, pt. 2 (Philadelphia: American Philosophical Society, 1951), 125–26, 221–22. However, the advertisements she cites in the Charleston *Times* for 1803–6 reveal the name of the miniaturist to be P. Vallée or P. R. Vallée: Charleston *Times*, Oct. 22, 1803, 3–3; Feb. 11, 1805, 2–4; Nov. 19, 1805, 3–2; Nov. 11, 1806, 3–2. "La vallee" is listed in the 1807 Charleston Directory under "Limners, or Miniature Painters." P. R. Vallée advertised in the *Louisiana Courrier* (New Orleans) on Oct. 10, 1810, and painted a miniature of Andrew Jackson (Collection of Historic Hudson Valley) there in 1815.

29. On costume, I consulted with Nancy Rexford.

30. On floral wreaths in funerals, see Phillis Cunnington and Catherine Lucas, *Costume for Births, Marriages and Deaths* (New York: Barnes and Noble Books, 1972), 71; on French practice, see Philippe Ariès, *Images of Man and Death* (Cambridge: Harvard University Press, 1985), p. 83, fig. 133; and Lou Taylor, *Mourning Dress: A Costume and Societal History* (London: George Allen and Unwin, 1983). On pages 182–84 Taylor cites examples in England and various European nations. I thank Nancy Rexford for calling my attention to this reference.

31. See Phoebe Lloyd, "Posthumous Mourning Portraiture," in Martha V. Pike and Janice Gray Armstrong, *A Time to Mourn: Expressions of Grief in Nineteenth America* (Stony Brook, N.Y.: The Museums at Stony Brook, 1980), 73–75. On rose symbolism, see Ferguson, *Signs and Symbols in Christian Art*, 37–38.

32. I am indebted to the discussion of the "desirable corpse" in Ariès, *Images,* 210–13.

33. Charleston *Courrier,* June 7, 1804, 3. Here Harriet's last name is given as Mackey, not Mackie, as it appears on her grave; it is not unusual for names to be variously spelled. The obituary states that she was taken ill on June 4 and died on June 5. My thanks to church historian Elizabeth Pinckney for confirming the inscription on Mackie's tombstone. For sharing archival information relevant to the life of Harriet Mackie, my sincere thanks to Angela Mack, Gibbes Museum of Art, and C. Patton Hash, South Carolina Historical Society. For research assistance, I warmly thank Sarah K. Rich.

34. John Blake White, "The Journal of John Blake White," ed. Paul R. Weidner, *South Carolina Historical and Genealogical Magazine* 42 (1942): 103.

35. Ibid., 103–4. Even had Harriet not been about to be married, she might have been dressed in a bridal gown, for in the nineteenth century the deceased was displayed on the deathbed in the attitude of a recumbent medieval mortuary figure, dressed in his or her best clothes or in a wedding costume. Young women were often dressed in white, emblematic of their purity (Ariès, *Images,* 112).

36. White, "Journal," 104. The Charleston *Directory* for 1806 lists a William Rose, merchant, at 15 Broad Street. The miniature may have belonged to Rose; it later appears to have descended through the family of Harriet's mother, Sarah. Sarah Mackie's maiden name was probably Pawley. In 1921 Vallée's portrait (now at Yale) of Harriet Mackie was owned by Mrs. Reid Whitford of Charleston; she also owned miniatures of the Pawley family: see Bolton 1921, 106–7. Furthermore, a "Miss Pawley" appears to be a relative of Harriet Mackie[ey] in White's journal. Sarah Pawley Mackie is named as the mother of Harriet Mackie in "Backward Glances," *News and Courrier,* April [?], 1962, file clipping, South Carolina Historical Society;

however, it should be noted that this report is late in date and contains some misinformation.

37. Beatrice Mackey Doughtie, "The Mackeys (variously spelled) and Allied Families," 659, errata sheet no. 2, including supplemental data, typescript in the South Carolina Historical Society, Charleston. The person contesting the Alstons' right to inherit the Mackie estate after Harriet's death is named as "her mother" in the body of the quoted text and as "Ann Mackie, wid. Of James Mackie" by Beatrice Mackey Doughtie at an unspecified later date. However, evidence close in date to the actual events convincingly establishes Sarah, not Ann, as the name of Harriet's mother and Dr. James Mackie's widow. The court case is in Henry Wm. DeSaussure, *South Carolina Reports, Equity* (1817), 2:362, cited by Doughtie, "The Mackeys," 659.

38. Honorable Robert Y. Hayne, "Obituary of Colonel William Alston," *Mercury* [Charleston], July 1, 1839, cited in Joseph A. Groves, M. D., *The Alstons and Allstons of North and South Carolina … Also Notes of Some Allied Families* (Atlanta, Ga.: Franklin Printing and Publishing, 1901), 76–77. William Allston dropped an "l" from his name to distinguish himself from his cousins. On Allston's consolidation of power through slavery, political activities, and marriage alliances, particularly that of his son Joseph to Theodosia Burr, see George C. Rogers, Jr., *The History of Georgetown County, South Carolina* (Columbia: University of South Carolina Press, 1970), 188–92. Although it is hard to define the boundaries of the estate because the records of Georgetown County were destroyed during the Civil War, some sense of what Harriet Mackie's inheritance would have been can be gleaned from Henry A. M. Smith, "The Baronies of South Carolina," *The South Carolina Historical and Genealogical Magazine* 14 (April 1913): 64–67, in which a typical plantation of Georgetown County is described.

39. "*Lily,*" review in Charleston *Mercury*, Nov. 21, 1855; Susan Petigru King, *Lily: A Novel* (New York: Harper and Brothers, 1855; rpt. Durham, N.C.: Duke University Press, 1993), 5. Susan Dupont Petigru was the youngest daughter of James Louis Petigru. After the death of his mother, Petigru's younger sister Adele lived in his household. Therefore, Susan grew up with her young aunt, who married Robert F. W. Allston (1801–1864). Correspondence between Susan Petigru King and Adele Allston is in the Allston Papers, South Carolina Historical Society. See James Louis Petigru, *Life, Letters and Speeches of James Louis Petigru, the Union Man of South Carolina* (Washington, S.C.: W. H. Lowdermilk, 1920), 60–61, 74–75.

40. King, *Lily*, 201–2.

41. Ibid., 201.

42. On June 13 and 29, 1803, Vallée placed notices in the Charlston *Times* of a "Raffle of Twelve Elegant ENGRAVINGS, that will take place at his Room, No. 15 QUEEN-STREET." The subjects of the engravings included "Love and Psyche" (Rutledge files, South Carolina Historical Society).

Chapter 5:
The Heyday of the American Miniature

1. An advertisement by E. Grosvenor Paine in *Antiques* 89 (March 1966): 322, identifies the sitter as "Alexander Lewis Macdonald . . . Born in New York City, 1772. Died White Plains, N. Y. 1864. Son of famous Surgeon General Macdonald attached to General Washington's staff." However, ongoing research does not substantiate the identities of father or son. Paine's additional statement that the miniature was painted by Robertson can be confirmed on the basis of technique and style; for conferring on the attribution, my thanks to Sarah Coffin, Katherine G. Eirk, and Elle Shushan.

2. *Letters and Papers of Andrew Robertson, A.M.*, ed. Emily Robertson (London, 1895), 22; quoted in Johnson 1990, 185.

3. Johnson 1990 gives a death date of 1802; Foskett 1987, of 1801. On the issue of his departure in 1795 or 1796, see Johnson 1990, 186. 1796 seems most probable. Information on Alexander Gray compiled from the *British Biographical Archive*, ed. Laureen Baillie (Munich and New York: K.G. Saur, 1984–88), s.v. "Gray, Alexander, Dr.," the online catalogue of the National Library of Scotland, and Dr. Gray's Hospital. A trade card found inside the locket identifies the casemaker as "J. MARTIN, /GOLDSMITH, ENGRAVER, AND ENAMELLER."

4. Dunlap, quoted in Johnson 1990, 215; Dunlap 1834, 1:414.

5. Dunlap 1834, 1:414.

6. See Alfred Coxe Prime, comp., *The Arts and Crafts in Philadelphia, Maryland and South Carolina*, 2 vols. (Topsfield, Mass.: Walpole Society, 1929–32), 1:42–43 and 2:85–87. For biographical data on Joseph Anthony, Jr., and his career in the art world of Philadelphia, see *Philadelphia: Three Centuries of American Art*, exh. cat. (Philadelphia: Philadelphia Museum of Art, 1976), 150–51, p. 177, cat. 146.

7. Lawrence Park, *Gilbert Stuart: An Illustrated List of His Works* (New York: William Edwin Rudge, 1926), 105–109, discusses Anthony family members painted by Stuart, including cat. 26, misidentified as Judge Joseph Anthony, Jr. That same portrait is identified as the silversmith Joseph Anthony, Jr., in John Caldwell and Oswaldo Rodriguez Roque, with Dale T. Johnson, ed. by Kathleen Luhrs, assisted by Carrie Rebora and Patricia R. Windels, *American Paintings in the Metropolitan Museum of Art, A Catalogue of Works by Artists Born by 1815* (New York and Princeton: Metropolitan Museum of Art in association with Princeton University Press, 1994), 1:179–80.

8. Charles Willson Peale, quoted in Wehle 1937, 82; Philadelphia *General Advertiser*, February 21, 1792, and *Pennsylvania Packet (Dunlap's American Advertiser)*, July 21, 1792, quoted in Prime, *Arts and Crafts in Philadelphia*, 2:8-9.

9. From my consultation with Nancy Rexford, based on costume alone, the portrait can be dated to 1796–1800.

10. Their letters define their relationship as a love match: see Annette Kolodny, ed., "The Travel Diary of Elizabeth House Trist: Philadelphia to Natchez, 1783–84," in William L. Andrews, ed., *Journeys in New Worlds: Early American Women's Narratives* (Madison: University of Wisconsin Press, 1990), 180–232. For research assistance on the Trist family, I thank Amy Kurtz.

11. Jane Flaherty Wells, "Thomas Jefferson's Neighbors: Hore Browse Trist of 'Birdwood' and Dr. William Bache of 'Franklin,'" *Magazine of Albemarle County History* 47 (1989): 2. In a letter of March 23, 1787, to Elizabeth Trist, Agnes Hore Trist reports from Totnes, England, "I received a letter from Mr. Jefferson who resides at present at the French Court—he gives me a very pleasing account of my Nephew," Nicholas Philip Trist Papers [hereafter Trist Papers], Southern Historical Collection, University of North Carolina, Chapel Hill, 1–13.

12. Trist returned from Virginia to Philadelphia in 1798 to arrange the move of his household to rented quarters in Charlottesville (Wells, "Thomas Jefferson's Neighbors," 3). Trist and Brown were married in Philadelphia (IGI). Sometime in 1799, Elouis left the city to serve as a draftsman on a scientific expedition to Mexico and South America, eventually returning to France.

13. Letter from Elizabeth Trist at Birdwood to Thomas Jefferson, June 13, 1801, 2, in the Trist

Papers. Jefferson was criticized for his preferential appointments of both Trist and Bache, two young men whose families he knew well. However, Trist, unlike Bache, "proved an exemplary choice for the offices he held" (Wells, "Thomas Jefferson's Neighbors," 13).

14. Letters from Hore Browse Trist, Danville, Kentucky, to Mary Trist, September 2 and 16, 1802, and from Natchez, February 17, 1803, Trist Papers.

15. Letters from Hore Browse Trist, near Natchez, to Mary Trist, July 1 and February 17, 1803, Trist Papers.

16. Hore Browse Trist to Mary Trist, November 18, 1803, Trist Papers.

17. Elizabeth Trist, New Orleans, to Thomas Jefferson, August 31, 1804, Trist Papers; Trist Family Correspondence and Documents [hereafter Trist Family Documents], box 3, folder 3, the Trist Family Papers, Williams Research Center, Historic New Orleans Collection. For generously sharing information from Trist Wood's unpublished "History of the Trist Family" and supporting correspondence and documents, my gratitude to Mark A. Cave, Reference Archivist, Williams Research Center.

18. See Hore Browse Trist [son of sitter] to his grandmother, March 15, 1817, Trist Family Documents, box 3, folder 4. Nicholas became a statesman and diplomat who is best remembered for his controversial negotiation of the treaty ending the war with Mexico in 1847. See Reel Index, Biographical Note to the Trist Papers, 4.

19. See *The Diary of William Dunlap: The Memoirs of a Dramatist, Theatrical Manager, Painter, Critic, Novelist, and Historian* (New York: New-York Historical Society, 1930). The date of Dunlap's *Self-Portrait*, published as c. 1812 in Stebbins, Jr., and Gorokhoff 1982, cat. 449M, has been revised to c. 1800 based on examination in comparison to other portraits by

him and consultation with Katherine G. Eirk and Sarah Coffin. Another *Self-Portrait* at Yale, 1968.12.1, does appear to be dated c. 1810–12.

20. The portrait of his wife may be a marital portrait pair with the *Self-Portrait*. The date of c. 1805, in Stebbins, Jr., and Gorokhoff 1982, cat. 447M, has been revised to c. 1800 based on examination in comparison to other portraits by him and consultation with Katherine G. Eirk and Sarah Coffin. It descended in the family of the sitter, and an inscription on the lid of the modern case in which it was housed when it came to Yale dated it to "about 1798." Based on technique, both portraits may have been painted in 1798, perhaps in honor of the Dunlap's tenth wedding anniversary.

21. On Dunlap and Dwight, see Robert H. Canary, *William Dunlap* (New York: Twayne, 1970), 20–22.

22. Cited in Leah Lipton, "William Dunlap, John Wesley Jarvis, and Chester Harding: Their Careers as Itinerant Portrait Painters," *American Art Journal* 13 (Summer 1981): 34–35.

23. On the conflicted circumstances of Malbone's family fortune and childhood, see R. T. H. Halsey, "Malbone and His Miniatures," *Scribner's Magazine*, May 1910, 558–61; Tolman 1958, 3–23.

24. Edward G. Malbone to John Malbone, Esq., Providence, October 11, 1794, quoted in full in Halsey, "Malbone and His Miniatures," 560. On Malbone's training, see Dunlap 1834 1:137; Bolton 1921, 99. However, Tolman 1958, 11, disagrees, claiming that "no certain evidence" of King's instruction has been found.

25. See Tolman 1958, 12–23.

26. *Columbian Centinel* (Boston), June 29, 1796; Tolman 1958, 16–17.

27. The discussion of Yale's *Thomas Russell* was published in an earlier form as Robin Jaffee Frank, with contributions by Katherine G. Eirk, "Miniatures Under the Microscope," *Yale University Art Gallery Bulletin* (1999): 60–73, and pls. 8a–d; this article also contained a discussion of the conservation of the miniature by Katherine G. Eirk, and the collaboration among curators, conservators, and fellows in researching its history. For research assistance on this miniature, I thank Sarah K. Rich and Amy Kurtz.

Only about a fifth of Malbone's works are signed, almost exclusively his early ones, and in a variety of configurations: "Malbone," "E G Malbone," "Edwd. G. Malbone," "Edw. G Malbone," "EGM," or "EM". On Malbone's signature, see Halsey, "Malbone and His Miniatures," 561; Tolman, "Newly Discovered Miniatures by Edward Greene Malbone," *Antiques* 16 (November 1929): 377–78; and Johnson 1990, 148. The signature on the verso of Yale's miniature compares closely to that on the backing of Malbone's *John Francis*, as shown in Tolman 1958, 19, and to the signature, "Edwd. G. Malbone/Miniature painter/1797," on the backing paper of *John Langdon Sullivan*, in Tolman 1958, 251. Tolman notes that the other portrait of John Langdon Sullivan and the one of his wife are signed on the back (250, no. 421; 252, no. 423). Theresa Fairbanks and I examined these two portraits for comparative analysis but could not see them unhoused. My thanks to Rhona MacBeth, Museum of Fine Arts, Boston, for sending a photograph of the artist's card found in the back of this version of *John Langdon Sullivan;* the signature, "Edw. G Malbone/Miniature painter/November 1797," resembles the signature on the backing paper of Yale's *Thomas Russell*.

28. The dealer who first offered *Thomas Russell* and *Mrs. Richard Sullivan* to the Yale University Art Gallery in 1948 observed: "There is no question about the portrait of Mrs. Sullivan. It is Malbone at his best. The miniature of Thomas Russell I am not so sure of. The technique appears to be different, but in quality it is certainly especially good." Soon after both

works entered the collection, John Marshall Phillips, curator of the Garvan collection and director of the Art Gallery, conferred with a leading expert on miniatures about "the problem of the Malbone attribution" (John Marshall Phillips to Theodore Bolton, the Century Association, April 6, 1949, American Arts Office files, Yale University Art Gallery). In 1958 Ruel Pardee Tolman, by reproducing Yale's *Thomas Russell* (p. 238, no. 365), accepted it without comment as being by Malbone. But without explanation of its stylistic sophistication, Stebbins, Jr., and Gorokhoff 1982, cat. 974M, left it as only "attributed to" Malbone. This is where the issue stood when we began our research.

29. "Obituary" in *The Sentinel* (Russell Family Papers, 1759–1928, Manuscript Collection, Massachusetts Historical Society, Boston); my thanks to Anne E. Bentley, Registrar, for so generously sharing information from these family papers.

30. Frederic Cople Jaher, *The Urban Establishment: Upper Strata in Boston, New York, Chicago, and Los Angeles* (Urbana: University of Illinois Press, 1982), 36.

31. Through her father, Thomas Russell's second wife Sarah was a descendant of Edward Winslow, governor of the Plymouth Colony, to which he came on the *Mayflower* in 1620: see Russell Family Papers, 26. The Yale University Art Gallery owns a portrait miniature of Major George Watson attributed to Malbone (Mabel Brady Garvan Fund, 1955.5.7), and one of Elizabeth Oliver Watson by an unidentified artist after John Singleton Copley (Mabel Brady Garvan Collection, 1955.5.8). Sarah Coffin and I are considering the possibility that the portrait is by Malbone; research is ongoing.

32. Family genealogy and related information compiled from several sources, including the Russell Family Papers; *The New England Historical and Genealogical Register* 26 (1871): 311 and

315, and supplement to April number 1909, lxiii; International Genealogical Index, Church of Latter-Day Saints, the Mormons, on the Internet (www.familysearch.com); letter from Ogden Codman [Corman] to Theodore Sizer, January 15, 1938, Sizer archive, American Arts Office, Yale University Art Gallery.

33. Not included in Tolman's monograph of 1958 is the portrait miniature of Thomas Russell published as an unidentified miniature in "Notes and Queries," *Connoisseur* 85 (March 1930): p. 181, fig. 778; and as *Thomas Russell* by Malbone in Robin Bolton-Smith, *Portrait Miniatures from Private Collections* (Washington, D.C.: National Collection of Fine Arts, Smithsonian Institution, 1976), p. 5, fig. 7; p. 11, cat. 55. This miniature is now at the Cincinnati Art Museum. According to Russell family tradition, Malbone depicted four sitters, each three times, during his stay in Boston 1796–97, but only eight miniatures are known. On the Russell-Sullivan miniatures, see Tolman 1958, 16–17, 137–38, 250–53. Also see Tolman, "Edward Greene Malbone's Self-Portraits," *Antiques* 42 (December 1942): 306–8. A portrait of John Langdon Sullivan was long erroneously thought to be a Malbone self-portrait.

34. George Eliot, *Middlemarch*, ed. Gordon S. Haight (Boston: Houghton Mifflin, 1956), 55.

35. For example, the curtain appears in *Nathaniel Pearce*, which is initialed and dated 1795 (Collection of Gloria Manney); see Johnson 1990, 148–49.

36. Thanks to Erica E. Hirshler, Associate Curator of American Paintings, Museum of Fine Arts, Boston, for facilitating comparison of Yale's *Thomas Russell* to the two versions in a private collection.

37. The relation between this portrait, until recently in a private collection, and the Yale version has long intrigued scholars. In 1949 Theodore Bolton came across an image of the

portrait now in Cincinnati, then published as an "unidentified miniature" in a private English collection. He sent a sketch to John Marshall Phillips at Yale and postulated, "It may be by Malbone after an English miniature, or then again it might be the miniature by an English painter that served as the prototype for Malbone's copy [at Yale]" (Theodore Bolton, the Century Association, to John Marshall Phillips, April 1, 1949, American Arts Office files, Yale University Art Gallery). Bolton saw the reproduction in "Notes and Queries." Robin Bolton-Smith later published it, without comment, as *Thomas Russell* by Malbone in *Portrait Miniatures from Private Collections*. For her helpful suggestions in locating this portrait, my thanks to Ellen G. Miles, National Portrait Gallery, Smithsonian Institution. For their generous response to my inquiries, I am indebted to Chris Maltry and Jennifer Reis at the Cincinnati Art Museum. I thank John Wilson, formerly of the Cincinnati Art Museum, for information about the signature. On the Russells in England see Codman [Corman] to Sizer, January 15, 1938, Sizer archive; and the Russell Family Papers.

38. Tolman 1958, 16–17. Miniaturists traditionally used gum arabic, a transparent resin, as a binder. It was dissolved in water, combined with pigment, then placed in a container, ready for use by rewetting with a brush. The more binder added, the harder and glossier the paint surface.

39. The painting descended in the family of Richard Sullivan: see Sizer archive. Independent research at Yale by the author, assisted by Amy Kurtz, the Cincinnati *Thomas Russell* has been catalogued as "after Trumbull," although no specific painting or source is recorded: Registrar's files, Cincinnati Art Museum, information courtesy Chris Maltry.

40. The Yale miniature of *Thomas Russell* is the only one of the four versions that contains a lock of hair. The new locket was made by R. J.

W. Products, Kent, England, to accommodate the original blue-glass oval and hair loop.

41. Malbone, quoted in R. T. Halsey, "Malbone and His Miniatures," *Scribner's Magazine* (May 1910): 562. See Dunlap 1834, 2:14–15, for an early positive appraisal of the influence of English miniatures on Malbone's art, although many characteristics of the federal style were already evident in his miniatures before he crossed the Atlantic.

42. Malbone's account book is now at the Henry Francis Dupont Winterthur Museum, Winterthur, Delaware; a facsimile is published in Tolman 1958, 84–122. For the Newport location and the price of the painting see Account Book facsimile p. 31, l. 16. On Malbone's intensive painting campaign in Charleston, with occasional breaks in Newport, see Tolman 1958, 31–35. On Archibald Taylor, see George C. Rogers, Jr., *The History of Georgetown County, South Carolina* (Columbia: University of South Carolina Press, 1970), 166, 283, 163. In the first census of the United States taken in 1790, Taylor, of Prince George Parish, is listed as the owner of 166 slaves.

43. See "Mansfield," in Alberta Morel Lachicotte, *Georgetown Rice Plantations* (Columbia, S.C.: State Commercial Printing Company, 1955), 78–81.

44. Tolman 1958, 105: Malbone's Account Book facsimile p. 19, ll. 7–8.

45. On changing family life, see for example Nancy F. Cott, *The Bonds of Womanhood: "Women's Sphere" in New England, 1780–1815* (New Haven: Yale University Press, 1977); Steven Mintz and Susan Kellogg, *Domestic Revolutions: A Social History of American Family Life* (New York: Free Press, 1988); and Lawrence Stone, *Family, Sex and Marriage in England, 1500–1800* (London: Weidenfeld and Nicolson, 1977).

46. Thomas C. Amory, *Memoir of Hon. Richard Sullivan* (Cambridge, Mass.: John Wilson and Son, University Press, 1885), 9–10, first published in *Memorial Biographies of the New England Genealogical Society* 4. Although Armory states "I have the miniatures," they are not listed in Tolman 1958.

Shays's Rebellion was a response to the depression of the 1780s, the culmination of a decade of painful adjustment following the wrenching of the American economy from Great Britain. Disputes between debtors and creditors exploded in armed conflict in western Massachusetts, where farm foreclosures and imprisonments for debt had skyrocketed. Led by former Revolutionary War officer Daniel Shays, some two thousand desperate farmers shut down the legal machinery for collecting debt and marched to the state arsenal in Springfield. State officials raised troops to crush the uprising. Americans like the Russells and Sullivans, with wealth to protect, supported government forces.

47. Amory, *Memoir of Richard Sullivan*, 9.

48. Ibid., 11.

49. Mrs. Robert Mackay, quoted in Tolman 1958, 203.

50. Nathaniel Hawthorne, *The House of Seven Gables* (1851; New York: Norton, 1967), 31–32.

51. Strickler 1989, p. 52, cat. 11.

52. Cited in Strickler 1989, p. 54, cat. 12.

53. Conservation Reports by Katherine G. Eirk, American Arts Office files. During conservation treatment, painting was discovered on the backs of the ivories of Henry Williams, *Thomas Fletcher* (1810, Mabel Brady Garvan Collection, Yale University Art Gallery, 1963.301), as well as on the two portraits by Doyle.

54. IGI and *The Boston Directory* (Boston: E. Cotton, 1813), 74. My thanks to Diane Waggoner for research assistance.

55. Johnson 1990, 114.

56. Elisabeth McClellan, *History of American Costume, 1607–1870* (1904; New York: Tudor, 1937), 303; see also 286, 302. My thanks to Nancy Rexford for this reference, and for finding a similar sheer dress, made without any lining, that belonged to a woman in Townsend, Massachusetts; it is now in the collection of Historic Northampton, Massachusetts.

57. These attributions come largely thanks to the dedicated scholarship of a descendant, Ramsay MacMullen; see his *Sisters of the Brush: Their Family, Art, Life and Letters, 1797–1833* (New Haven: Past Times Press, 1997). I am also indebted to discussions with Davida Tenenbaum Deutsch, whose collection includes examples of Mary Way's work in a variety of media. For more on the artist, see William Lamson Warren, "Mary Way's Dressed Miniatures," *Antiques* 142 (October 1992): 540–48.

58. On costume, I consulted with Nancy Rexford. The previously unattributed miniatures of the Briggs family were dated c. 1835 in Stebbins, Jr., and Gorokhoff 1982, cats. 1929M–1931M.

59. For an example close in date, see Jacob Eichholtz's posthumous portrait of Edward Eichholtz, 1821, in Rebecca J. Beal, *Jacob Eichholtz, 1776–1842, Portrait Painter of Philadelphia* (Philadelphia: Historical Society of Pennsylvania, 1969), p. 321, fig. 196. My thanks to Nancy Rexford for calling this to my attention.

60. Typed transcript, in American Arts Office files, of broadside dated October 19, 1786, with reference to the following source: *Art in America and Elsewhere*, October 1936, 162; Sellers 1952, 9; Johnson 1990, 162.

61. Miller, Hart, and Ward 1988, 105. For a succinct discussion of the lives and personalities of the brothers, see Lillian B. Miller, "Biography of a Family," in Lillian B. Miller, ed., *The Peale Family, Creation of a Legacy, 1770–1870*, exh. cat. (Washington, D.C.: Abbeville Press in association with the Trust for Museum Exhibitions

and the National Portrait Gallery, Smithsonian Institution, 1996), 29–35.

62. Rembrandt Peale, quoted in Ellen G. Miles, *George and Martha Washington: Portraits from the Presidential Years*, exh. cat. (Washington, D.C., and Charlottesville: Smithsonian Institution, National Portrait Gallery, in association with the University Press of Virginia, 1999), 39; Dunlap 1834, 1:206; Stuart, quoted in Miles, *George and Martha Washington*, 42.

63. Some miniatures signed "R.P." formerly accredited to Rembrandt are now believed to be by Raphaelle, but more work needs to be done. See E. Grosvenor Paine, "Miniaturists in the Peale Family," in *The Peale Family: Three Generations of American Artists*, an exhibition organized by Charles H. Elam (Detroit: Detroit Institute of Arts and Wayne State University Press, 1967), 32.

64. Johnson 1990, 175. See Lillian B. Miller, "Father and Son: The Relationship of Charles Willson Peale and Raphaelle Peale," *American Art Journal* 25 (1993): 5–53.

65. *The Dr. Samuel W. Woodhouse, Jr., Collection: Antique Miniatures and Small Pictures* (Philadelphia: Samuel T. Freeman, auction catalogue dated November 14, 1934), lot 54, describes this object as follows: "In a Carved Gold Medallion. Com. Samuel Woodhouse, U.S.N., Wearing Uniform. U.S.S. Hornet in Background. Painted by Joseph Wood in Philadelphia, 1816." The reattribution to Raphaelle Peale is based on my examination of the stylistic evidence and consultation with Davida Tenenbaum Deutsch, Katherine G. Eirk, Elle Shushan, and Sarah Coffin.

66. Costume consultation with Claudia Brush Kidwell and Nancy Rexford; object dating consultation with Sarah Coffin. Rohr's hairstyle, popular in France in the 1790s, did not become fashionable in America until the early nineteenth century. Other costume clues, including the

M-cut lapel that came into style by 1803 and the lack of a shirt ruffle, imply a date of circa 1805–10, which accords with Peale's stylistic evolution.

67. "The Uniform Dress of the Officers of the Navy of the United States," U.S. Navy Department, November 23, 1813. For sharing information on uniforms and the career of Samuel Woodhouse, my thanks to Alice S. Creighton, former head, Special Collections and Archives, U.S. Naval Academy, Annapolis, Md. Note that posture conventions make it impossible for an epaulet on his left shoulder to be invisible here: this information from discussion with Claudia Brush Kidwell and Nancy Rexford. For research assistance on Woodhouse, my thanks to Dennis A. Carr.

68. *Dr. Samuel W. Woodhouse, Jr., Collection* auction catalogue, lot 54, identifies the ship as the *Hornet*. However, according to naval records, Woodhouse did not command the *Hornet* until November 1, 1826.

69. Nathan Miller, *The U.S. Navy: An Illustrated History* (New York: American Heritage, 1977), 89.

70. Information on the *Hornet* courtesy of Alice S. Creighton, former head, Special Collections and Archives, U.S. Naval Academy, Annapolis, Md. Commodore Jesse D. Elliott to the Department of the Navy notifying them of Woodhouse's death, July 17, 1843; and similar letter from Commodore G. C. Read, July 18, 1843 (Record of Officers, Special Collections and Archives, U.S. Naval Academy, Annapolis, Md.).

71. Examples are numerous: among the earliest American paintings are Thomas Smith, *Self-Portrait*, c. 1690, Worcester Art Museum, Massachusetts. Such oil paintings could serve as memorials, for example, Samuel F. B. Morse's *Alexander Metcalf Fisher*, 1822, Yale University Art Gallery, New Haven, Conn. See especially

the strikingly similar miniature *Edward Hunt of Philadelphia*, a waist-length portrait portraying the shipmaster with a clipper ship on the water in the background, framed with original label of "Thomas Birch, Miniature & Profile Painter, No. 39 Spruce St., Philadelphia," on the back; this labeled miniature, recto and verso, is illustrated and discussed in "The Almanac," *Antiques* 47 (June 1945): 348; a clearer reproduction of the verso appears in [Sotheby] Parke Bernet Galleries, American and Other Decorative Arts, Part Three [Final] Collection of the Late Arthur J. Sussel, Philadelphia, Auction in New York on March 19, 20, and 21, 1959, catalogue 1888, lot 536. Also the signed oil of Commodore Silas Talbot, as well as the discussion of Thomas Birch in the context of the Philadelphia maritime tradition by William Gerdts, in *Thomas Birch, 1779–1851, Paintings and Drawings* (Philadelphia: Philadelphia Maritime Museum, 1966), pp. 10–17, fig. 5. For research assistance on this miniature, I thank Amy Kurtz.

72. Gerdts, *Thomas Birch*, 17.

73. See especially *"Don't Give Up the Ship": A Catalogue of the Eugene H. Pool Collection of Captain James Lawrence* (Salem, Mass.: Peabody Essex Museum, 1942). Also see Ellen G. Miles, *Saint Mémin and the Neoclassical Profile Portrait in America* (Washington, D.C.: National Portrait Gallery, Smithsonian Institution Press, 1994), p. 335, cat. 486.

74. Charles Willson Peale, diary entry, January 29, 1819, in Miller, Hart, Ward, and Emerick 1992, 648–49.

75. On the historical context of this portrait, I am indebted to James G. Barber, *Andrew Jackson: A Portrait Study* (Washington, D.C., Nashville, and Seattle: National Portrait Gallery, Smithsonian Institution, and the Tennessee State Museum, in association with the University of Washington Press, 1991), 51–54. On the sittings, see Charles Willson Peale to Rembrandt Peale,

January 23, 1819, Charles Willson Peale to Rubens Peale, January 24, 1819, and Charles Willson Peale Diary, January 19, 1819, Peale-Sellers Papers. See also Anna Wells Rutledge, comp. and ed., *Cumulative Record of Exhibition Catalogues, the Pennsylvania Academy of the Fine Arts, 1807–1870* (Philadelphia: American Philosophical Society, 1955), 162. Anna Claypoole Peale also exhibited a portrait miniature of President James Monroe.

76. For an excellent discussion of the daughters' careers in the context of art and women's history, see Anne Sue Hirshorn, "Anna Claypoole, Margaretta, and Sarah Miriam Peale: Modes of Accomplishment and Fortune," in Miller, *Peale Family, Creation of a Legacy,* 221–47.

77. Charles Willson Peale to Raphaelle Peale, November 15, 1817, in Miller, Hart, Ward, and Emerick 1992, 549. Also see letter of June 26, 1818, 595.

78. Rutledge, *Cumulative Record of Exhibition Catalogues,* 162–163.

79. The miniature is identified as "possibly" *Rachel Brewer Peale* (Art Institute of Chicago) in Anne Sue Hirshorn, "Legacy of Ivory: Anna Claypoole Peale's Portrait Miniatures," *Bulletin of the Detroit Institute of Arts* 64, no. 4 (1989): 25. The identification is convincing.

80. Rembrandt's daughter Rosalba Carriera Peale (1799–1874) was named after Rosalba Carriera (1675–1758), who applied a watercolor technique to the decoration of ivory snuffboxes, providing a precedent for ivory as a miniature support.

81. I am indebted to Anne Sue Hirshorn, "Legacy of Ivory," on the new palette and shape, see pp. 24–25; on speculation that it may be unfinished, see p. 26. Also see pp. 16–27 for a discussion of this portrait in relation to Charles Willson Peale's *Lamplight* portrait.

82. My thanks to Nancy Rexford, costume consultant.

83. For an interesting study of Anna Claypoole Peale's patronage, based largely on the twenty-four extant miniatures by her of Philadelphia sitters with some references to Baltimore clients, see Verplanck 1996, 126–34.

84. Charles Willson Peale to Rembrandt Peale, July 23, 1820, quoted in Hirshorn, "Legacy of Ivory," 25.

Chapter 6: The Miniature in the Public Eye

1. Andrew Robertson, "Treatise on Miniature Painting," written as a letter to Archibald Robertson, Sept. 25, 1800, in *Letters and Papers of Andrew Robertson*, *A.M.*, ed. Emily Robertson (London, 1895), 66.

2. Thanks to Andrew Connors, formerly of the National Museum of American Art, Smithsonian Institution, for allowing Katherine G. Eirk and me to examine the NMAA's miniatures collection, including a later version of figure 116 by Robertson (formerly attributed to Alfred Agate, 1944.41) and a copy made about 1830 by Thomas Seir Cummings (1942.11.9). (A leading American advocate of painting miniatures as if they were full-size paintings, Cummings probably wanted to master Robertson's technique.) In support of these attributions, I also thank Mr. Connors for sharing correspondence from the 1940s between Ruel Pardee Tolman at the Smithsonian, Theodore Sizer at Yale, and James Laver and Carl Winter at the Victoria and Albert Museum, London. Comparative technical examination and provenance history support these attribution conclusions.

3. *Catalogue of the Very Important Collection of Studies and Sketches Made by Col. John Trumbull … from the Old Coffee-House, Phild.*, sale held Dec. 17, 1896, catalogue compiled and sale conducted by Stan V. Henkels, at the Art Auction Rooms of Thos. Birch's Sons (Philadelphia: Bicking Print, 1896), p. 37, lot 362. On page 29, John Hill Morgan notes: "Sold by order of Benjamin Silliman [Trumbull's nephew-in-law] of Brooklyn, who had inherited them in direct descent from Trumbull's estate."

4. Theodore Sizer, ed., *The Autobiography of Colonel John Trumbull, Patriot-Artist, 1756–1843* (1953; New York: Da Capo, 1970), xvii, 268n22, 332. Most of the correspondence is now in the Yale University Library in the John Trumbull Papers (henceforth YUL-JT).

5. John Trumbull to James Wadsworth, July 26, 1799, YUL-JT, quoted in Sizer, *Autobiography of Trumbull*, 333–34.

6. James Wadsworth to John Trumbull, Feb. 1, 1801, YUL-JT, quoted in Sizer, *Autobiography of Trumbull*, 335–36.

7. Ibid., 337; Information deduced from a letter from John Trumbull to John Trumbull Ray, Sept. 6, 1818, YUL-JT, quoted in Sizer, *Autobiography of Trumbull*, 347.

8. John Trumbull Ray to John Trumbull, June 22, 1811, YUL-JT, quoted in Sizer, *Autobiography of Trumbull*, 340; John Trumbull to John Trumbull Ray, July 10, 1811, YUL-JT, quoted in Sizer, *Autobiography of Trumbull*, 341.

9. John Trumbull to Rufus King, Aug. 19, 1812, in the New-York Historical Society, John Trumbull Papers, quoted in Sizer, *Autobiography of Trumbull*, 342n2; letter from the War Office, London, to Ruel Pardee Tolman, Sept. 5, 1945, NMAA files, Smithsonian Institution.

10. John Trumbull Ray to John Trumbull, Aug. 16, 1814, YUL-JT, quoted in Sizer, *Autobiography of Trumbull*, 343–44; John Trumbull to John Trumbull Ray, August 1814, YUL-JT, quoted in Sizer, *Autobiography of Trumbull*, 344; John Trumbull Ray to John Trumbull, Aug. 24, 1814, YUL-JT, quoted in Sizer, *Autobiography of Trumbull*, 344.

11. Letter from the War Office, London, to Ruel Pardee Tolman, Smithsonian Institution, Sept. 5, 1945, NMAA; John Trumbull to John Trumbull Ray, July 26, 1815, YUL-JT, quoted in Sizer, *Autobiography of Trumbull*, 345.

12. John Trumbull Ray to Sarah Trumbull, Aug. 13, 1817, YUL-JT; for information about Trumbull's own marriage see Sizer, *Autobiography of Trumbull*, 350–65; John Trumbull to John Trumbull Ray, Oct. 20, 1817, YUL-JT, quoted in Sizer, *Autobiography of Trumbull*, 346.

13. John Trumbull Ray to John Trumbull, Mar. 16, 1829, YUL-JT, quoted in Sizer, *Autobiography of Trumbull*, 349.

14. John Trumbull's will, dated Dec. 19, 1842, Probate Court, New Haven (Connecticut) City Hall, 55, 491–494, quoted in Sizer, *Autobiography of Trumbull*, 304.

15. In a letter following years of silence, Ray told the man he considered his father, but whom he was never allowed to call by that name, "I sincerely wish that all animosity between us was buried in oblivion" (John Trumbull Ray to John Trumbull, Jan. 7, 1823, YUL-JT, quoted in Sizer, *Autobiography of Trumbull*, 349). The idea that character could be read in physiognomical perception was codified into an influential science by Johann Lavater in the late eighteenth century.

16. On how the changing design and addresses of Dickinson's trade cards are tools for dating his miniatures, see Mona Leithiser Dearborn, *Anson Dickinson: The Celebrated Miniature Painter, 1779–1852* (Hartford: Connecticut Historical Society, 1983), 146–50. The 1819 date inscribed by a later hand accords with the New York address of "222 Broadway." The sitter, identified by an inscription on the reverse of the trade card as "Mr. Dunlap," correlates with Dickinson's 1819 entry in his account book for a "Mr. Dunlap."

17. Dearborn, *Anson Dickinson*, 14–15.

18. Costume consultation with Nancy Rexford.

19. Biographical information on the Champion and Bacon families compiled from Dearborn, *Anson Dickinson*, cats. 51, 52, 53, and 78; and from Francis Bacon Trowbridge, *The Champion Genealogy: History of the Descendants of Henry Champion* (New Haven: Printed for the author, 1891), 284–302; and Franklin Bowditch Dexter, *Biographical Notices of Yale Graduates* (New Haven: Issued as a Supplement to the Obituary Record, 1913), 235, 285.

20. Dunlap 1834, 2:150; 2:474 (cited in Severens and Wyrick, Jr., 1983, 72); Fraser's Account Book, Carolina Art Association, Gibbes Art Museum, Charleston, published in Severens and Wyrick, Jr., 1983, 115–46. For a thoughtful assessment of Fraser's career, see Paula Welshimer, "Charles Fraser: The Miniatures," in Severens and Wyrick, Jr., 1983, 57–74.

21. Charles Fraser to Mary Winthrop, Sept. 17, 1824, Winthrop-Fraser papers, South Carolina Historical Society, quoted in part in Paula Welshimer, "The Miniatures," in Severens and Wyrick, Jr., 1983, 73.

22. Alan Burroughs, *Limners and Likenesses: Three Centuries of American Painting* (Cambridge: Harvard University Press, 1936), 140.

23. Severens and Wyrick, Jr., 1983, 53. Fraser charged Weston $50 for the portrait, $10 more than he charged for portraits with plain backgrounds that had no props. See Severens and Wyrick, Jr., 1983, 73, and Fraser's Account Book, 125.

24. Severens and Wyrick, Jr., 1983, 73, and Fraser's Account Book, 128.

25. William Willis Boddie, *History of Williamsburg: Something About the People of Williamsburg County, South Carolina, … Until 1923* (Columbia, S.C.: State Company, 1923), 248; *Transactions of the Huguenot Society of South Carolina, No. I* (Charleston: Walker,

Evans, and Cogswell, 1889), 42. This publication includes information on the interrelated Gourdin, Gaillard, Ravenel, and DeSaussure families. For research assistance on the Gourdin miniatures, I thank Sarah K. Rich, Laura Simo, and Diane Waggoner.

26. Boddie, *History of Williamsburg*, 84, 248. Gourdin's holdings appear in Williamsburg Census, 1790. Also see Williamsburg District, South Carolina map, surveyed by Harlee, 1820, improved for Mills' Atlas, 1825, which shows the Gourdin name appearing on extensive tracts of land along the Nantee and Santee Rivers. The Gourdins also controlled a ferry across these rivers to Charleston. Gourdin's obituary appears in *Charleston Courier*, Jan. 27, 1826.

27. Inscription found on card inside locket. Gaillard history compiled from Gaillard Family genealogical chart and Bible records, Manuscript Collection of the South Caroliniana Library, University of South Carolina, Columbia, South Carolina.

28. Fraser's Account Book, in Severens and Wyrick, Jr., 1983, 126. Among the miniatures exhibited at the Carolina Art Association in 1934 were those of Mr. and Mrs. Henry Broughton Mazyck (née Gaillard): see Alice R. Huger Smith, "Charles Fraser," *Art in America* 23 (December 1934): 31. In addition to the Mazycks, a Mr. Sextus Gaillard is listed in Fraser's Account Book in 1826: see Severens and Wyrick, Jr., 1983, 127.

On the 1857 exhibition see James L. Yarnall and William H. Gerdts, comps., *The National Museum of American Art's Index to American Art Exhibition Catalogues from the Beginning Through the 1876 Centennial Year*, 6 vols. (Boston: G.K. Hall, 1986), 2:1319–28; and retrospective held at the Fraser Gallery, February–March 1857, cat. 204. In the 1857 exhibition checklist, only *Mrs. Theodore Gourdin* is listed as by Fraser. The catalogue of the major Fraser exhibition held in

Charleston in 1934 lists both miniatures as being by him. In the latter, the compiler noted that Mrs. Gourdin's portrait "was probably painted a few years later" than her husband's: *A Short Sketch of Charles Fraser and a List of Miniatures and Other Works* (Charleston: Gibbes Art Gallery, 1934), entries 75 and 76 on pp. 16–17. The two Yale collections catalogues in which these miniatures appear reveal that curators at one time questioned the attribution of *Theodore Gourdin*, but later accepted both portraits as being by Fraser: *Yale University Portrait Index* (New Haven: Yale University Press, 1951), 47; Stebbins, Jr., and Gorokhoff 1982, cat. 556M. Attribution research of *Theodore Gourdin* is ongoing.

29. For a published example, see Fraser's *James Reid Pringle* (1803; Carolina Art Association, Gibbes Art Museum, Charleston). On Fraser's technical development, see Ruel P. Tolman, "The Technique of Charles Fraser, Miniaturist," *Antiques* 27 (January 1935): 19–22 and 60–62. My thanks to Angela Mack, Gibbes Art Museum, for allowing me to examine the Fraser miniatures in their extensive collection.

30. *Biographical Dictionary of the United States Congress, 1774–1989* (Washington, D.C.: Government Printing Office), 1081. My thanks to Nancy Rexford, who concurred that Mr. Gourdin's costume in the miniature dates to this time.

31. Charles Fraser, Account Book, in Severens and Wyrick, Jr., 1983, 128. My thanks to William Kloss, who correctly identified the sitter in a letter to Helen Cooper, received Mar. 4, 1993, American Arts Office files. For a discussion of Morse's portrait, see Kloss, *Samuel F. B. Morse* (New York: Abrams, 1988), 53–55. The sitter was formerly incorrectly identified as Mrs. Wade Hampton; Stebbins, Jr., and Gorokhoff, 1982, cat. 557M.

32. Kloss, *Samuel F. B. Morse*, 54.

33. Smith, "Charles Fraser," 32. On the Pawleys and LaBruces, see Joseph A. Groves,

The Alstons and Allstons of North and South Carolina … also Notes of Some Allied Families (Atlanta, Ga.: Franklin Printing and Publishing, 1901), 67–68; and J. H. Easterby, ed., *The South Carolina Rice Plantation as Revealed in the Papers of Robert F. W. Allston* (Chicago: University of Chicago Press, 1945).

34. *The Crayon* 4 (1857): 157: cited in Severens and Wyrick, Jr., 1983, 57; Frederic Cople Jaher, *The Urban Establishment: Upper Strata in Boston, New York, Charleston, Chicago, and Los Angeles* (Urbana: University of Illinois Press, 1982), 392–93.

35. See Johnson 1990, pp. 126–27, cat. 89.

36. Ibid.

37. The letters are in the Massachusetts Historical Society and Museum of Fine Arts, Boston. See John Updike, "The Revealed and the Concealed," *Arts and Antiques* 15 (February 1993): 70–76. Updike also quotes from many of Webster's letters and places Goodridge's miniature in the context of "America's ambivalent relationship to the nude."

38. See G. C. Williamson, "Miniature Paintings of Eyes," *Connoisseur* 10 (1904): 149.

39. On *Mrs. Fitzherbert's Eye*, see Graham Reynolds with the assistance of Katherine Baetjer, *European Miniatures in the Metropolitan Museum of Art* (New York: Metropolitan Museum of Art, 1996), cat. 291, "Five Eye Miniatures." For the alleged Malbone, see Tolman 1958, p. 185, cat. 187, *Eye of Maria Miles Heyward (later Mrs. William Drayton)*.

40. The miniatures are dated circa 1825–28 in Stebbins, Jr., and Gorokhoff 1982, cats. 720M and 721M. That dating can be revised to probably 1823–24, coinciding with the sitters' courtship and marriage, based on an analysis of Inman's technique and my costume consultation with Nancy Rexford. When *Mrs. Johnson* was given to Yale by a descendant, it was accompanied by a slip of paper inscribed: "Painted by Inman 1825/at her marriage." IGI research

revealed the actual marriage date to be 1824 and also slightly adjusted the life dates given by the family and published in 1982.

41. William Samuel Johnson Papers, Manuscript and Archives, Yale University Library.

42. Thomas Seir Cummings, *New-York Mirror*, Jan. 2, 1841.

43. *National Academy of Design Exhibition Records, 1826–1860*, 2 vols. (New York: New-York Historical Society, 1941–42), 1:105. Based on the exhibition record, the date of the miniature has been changed to probably 1828 or 1829 from circa 1830 (Stebbins, Jr., and Gorokhoff 1982, cat. 366M).

44. Thomas Seir Cummings, "Practical Directions for Miniature Painting," originally published in Dunlap 1834, 2:10–14, quoted in Johnson 1990, 100.

45. Smith's *Self-Portrait*, a miniature of his father by Benjamin Trott (now also in the Deutsch collection promised to the Yale Art Gallery), and Eichholtz's oil portrait of Smith, were all sold as part of the estate of James P. Smith, Stan V. Henckels auction catalogue, Philadelphia, Dec. 14, 1920, lots 78, 79, and 91. On this painting, see Franklin Kelly with Nicolai Cikovsky, Jr., Deborah Chotner, and John Davis, *American Paintings of the Nineteenth Century*, Part 1: *The Collections of the National Gallery of Art Systematic Catalogue* (Washington, D.C.: National Gallery of Art, 1996), 218–20.

46. See Johnson 1990, 203. Smith's *Self-Portrait* has been dated to circa 1830–35 on the basis of technique as well as my costume consultation with Nancy Rexford.

Chapter 7: "Like a Bird Before a Snake"

1. Wehle 1927, 69.

2. New York *Mirror*, November 7, 1840: quoted in Robin Bolton-Smith and Dale T. Johnson, "The Miniature in America," *Antiques* 138 (November 1990): 1051.

3. Verplanck 1996, an important model for further research, focuses on patronage in Philadelphia. Verplanck's thoughtful discussion of miniatures and daguerreotypes (118–82) focuses on the careers of Anna Claypoole Peale and John Henry Brown. Regrettably, not many miniaturists' careers are as well documented through extant primary sources.

In explaining the continued desire for miniatures in the age of photography, Verplanck cites anthropologist Grant McCracken's connection of newness with commonness and "the patina of use" with social standing. She extends his analysis to include not only "aged goods," but also "goods with aged *associations*," like miniatures (123–24).

4. Ellen Hickey Grayson, "Toward a New Understanding of the Aesthetics of 'Folk' Portraits," *Painting and Portrait Making in the American Northeast*, The Dublin Seminar for New England Folklife, June 1994 Annual Proceedings (Boston: Boston University Scholarly Publication, 1995), 231; L. C. Champney to A. S. Southworth, Bennington, Ver., Mar. 9, 1943, George Eastman House Collection of the Business Papers of Southworth and Hawes, as cited in Grayson, "Toward a New Understanding," 230.

5. Miniatures by Mrs. Moses B. Russell (Clarissa Peters) are often misattributed to her husband or to Joseph Whiting Stock; for an informative study of her style, see Randall L. Holton and Charles A. Gilday, "Mrs. Moses B. Russell," *Antiques* 156 (December 1999): 816–23.

6. See Larry West and Patricia Abbott, "Daguerreian Jewelry: Popular in Its Day," *The Daguerreian Annual 1990: Official Yearbook of the Daguerreian Society*, ed. Peter E. Palmquist (Eureka, Calif: Daguerreian Society, 1990), 136–40.

7. *The Journals and Miscellaneous Notebooks of Ralph Waldo Emerson*, ed. William H. Gilman and J. E. Parsons (Cambridge: Belknap, 1970), 8:115–16.

8. Daguerreotype in the collection of the International Museum of Photography, George Eastman House. Reproduced in Joan L. Severa, *Dressed for the Photographer: Ordinary Americans and Fashion* (Kent, Ohio: Kent State University Press, 1995), 48. I thank Nancy Rexford for calling this reference to my attention.

9. See Levi L. Hill, *Photographic Researches and Manipulations, Including the Author's Former Treatise on Daguerreotype*, 2d rev. ed. (Philadelphia: Myron Shaw, 1854), 123.

10. Albert Southworth, "An Address to the National Photographic Association of the United States," *Philadelphia Photographer* 8 (October 1871): 332, cited in Charles Moore, "Two Partners in Boston: The Careers and Daguerreian Artistry of Albert Southworth and Josiah Hawes" (Ph.D. diss., University of Michigan, 1975), 293. On the relationship between the partners' portraits and romantic ideals in American art and literature, also see my "Portraits by Southworth and Hawes," in Richard S. Field and Robin Jaffee Frank, *American Daguerreotypes from the Matthew R. Isenburg Collection* (New Haven: Yale University Art Gallery, 1989), 92–120.

11. Holgrave, the daguerreotypist in *The House of Seven Gables*, also lectures on mesmerism and has the power to entrance other characters. He plays a revelatory role in the story. See Nathaniel Hawthorne, *The House of Seven Gables* (1851; New York: Norton, 1967), esp. 85–86, 187.

12. Information on Cushman's biography from George C. Croce and David H. Wallace, *The New-York Historical Society's Dictionary of Artists in America, 1564–1860* (New Haven: Yale University Press, 1957), 160. On the connections between Allston, Cheney, and Southworth and Hawes, see Moore, "Two Partners in Boston," 225, 227–29; and Frank, "Portraits by Southworth and Hawes," 107.

13. George Hewitt Cushman to Susan Wetherill, Dec. 22, 1845, Wetherill Family Papers, Historical Society of Pennsylvania, Philadelphia. For generously sharing information, my thanks to Kristen Froehlich, Artifact Collections Manager. For research assistance on the Wetherill family and papers, thanks to Dennis A. Carr. On costume, I consulted with Nancy Rexford, who further suggested that the plainness of the sitter's costume may indicate the later stages of mourning, in which one wore black with white collar and cuffs. Research is ongoing. See Bolton 1921, 32.

14. See *Dictionary of American Biography*, s.v. "Wetherill, Samuel"; and Henry Simpson, *The Lives of Eminent Philadelphians, Now Deceased*, 2 vols. (Philadelphia: William Brotherhead, 1859), 2:944–46.

15. George Hewitt Cushman to Susan Wetherill, Nov. 29 and Dec. 9, 1847, Wetherill Family Papers.

16. Susan Wetherill to George Hewitt Cushman, undated [probably before 1847], and George Hewitt Cushman to Susan Wetherill, July 23, 1848, Wetherill Family Papers.

17. George Hewitt Cushman to John Wetherill, May 8, 1849, Wetherill Family Papers; notebook at Philadelphia Museum of Art documenting the distribution of Cushman's miniatures.

18. John Henry Brown Journal and Account Book, c. 1840–90, Rosenbach Museum and Library, cited in Verplanck 1996, 144–45; Henry T. Tuckerman, *Book of the Artists, . . . Preceded by an Historical Account of the Rise and Progress of Art in America* (New York: Putnam, 1867), 479. I am indebted to Derick Dreher, Rosenbach Museum and Library, for generously sharing information.

19. Bonhams Knightsbridge auction catalogue for Apr. 22, 1998, lot 234, p. 42. Lot 205, listed as *Catherine Bohlen*, is most likely a portrait of her

mother, Jane G. Bohlen. For research assistance on Brown's *Catherine Bohlen*, I thank Amy Kurtz, Jennifer Harper, Tavia Nyong'o Turkish, and Diane Waggoner.

20. For example, two portraits of women wearing ermine, painted in the 1830s, are illustrated in Wilbur Harvey Hunter and John Mahey, *Miss Sarah Miriam Peale* (Baltimore: Peale Museum, 1967), *Louise Emily Key*, c. 1830 (27), and *Mrs. Charles Tieran*, c. 1838 (29). Robert Devlin Schwarz identifies *Elenora Kell* as being by Sarah Peale in part based on the well-known ermine prop: *A Gallery Collects Peales* (Philadelphia: Schwarz and Son, July 1987), p. 64, cat. 50. In a painting now at the Yale University Art Gallery, Mrs. John Bacon Pearce (Sophia Myers) wears a robe trimmed with ermine that a descendant of the sitter believes to be an artist's prop.

21. On costume, I consulted with Nancy Rexford.

22. Peter Hastings Falk, ed., *The Annual Exhibition Record of the Pennsylvania Academy of the Fine Arts, 1807–1870* (rpt.; Madison, Conn.: Soundview Press, 1988), 297.

23. See Verplanck 1996, 126–82; Sully placard, National Portrait Gallery, Smithsonian Institution, DA 74.26.

24. According to William Doyle Galleries, a private collector acquired the miniature in the 1930s from a direct descendant of the sitter.

25. James McLees, *Elements of Photography* (Philadelphia: Jas. McLees, 1855), 18, in Verplanck 1996, 121; Journal and Account Book of John Henry Brown, c. 1840–90, Rosenbach Museum and Library, inventory number AMs 573/14.1, Mar. 31, 1843, and 1855. Alan Trachtenberg postulates social stratification based on the size, embellishments, and packaging of daguerreotypes: see "The Daguerreotype: American Icon," in Field and Frank, *American Daguerreotypes*, 18.

26. *American Biographical Archive*, Laureen Baillie, ed., 6 vols. (London and New York: K.G. Saur, 1993), s.v. "Bohlen, John."

27. Obituary for Henry Bohl Bohlen, Philadelphia *Public Ledger*, Mar. 15, 1849 (the family lived on Juniper and Walnut Street, near the sitter); Journal and Account Book of John Henry Brown, entries for Mar. 2–17, 1849, for "Mrs. John Bohlen"; Apr. 7–16, 1849, for "Mr. Bohlen's deceased son, from a daguerreotype"; July 1850 for "Mr. John Bohlen, deceased"; November 2–27, 1850, and Dec. 2, 1850, for "Miss Catherine Bohlen." My thanks to Derick Dreher, Rosenbach Museum and Library, for generously sharing information.

28. U.S. Population Census, Locust Ward, Philadelphia, Penn., 1850, n.p.; U.S. Population Census, Eighth Ward, Philadelphia, Penn., 1860, 70.

29. William C. Taylor, "Art and Mechanism," *Philadelphia Photographer* 12 (December 1875): 355; M. A. Root, *The Camera and the Pencil, or The Heliographic Art* (1864; Pawlet, Ver.: Helios, 1971), 303; Account Book of John Henry Brown, Feb. 8, 1876; Frederick A. Wenderoth, William C. Taylor, and John H. Brown, *Gallery of Arts and Manufacturers of Philadelphia* (Philadelphia: Wenderoth, Taylor, and Brown, 1871), 1, collection of the Library Company of Philadelphia. On Wenderoth's role in the invention of the American version of the Ivorytype, also see George B. Ayres, *How to Paint Photographs in Water Colors* (Philadelphia: Benerman and Wilson, 1870), 124–25. My thanks to Tavia Nyong'o Turkish for research assistance.

30. Account Book of John Henry Brown, Aug. 4, 1860; also see Verplanck 1996, 145–146n48.

31. New York *Home Journal*, Feb. 9, 1856: quoted in Bolton-Smith and Johnson, "Miniature in America," 1051.

32. Root, *Camera and the Pencil*, 26.

33. Alice R. Huger Smith, "Charles Fraser," *Art in America* (December 1934): 199.

All works are in the collection of the Yale
University Art Gallery unless otherwise noted.
Dimensions are given in inches, followed by
centimeters; height precedes width. Miniatures
are frequently unsigned. Unsigned works are
assigned to artists largely on the basis of style.

1. Unidentified artist
 Elizabeth Eggington, 1664
 Oil on canvas, 36 ¼ x 29 ½ (92.1 x 74.9)
 Wadsworth Atheneum, Hartford, Conn.,
 Gift of Mrs. Walter H. Clark and her daughter,
 Mrs. Thomas L. Archibald

2. Mary Roberts (d. 1761)
 Woman of the Gibbes or Shoolbred Family,
 1740–50
 Watercolor on ivory, 1 5⁄16 x 1 ⅛ (3.4 x 2.8)
 Carolina Art Association, Gibbes Museum
 of Art, Charleston, S.C., Bequest of Amelia
 Josephine Emanuel

3. John Watson (Scotland, 1685–1768)
 David Lyell (England, 1670–1725), c. 1715–25
 Graphite pencil and watercolor on vellum,
 3 x 2 ⅜ (7.6 x 6.0)
 Reverse inscribed "Mr. Lyell"
 Lelia A. and John Hill Morgan Collection,
 1942.210

4. Charles Willson Peale (1741–1827)
 James Peale Painting a Miniature, c. 1795
 Oil on canvas, 30 ⅛ x 25 ⅛ (76.5 x 63.8)
 Mead Art Museum, Amherst College, Amherst,
 Mass., Bequest of Herbert L. Pratt, Class of 1895

5. Robert Field (England, c. 1769–1819)
 Benjamin Frederick Augustus Dashiell
 (1763–1820), 1803
 Watercolor on ivory, 2 ¹¹⁄16 x 2 3⁄16 (6.8 x 5.6)
 Signed l.r.: "R F / 1803"

Reverse of locket: cobalt-glass surround
over magenta-toned embossed foil, inner
gold-over-copper rim and inset oval compart-
ment containing opal glass over magenta-
toned embossed foil with brown hair clasped
with pearls and decorated with gold wire
Lelia A. and John Hill Morgan Collection,
1940.499

6. Bevel-edged cobalt-glass surround over
 ray-patterned embossed foil, inner rim of
 prong-set pearls and inset oval compartment
 containing bright-cut gold initial "W" and
 design on brown hair plaid on reverse of
 Attributed to William Lovett (1773–1801),
 Lucretia Tuckerman Wier, c. 1797
 Promised Bequest of Davida Tenenbaum
 Deutsch and Alvin Deutsch, LL.B. 1958, in
 honor of Kathleen Luhrs, ILE1999.3.5

7. Unidentified artist
 Landscape on the reverse of *Lady*, c. 1775
 Watercolor and chopped hair on ivory,
 1 5⁄16 x 1 ¼ (3.3 x 3.2)
 Promised Bequest of Davida Tenenbaum
 Deutsch and Alvin Deutsch, LL.B. 1958,
 in honor of Kathleen Luhrs, ILE1999.3.10

8. Unidentified artist, probably with the initials G.K.
 Memorial on the reverse of *Gentleman*,
 c. 1820–25
 Watercolor and natural and chopped hair on
 ivory, 1 ⅞ x 1 7⁄16 (4.8 x 3.7)
 Inscribed on tomb "PTH";
 on pyramid "JTH"; and on palette "GK."
 Lelia A. and John Hill Morgan Collection,
 1940.540

9. Miniaturist's Sample Case, c. 1825
 Mahogany box containing samples of braided
 hair and designs worked in hair on ivory,
 6 ¾ x 14 x 9 (17.1 x 35.6 x 22.9)
 Courtesy Winterthur Museum, Winterthur, Del.

10. John Closterman (1660 – 1711)
 Daniel Parke (1669 – 1710), c. 1705
 Oil on canvas, 56 x 47 (142.4 x 119.4)
 Courtesy of the Virginia Historical Society,
 Richmond

11. Johann Zoffany (1733 – 1810)
 Queen Charlotte (1744 – 1818), 1771
 Oil on canvas
 The Royal Collection © 2000 Her Majesty
 Queen Elizabeth II

12. Charles Willson Peale (1741 – 1827)
 Walter Stewart (Ireland, c. 1756 – 96), 1781
 Oil on canvas, 50 ⅛ x 40 ⅛ (127.3 x 101.9)
 Gift of Robert L. McNeil, Jr., 1991.125.1

13. Charles Willson Peale (1741 – 1827)
 Mrs. Walter Stewart (Deborah McClenachan)
 (1763 – 1823), 1782
 Oil on canvas, 50 ⅛ x 40 ⅛ (127.3 x 101.9)
 Gift of Robert L. McNeil, Jr., 1991.125.2

14. The Beardsley Limner (active c. 1785 – c. 1800)
 Dr. Hezekiah Beardsley (1748 – 90),
 between 1788 and 1790
 Oil on canvas, 45 x 43 (114.3 x 109.2)
 Gift of Gwendolen Jones Giddings, 1952.46.1

15. The Beardsley Limner (active c. 1785 – c. 1800)
 Mrs. Hezekiah Beardsley (Elizabeth Davis)
 (1748 or 1749 – 1790), between 1788 and 1790
 Oil on canvas, 45 x 43 (114.3 x 109.2)
 Gift of Gwendolen Jones Giddings, 1952.46.2

16. Philip Mercier (1689? – 1760)
 A Woman in Love (also known as
 Peg Woffington), c. 1735
 Oil on canvas, 28 x 36 (71.1 x 91.4)
 The Garrick Club, London. Photograph
 courtesy of the Paul Mellon Centre for Studies
 in British Art, London

17. Unidentified artist
 Romance Allegory, c. 1795
 Watercolor and chopped hair on ivory,
 1 ⅛ x ¾ (3.5 x 1.9)
 Reverse engraved "C J C"
 Provenance unknown, 1994.1.18

18. Unidentified artist
 Friendship or Romance Allegory, c. 1785 – 90
 Dissolved hair on ivory, 1 1/16 x ½ (2.4 x 1.3)
 Lelia A. and John Hill Morgan Collection,
 1951.44.1

19. Unidentified artist
 Memorial on the reverse of *Gentleman*, c. 1810
 Watercolor on ivory; reverse-glass painting,
 1 15/16 x 1 ⅝ (4.9 x 4.1) sight
 Inscribed on plinth "WERTER"
 Promised Bequest of Davida Tenenbaum
 Deutsch and Alvin Deutsch, LL.B. 1958,
 in honor of Kathleen Luhrs, ILE1999.3.44

20. Charles Willson Peale (1741 – 1827)
 Miss Mary Tilghman (Mrs. Edward Roberts)
 (1753 – 1819), 1790
 Oil on canvas, 35 ⅛ x 26 (87.8 x 65)
 Signed and dated l.r.: "C.WPeale 1790"
 The Maryland Historical Society, Baltimore,
 Bequest of Miss Agnes Riddle Owen
 Tilghman, Descendant, 1973

21. Aldridge (or Oldridge)
 Sarah Bell, c. 1808
 Pastel on paper, 23 x 18 ¾ (58.4 x 47.6)
 Abby Aldrich Rockefeller Folk Art Center,
 Williamsburg, Va.

22. Unidentified artist
 Lady, probably with the initials E. P., 1792
 Watercolor on ivory, 1 15/16 x 1 9/16 (4.9 x 4.0)
 Inscribed on urn "EP."; and on plinth
 "OB/Dec.ʳ/29/ 1792/AE/28/yrˢ"

Promised Bequest of Davida Tenenbaum
Deutsch and Alvin Deutsch, LL.B. 1958,
in honor of Kathleen Luhrs, ILE1999.3.87

23. Unidentified artist
Memorial for E. P., 1792
Reverse of *Lady, probably with the initials
E. P.* (fig. 22)
Watercolor on ivory, $\frac{7}{8}$ x $\frac{9}{16}$ (2.2 x 1.7) sight,
in inset oval compartment surrounded by
bright-cut scalloped engraving, hair plaid,
and bright-cut scalloped fillet

24. Benjamin West (1738–1820)
Self-Portrait, 1758 or 1759
Watercolor on ivory, 2 $\frac{1}{2}$ x 1 $\frac{13}{16}$ (6.4 x 4.6)
Lelia A. and John Hill Morgan Collection,
1940.529

25. Reverse of West, *Self-Portrait* (fig. 24)
Engraved in calligraphic script "Benjn
West./Aged 18./Painted by himself/in the year
1756./& presented to Miss Steele./
of Philadelphia."

26. Benjamin West (1738–1820)
The Artist's Family, 1772
Oil on canvas, 20 $\frac{1}{2}$ x 26 $\frac{1}{4}$ (52.1 x 66.7)
Yale Center for British Art, New Haven, Conn.,
Paul Mellon Collection

27. Benjamin West (1738–1820)
Self-Portrait Miniature/Miniature of a Woman,
c. 1755–60
Pencil on paper, 6 $\frac{1}{2}$ x 3 $\frac{7}{8}$ (16.5 x 9.8)
The Historical Society of Pennsylvania (HSP),
Philadelphia, AM/.186 (25a)

28. Charles Willson Peale (1741–1827)
Matthias and Thomas Bordley
(1757–1828; 1755–71), between 1767 and 1769
Watercolor over graphite pencil on ivory,
3 $\frac{5}{16}$ x 4 (8.4 x 10.2)

Acquired in honor of Jules David Prown,
Paul Mellon Professor of the History of Art;
Leonard C. Hanna, Jr., B.A. 1913, Fund,
1998.40.1

29. Charles Willson Peale (1741–1827)
Matthias and Thomas Bordley, 1767
Watercolor on ivory, 3 $\frac{5}{8}$ x 4 $\frac{1}{4}$ (9.0 x 10.8)
National Museum of American Art,
Smithsonian Institution, Washington, D.C.,
Museum purchase and gift of
Mr. and Mrs. Murray Lloyd Goldsborough, Jr.

30. Charles Willson Peale (1741–1827)
George Walton (1749 or 1750–1804), c. 1781
Watercolor on ivory, 1 $\frac{3}{8}$ x 1 $\frac{1}{16}$ (3.5 x 2.7)
Mabel Brady Garvan Collection, 1944.74

31. John Singleton Copley (1737–1815)
Andrew Oliver (1706–74), c. 1758
Oil on ivory, 2 x 1 $\frac{3}{4}$ (5.1 x 4.4)
Mabel Brady Garvan Fund, 1955.5.5

32. John Singleton Copley (1737–1815)
Mrs. Andrew Oliver (Mary Sanford)
(1731–73), c. 1758
Oil on gold-leafed copper blank,
1 $\frac{3}{4}$ x 1 $\frac{3}{8}$ (4.4 x 3.5)
Mabel Brady Garvan Fund, 1955.5.12

33. John Singleton Copley (1737–1815)
Mrs. Samuel C. Waldo (Grizzel Oliver) (1737–61),
probably 1760
Oil on gold-leafed copper,
3 $\frac{3}{8}$ x 2 $\frac{1}{8}$ (8.6 x 6.7)
Mabel Brady Garvan Fund, 1955.5.6

34. John Singleton Copley (1737–1815)
Peter Oliver (1713–91), c. 1760
Oil on gold-leafed copper, 5 $\frac{3}{8}$ x 4 $\frac{5}{8}$ (13.6 x 11.7)
Collection of Andrew Oliver, Jr., Daniel Oliver,
and Ruth Morley Oliver

35. John Singleton Copley (1737–1815)
 Reverend Samuel Fayerweather (1725–81),
 probably 1760 or 1761
 Oil on gold-leafed copper, 3 x 2 ½ (7.6 x 6.4)
 Mabel Brady Garvan Collection, 1948.69

36. John Singleton Copley (1737–1815)
 Portrait of the Artist, 1769
 Pastel on paper mounted on canvas,
 23 ⅛ x 17 ½ (58.7 x 44.5)
 Courtesy Winterthur Museum, Winterthur, Del.

37. John Singleton Copley (1737–1815)
 Self-Portrait, 1769
 Watercolor on ivory, 1 ⅝₆ x 1 ¹⁄₁₆ (3.3 x 2.7)
 Signed and dated l.r.: "JSC 1769"
 Gloria Manney Collection

38. Joseph Dunkerley
 (active in U.S. before 1784–88)
 Ebenezer Storer II (1730–1807), c. 1785
 After a pastel portrait by John Singleton Copley,
 c. 1767–69
 Watercolor on ivory, 1 ³⁄₁₆ x 1 ¹⁄₁₆ (3.0 x 2.7),
 set in gold, rolled-edge bezel with
 bracelet clasps attached to c. 1850 end caps
 and hairwork bracelet
 Signed c.r.: "I:D"
 John Hill Morgan, B.A. 1893, Fund, 1949.96

39. Joseph Dunkerley
 (active in U.S. before 1784–88)
 Mrs. Ebenezer Storer II (Elizabeth Green)
 (1734–74), c. 1785
 After a pastel portrait by John Singleton Copley,
 c. 1767–69
 Watercolor on ivory, 1 ³⁄₁₆ x 1 ¹⁄₁₆ (3.0 x 2.7),
 set in gold, rolled-edge bezel with
 bracelet clasps attached to c. 1850 end caps
 and hairwork bracelet
 Signed c.r.: "ID"
 John Hill Morgan, B.A. 1893, Fund, 1949.97

40. Nathaniel Hancock (active 1792–1809)
 Self-Portrait, c. 1792
 Watercolor on ivory, 1 ¾ x 1 ¼ (4.4 x 3.2)
 Mabel Brady Garvan Collection, 1946.303

41. Nathaniel Hancock (active 1792–1809)
 Jedidiah Morse (1761–1826), c. 1795
 Watercolor on ivory, 1 ¹¹⁄₁₆ x 1 ³⁄₁₆ (4.3 x 3.0)
 Mabel Brady Garvan Collection, 1935.255

42. Nathaniel Hancock (active 1792–1809)
 Geographer Discoursing to a Group of Ladies,
 c. 1795
 Reverse of Hancock, *Jedidiah Morse* (fig. 41)
 Watercolor on ivory, 1 ¼ x ¹⁵⁄₁₆ (3.2 x 2.4),
 in inset oval compartment surrounded by
 engraved and punched gold border

43. John Ramage (Ireland, c. 1748–1802)
 New York Dandy, c. 1785
 Watercolor on ivory, 1 ½ x ¹⁵⁄₁₆ (3.8 x 2.4)
 Lelia A. and John Hill Morgan Collection,
 1940.517

44. John Ramage's work desk and tools, 1775–95
 Mahogany slant-top desk with drawers,
 probably New York, 42 ¾ x 27 ¾ x 21 ½
 (108.6 x 70.5 x 54.6)
 Collection of The New-York Historical Society,
 New York; Gift of an anonymous donor

45. John Ramage's sample card,
 "Mourning, Love, and Fancy," 1775–95
 Watercolor, gold, and hair on ivory,
 2 ¾ x 3 ½ (7.0 x 8.9)
 Collection of The New-York Historical Society,
 New York; Gift of an anonymous donor

46. John Ramage (Ireland, c. 1748–1802)
 Romantic Allegory, c. 1785
 Watercolor on ivory, 1 7/16 x 3/4 (3.7 x 1.9)
 Promised Bequest of Davida Tenenbaum

Deutsch and Alvin Deutsch, LL.B. 1958,
in honor of Kathleen Luhrs, ILE1999.3.20

47. John Ramage (Ireland, c. 1748–1802)
 Anthony Rutgers, probably 1790
 Watercolor on ivory, 1 ⅞ x 1 ½ (4.8 x 3.8)
 Reverse engraved "Cornelia M Rutgers"
 Lelia A. and John Hill Morgan Collection,
 1940.515

48. Brown hair plaid on reverse of Henri,
 Mrs. Alexander Rose (Margaret Smith) (fig. 49)

49. Pierre Henri (c. 1760–1822)
 Mrs. Alexander Rose (Margaret Smith) (b. 1747),
 between 1790 and 1793
 (formerly attributed to John Ramage)
 Watercolor over graphite pencil on ivory,
 2 x 1 ⁹⁄₁₆ (5.1 x 4.0)
 Lelia A. and John Hill Morgan Collection,
 1940.516

50. James Peale (1749–1831)
 George Washington (1732–99), LL.D. 1781,
 c. 1785
 Watercolor on ivory, 1 ⅝ x 1 ⅜ (4.1 x 3.5)
 Reverse engraved "Geo: Washington / A.D.
 1785. / Painted by Peal. / Presented by
 Washington. / to / → Anna Constable.
 1785. / Anna Pierrepont. / → Theresa Bicknell.
 1842 / → Josephine Foster. 1874."
 Gift of Miss Josephine B. Foster, 1951.43.1

51. Marquise Jean-François-René-Almaire de
 Bréhan (Anne Flore Millet) (France, b. 1752?)
 George Washington (1732–99), LL.D. 1781, 1789
 Watercolor (grisaille) on ivory,
 2 ⅝ x 2 ⅛ (6.7 x 5.4)
 Signed in sgraffito l.c.: "Mᵉ La Mssᶜ de
 Brehan F"; inscribed in opaque white u.l.:
 "GEORGE"; u.r.: "WASHINGTON"
 Mabel Brady Garvan Collection, 1947.220

52. Marquise Jean-François-René-Almaire de
 Bréhan (Anne Flore Millet) (France, b. 1752?)
 *Eleanor (Nelly) Parke Custis (Mrs. Lawrence
 Lewis)* (1779–1852), 1789
 Reverse of Bréhan, *George Washington* (fig. 51)
 Signed in sgraffito l.c.: "Mᵉ La Mssᶜ de Brehan F"

53. Marquise Jean-François-René-Almaire de
 Bréhan (Anne Flore Millet) (France, b. 1752?)
 George Washington (1732–99), LL.D. 1781, 1789
 Watercolor (grisaille) on ivory,
 1 ⅛ x ⁹⁄₁₆ (2.9 x 1.4)
 Lelia A. and John Hill Morgan Collection,
 1940.491

54. Unidentified artist
 George Washington (1732–99), LL.D. 1781,
 between 1796 and 1799
 Ink on paper, ⅜ x ¼ (1.0 x 0.6) sight,
 set in gold and silver foliate brooch with
 14 diamonds; linked with gold chain to silver
 and gold stickpin with pearl head
 Engraved on reverse of bezel "D.T.
 LANMAN. / 69 / Water St / N.Y."
 Gift of Mr. and Mrs. Ezra P. Prentice, Jr., 1980.95

55. William Russell Birch (England, 1755–1834)
 George Washington (1732–99), LL.D. 1781,
 c. 1796
 Enamel on copper, 2 ⁵⁄₁₆ x 1 ⅞ (5.9 x 4.8),
 set in rectangular gold snuffbox covered
 with tortoiseshell
 Signed l.r.: "W B / 6"
 Gift of Mrs. Edward R. Wardwell for the Lelia A.
 and John Hill Morgan Collection, 1945.469.2

56. Side view of Birch, *George Washington* (fig. 55)

57. Attributed to Ruth Henshaw Bascom
 (1772–1848)
 Eliza Jane Fay (1832–99), 1840
 Pastel and graphite pencil on laid paper,
 17 ¼ x 12 ⅞ (43.8 x 32.7)

Inscribed l.c.: "Eliza Jane Fay/Fitzwilliam N.H. Aged 8 years & 4 m. 1840"; and on pendant "In Memy/Geo./Washingt"
New York State Historical Association, Cooperstown

58. Attributed to Samuel Folwell (1764–1813)
Memorial for George Washington (1732–99), LL.D. 1781, c. 1800
Watercolor and chopped hair on ivory, 1 7/8 x 1 5/16 (4.8 x 3.3)
Lelia A. and John Hill Morgan Collection, 1940.537

59. Robert Field (England, c. 1769–1819)
Mrs. George Washington (Martha Dandridge, Mrs. Daniel Parke Custis) (1732–1802), 1801
Watercolor on ivory, 2 5/8 x 2 1/8 (6.7 x 5.4)
Signed and dated l.l.: "RF/1801"
Mabel Brady Garvan Collection, 1947.222

60. Robert Field (England, c. 1769–1819)
JOIN'D BY FRIENDSHIP, CROWN'D BY LOVE, 1801
Reverse of Field, *Mrs. George Washington* (fig. 59)
Chopped hair and watercolor or dissolved hair on ivory, 1 5/16 x 7/8 (3.3 x 2.2) sight, in inset oval compartment surrounded by 67 prong-set full pearls set in rim, cobalt-glass surround over ray-patterned embossed foil, and inner gold-colored rim enameled in pale blue and white with bright-cut leaves

61. Unidentified artist
Mourning Ring for Thomas Clap, 1767
Gold band formed of three scrolls linked by short struts, attached to setting with painted paper skeleton under coffin-shaped crystal, and scalloped reverse; in gold letters with black enamel infilling "T:CLAP: /OB: IEN: 7/1767: AE 63," 7/8 (2.2) diameter
Gift of Mrs. Charles Seymour, in memory of Charles Seymour (1885–1963), fifteenth

president of Yale and a descendant of Thomas Clap (1703–67), fifth president of Yale, 1964.17

62. Attributed to John Brevoort (1715–75)
Mourning Ring for John Brovort Hicks (c. 1758–61), 1761
Gold band formed of four scrolls linked by struts, attached to setting with square faceted crystal over painted skull; in gold letters with white enamel infilling "JNᴼ : BROVORT/HICKS: OB: 23/MARCH: 1761 ·/AE: 2 : Y: 6: M.," 13/16 (2.1) diameter
Mabel Brady Garvan Collection, 1934.343

63. Attributed to Samuel Folwell (1764–1813)
Memorial for SP, ARP, and SP, c. 1795
Watercolor and chopped hair with applied ivory on ivory, 2 1/8 x 1 11/16 (5.4 x 4.3)
Inscribed on three urns of raised ivory "SP/ARP/SP" and on plinth "my Parents/and/Sister/I mourn"
Promised Bequest of Davida Tenenbaum Deutsch and Alvin Deutsch, LL.B. 1958, in honor of Kathleen Luhrs, ILE1999.3.19

64. Attributed to William Verstille (c. 1755–1803)
Memorial for M. Bull, c. 1786
Reverse of Attributed to Verstille, *Mrs. Caleb Bull (Mary Otis)* (fig. 65)
Watercolor and chopped hair on ivory
Inscribed on plinth "*To the/memory/of* M · BULL/OB. May 19ᵗʰ/1786. AE · 36"

65. Attributed to William Verstille (c. 1755–1803)
Mrs. Caleb Bull (Mary Otis) (1750–86), c. 1786
Watercolor on ivory, 1 5/8 x 1 (4.1 x 2.5)
Mabel Brady Garvan Collection, 1935.257

66. William Verstille (c. 1755–1803)
Caleb Bull (1746–97), c. 1790–95
Watercolor on ivory, 1 3/8 x 1 3/16 (3.5 x 3.0)
Signed c.l.: "Verstille"
Mabel Brady Garvan Collection, 1935.256

67. Attributed to John Ramage (Ireland, c. 1748–1802)
Memorial for Hannah Hodges (1780–92), 1792
Watercolor and chopped hair on ivory,
1 ¹⁄₂ x ⁷⁄₈ (3.8 x 2.2)
Inscribed on plinth "NOT/ LOST"
Reverse engraved "Hannah Hodges/OB. 9.
OCTr 1792 AE 12"
Lelia A. and John Hill Morgan Collection,
1940.539

68. Unidentified artist, possibly Ezra Ames
(1768–1836)
Memorial for Henry G. Staats, c. 1802
Watercolor, chopped hair, and graphite pencil
on ivory; reverse-glass painting,
2 ⁷⁄₁₆ x 1 ¹⁵⁄₁₆ (6.2 x 4.9)
Inscribed on plinth "HGS"
Lelia A. and John Hill Morgan Collection,
1940.534

69. Inset oval compartment containing gold cypher
"RC" on brown hair plaid with faceted rim
on reverse of Unidentified artist,
Memorial for Henry G. Staats (fig. 68)
Engraved at top "CCS"

70. Unidentified artist
Memorial for Solomon and Joseph Hays, 1801
Watercolor, pearls, gold wire, and beads,
and locks of blond and brown hair
(natural, chopped, and dissolved) on ivory,
1 ⁷⁄₈ x 1 ¹³⁄₁₆ (4.8 x 4.6)
Inscribed on monuments "IN /MEMORY/
of SOLMN/HAYS/IN INFANT/YEARS/1798"
and "IN /MEMORY/ OF JOSH/HAYS/IN
INFANT/YEARS/1801"
Promised Bequest of Davida Tenenbaum
Deutsch and Alvin Deutsch, LL.B. 1958,
in honor of Kathleen Luhrs, ILE1999.3.21

71. Inset round compartment containing gold cypher
"H/JS" on blond and brown hair plaid on

reverse of Unidentified artist,
Memorial for Solomon and Joseph Hays (fig. 70)

72. Thomas Sully (1783–1872)
Memorial to His Mother, Sarah Sully, c. 1801
Watercolor on ivory, 1 ³⁄₈ x 1 ³⁄₈ (3.5 x 3.5)
Inscribed on plinth "SACRED TO THE /MEMORY/
OF /SARAH SULLY" and on urn "SS"
Lelia A. and John Hill Morgan Collection,
1940.536

73. Unidentified artist
Memorial for Abigail Rogers (1753–91), 1791
Watercolor, chopped and possibly dissolved hair,
applied ivory, pearls, and engraved gold bands on
ivory, 1 ¹⁄₂ x ⁷⁄₈ (3.8 x 2.2)
Inscribed on plinth "ABIGAIL/ROGERS/OB. 7 OCTR
./ ...1791..."
Reverse engraved (c. 1842) "Martha Ann/[B.]
Lovering/died Aug! 27. 1842/Aged 19 yrs."
Gift of Walter M. Jeffords, B.A. 1905, 1947.214

74. John Singleton Copley (1737–1815)
Mrs. Daniel Denison Rogers (Abigail Bromfield)
(1753–91), c. 1784
Oil on canvas, 50 x 40 (127 x 101.6)
Courtesy of the Fogg Art Museum, Harvard
University Art Museums, Cambridge, Mass., Gift
of Paul C. Cabot, treasurer of Harvard
University, 1943–65, and Mrs. Cabot, 1977.179

75. Unidentified artist, possibly Samuel Folwell
(1764–1813)
Maternal Allegory, c. 1795
Watercolor and chopped hair on ivory,
1 ⁵⁄₁₆ x ³⁄₄ (3.3 x 1.9) sight
Reverse engraved "W: Shaw"
Provenance unknown, 1972.140.2

76. Unidentified artist
Memorial for S. C. Washington, c. 1789
Watercolor, chopped hair, gold wire, pearls,

and applied ivory on ivory,
1 $^{1}/_{16}$ x $^{11}/_{16}$ (2.7 x 1.7)
Reverse engraved "S.C. Washington. Ob9th.
Nov. 1789./Aet: 19."
On back of ivory, cut paper with remnants of
note: "[…]n weeping by […]/like the locke
[…]/hood on the w[…]"
Promised Bequest of Davida Tenenbaum
Deutsch and Alvin Deutsch, LL.B. 1958,
in honor of Kathleen Luhrs, ILE1999.3.18

77. P. R. Vallée (France; active in U.S. 1803–15)
Harriet Mackie (The Dead Bride)
(1788–1804), 1804
Watercolor and graphite pencil on ivory,
2 $^{7}/_{16}$ x 1 $^{15}/_{16}$ (6.2 x 4.9)
Signed in graphite pencil l.l.: "Vallée"
Mabel Brady Garvan Collection, 1936.300

78. Anne-Louis Girodet-Trioson
Les Funerailles d'Atala
(The Entombment of Atala), 1808
Oil on canvas, 83 $^{3}/_{4}$ x 105 (212.7 x 266.7)
Musée du Louvre, Paris

79. P. A. Vafflard
Young et sa fille, 1804
Oil on canvas, 95 $^{1}/_{4}$ x 76 $^{3}/_{8}$ (242 x 194)
Musée des Beaux-Arts, Angoulême

80. Inset oval compartment containing brown
hair plaid on reverse of Vallée, *Harriet Mackie*
(fig. 77)

81. Archibald Robertson (Scotland, 1765–1835)
Gentleman, c. 1795
Watercolor on ivory, 2 $^{3}/_{16}$ x 1 $^{11}/_{16}$ (5.6 x 4.3)
Promised Bequest of Davida Tenenbaum
Deutsch and Alvin Deutsch, LL.B. 1958,
in honor of Kathleen Luhrs, ILE1999.3.73

82. Walter Robertson (Ireland, c. 1750–1801
or 1802)
Gentleman, c. 1795
Watercolor on ivory, 2 $^{3}/_{4}$ x 2 $^{1}/_{4}$ (7.0 x 5.7)
Lelia A. and John Hill Morgan Collection,
1940.518

83. Walter Robertson (Ireland, c. 1750–1801
or 1802)
Dr. Alexander Gray (Scotland,1751–1807), c. 1797
Watercolor on ivory, 2 $^{13}/_{16}$ x 2 $^{5}/_{16}$ (7.1 x 5.9)
Promised Bequest of Davida Tenenbaum
Deutsch and Alvin Deutsch, LL.B. 1958,
in honor of Kathleen Luhrs, ILE1999.3.55

84. Benjamin Trott (c. 1770–1843)
Joseph Anthony, Jr. (1762–1814), c. 1794–95
Watercolor over graphite pencil on ivory,
2 $^{15}/_{16}$ x 2 $^{3}/_{8}$ (7.5 x 6.0)
Mabel Brady Garvan Collection, 1936.299

85. Jean Pierre Henri Elouis (France, 1755–1840)
Hore Browse Trist (1775–1804),
probably 1798 or 1799
Watercolor on ivory, 3 $^{3}/_{16}$ x 2 $^{1}/_{2}$ (8.1 x 6.4)
Signed l.l.: "Elouis"
Mabel Brady Garvan Collection, 1936.303

86. Seed-pearl cypher "HBT" on brown hair plaid
on reverse of Elouis, *Hore Browse Trist* (fig. 85)

87. William Dunlap (1766–1839)
Mrs. William Dunlap (Elizabeth Woolsey)
(1768–1848), c. 1805
Watercolor on ivory, 2 $^{5}/_{8}$ x 2 $^{1}/_{16}$ (6.7 x 5.2)
Gift from the estate of Geraldine Woolsey
Carmalt, 1968.12.2

88. William Dunlap (1766–1839)
Self-Portrait, c. 1805
Watercolor on ivory, 2 $^{9}/_{16}$ x 2 (6.5 x 5.1)
Lelia A. and John Hill Morgan Collection,
1938.95

89. Edward Greene Malbone's ivory
painting case, c. 1800
Ivory cylinder with 18 palettes,
5 $\frac{1}{4}$ (13.3) length, 1 $\frac{5}{8}$ (4.1) diameter
Engraved "EGM"
Gift of Mr. and Mrs. Maxim Karolik, for the
M & M Karolik Collection of Eighteenth-
Century American Arts, Museum of
Fine Arts, Boston

90. Edward Greene Malbone (1777–1807)
Thomas Russell (1740–96), 1796
After a portrait by John Trumbull,
between 1789 and 1794
Watercolor on ivory, 2 $\frac{5}{8}$ x 2 $\frac{1}{16}$ (6.7 x 5.2)
Signed and dated in red paint on backing paper
"EG Malbone/[?]/July 1796"
Lelia A. and John Hill Morgan Collection,
1948.260

91. Edward Greene Malbone (1777–1807)
Thomas Russell, c. 1797
Watercolor on ivory, 2 $\frac{1}{8}$ x 1 $\frac{3}{4}$ (5.4 x 4.4)
Private Collection, Photograph courtesy
the Museum of Fine Arts, Boston

92. Edward Greene Malbone (1777–1807)
Thomas Russell, 1797
Watercolor on ivory, 3 $\frac{1}{2}$ x 2 $\frac{3}{4}$ (8.9 x 7.0)
Private Collection, Photograph courtesy
the Museum of Fine Arts, Boston

93. Edward Greene Malbone (1777–1807)
Thomas Russell, c. 1796
Watercolor on ivory, 2 $\frac{3}{4}$ x 2 $\frac{15}{16}$ (7.0 x 7.5)
Cincinnati Art Museum, Gift of the Fleischmann
Foundation in memory of Julius Fleischmann

94. John Trumbull (1756–1843)
*Hon. Thomas Russell and Mrs. Thomas Russell
(Elizabeth Watson)*, between 1789 and 1794
Oil on canvas, 18 x 10 (45.7 x 25.4)

Location unknown, reproduced from a
photograph in the archival files of Theodore
Sizer, Yale University Art Gallery

95. Cobalt-glass surround, inner rose-gold-over-
copper tooth rim, and inset oval compartment
containing lock of hair on card covered
with white silk on reverse of Malbone, *Thomas
Russell* (fig. 90)

96. Edward Greene Malbone (1777–1807)
Archibald Taylor (c. 1750–1821), 1802
Watercolor on ivory, 2 $\frac{15}{16}$ x 2 $\frac{1}{4}$ (7.5 x 5.7)
Inscribed on back of card used to support
hair plaid, a portion of a recipe: ". . . parts
water/6 parts wax/part [?] of tartar/the wax
to be shaved and to/be stirred in [?] the
water./Gum mastik to"
Lelia A. and John Hill Morgan Collection,
1940.507

97. Edward Greene Malbone (1777–1807)
Mrs. Richard Sullivan (Sarah Russell)
(1786–1831), 1804
Watercolor on ivory, 3 $\frac{3}{8}$ x 2 $\frac{11}{16}$ (8.6 x 6.8)
Lelia A. and John Hill Morgan Collection,
1948.259

98. William M. S. Doyle (1769–1828)
David Bradlee (1786–1814), 1813
Watercolor on ivory, 3 x 2 $\frac{7}{16}$ (7.6 x 6.2)
Signed and dated l.r.: "Doyle 1813"
Promised Bequest of Davida Tenenbaum
Deutsch and Alvin Deutsch, LL.B. 1958,
in honor of Kathleen Luhrs, ILE1999.3.3

99. Matte gold fillet, rose-gold surround, inner rim
of half-pearls, and inset oval compartment
containing opal glass over scallop-patterned
embossed foil with two hair feathers and
half-pearl and gold wire decoration on reverse
of Doyle, *David Bradlee* (fig. 98)

100. William M. S. Doyle (1769–1828)
Young Lady in a Sheer White Dress, c. 1805
Watercolor on ivory, 2 ¾ x 2 ¹⁵/₁₆ (7.0 x 7.5)
Signed l.r.: "Doyle"
Promised Bequest of Davida Tenenbaum
Deutsch and Alvin Deutsch, LL.B. 1958,
in honor of Kathleen Luhrs, ILE1999.3.2

101. Painting on back of ivory of Doyle,
Young Lady in a Sheer White Dress (fig. 100)

102. Mary Way (1769–1833)
Gentleman, c. 1800
Collage-appliqué on fabric, 2 ⅝ x 2 (6.7 x 5.1)
Lelia A. and John Hill Morgan Collection,
1940.532

103. Mary Way (1769–1833)
Child of the Briggs Family, c. 1820
Watercolor on ivory, 1 ½ x 1 ³/₁₆ (3.8 x 3.0)
Gift of Mildred S. Prince, 1969.37.3

104. Mary Way (1769–1833)
Mrs. Charles Briggs (Elizabeth Bassal Meiller),
c. 1820
Watercolor on ivory, 2 ¹/₁₆ (5.2) diameter
Gift of Mildred S. Prince, 1969.37.2

105. Mary Way (1769–1833)
Charles Briggs, c. 1820
Watercolor on ivory, 2 ¹/₁₆ (5.2) diameter
Gift of Mildred S. Prince, 1969.37.1

106. James Peale (1749–1831)
Rembrandt Peale (1788–1860), 1795
Watercolor on ivory, 2 ⁵/₁₆ x 1 ¹³/₁₆ (5.9 x 4.6)
Signed and dated in red watercolor l.r.:
"IP/1795"
Lelia A. and John Hill Morgan Collection,
1940.510

107. Raphaelle Peale (1774–1825)
Robert Kennedy (1770–1849), 1799
Watercolor on ivory, 3 ⁹/₁₆ x 2 ¹⁵/₁₆ (9.0 x 7.5)
Signed and dated in watercolor c.r.: "RP./99"
Mabel Brady Garvan Collection, 1936.304

108. Raphaelle Peale (1774–1825)
John Frederick Rohr, c. 1805
Watercolor on ivory, 2 ½ x 2 (6.4 x 5.1)
Promised Bequest of Davida Tenenbaum
Deutsch and Alvin Deutsch, LL.B. 1958,
in honor of Kathleen Luhrs, ILE1999.3.12

109. Raphaelle Peale (1774–1825)
Commander Samuel Woodhouse (1784–1843),
1816 or 1817
Watercolor on ivory, 2 ⁷/₁₆ x 2 (6.2 x 5.1)
Reverse engraved "COMR SAML
WOODHOUSE/U.S. Navy" with image
of upraised forearm branding club
and emerging from clouds
Promised Bequest of Davida Tenenbaum
Deutsch and Alvin Deutsch, LL.B. 1958,
in honor of Kathleen Luhrs, ILE1999.3.13

110. Attributed to Thomas Birch (1779–1851)
Captain James Lawrence (1781–1813), c. 1810–13
Watercolor on ivory, 2 ¹¹/₁₆ x 2 (6.8 x 5.1)
Promised Bequest of Davida Tenenbaum
Deutsch and Alvin Deutsch, LL.B. 1958,
in honor of Kathleen Luhrs, ILE1999.3.64

111. Anna Claypoole Peale (1791–1878)
Andrew Jackson (1767–1845), 1819
Watercolor on ivory,
3 ⅛ x 2 ⁷/₁₆ (7.9 x 6.2) sight
Signed and dated l.r.: "Anna C./Peale/1819"
Mabel Brady Garvan Collection, 1936.302

112. Charles Willson Peale (1741–1827)
James Peale by Lamplight, 1822
Oil on canvas, 24 ½ x 36 (62.2 x 91.4)

The Detroit Institute of Arts, Founders Society
Purchase with Funds from Dexter M. Ferry, Jr.

113. Anna Claypoole Peale (1791–1878)
Rosalba Peale, (1799–1874), 1822
Watercolor on ivory, 3 ⅛ x 2 ¾ (7.9 x 7.0)
The Detroit Institute of Arts, Founders Society
Purchase, Gibbs-William Fund

114. Anna Claypoole Peale (1791–1878)
Eleanor Britton (Mrs. William Musgrave), 1821
Watercolor on ivory, 2 ⁷⁄₁₆ x 1 ¹⁵⁄₁₆ (6.2 x 4.9)
Signed l.l.: "Anna C/Peale/1821"
Lelia A. and John Hill Morgan Collection,
1940.513

115. Anna Claypoole Peale (1791–1878)
Lady with a Shawl, 1821
Watercolor on ivory, 2 ¹⁵⁄₁₆ x 2 ⁵⁄₁₆ (7.5 x 5.9)
Signed and dated l.l.: "Anna C Peale/1821"
Gift of Mrs. Anthony N. B. Garvan, 1999.32.1

116. Andrew Robertson (England, 1777–1845)
Lieutenant John Trumbull Ray (c. 1792–?), 1814
Watercolor on ivory, 3 ³⁄₁₆ x 2 ½ (8.1 x 6.4)
Gift of Maria Trumbull Dana, 1938.62

117. Anson Dickinson's trade card found on
reverse of Anson Dickinson (1779-1852),
Gentleman of the Dunlap Family, 1819
Watercolor on ivory, 2 ¹¹⁄₁₆ x 2 ⅜ (6.8 x 6.0)
Trade card inscribed "A. Dickinson/MINIATURE
PAINTER /222 Broad Way/New York."
Lelia A. and John Hill Morgan Collection,
1940.496

118. Anson Dickinson's paintbox, brushes
(called pencils), and reducing glass
The Stamford Historical Society,
Stamford, Conn.

119. Anson Dickinson (1779–1852)
General Epaphroditus Champion
(1756–1834 or 1835), 1825
Watercolor on ivory, 3 ⁵⁄₁₆ x 2 ¹¹⁄₁₆ (8.4 x 6.8)
Signed l.r.: "A. Dickinson/1825"
Gift of Francis Bacon Trowbridge, B.A. 1887,
LL.B. 1890, 1943.31

120. Anson Dickinson (1779–1852)
Mrs. Epaphroditus Champion (Lucretia Hubbard)
(1760–1836), 1825
Watercolor on ivory, 3 ⁵⁄₁₆ x 2 ¹¹⁄₁₆ (8.4 x 6.8)
Signed c.r.: "A Dickinson/1825"
Gift of Francis Bacon Trowbridge, B.A. 1887,
LL.B. 1890, 1943.32

121. Anson Dickinson (1779–1852)
The Honorable Asa Bacon (1771–1857), 1825
Watercolor on ivory, 3 ⁵⁄₁₆ x 2 ¹¹⁄₁₆ (8.4 x 6.8)
Signed l.r.: "A. Dickinson/1825"
Gift of Francis Bacon Trowbridge, B.A. 1887,
LL.B. 1890, 1943.33

122. Anson Dickinson (1779–1852)
Epaphroditus Champion Bacon (1810–45) B.A.
1833, M.A. 1856, c. 1835
Watercolor on ivory, 3 ⅛ x 2 ½ (7.9 x 6.4)
Gift of Francis Bacon Trowbridge, B.A. 1887,
LL.B. 1890, 1943.34

123. Charles Fraser (1782–1860)
Self-Portrait, 1823
Watercolor on ivory, 4 ⁵⁄₁₆ x 3 ⁹⁄₁₆ (11.0 x 9.0)
Carolina Art Association, Gibbes Museum
of Art, Charleston, S.C., Gift of J. Alwyn Ball

124. Charles Fraser (1782–1860)
H. F. Plowden Weston (1738–1827), 1824
Watercolor on ivory, 3 ¹³⁄₁₆ x 3 ¼ (9.7 x 8.2)
Signed l.r.: "CF"
Carolina Art Association, Gibbes Museum
of Art, Charleston, S.C., Purchase, Kammerer
Fund, in memory of Helen G. McCormack

125. Charles Fraser (1782–1860)
Young Lady in White, c. 1820–25
Watercolor on ivory, 3 ⅛ x 2 ⅜ (7.9 x 6.0)
Signed in iron gall ink on backing paper l.l.:
"C Fraser"
Provenance unknown, 1972.140.1

126. Charles Fraser (1782–1860)
Mrs. Theodore Gourdin (Elizabeth Gaillard)
(1766–1835), 1826
Watercolor on ivory, 2 ¹⁄₁₆ x 2 ¹⁄₁₆ (5.2 x 5.2)
Lelia A. and John Hill Morgan Collection,
1940.501

127. Unidentified artist, formerly attributed
to Fraser
Theodore Gourdin (1764–1826),
probably 1813–15
Reverse of Fraser, *Mrs. Theodore Gourdin*
(fig. 126)
Watercolor over graphite pencil on ivory,
2 ¹⁄₁₆ x 2 ¹⁄₁₆ (5.2 x 5.2)

128. Charles Fraser (1782–1860)
Mrs. John LaBruce (Martha Pawley)
(1766–1822), 1828
After a portrait by Samuel F. B. Morse, 1819
Watercolor on ivory, 3 ⅞ x 3 ⅛ (9.8 x 7.9)
Signed and dated in watercolor on reverse
of backing card l.c.: "C Fraser, 1828"
Mabel Brady Garvan Collection, 1935.254

129. Samuel F. B. Morse (1791–1872)
Mrs. John LaBruce (Martha Pawley)
(1766–1822), c. 1819
Oil on canvas, 30 x 25 (76.2 x 63.5)
Private Collection

130. Sarah Goodridge (1788–1853)
Beauty Revealed (Self-Portrait), 1828
Watercolor on ivory, 2 ⅝ x 3 ⅛ (6.7 x 7.9)
Gloria Manney Collection

131. Unidentified artist, probably British
Eye, c. 1805–10
Watercolor on ivory, ¹¹⁄₁₆ x ¾ (1.7 x 1.9) sight
Lelia A. and John Hill Morgan Collection,
1940.538

132. Henry Inman (1801–46)
William Samuel Johnson (1795–1883),
probably 1823–24
Watercolor on ivory, 2 ¾ x 2 ¼ (7.0 x 5.7)
Gift from the estate of Geraldine Woolsey
Carmalt, 1968.12.5

133. Henry Inman (1801–46)
Mrs. William Samuel Johnson (Laura Woolsey)
(1800–80), probably 1823–24
Watercolor on ivory, 3 ⅛ x 2 ½ (7.9 x 6.4)
Gift from the estate of Geraldine Woolsey
Carmalt, 1968.12.6

134. Thomas Seir Cummings (1804–94)
Thomas Cole (1801–48), probably 1828 or 1829
Watercolor on ivory, 3 ¼ x 2 ⅝ (8.3 x 6.7)
Mabel Brady Garvan Collection, 1948.225

135. James Passmore Smith (1803 or 1804–88)
Self-Portrait, c. 1830–35
Watercolor on ivory, 1 ¼ x 1 ⅛ (4.4 x 3.5) sight
Promised Bequest of Davida Tenenbaum
Deutsch and Alvin Deutsch, LL.B. 1958,
in honor of Kathleen Luhrs, ILE1999.3.16

136. Jacob Eichholtz (1776–1842)
James P. Smith (1803 or 1804–88), c. 1835
Oil on canvas, 29 ¾ x 25 (75.5 x 63.5)
Andrew W. Mellon Collection © 1999
Board of Trustees, National Gallery of Art,
Smithsonian Institution, Washington, D.C.

137. Lid of gutta percha Union case containing
Mrs. Russell, *Child in a Pink Dress* (fig. 138)

138. Mrs. Moses B. Russell (Clarissa Peters)
(1809–54)
Child in a Pink Dress, c. 1850
Watercolor on ivory, 2 7/16 x 1 7/8 (6.2 x 4.8)
Promised Bequest of Davida Tenenbaum
Deutsch and Alvin Deutsch, LL.B. 1958,
in honor of Kathleen Luhrs, ILE1999.3.39

139. Closed lid of engraved gold locket containing
Unidentified artist,
Lady of the Sully Family (fig. 140)
Engraved "MAS"

140. Unidentified artist
Lady of the Sully Family, c. 1844
Watercolor on ivory, 1 7/8 x 1 1/2 (4.8 x 3.8)
On inside of locket inscribed c.r.:
"Geo W Webb/Balto/1844/25 dolls";
and u.c.: "RW"; printed on card inside locket:
"YOUNG CATHOLIC'S/LECTURE/COURSE"
Lelia A. and John Hill Morgan Collection,
1940.521

141. Unidentified artist
Gentleman, c. 1850–52
Hand-tinted daguerreotype,
1 7/8 x 1 9/16 (4.8 x 4.0) sight,
set in gold locket with foliate chased rim, barrel
bail, and hanger attached to hairwork watch
chain with gold-over-white-metal findings
Private Collection

142. Unidentified artist with the initials J.H.
Anne Sherman, 1896
Opalotype (hand-colored photograph on opal
or white glass), 4 1/2 x 3 7/8 (11.4 x 9.8) sight
Signed l.r.: "J.H. 1896"
Provenance unknown, 1988.8.1

143. Albert Sands Southworth (1811–94)
and Josiah Johnson Hawes (1808–1901)
Young Girl, Hand on Shoulder
Hand-tinted whole-plate daguerreotype,
6 1/2 x 8 1/2 (16.5 x 21.6)
Matthew R. Isenburg Collection

144. George Hewitt Cushman (1814–76)
Susan Wetherill (Mrs. George Hewitt Cushman)
(1817–57), c. 1843–45
Watercolor on ivory, 3 1/4 x 2 11/16 (8.3 x 6.8)
Gift of Miss Alice Cushman, 1940.45

145. Cushman, *Susan Wetherill* (fig. 144),
showing miniature uncased

146. John Henry Brown (1818–91)
Catherine Bohlen (probably 1830-?), 1850
Watercolor on ivory, 4 7/16 x 3 3/8 (11.3 x 8.6)
Dated in white opaque watercolor l.c.: "1850"
John Hill Morgan, B.A. 1893, Fund,
1998.21.1

Page numbers in *italics* refer to illustrations.